2 0 JAN 2014 CHURCH E
 LIBRARY
2 0 JUN 2014 020 8359 3800

KT-195-532

Oxford History of Art

Malcolm Andrews is Professor of Victorian and Visual Studies at the University of Kent at Canterbury. His publications on landscape art include *The Search for the Picturesque: Landscape Aesthetics and Tourism in Britain,* 1760–1800 (1989), and *The Picturesque: Sources and Documents,* three vols (1994). He is editor of the journal *The Dickensian* and author of the study *Dickens and the Grown-up Child* (1994).

30131 03937504 0

LONDON BOROUGH OF BARNET

Oxford History of Art

Titles in the Oxford History of Art series are up-to-date, fully illustrated introductions to a wide variety of subjects written by leading experts in their field. They will appear regularly, building into an interlocking and comprehensive series. In the list below, published titles appear in bold.

WESTERN ART

Archaic and Classical Greek Art
Robin Osborne

Classical Art From Greece to Rome
Mary Beard & John Henderson

Imperial Rome and Christian Triumph
Jas Elsner

Early Medieval Art
Lawrence Nees

Medieval Art
Veronica Sekules

Art in Renaissance Italy
Evelyn Welch

Northern European Art
Susie Nash

Early Modern Art
Nigel Llewellyn

Art in Europe 1700–1830
Matthew Craske

Modern Art 1851–1929
Richard Brettell

After Modern Art 1945–2000
David Hopkins

Contemporary Art

WESTERN ARCHITECTURE

Greek Architecture
David Small

Roman Architecture
Janet Delaine

Early Medieval Architecture
Roger Stalley

Medieval Architecture
Nicola Coldstream

Renaissance Architecture
Christy Anderson

Baroque and Rococo Architecture
Hilary Ballon

European Architecture 1750–1890
Barry Bergdoll

Modern Architecture
Alan Colquhoun

Contemporary Architecture
Anthony Vidler

Architecture in the United States
Dell Upton

WORLD ART

Aegean Art and Architecture
Donald Preziosi & Louise Hitchcock

Early Art and Architecture of Africa
Peter Garlake

African Art
John Picton

Contemporary African Art
Olu Oguibe

African-American Art
Sharon F. Patton

Nineteenth-Century American Art
Barbara Groseclose

Twentieth-Century American Art
Erika Doss

Australian Art
Andrew Sayers

Byzantine Art
Robin Cormack

Art in China
Craig Clunas

East European Art
Jeremy Howard

Ancient Egyptian Art
Marianne Eaton-Krauss

Indian Art
Partha Mitter

Islamic Art
Irene Bierman

Japanese Art
Karen Brock

Melanesian Art
Michael O'Hanlon

Mesoamerican Art
Cecelia Klein

Native North American Art
Janet Berlo & Ruth Phillips

Polynesian and Micronesian Art
Adrienne Kaeppler

South-East Asian Art
John Guy

Latin American Art

WESTERN DESIGN

Twentieth-Century Design
Jonathan Woodham

American Design
Jeffrey Meikle

Nineteenth-Century Design
Gillian Naylor

Fashion
Christopher Breward

PHOTOGRAPHY

The Photograph
Graham Clarke

American Photography
Miles Orvell

Contemporary Photography

WESTERN SCULPTURE

Sculpture 1900–1945
Penelope Curtis

Sculpture Since 1945
Andrew Causey

THEMES AND GENRES

Landscape and Western Art
Malcolm Andrews

Portraiture
Shearer West

Eroticism and Art
Alyce Mahon

Beauty and Art
Elizabeth Prettejohn

Women in Art

REFERENCE BOOKS

The Art of Art History: A Critical Anthology
Donald Preziosi (ed.)

Oxford History of Art

Landscape and Western Art

Malcolm Andrews

OXFORD
UNIVERSITY PRESS

FOR JACK, OLIVER, AND BEN, WITH LOVE

Oxford University Press, Great Clarendon Street, Oxford OX2 6DP
Oxford New York
Athens Auckland Bangkok Bogotá Buenos Aires
Cape Town Chennai Dar es Salaam Delhi Florence
Hong Kong Istanbul Karachi Kolkata Kuala Lumpur
Madrid Melbourne Mexico City Mumbai Nairobi Paris
São Paulo Shanghai Singapore Taipei Tokyo Toronto Warsaw
and associated companies in
Berlin Ibadan

Oxford is a trade mark of Oxford University Press

Published in the United States by Oxford University Press Inc., New York

© Malcolm Andrews 1999

First published 1999 by Oxford University Press

All rights reserved. No part of this publication may be reproduced, stored in a retrieval
system, or transmitted, in any form or by any means, without the prior permission in writing
of Oxford University Press. Within the UK, exceptions are allowed in respect of any fair
dealing for the purpose of research or private study, or criticism or review, as permitted under
the Copyright, Designs and Patents Act, 1988, or in the case of reprographic reproduction in
accordance with the terms of the licences issued by the Copyright Licensing Agency.
Enquiries concerning reproduction outside these terms and in other countries should be sent
to the Rights Department, Oxford University Press, at the address above.

This book is sold subject to the condition that it shall not, by way of trade or otherwise, be
lent, re-sold, hired out or otherwise circulated without the publisher's prior consent in any
form of binding or cover other than that in which it is published and without a similar
condition including this condition being imposed on the subsequent purchaser.

British Library Cataloguing in Publication Data
Data available

Library of Congress Cataloging in Publication Data
Data available

0-19-284233-1 Pbk

10 9 8 7 6 5 4 3 2

Picture research by Elizabeth Agate
Designed by Esterson Lackersteen
Typeset by Paul Manning

Printed in Hong Kong on acid-free paper
by C&C Offset Printing Co., Ltd

BARNET LIBRARIES	
Cypher	16.07.04
704.943	£11.99

Contents

Acknowledgements

Among the very many friends and colleagues from whose enthusiasm and expertise in landscape studies I have benefited over many years, I would like to mention particularly those who have read and commented on various early drafts for this book: Stephen Bann, Roger Cardinal, Maurice Raraty, Richard Andrews, Alan Millen. Their help, criticism and encouragement have been invaluable. So too have Simon Mason's risk-taking invitation to me to write this book, his continual support for it in its exploratory stages, and his courteous spurring in its later stages. I also owe much to Lisa Agate's perseverance in tracking down the pictures and her enthusiasm for the project, and to Lynn Brown's vigilant editorial discrimination. My gratitude to my family's patience with a distracted father and husband over a long period has perhaps been more appreciated than demonstrated, and this acknowledgement is a very small return. To have had so much support from friends and family in writing a book on a subject I so love is quite extraordinary good fortune.

Malcolm Andrews

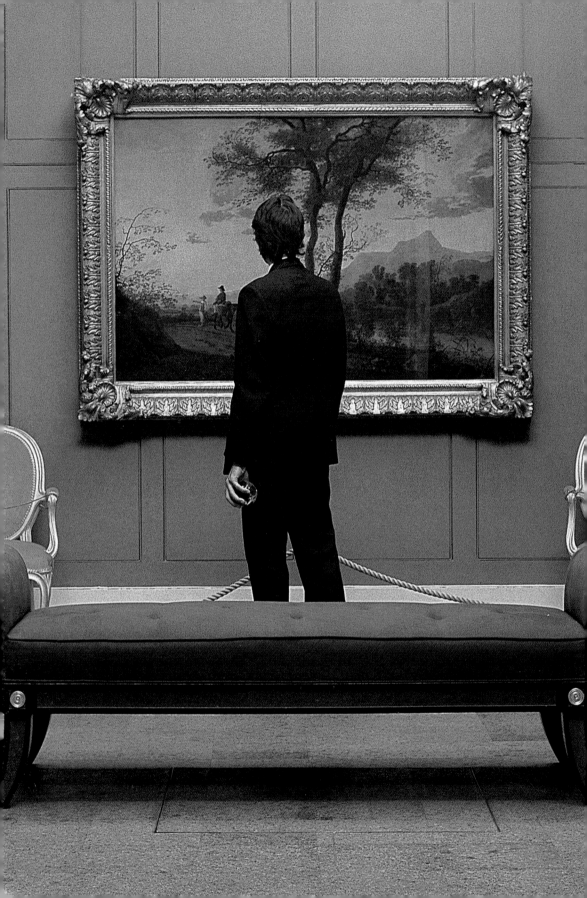

Land into Landscape

1

A 'landscape', cultivated or wild, is already artifice before it has become the subject of a work of art. Even when we simply *look* we are already shaping and interpreting. A landscape may never achieve representation in a painting or photograph; none the less, something significant has happened when land can be perceived as 'landscape'. We may well follow an impulse to sketch or photograph a particular tract of land in view and call the resulting picture 'a landscape', but it is not the formal making of an artistic record of the view that has constituted the land as landscape. Whether or not we are artists, we have been making this kind of mental conversion for centuries. The habit is part of the whole history of our relationship with the physical environment, and the visual tradition of landscape representation from the start has been one vital element in that relationship.

Landscape pictures breed landscape pictures, and one can—as this book will—trace various typological genealogies in this genre. Landscape pictures also breed visual prejudices that may never find formal expression in works of art, but that are crucial shaping influences in terms of the way in which we privately respond both to our natural environment and to pictures of that environment. The illustrations in this book include many familiar images—their very familiarity has contributed to the way in which we perceive land as landscape. These works of art are not the end products, nor are they the initiating stimulants in the whole process of perception and conversion. They happen along the way. We may not recognize the extent to which we are involved in this process, especially if we see ourselves simply as consumers rather than creative producers of landscape images.

A measure of the degree to which we seem, quite understandably, to have become detached consumers can be gauged from a photograph by Karen Knorr, *Pleasures of the Imagination: Connoissseurs* (1986) [1]. In this image, the immaculate symmetry of the room, its cool, classical decor, its controlled, evenly distributed lighting, its smooth, sedative contours, all represent a highly refined, civilized chamber for viewing

scenes of the natural world that have little or nothing in common with the way this interior space is organized. The painted landscapes have rough textures, freely proliferating and ramifying organic forms, asymmetrical compositions, highly variegated lighting and measureless depths. Their heavy gilt frames mark them off as objects of high value, a status reinforced by the discreet cordon. The photograph's title, *Pleasures of the Imagination: Connoisseurs*, is no doubt ironic. One wonders what imaginative pleasure the lone, suited spectator is enjoying, as he pauses to look at the large landscape, his body half angled towards it, casually: 'Viewers tend to devour images without digesting them,' observes Karen Knorr.[1]

What does it mean to consume a painted image? What does 'landscape' represent in this context? A rarefied, privileged experience, confined to a cultural elite? If so, what has happened to the sense that the natural world is free and open to us all? How much of the encounter between the visitor and the landscape painting is true connoisseur appraisal, and how much a daydream of venturing into the seductive world depicted on the canvas? What relation does the loitering gallery visitor feel he has to the loitering figures in the landscapes; and what relation do we feel *we* in turn have to both the visitor, right in the centre of Knorr's photograph, and the painted figures?

Such questions seem endlessly ramifying and they go to the heart of the issues discussed in the chapters that follow. The book is not intended to be a history of landscape painting or more broadly of landscape art. Even a potted history of the subject would be barely manageable now, given the geographical scope indicated in my title. What I intend here is to take up some questions of the kind already raised in my preamble. It is my concern not merely to conduct the reader through another kind of art gallery, or more particularly through those rooms devoted to 'Landscapes' (although that is an agreeable enough activity), but to raise questions about our relationship with the subject of landscape and its representation over the last 500 years in Europe and North America. Sometimes such questions will be focused on certain 'moments' in the history of landscape art (in Chapters 2 and 4, for example). These moments will follow a historical chronology for the most part, so that some sense of the continuity of traditions in landscape art will be highlighted. However, that kind of diachronic study will be linked to more purely conceptual enquiries, and there will be chapters that are more thematically based (Chapter 6, for example). All this amounts to a stocktaking exploration of the idea of landscape and of aspects of its multifaceted expression over a long span of cultural history in the West.

Half a century ago, Kenneth Clark wrote a pioneering study of landscape painting and entitled it *Landscape into Art*. That title assumed a

fairly simple relationship between its two substantives: for 'landscape' meant a good view of a stretch of countryside, while 'art' was what happened to that landscape when it was translated into a painted image by a person with vision, flair and technical skill. In Clark's title, landscape was the raw material waiting to be processed by the artist. I began by implying that land rather than landscape is the raw material, and that in the conversion of land into landscape a perceptual process has already begun whereby that material is prepared as an appropriate subject for the painter or photographer, or simply for absorption as a gratifying aesthetic experience. The process might, therefore, be formulated as twofold: land into landscape; landscape into art.

Two questions immediately arise. What constitutes landscape as distinct from land? And (for later consideration) who is this 'we' assumed in my generalizations about the response to landscape? The etymology of the word landscape I leave for the next chapter. Here, I am concerned less with the history of the meaning of the term than with its present vernacular currency. In judging what is a 'good view' we are preferring one aspect of the countryside to another. We are selecting and editing, suppressing or subordinating some visual information in favour of promoting other features. We are constructing a hierarchical arrangement of the components within a simple view so that it becomes a complex mix of visual facts and imaginative construction. The process of marking off one particular tract of land as aesthetically superior to, or more interesting than, its neighbours is already converting that view into the terms of art; it is what we do as we aim the camera viewfinder. This description of the intricate process of discrimination needed to produce a landscape makes it sound inordinately busy; for it has become so much a habit as to seem now little more than a perceptual reflex. On the other hand, some would maintain that our response to country scenery is actually just the reverse, that it is one of the few utterly simple pleasures we have, an almost spontaneous act of appreciation of which anyone and everyone is capable. It is, so the argument goes, an instinctive human response that cultural influences may colour and modify but not originate. Later, I shall return to this question of landscape appraisal as something instinctive.

The relationship between these two positions has exercised recent thinking about landscape and human responses to it. The 'constructionist' view, as I shall call it, has dominated during the last few decades. E. H. Gombrich's ground-breaking study *Art and Illusion* (1960) was a particular stimulus in this respect. 'The innocent eye is a myth', he argued. 'All thinking is sorting, classifying. All perceiving relates to expectations and therefore to comparisons.'[2] Gombrich's account, drawing on perceptual psychology, reinforces the constructionist

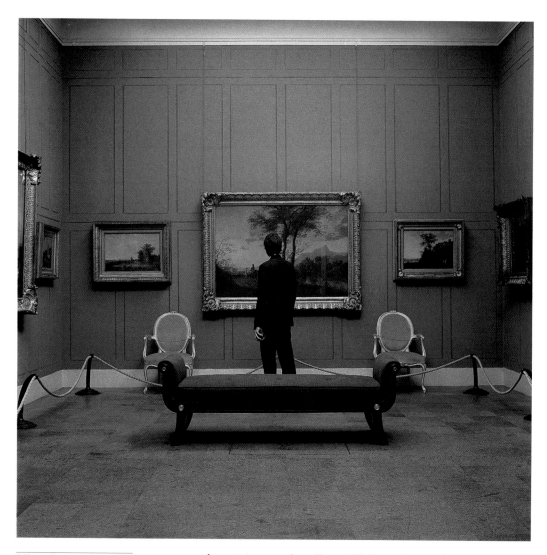

1 Karen Knorr

*Pleasures of the Imagination:
Connoisseurs*, 1986

argument that we carry culturally prefabricated mental templates with us wherever we go and that what we see and reflect upon is continually adjusted to these templates. What is new is always accommodated to what is familiar. The value and meaning derived from this experience—of landscape, for instance—then becomes a matter of how culturally constituted the viewer is, and that will be different with each viewer. Such relativist, constructionist beliefs insist that the aesthetic value of a landscape is not inherent in the spectacle—not a part of its 'essence'—but 'constructed' by the perceiver.

A landscape, then, is what the viewer has selected from the land, edited and modified in accordance with certain conventional ideas about what constitutes a 'good view'. It is land organized and reduced to the point where the human eye can comprehend its breadth and depth within one frame or short scan. I asked my 13-year-old son what

he thought 'landscape' meant. He replied, 'A scene in the country.' I then asked him, 'When you go for a walk in the countryside, do you see that whole area as "the landscape", or do you see, as you walk, several "landscapes" in that area?' 'Several', was the reply; and, after a pause, 'It's weird, isn't it?' For him landscape was not identical with the countryside: the countryside had a repertoire of several scenes visually auditioning to be landscapes. What, then, constitutes a 'scene'? Does every view during a walk qualify as a scene? Can we arrest the moving panorama at any point and be satisfied that the segment of land now in focus is a landscape?

The landscape acquires significant organization as a result of certain extrinsic and intrinsic factors. A frame establishes the outer boundaries of the view; it gives the landscape definition. The frame literally defines the landscape, both in the sense of determining its outer limits and in the sense that landscape is constituted by its frame: it wouldn't be a landscape without that frame. The landscape may also be internally focused and organized by its relation to what is non-landscape—a human figure in heroic action, for instance. That narrative element is what used to be termed the 'Argument' of the picture, that is, its principal theme or subject. Remove the frame, empty out the Argument, and the landscape spills into a shapeless gathering of natural features. It has nothing to contain or shape its constituents, nothing to environ, nothing for which to be a setting, nothing to supplement.

A teasing allegorical dramatization of the reversal of this spillage, one in which Argument imperiously organizes wilderness simply by its presence, can be found in a poem by Wallace Stevens, 'Anecdote of the Jar', from *Harmonium* (1923):

> I placed a jar in Tennessee,
> And round it was, upon a hill.
> It made the slovenly wilderness
> Surround that hill.
>
> The wilderness rose up to it,
> And sprawled around, no longer wild.
> The jar was round upon the ground
> And tall and of a port in air.
>
> It took dominion everywhere.
> The jar was gray and bare.
> It did not give of bird or bush,
> Like nothing else in Tennessee.

The poem proposes a dynamic relationship between two objects or conditions that appear to have nothing at all to do with each other: a round grey jar and a wilderness region of Tennessee. Once the jar was

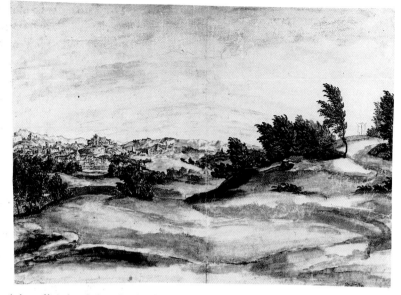

'placed', it both 'made the slovenly wilderness / Surround' the hill, and also made the wilderness 'no longer wild'. What might be thought the most minimal intervention has the effect of transforming a vast, unruly area of land: the jar 'took dominion everywhere'.

At the risk of disturbing the enigmatic charm of the poem, one might speculate on the levels of significance beneath the surface simplicity of these images. The jar is an artefact, a product of civilization. The slovenly wilderness is untamed, uncharted, an image perhaps of primal chaos. So we might read the poem as a kind of allegory, telling of the transformation of the wilderness into an ordered, habitable domain, a version of the birth of civilization. A mere jar has the effect of transforming a region of wilderness into a comprehensible landscape, not by an act of clearance or by remodelling the land, but simply by being placed there. Once the jar is introduced, the wilderness seems suddenly to orientate itself. It 'rose up to it / And sprawled around, no longer wild' but obeying the pull of a force field.

Wolf Huber's (*c.*1490–1553) *Landscape with Golgotha* (*c.*1525–30) [2] seems almost to be testing out the relationship between landscape and Argument. The watercolour view seems peculiarly inconsequential, as if waiting for the introduction of the Argument. In fact, the Argument, or the scaffolding for it, is vestigially present: the crosses on Golgotha recede almost to invisibility on the horizon to the right; the city in the background is presumably Jerusalem. Neither of these narrative features, however, commands the picture. Instead we are left with the strange arena stretching right across the foreground, like an empty stage waiting for the human action to begin. Is the subject an unfinished religious painting? Is it a topographical view? A landscape *capriccio*?

The presence of Argument, the embodiment of a principal thematic motif, subordinates the landscape setting. Indeed, Argument used to be seen in opposition to 'by-work' or *parergon*, the accessory element. Jacques Derrida (b. 1930) has questioned the traditional assumptions about the marginality of *parergon*.[3] Characteristically, he challenges the outside–inside, centre–periphery antitheses implied in the term: *par* means 'alongside' or 'against', *ergon* means 'work', that is, the main subject, the Argument; so 'by-work' is a reasonable translation. 'A *parergon* comes against, beside, and in addition to, the *ergon* … the work, but it does not fall to one side, it touches and co-operates within the operation, from a certain outside.' Bit by bit, Derrida shows how porous is the barrier between *ergon* and *parergon* in the examples he borrows from Immanuel Kant's (1724–1804) *Critique of Judgment*: the drapery on near-nude statues and the frames for paintings are types of *parerga*, accessories, ornaments. In the first instance the *ergon* is the nude (literally as well as figuratively it is the 'body') and the drapery is the ornamental extra. But the body as 'nude' is partly constituted by the co-presence of the drapery. The nude needs the *parergon* drapery to reinforce the sense of nudity; so it is dependent upon, and collaborative with, the so-called ornamental extra, and that ornamental extra loses its status as independent, dispensable supplement. The presence of the supplement signals 'an internal lack in the system to which it is added'.

These are fruitful cautions and encourage us to think that the traditionally inferior status of landscape in art, which is inherent in the term by-work (as opposed to the terms body and Argument), has allowed us often to overlook or marginalize the significance of its function. We will be looking again, in subsequent chapters, at the play between outside and inside, subject and accessory, centre and periphery where landscape is concerned.

Landscape, whether as *parergon* or Argument, is mediated land, land that has been aesthetically processed. It is land that has arranged itself, or has been arranged by the artistic vision, so that it is ready to sit for its portrait. But how do we know when it is ready to sit for its portrait? One of the many resonant generalizations offered by Kenneth Clark is this: 'with the exception of love, there is perhaps nothing else by which people of all kinds are more united than by their pleasure in a good view'.[4] Clark makes this comment at the beginning of a chapter on what he calls 'the natural vision', in which he goes on to explore what he acknowledges to be the revolutionary changes of taste in landscape associated with the work of John Constable (1776–1837). The two points seem to be in contradiction: the implicitly essentialist consensus over what makes a 'good view'; and the acknowledged changeability of tastes in landscape. Are there

values in landscape that transcend cultural differences? We are back to the same fundamental dilemma, whether we call it 'relativist/ absolutist', 'constructionist/essentialist', or whatever.

We are dealing with landscape here as an idea and as an experience in which we are creatively involved, whether or not we are practising artists. In spite of the elegant ironies in Karen Knorr's photograph [1], we are not passive consumers of landscape images. Our sense of our own identity and relationship to our environment is implicated in our response to such pictures, as might be suggested in the ambiguous attitude of the man in Karen Knorr's photograph. Landscape in art tells us, or asks us to think about, where we belong. Important issues of identity and orientation are inseparable from the reading of meanings and the eliciting of pleasure from landscape. The connection between such fundamental issues and our perception of the natural world is a key reason for the proliferation of images of landscape over the last 500 years in the West, and particularly over the last 250 years.

This brings us to the other question posed near to the beginning of this chapter: the identity of the 'we' I have presumptuously enlisted in these speculations about the constitution of landscape. Most readers of this volume on *Landscape*, in this series on the history of art, are likely to recognize the common culture signalled in the book's title, the culture founded on western European traditions. Just as many of the images of landscape in the book's illustrations will be familiar to such readers, so the kind of generalizations I have been making about standards of beauty in landscape terms will seem familiar. However, we have only to ask ourselves a few questions in order to realize the extent to which landscape appreciation depends as much, if not more, on learned rather than innate criteria. The implied consensus in 'we' then becomes distinctly unstable. For instance, ask an 8-year-old if he or she likes a certain landscape and, if so, why. He or she might talk about the size of the hills, the distance of the view, the colours of fields and woods and so on, and that will probably exhaust his or her interest in the question. Does that child have a concept of a particular entity, 'landscape', as distinct from the experience of a random variety of natural phenomena assembled within the view? Is the child able or willing to consider the *ways* in which those natural forms are arranged in the scene? In other words, to what extent is that child aware of what he or she sees as a landscape as distinct from land? Young children frequently seem baffled and bored by the kind and degree of attention grown-ups pay to the beauties of natural scenery, from which one might infer that the appreciation of landscape is an acquired taste.

A particularly interesting meditation on the evolving human sense of land as landscape is to be found in William Wordsworth's

(1770–1850) poem 'Lines Written a few Miles above Tintern Abbey' (1798), against which any of us may test our own experience. 'Tintern Abbey', drawing on the poet's perception of his own early life, offers a developmental model of the changing appreciation of natural scenery. Three stages are identified. The earliest stage recalled is of the 'coarser pleasures' of his childhood enjoyment of nature as an arena for physical recreation. He writes of those 'glad animal movements' which pass away with childhood. The second stage is one where, as a young man in his early twenties, he experienced nature as a source of sensuous re-freshment. All his senses were alive to the forms, colours and sounds of the natural world:

> The sounding cataract
> Haunted me like a passion: the tall rock,
> The mountain, and the deep and gloomy wood,
> Their colours and their forms, were then to me
> An appetite: a feeling and a love,
> That had no need of a remoter charm,
> By thought supplied, nor any interest
> Unborrowed from the eye.

This predominantly sensuous delight, touched with aesthetic thrills, then gives way to a more reflective and complex response to the natural world, one preoccupied by the relations between man and nature, cultivation and the wild, and one that values landscape beauty as a moral and spiritual experience:

> well pleased to recognize
> In nature and the language of the sense
> The anchor of my purest thoughts, the nurse,
> The guide, the guardian of my heart, and soul
> Of all my moral being.

The modulation is from the crude 'animal' reflexes to the more highly evolved and refined perception of nature's metaphysical solaces.

The points I wish to draw from this brief account of Wordsworth's sense of his own changing relationship to natural scenery and to land-scape connoisseurship are the elements of subjectivity and relativity in the experience of landscape. Just as the individual human response to rural scenery changes from childhood to maturity, so landscape may be valued differently by different cultures, which are themselves, of course, in the process of change and development. There is in fact no consensual 'we'. This proposition, by no means controversial in itself, is somewhat at odds with that broad generalization offered by Kenneth Clark, albeit tentatively: 'with the exception of love, there is perhaps nothing else by which people of all kinds are more united than by their pleasure in a good view'.[5] The contention takes for granted that the

sight of a 'good view' (and who judges, and by what criteria, what a 'good view' might be?) is one of the very few experiences in life that human beings are likely to share, in spite of differences of race, creed, and so on. It is almost a transcendental absolute, like the idea of Nature, and therefore implicitly dismisses the argument of the relativity of beauty in landscape, the view that the aesthetic status of a landscape is a product of cultural processes continually subject to change.

The incompatibility of these views is one of many issues to be raised in considering landscape art. Landscape in art, historically traced within a particular tradition or studied comparatively across a range of cultural traditions, testifies to the great variety of ways in which landscape acquires significance and value: it seems almost to celebrate relativism. Yet the landscape celebrated—particularly in post-Renaissance Europe and America—has also fairly consistently stood for that 'other', the non-human world that is, or was, our home. It therefore constitutes a kind of absolute, a constant. Landscape as the portrait of Nature in her physical forms can function as the embodiment of an abstract. It may offer itself as a section of the countryside, a frameable transcript, a topographical record, but it is also (or may be) a symbolic form of an ideal world. In other words, to return to Wordsworth's model of the successive stages of landscape experience and appreciation, those perceptions are not necessarily discrete and sequential; they can amalgamate and blend. One may not wholly lose one kind of response as another assumes precedence. Thus, if we consider those three stages, our absorption in the real or the pictured landscape may well be recreational, aesthetic and spiritual all at once. In its recreational capacity, landscape opens up an alluring space, alive with light and shade, in which the claustrophobic eye can wander at large. Imagine the simple pleasures of this kind of visual exploration and recreation afforded to the lone gallery visitor in Knorr's photograph [1], as he gazes into those framed landscapes (although it doesn't look as if he is lingering there long enough). This kind of experience shades into the singling out of the particular sensuous, aesthetic pleasures of form, contour, texture, and variation of light that Wordsworth associated with the second phase: 'An appetite; a feeling and a love, / That had no need of a remoter charm, / By thought supplied, nor any interest / Unborrowed from the eye.' This is still an essentially sensuous experience (auditory and visual), and lacks the discriminations of connoisseurship. The third stage, the spiritual, may be generated by submergence into the sensuous experience already described, from which arises a feeling for the numinous quality of that whole setting. In addition to *being* something, it begins to *mean* something; or we so work on it with those reflexes that it comes to mean something. The meaning (to whatever extent that 'meaning' may be generated by the projection of needs on to the landscape) is hard to express in words,

and Wordsworth's language changes from the concreteness associated with the second, sensuous phase—'the tall rock', 'the deep and gloomy wood', 'the sounding cataract'—to the vague abstractions of the later phase: 'A presence that disturbs me', 'a sense sublime', 'something far more deeply interfused'. Wordsworth, at this stage, has passed through and left behind those earlier responses. The time of 'aching joys' and 'dizzy raptures' is past. He has learned 'To look on nature, not as in the hour / Of thoughtless youth'. He implies that the mature, spiritualized perception of nature is acquired only at the cost of shedding the immature, sensuous responses. But do the sensuous, aesthetic and spiritual experiences of landscape have to be mutually exclusive? Can we not hold land and landscape and the range of responses in one complex appreciation?

We might take a particular scene in order to think about this further. The American photographer Ansel Adams (1902–84) produced a magnificent range of photographs of Yosemite National Park in the earlier part of the twentieth century. Adams in Yosemite is a good representative of the issues discussed in the early part of this chapter; he is most certainly in the business of converting land into landscape. By what criteria does a photographer decide, given the whole of this vast glacier-sculpted National Park, on the particular scene to be framed in his camera lens? The more famous Adams landscapes are his photographs of Yosemite Valley with the awesome shape of the 2000-foot Half-Dome Rock dominating the scene. *Tenaya Creek, Dogwood, Rain, Yosemite National Park* [**3**], photographed in 1948, is on a smaller scale. Some years later Adams recalled his experience of selecting and photographing this scene:

Spring—the time of roaring waterfalls and dogwood blossoms—is often graced with showers; it is a time for enjoyment of various subtleties of the natural scene, which are sometimes elusive and difficult to photograph.

One cloudy spring day I was searching for dogwood displays, and as I was driving up the Mirror Lake Road I glimpsed an attractive possibility near Tenaya Creek. I parked the car and walked about six hundred feet toward the dogwood I saw glimmering in the forest. On reaching the creek I saw an inevitable opportunity … A light rain began to fall, and I considered giving up for the day, but when I came to an opening in the trees and saw this subject open up before me I banished such thoughts of defeat and set up the camera …

As with many of my photographs, this picture opportunity seemed to be waiting for me; the visualization was immediate and complete. I hope that the print conveys not only the moment but some evidence of my perception to which the viewer may respond. Just what this expressive perception contains must be sought for only in the print. I repeat my conviction that photographs alone can express the experiences of photography. We can describe and explain the physical elements of the scene, the forest, rain, white blossoms, the

3 Ansel Adams
*Tenaya Creek, Dogwood,
Rain, Yosemite National Park,
1948*

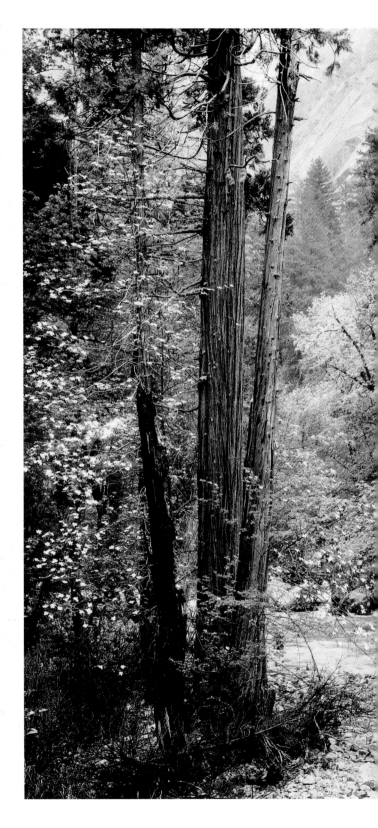

flowing stream and the lichened rock; but to try to express the photographer's emotional–aesthetic response might cause confusion for viewers and limit their response.[6]

Adams was hunting for spring subjects in Yosemite, and more specifically, for dogwood displays. Thus far he is wholly conscious and purposeful in his quest; but from that point on some kind of mysterious aesthetic instinct seems to take over. The glimpse of a distant 'attractive possibility' turns into 'an inevitable opportunity' that cannot be neglected in spite of rainfall. The opportunity 'seemed to be waiting' for him: 'the visualization was immediate and complete'. He records later that 'exposure and development decisions were relatively simple'. Even if he had wanted to, he found himself unable satisfactorily to explain how this small section of Yosemite, once perceived, came to have such obvious, 'inevitable' photogenic value and to initiate what he calls a 'creative reaction'. It does seem, beyond a certain point (the car drive in search of dogwood), to have become exactly that—a 'reaction', a reflex: 'Unless I had reacted to the mood of this place with some intensity of feeling, I would have found it a difficult and shallow undertaking to attempt a photograph.'[7]

If, as Adams insists, the question of 'just what this expressive perception contains must be sought for only in the print', we might look more intently for guidance and elucidation at the picture itself. The title is not simply the location, Tenaya Creek, nor is it simply 'Dogwood'. It is the combination of location, dominant natural detail, and weather condition. It wants to draw attention to specifics. But without the title would we, in our response to the picture, give prominence to these particular details? The rain is invisible, the creek might be anywhere, the glimmer on the foreground foliage is certainly arresting but the botanical identity of the plant doesn't add much value to that effect. The title's specifics pin down a precious memory, certainly, but may not have much to do with the landscape value for the viewer. So what is that value? Why select this particular scene? Does the answer lie in the image itself?

The eye has little depth to negotiate. The stream with its bright creamy rapids draws the viewer into the middle ground, but its further course is then blocked from view. At that point the path of light leads steeply upwards, along the firm vertical margin of pines on the left, catching the leaning tree with its bright foliage and finishing at the top with the reverse diagonal of the sunlit mountainside. That visual excursion is soon over and we return to the foreground with its infinite variety of light effects and textures. The relatively occluded scene in this way forces attention on the shallow foreground and intricacy of detail.

As Adams observed, we thus go some way towards describing and explaining the physical elements of the scene, although the

photographer's subjective response can be articulated only in the obscurely coded terms of the photographic image itself. However, in terms of the sequential or synchronized sensual, intellectual and spiritual paradigm of responses to landscape, we notice that Adams describes his response as 'emotional–aesthetic'. This compound epithet synchronizes responses that Wordsworth had tried to plot as a diachronic sequence.

Increasingly in recent years landscape has been understood less in terms of visible, concrete objects than as a kind of cultural instrument. Take, for instance, these propositions by W. J. T. Mitchell:

Landscape is not a genre of art but a medium.
Landscape is a medium of exchange between the human and the natural, the self and the other. As such, it is like money: good for nothing in itself, but expressive of a potentially limitless reserve of value.
Landscape is a natural scene mediated by culture. It is both a represented and presented space, both a signifier and a signified, both a frame and what a frame contains, both a real place and its simulacrum, both a package and the commodity inside the package.[8]

Landscape, which has long meant either the real countryside or the pictured representation of it, is in effect the combination of the two, or the dissolving of the two together, 'a natural scene mediated by culture'. This description would be recognized in the professional practice of landscape 'character assessment', a sophisticated diagnostic technique under development in environmental planning.

According to two writers currently working on this project, such assessment needs to distinguish between 'landscape character' and 'scenic beauty': 'by giving equal weight to the natural, cultural and visual dimensions of the landscape, it is possible to develop more appropriate techniques for landscape evaluation'. 'Landscape character' is described as 'an expression of pattern, resulting from particular combinations of natural (physical and biological) and cultural factors that make one place different from another … [it] focuses on the nature of the land rather than the response of the viewer, in order to convey an informal picture of the landscape without making value judgements'. 'Scenic beauty' is 'a measure of the aesthetic appeal which a person experiences when viewing a particular scene', an appeal which is conditioned by 'innate appreciation of the aesthetic qualities of the landscape', by personal associations, cultural conditioning, and familiarity with the area.[9] As will be evident from arguments rehearsed elsewhere in this chapter, the notion of 'innate' appreciation of landscape beauty, and the idea that one can eliminate value judgements in the act of conveying a picture of the landscape, however objectively constituted, might be difficult to sustain.

4 Joel Meyerowitz
Broadway and West 46th Street, New York, 1976

'Landscape is a cultural reading that renews the concrete space and what surrounds us', the landscape designer Bernard Lassus[10] has remarked. Landscape as a perceived version of the natural world is reconstructed to correspond to human needs, to the changing living circumstances we experience: thus, for instance, within the proliferating modern metropolis the desired 'other' was not just a space with refreshing glades and quiet open spaces. In his subtle study of changes in the metropolitan culture of nineteenth-century Paris, Nicholas Green has pointed to what he calls 'codes of looking' manipulated by the development of the new commercial centres in the city:

To read the streets meant to adopt codes of looking that could single out, sift and move across the meanings of public spaces. All of which suggests an individualisation of vision, a fragmentation of earlier, more totalising social panoramas into a picture built up from individual objects and images.[11]

The same might be said of the London of the same period. The sprawling metropolis cannot be totalized in any one perspective, which may perhaps explain the popularity of the city maps or aerial views of the city that proliferated in nineteenth-century London and Paris.

The difficulty of gaining a coherent sense, at street level, of the modern city, and the experience of being bombarded by noise and a battery of heterogeneous visual information, suggest that a non-urban environment should have a compensatory simplicity. A single framed

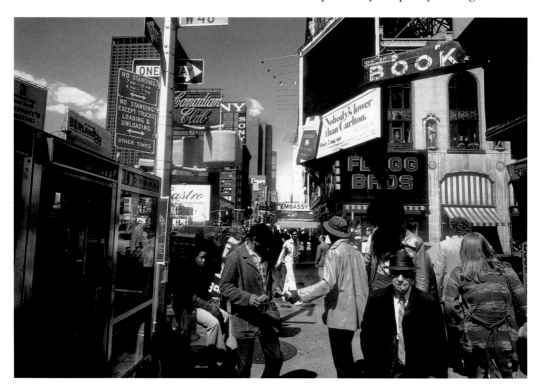

view of countryside offers the opportunity for an apparently totalizing view of a wide space, an experience no longer possible within the city. As an example of this sense of how landscape is constructed as the obverse of the experience of the modern city, let us take Joel Meyerowitz's (b. 1938) cityscape, *Broadway and West 46th Street, New York* (1976) [**4**], and Monet's (1840–1926) landscape painting, *Meadow with Poplars* [**5**]. In Meyerowitz's photograph the city has become a bewildering combination of signs. Buildings seem to have become simply hoardings. Although the caption is topographically specific, the experience of trying to make human or architectural sense of the location is baffling. There is no human encounter here, as far as one can see. Some gesture of material exchange is happening in the foreground, but the two men do not meet each other with any eye contact. Signposts, directional, regulatory ('No Standing …') and commercial, combine in a meaningless kaleidoscopic swirl. What seem to be passages of access into the city space are blocked. Graham Clarke has described this photograph as an image of New York as the postmodern city, in which 'The eye is overwhelmed by signs, and the colour adds to the effect of

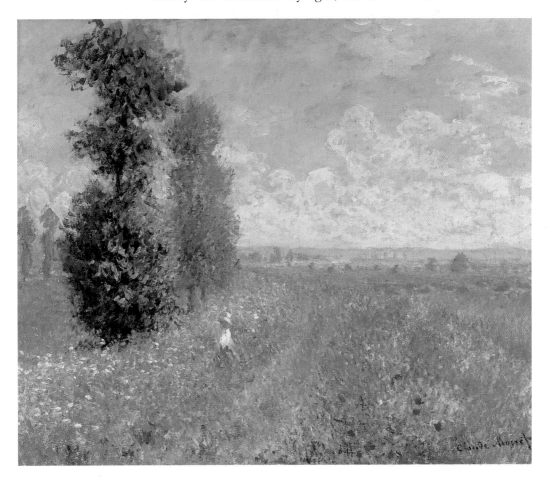

chaos … it is difficult to find a solid building at all.'[12] This is the new wilderness, but a wilderness constituted by almost the opposite components to those of the natural wilderness: instead of a place almost wholly empty of humans and devoid of any artefacts, the city is a place overused by humans and consisting wholly of artefacts. Above all, perhaps, in this picture of New York, it is the congestion that impresses us.

By comparison, the country offers us locations that seem spacious, coherent, and easy to read. Monet's *Meadow* appears to rejoice in everything that the modern metropolis is not: apparently boundless prospect instead of shallow, occluded spaces; gently curving contours instead of rectilinear blocks; soft, yielding, feathery textures instead of hard metallic and glass surfaces; a single figure seeming almost to be one of the natural forms in the field, instead of crowds of isolates bunched together in cramped spaces. The passage in to the landscape's space is simple and alluring. Whether or not this is a particular place, local features and forms are loosely generic rather than insistently specific. This is an experience of place that can be totalized. The 'compensation' thesis offered in positioning the Meyerowitz photograph [4] of New York City against Monet's *Meadow* [5] depends on accentuating the contrasts between city and country, so that the country is constructed as the obverse of the disorientating, fragmenting assault on the senses that typifies metropolitan living. By such polarizing manoeuvres is land constituted as landscape.

In most of the account so far of ways in which land becomes landscape, and of how we establish criteria for landscape aesthetics, we have concentrated on culturally induced mental habits, in the forming of which landscape in art has played such a prominent part. How, when, and why such habits were formed, and whether or not in response to primary needs rather than cultural conditioning, remain questions that are hard to answer. Geographers have offered to explain them in some interesting ways, and I take just a few examples here, some of which I shall return to in the context of later discussions in this book.

Jay Appleton's much-cited 'habitat theory' was the basis of his study *The Experience of Landscape* (1975). There he argued that, in our assessment of the aesthetic pleasures in landscape, we may unconsciously be calling upon atavistic modes of valuing territorial advantages that were almost instinctive to hunter–gatherer societies. The strategic importance of seeing the hunter's prey or hostile forces without being seen oneself translates naturally into a sense of greater security. Land forms that offer images of prospect and refuge, therefore, satisfy ancient survival needs that are buried deep in the human psyche. An appealing landscape is a single view of aptly disposed prospect–refuge opportunities.

The appeal of landscapes to which humans have been biologically adapted through history in a survival culture would perhaps translate naturally into an aesthetic appeal once the survival culture no longer obtains. Scientifically conducted studies of landscape preference have been growing since 1970 and much of the research has been devoted to investigating whether or not there are genetic factors affecting landscape appreciation, and what kinds of landscape forms are particularly favoured. Much of the research tends to support the proposition that 'modern humans retain a partly genetic predisposition to like or visually prefer natural settings having savannah-like or park-like properties, such as spatial openness, scattered trees or small groupings of trees, and relatively uniform grassy ground surfaces'.[13] Primitive humans are believed to have exchanged predominantly forested habitats for the more open savannahs, where prey and predators could be more easily sighted: hence, according to the hypothesis, the partly genetic preference today for this kind of landscape as favouring ancient survival instincts. That may be so, but it will also strike many that the quoted description conforms remarkably closely to characteristic eighteenth-century landscaping traditions, epitomized in the work of 'Capability' Brown (1716–83), which have been widely disseminated through the western world as ideal landscapes. How many participants in those landscape preference studies were unconsciously recalling these venerable models of gardening, rather than responding to primitive survival instincts? Conversely, was Brown's extraordinary success,

6 Humphrey Repton
From the 'Red Book' for Longleat, 1804

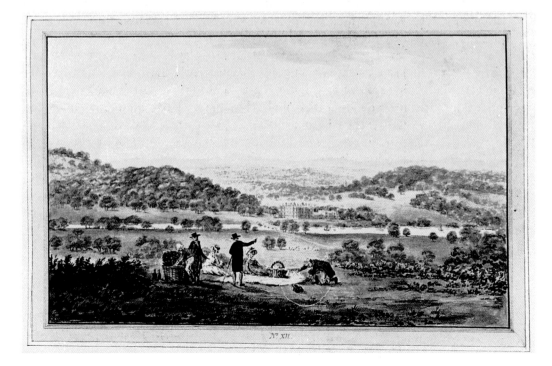

with his grassy parkland and scattered clumps of trees, simply due to his having accidentally tapped into ancient human reflexes? Some of the contributors to *The Biophilia Hypothesis* conducted a study of Humphrey Repton's 'Red Books', and detected, in the 'before' and 'after' designs for gardens [6], a tendency to make changes that, by and large, favoured features characteristic of savannah environments.

The contention that there might well be a culturally transcendent landscape ideal, thereby, perhaps, reinforcing the argument for the genetic basis of landscape appreciation, was given some support in an extraordinary project, undertaken over recent years, by Alex Melamid and Vitaly Komar. It is known as 'The People's Choice'. Thousands of people in several countries were invited to complete a questionnaire designed to find out what were the world's most and least wanted paintings. The tabulated results were published on the Internet. People were asked questions such as: what was their favourite subject for a painting (portrait, still life, religious, landscape, for example); what were their favourite colours; what were their favourite forms (human, architectural, and so on). The returns for each country were then computer-assessed in order to produce a composite picture that reflected the majority preferences. Of the 15 countries whose results appear on the Internet pages, 11 produce, as their 'most wanted' painting, a landscape. In these 11 landscapes the proportion of water surface to mountainside to trees to level ground is remarkably consistent, as a selection of the results illustrates [7]. These landscapes are sparsely populated. Animal life is minimal (the animals are usually national emblems). Could it be that these results vindicate Kenneth Clark's convictions about the consensus over a 'good view'? They demonstrate striking consistency, not only in the proportioning of the fundamental landscape components, but also in their disposition.

Another geographer, Denis Cosgrove, has argued for the idea of landscape as 'a way of seeing' determined by specific historical, cultural forces. He associates the evolution of the concept of landscape with early modern capitalism and the relinquishing of feudal systems of land tenure. According to this argument, those for whom land is the fabric of their lives, for whom it is livelihood and home environment, do not see that land as landscape. They relate to the land as 'insiders':

> For the insider there is no clear separation of self from scene, subject from object. There is, rather, a fused, unsophisticated and social meaning embodied in the milieu. The insider does not enjoy the privilege of being able to walk away from the scene as we can walk away from a framed picture or from a tourist viewpoint.[14]

Landscape arises increasingly as land acquires capital value, becomes itself a form of capital—a commodity with little or nothing of the personal value and 'social meaning' it had for those for whom it was

**7 Vitaly Komar
and Alex Melamid**

*America's Most Wanted
Painting,* 1994, and
*Denmark's Most Wanted
Painting,* 1995–97

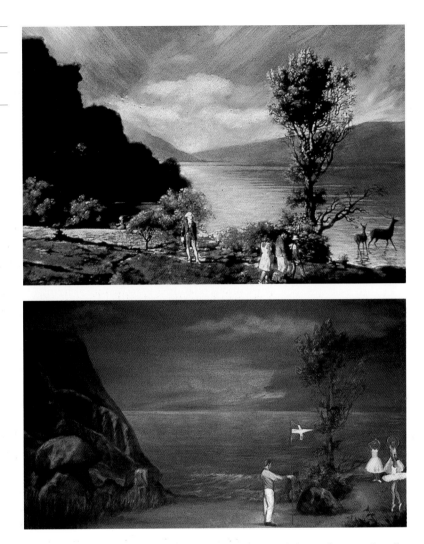

home—and an aesthetic value replaces a use and dependency value. In Cosgrove's phrase, this is the 'outsider's perspective', through which land is reconstituted as landscape.

Cosgrove closes his book with a moving passage from John Berger's *A Fortunate Man*:

Landscapes can be deceptive.

Sometimes a landscape seems to be less a setting for the life of its inhabitants than a curtain behind which their struggles, achievements and accidents take place. For those who, with the inhabitants, are behind the curtains, landmarks are no longer geographic but also biographical and personal.[15]

The insight, introduced as a corrective to the outsider's perspective, is a valuable one. Landscape can mask the land.

Looked at from one point of view, landscape art in the West, over the last 500 years, can be read as the elegaic record of humanity's sense

of alienation from its original habitat in an irrecoverable, pre-capitalist world. There is as much myth as history in that. Since the late 1970s the Marxist art historians and the 'heritage industry' critics have made us, perhaps reluctantly, more habitually suspicious of the elegaic serenities of landscape painting, that seductive 'curtain', in Berger's terms. That has been an intellectual corrective. The more pervasive and profound challenge to the outsider's perspective has come not from the academies but from the environmentalist movement. It is difficult to escape the feeling that we are all 'insiders' now, alarmingly aware of the finiteness of the natural resources we used to take for granted as Nature's endless bounty. We don't have to imagine, with the aid of alluring images of Arcadian natural simplicity, what it must have been like to live *in* Nature; we are all too aware of our dependency on Nature now. More crucially still, we feel Nature's dependency on us. Landscape as a way of seeing from a distance is incompatible with this heightened sense of our relationship to Nature as living (or dying) *environment*. As a phase in the cultural life of the West, landscape may already be over.

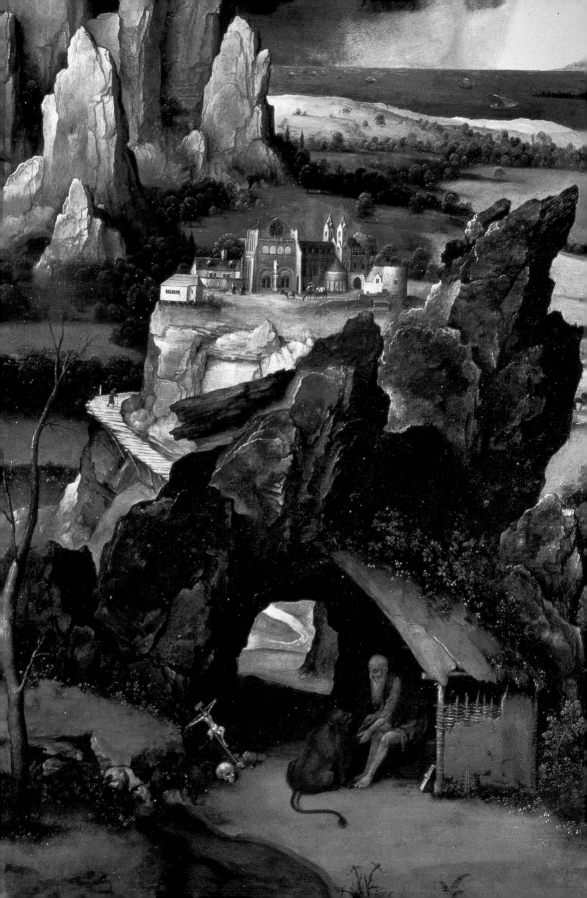

Subject or Setting?

Landscape and
Renaissance Painting

2

In the Städelsches Kunstinstitut, Frankfurt, there is an unassuming pen drawing of a landscape by a German master [8] from the first decade or two of the sixteenth century. Our viewpoint is perhaps from the edge of a wood, looking out over a stretch of more open countryside. Two trees—one a broadleaf, scarred and half dead, the other a scrawny fir—stand a little in from the edges of the picture and frame our view. A stone and brick cottage on the left, perhaps a mill house, seemingly abandoned, stops our eye from wandering far into the left, and on the opposite margin a dense stand of trees similarly blocks us and returns the eye to the centre to explore the middle ground. Zigzagging diagonals lead us from the foreground past the small waterfall and its rocky basin into an area much more lightly drawn: two indistinct figures, one perhaps on a rearing horse, follow a road leading to a city where a church spire rises against the background mountains.

The frequency of use of the word 'perhaps' in the above account reflects an uncertainty not only about some of the details, but also the project as a whole. Why was it drawn? What is the chief focus or motif here? Repoussoir features manoeuvre our attention to the central area only for us to find that detail fades away beyond the middle ground. The little waterfall, in an area which has the only dramatic lighting in the whole picture, is somewhat clumsily represented as a spout and hardly functions as the commanding feature in the composition. The one building close to us is literally marginalized. The foreground, rendered with heavier pen strokes, has nothing distinctive to catch the attention.

It may possibly be a record of a real place, simply a transcription without any attempt at this stage to adjust it. So why bother trying to infer a rationale from its graphic data? The reason is that this scene, almost detail for detail, is the setting for a woodcut portrayal of St Jerome in penitence, executed by Lucas Cranach (1472–1553) in 1509 [9]. Art historians have variously argued that the pen drawing was a study for the Jerome woodcut, or that it was deliberately copied from

the woodcut by someone who simply wanted to make it a landscape by omitting all trace of its devotional subject matter.[1] Either way, the relationship between the woodcut and the drawing raises questions about the dependent, attributive status of landscape in the early modern period, a status this chapter is to explore. Once Jerome is introduced into the setting, certain components in the landscape begin to acquire significance, for they can be seen to belong to a conventional iconography associated with Jerome pictures. The little life-giving stream or waterfall and the scarred tree were familiar features in Venetian and Netherlandish paintings of Jerome, and in the Cranach woodcut the saint is positioned exactly between these two features. The crucifix (the Cross as the Tree of Salvation) before which Jerome kneels seems to grow from the roots of a tree which, in its indeterminate state between life and death, is perhaps awaiting the spiritual outcome of Jerome's act of penitence. Bit by bit the separate elements in the landscape seem less disparate, more co-ordinated. The introduction of the human subject focuses the landscape, salient details of which now function to illustrate the narrative of Jerome's spiritual crisis.

A more clear-cut example of a landscape study executed independently and then harnessed to a religious subject is seen in two earlier works by Albrecht Dürer (1471–1528), both dated *c.*1497. The watercolour *Little Pond House* [10] is a piece of topography enriched by a wonderful stillness of atmosphere spreading from the evening sky.

10 Albrecht Dürer
Little Pond House, c.1497

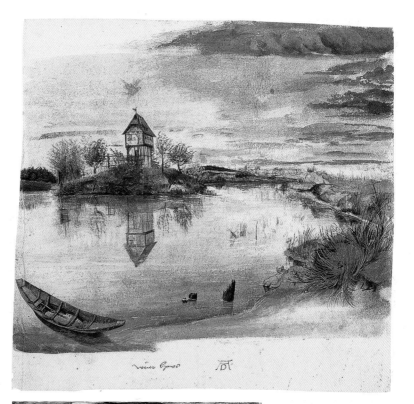

11 Albrecht Dürer
The Virgin and the Long-tailed Monkey, c.1497–98

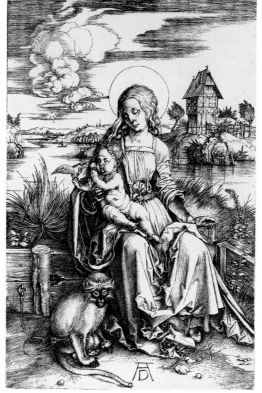

Dürer then uses the prominent features of this—the fenced and isolated house, the pond and the marsh grasses—as the setting for the Virgin and Child in *The Virgin and the Long-tailed Monkey* [11]. The peaceful stillness of the background is offset by the activity of the Child, and Dürer has exchanged the horizontality of the watercolour composition for a more concentrated vertical structure which aligns the human figure with the pond house, and perhaps gives to the pond house symbolic nuances. The introduction of the religious subject has not only displaced the landscape into background, it has also inflected it with new significance.

The two Dürers, the Jerome woodcut, the pen landscape drawing, and the controversy over their relationship, is a useful way into the whole debate about the role of landscape in relation to narrative and iconography in this period. For it was in the late fifteenth and early sixteenth centuries that landscape assumed a more independent role in paintings and in some few cases seemed to have become almost wholly emancipated as a genre. The qualification 'seemed' should be emphasized, because such a contention remains controversial both as a historical question and as a theoretical issue—is landscape representation ever independent of human narrative even if the human presence is removed?

The part played by landscape in Renaissance painting is tied closely to the status it occupied in contemporary thinking about art, about the proper subjects for formal representation and about the proper balance of attention to different kinds of subject matter. In particular, the hierarchizing of landscape and iconic subject, whether hagiographical or mythological, needs to be taken into account. Landscape in this period has conventionally only a supplementary role to play, it is marginal to the main human or divine subject, it is *parergon* to the Argument. It occupies a low status in a hierarchy dominated by the human presence. The heroic human or divine presence bestows dignity and significance on the natural setting; it elevates and validates it. Conversely, the natural setting can give contextual substance and corroborative metaphorical force to the human or divine subject and narrative. We have seen something of this emerging in the Dürer and Cranach examples discussed above. There is thus a kind of dialectic between the two, between the elevated and the lowly in this hierarchy of genres, between the human and the natural world.

In Chapter 1 we considered the mental and cultural processes that help us to perceive land as landscape. Historically, landscape has had a range of meanings, some quite unrelated to art. One such meaning applies to civic classification of territory. It has been argued that the German *Landschaft* or *Lantschaft* was not originally a view of nature but rather a geographic area defined by political boundaries. In the late fifteenth century, the land around a town was referred to as its landscape,

a meaning that still survives in some places, as in the Swiss canton of Basel Landschaft. Thus in the woodcut townscapes of Hartmann Schedel's *Nuremberg Chronicle* (1493) each city is shown in its landscape environs and that adjacent rural territory could be designated the city's *Landschaft*.[2] In the topographical view, the environing landscape serves as the natural setting for the portrait's main subject, the city; and that environment is understood as being part of the territorial domain of the city.

Landschaft's status as periphery to, and setting for, the main subject is analogous to the contemporary status of landscape in relation to the religious subjects of painting. In 1490 a contract for an altarpiece in Haarlem stipulated a 'landscap' as the necessary setting for the figural subjects.[3] 'Setting', 'environs'—the emphasis, whether cartographical or painterly, is always on the subsidiary, accessory, peripheral status of landscape. This is borne out by early glossarists, who, whether they derive the English word from Belgian, Dutch or German prototypes, couple 'landscape' with the idea of 'ornament', 'adjunct', 'by-work' or *parergon*. 'By-work', according to the *Oxford English Dictionary*, means (among other things) an 'accessory and subsidiary work'. Henry Peacham in *Graphice* (1612) wrote:

Landtskip is a Dutch word, and it is as much as we should say in English landship, or expressing of the land by hilles, woods, Castles, seas, vallies, ruines, hanging rocks, Cities, Townes, &c. As farre as may be shewed within our Horizon. If it be not drawne by itselfe, or for its own sake, but in respect, and for the sake of some thing else: it falleth out among those things which we call *Parerga*, which are additions or adiuncts rather of ornament, then otherwise necessarie.

Peacham associates landscape with *parerga*. By the time he is writing it seems that landscape can be 'drawne … for its own sake'. In other words, landscape is not automatically relegated to 'by-work'; it is only so when an accompanying subject assumes precedence.

Earlier, in 1527, in Bishop Paolo Giovio's *Dialogue*, we find the term *parerga* used in association with the work of the Ferrarese painter Dosso Dossi (*c.*1497/9–1542), and here *parerga* does seem to be restricted to those elements in a painting that are accessories to, or relaxed diversions from, the 'proper' subjects of painting:

The elegant talent of Dosso of Ferrara is proven in his proper works [*justis operibus*], but most of all in those that are called *parerga*. For in pursuing with pleasurable labour the delightful diversions of painting, he used to depict jagged rocks, green groves, the firm banks of traversing rivers, the flourishing work of the countryside, the joyful and fervid toil of the peasants, and also the distant prospects of land and sea, fleets, fowling, hunting, and all those sorts of things so agreeable to the eyes in an extravagant and festive manner.

Dosso Dossi could paint both 'proper' works (presumably portraits, historical and religious subjects) and these landscape *divertissements*. He could finish them either as generically separate pictures or in combination in one painting. The distinction between 'proper' works and *parerga* implies an acceptance of a hierarchy of subjects in painting, and indeed this is confirmed in the next century in Thomas Blount's *Glossographia* (1670):

Landtskip (Belg.) Parergon, Paisage, or By-work, which is an expressing the Land, by Hills, Woods, Castles, valleys, Rivers, Cities &c as far as may be shewed in our Horizon. All that which in a Picture is not of the body or argument thereof is *Landskip, Parergon,* or *by-work.* As in the Table of our Saviors passion, the picture of Christ upon the *Rood* (which is the proper English word for *Cross*) the two theeves, the blessed Virgin *Mary*, and St. *John*, are the Argument: But the City, *Jerusalem*, the Country about, the clouds, and the like, are *Landskip.*

Here the by-work is subordinated to the Argument in the same way as, in the *Dialogue, parerga* are subordinated to 'proper' works, and, in topographical views, the *Landschaft* is subordinated to the city. Like Peacham, Blount identifies *parerga* specifically with landscape subjects. His list of synonyms makes *parergon* and by-work equivalent to 'Paisage' (though the first two belong to a semantic grouping that has no necessary connection with 'Paisage').

In following this line of debate, I have chosen to focus initially on a variety of Renaissance paintings of Jerome. The subject of Jerome in the wilderness was, for reasons to be outlined later, a compelling one at the time of the Reformation and the ideological challenges to the Roman Church. Artists working in an emergent humanist culture had additional interest in the pictorial potential of the figure of the lonely saint, isolated in natural surroundings. The subject gave great scope for the elaboration of natural detail, exercises in perspective, and construction of depth in landscape. The significance of landscape in relation to the human subject could be manipulated in revealing ways: painters could use the Jerome legends to explore evolving ideas about solitude, about tensions between city and country, and about the natural world and humanity's place within it. These ideas constitute some of the principal foundations for the traditions of landscape art in the West.

Landscape without a human subject is a very rare phenomenon in the finished, formal paintings of this period. There are some magnificent and complex landscape passages in the works of the great Renaissance masters, but, with very few and often controversial exceptions, they do not exist as an independent genre. They appear as watercolour sketches, or pen and ink drawings, as in Leonardo da Vinci's (1452–1519) 1473 drawing of a view of the Arno Valley(?) [39], or in

other ephemeral forms, but seldom ever as finished oils or frescos. Likewise they occupy marginal areas in the grander compositional structures, such as altarpieces, where landscapes sometimes flourish on predella panels, or polyptychs as ornamentation for side panels or folding covers. We naturally ask why the subject is so habitually marginalized. In approaching this question I will examine some of the ways in which the painters portray the relationship between the human subject and the natural world in the later fifteenth and early sixteenth centuries, and will concentrate on work from three schools: Venetian, Netherlandish, and Danube.

The decision to concentrate on Jerome paintings from each of these schools has already been signalled. One might have ranged across a greater variety of religious subjects, from Leonardo's rocky backgrounds or Giovanni Bellini's (*c.*1430–1516) undulating farmed settings to Holy Family paintings, but the kinds of point one would be making about them can be made just as well about the Jerome backgrounds, as I hope will be apparent. Furthermore, maintaining a consistency of *subject*—Jerome's penitence in the wilderness—might have the additional benefit of enabling us to see in sharper relief the differences in the handling of the 'accessory' element; or, to put it in more contemporary terms, where the Argument remains the same, the variation in *parerga* will be more conspicuous.

One cannot discuss the issue of landscape's relation to the human subject in painting without an awareness, however sketchy, of the larger cultural context in which these pictures were produced. What prejudices about city and country were prevalent in this period and how were they changing? What views, Christian or secular, were held about isolation in the natural setting? Some understanding of this changing context, during the Renaissance and Reformation periods, might help to explain why landscape's emancipation as a subject was withheld for so long. It is with some discussion of these ideas that we begin.

The idea of solitude in a natural setting becomes a powerful attraction for writers and painters, especially, but not only, when cities develop their own distinctive cultures and pressures to the point where the citizen begins to sense that there is a profound division between the civilized and the natural. Much of the literature of Augustan Rome and Elizabethan England, and many paintings of the early Italian and Northern Renaissance, celebrate the fugitive from civilization, the figure who recovers a kind of spiritual integrity and wisdom by immersion in the natural setting. Examples can be found in the 'beatus vir' topos in Virgil's (70–19 BC) *Georgics* and Horace's (65–8 BC) *Epodes*, Petrarch's (1304–74) meditations on a life of solitude, and Shakespeare's (1564–1616) lyrical evocation of retreat from court and city expressed by Duke Senior in *As You Like It* (Act II, Scene I):

Now, my co-mates and brothers in exile,
Hath not old custom made this life more sweet
Than that of painted pomp? Are not these woods
More free from peril than the envious court?
… our life exempt from public haunt,
Finds tongues in trees, books in the running brooks,
Sermons in stones, and good in every thing.

Literary and pictorial representations of voluntary exile from the centres of civilization can be ambiguous: for example, do we always know whether the image is a celebration of ascetic or epicurean values? Much depends on how the enveloping landscape is presented. For instance, one might expect the natural setting for a painting of St Jerome to be consistently austere as the accessory in his chosen self-mortification. We know from Jerome's own account that his life while in the desert was one of rigorous penance in a harsh setting; but the desert or wilderness in early Christian thought is a mesh of contradictions: it is a moral waste but a potential paradise, the haunt of demons and the realm of bliss and harmony with the creaturely world.[4]

The wilderness in Isaiah is equated with 'the solitary place' and 'the desert' as a region of savagery, the landscape of God's vengeance against the enemies of his church. But for those who are redeemed the transformation in the landscape is spectacular:

In the wilderness shall waters break out, and streams in the desert … the parched ground shall become a pool, and the thirsty land springs of water: and in the habitation of dragons, where each lay, shall be grass with reeds and rushes. (*Isaiah*, 35)

A number of paintings of Jerome in the wilderness attempt to portray such a landscape undergoing change as the saint's act of penitence redeems it from sterility: for example, the little waterfall in Cranach's woodcut [**9**]. Jerome's confessed admiration for the desert living of John the Baptist, together with the experience of his own spiritual struggles, made him sympathetic to the traditional antithesis: city and country, community life and seclusion. 'To me,' he wrote, 'town is a prison and a solitude paradise. Why do we long for the bustle of cities, we whose very name ['monk', from *monachus* meaning 'solitary'] speaks of lone lives?'[5]

Early Christian and medieval attitudes towards a life lived in seclusion, remote from centres of civilization, were as ambivalent as attitudes towards wilderness itself. There are, so St Augustine of Hippo argued in *City of God*, three kinds of life: 'one which, not lazily, but in the contemplation and examination of the truth, is leisured; another which is busied in carrying on human affairs; and a third which combines both of these'.[6] Total isolation was a dangerous enterprise. Even

Jerome, who to later ages seemed the most dedicated anchorite, warned against the temptations to which the solitary could be subject: 'In loneliness pride creeps upon a man: if he has fasted for a little while and seen no one, he fancies himself a person of some note; forgetting who he is, whence he comes, and whither he goes, he lets his thoughts riot within and outwardly indulges in rash speech.' The point is that the solitary walks a difficult tightrope: he has freed himself from the distractions and pressures of human society but, once isolated, loses any of those checks to his naturally errant soul that the company of other people could provide.

The vexed predicament of the solitary in a natural setting, which Renaissance painters inherited, has more than one genealogy. The Christian penitential tradition intersects with classical and humanist explorations and celebrations of rural retirement. A key figure in this context is Petrarch. Petrarch lived for a period in the depths of the French countryside, about 20 miles from Avignon and he relished his isolation and the rural beauty of his surroundings. In his *De Vita Solitaria* (1346) Petrarch made clear the association between moral integrity and the regenerative influence of the natural world, in terms that would make an ideal caption for the many Renaissance paintings of St Francis pouring forth his Canticle to the Sun [**12**]:

The retired man, as soon as he has gained a flowery spot on some salubrious hill, the sun being now risen in his splendour, breaks joyously with pious lips

12 Giovanni Bellini
St Francis in the Desert,
*c.*1480

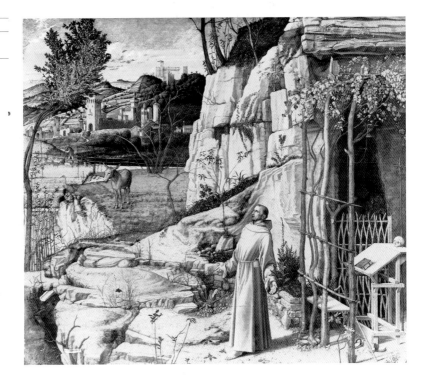

into the daily praises of the Lord, the more delightedly if with his devout breath are harmonized the gentle murmur of the down-rushing stream and the sweet plainings of the birds.[7]

The harmonious integration of human prayer with sounds from the natural world represents an ideal in the relationship between pious man and the landscape. Petrarch presses hard and eloquently on this relationship between solitude, integrity, spiritual purity and natural surroundings: the natural world becomes not just an ornamental setting but a metaphorical analogue for solitude and spiritual purity. Through Petrarch, the traditions of Virgilian pastoral and Horatian celebration of rural retirement are fused with the contemplative tradition in Christian thought. Jerome-inspired and Petrarchan celebrations of solitude and intimacy with the natural world come to have much in common. Coincidentally, early representations of St Jerome are sometimes indistinguishable from the representations of Petrarch: both were interpreted as pioneers of humanist thought.[8] The inspirational asceticism of Jerome came to have a particular force during the Reformation, when the corruption and wordliness of the established church was under attack.

One further reason for the increased frequency in the Renaissance of paintings of Jerome in the wilderness might be the flourishing of communities founded under the spiritual patronage of Jerome and supported by the worldly patronage of some of the most powerful figures of this period. Cosimo de' Medici (1389–1464) built, in the middle of the fifteenth century, a new monastery and church for one of the orders of Hieronymites, not far from his own retreat, the Villa Medici at Fiesole. Indeed, the idea of rural retreat, whether for spiritual or recreational motives, is an important factor in shaping the appeal of landscape in art, as the next chapter will suggest.

Many prejudices have to be overcome before landscape assumes legitimacy as a subject on its own. The human or divine subject monopolizes the painter's attention; but the painter with an inclination for landscape can enlist iconically potent figures such as Petrarch and Jerome and exploit their historical or legendary intimacy with the world beyond city and civilization. They thus act as mediating agents. Jerome as a subject becomes a pretext for elaborate exercises in landscape painting; it offers a way of legitimizing the predominance of landscape in a painting as an articulate vehicle for spiritual meaning: 'wherever I saw hollow valleys, craggy mountains, steep cliffs, there I made my oratory', Jerome wrote.[9] It is from just this period onwards, the middle of the fifteenth century, when the Medici-sponsored monastery was established, that the image of the gaunt, ragged anchorite in a rocky setting was seized upon by painters.

13 Giovanni Bellini
St Jerome in the Wilderness,
c.1450

14 Giovanni Bellini
St Jerome, c.1471–74

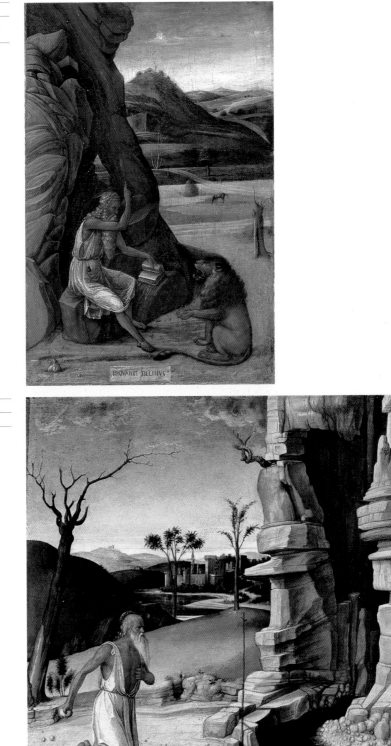

Jerome and the wilderness

Giovanni Bellini painted two versions of Jerome in the desert, *St Jerome in the Wilderness* [13] and a predella panel for his Pesaro altarpiece [14]. A third version, in the National Gallery, London, is partly the work of Bellini's studio assistants.

The Birmingham *Jerome* [13] was painted when Bellini was about 16, and there is a naive simplicity in the representation of the human, animal and landscape forms. The composition is dominated by the steep diagonal of the foreground cliff, and then by the abrupt horizontal division between flat tawny desert and rolling green background. A path perfunctorily rendered by one or two brushstrokes is the only link between these two landscapes. Jerome's position within this mixed landscape expresses his predicament. His chosen dwelling is the rocky den in the desert ('there I made my oratory'), but the choice he has made to relinquish the more comfortable world is dramatized by allowing that forsaken world to appear as the background. Jerome is in sight of it here, as a way of figuring his consciousness of the life deliberately left behind. There is a correspondence between the meagre-fleshed saint and the parched, leafless tree that is the only vegetation in the desert. The landscape is thus representing, in metaphorical terms, the spiritual dilemma with which the human subject is confronted. Most fifteenth- and sixteenth-century paintings of Jerome in a landscape follow this basic compositional idea and thereby charge the natural setting with dramatic significance, enabling the viewer to read in the landscape much of the meaning of the saint's self-sacrificial decision. In the mutually dependent relationship between landscape and saint, landscape depends on the human subject for giving it moral or spiritual significance, but the human subject needs the landscape to complete his meaning. Landscape becomes a dramatic agent rather than simply a decorative setting.

In the other Bellini painting of Jerome, a small predella panel in the Pesaro altarpiece, the desert foreground, with the hard, stratified cliff face, is marked off not only from a fertile river landscape, with sinuous lines and softened hill forms, but also from an elegant walled city. These are images of the double sacrifice Jerome has made in renouncing both nature in her most benign forms and the human community. The city towers cutting the horizon line, which to a later age of landscape painting might become simply 'eye-catchers', are here integrated into the narrative design. Other forms in the landscape reinforce this. In the predella panel the bare tree on the left with its bark partly stripped echoes the ravaged saint who has stripped his chest bare to receive the penitential beating. The cross he addresses continues its line upwards with the tree just behind it, and ends in a little fan of foliage. The Tree of Salvation (the Cross) thus issues in a Tree of Life.

Bellini's predella painting uses many of the structuring resources that were to become standard in later painting in terms of the way the eye is led in to the landscape. The coulisses are provided by the withered tree on the left and the cliff face on the right. The overlapping planes of the middle-ground hills, alternating in light and dark, take the eye in to the background where it is picked up by the zigzagging of river and path which wind away into the distant mountains on the horizon. The figure of Jerome himself has been reduced, when one compares his prominence in the Birmingham *Jerome*, and the landscape is given more expressive work to do.

Jerome is subordinated still further in Lorenzo Lotto's (*c*.1480–1556/7) *St Jerome in the Wilderness* [15]. Lotto painted a number of versions of this subject and the figure of the saint in his later paintings becomes more prominent, in terms both of scale in relation to the landscape and of histrionic intensity. The Paris *Jerome* is his earliest known painting of the subject. It is conscious of its Venetian predecessors (Bellini, Alvise Vivarini) but diverges from them in important ways. The hard contours and surfaces of the rock are softened by the rich glow of light, sunset or dawn. The light source appears to come from the distant background and strikes the left flank of the far cliff; but it changes in the foreground and seems to issue from the right. There is no contrast of landscapes in this painting, none of the expressive juxtaposition of arid and fertile, wilderness and city that gave dramatic force to the earlier depictions of Jerome's asceticism. The small, dead trees in the foreground are only yards away from their flourishing counterparts which help to embower the figure. Perhaps the most arresting feature of this painting is the handling of the landscape. This is more than an emblematically austere setting for the saint's act of penitence, as for instance was paramount in the stylized stratification of the rocks in Bellini's predella. Lotto shows a relish for the movement of natural forms, for surface textures, foliage glimmering with light. The strong rhythm of the diagonals into which Jerome's figure is absorbed, and his reduced scale, both suggest that the landscape has begun to predominate as the vehicle for the spiritual drama.

In each of these examples, the question is how we are to integrate the landscape with the figure so that the combination offers us a coherent, readable narrative. Is the landscape there to reinforce mood and feeling, the drama of the story, or is it being enlisted allegorically to articulate Jerome's spiritual quest? Or are the two mixed? To what extent are buildings, trees, flowers, cornfields and rivers, however naturalistically rendered, each invested with coded meanings, such that if we fail to grasp their symbolic significance we have failed to understand the picture as a whole?

St Thomas Aquinas (1225–74) argues in *Summa Theologiae* that holy teaching may legitimately employ metaphorical or symbolic language,

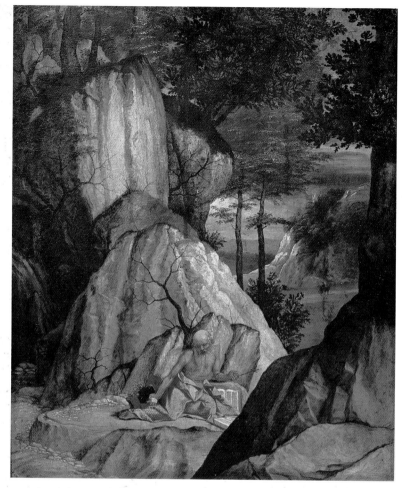

and that it is especially appropriate for the uneducated (*rudes*), 'who are not ready to take intellectual truths neat with nothing else'. The biblical proverbs and parables exemplify such a procedure:

Now we are of the kind to reach the world of intelligence through the world of sense, since all our knowledge takes its rise from sensation. Congenially, then, holy Scripture delivers spiritual things to us beneath metaphors taken from bodily things … Poetry employs metaphors for the sake of representation, in which we are born to take delight. Holy teaching, on the other hand, adopts them for their indispensable usefulness.[10]

Painting, like poetry, can represent spiritual lessons to us by depicting the world of sense. Natural objects can be invested with spiritual or moral meanings that can congeal into an emblematic iconography, a visual language every bit as articulate as a developed literary language. A good example of such emblematic vocabulary can be found in Lorenzo Lotto's *Allegory* [**16**]. Even without its title, the broad sense of this allegory is clear. The central broken tree divides the landscape

16 Lorenzo Lotto

Allegory of Virtue and Vice,
1505

vertically in two. On the right, a drunken satyr sprawls amidst his wine jars. A storm broods over and behind him, and a ship founders. On the left, backed by a bright, sunlit landscape and a break in the clouds, an alert cupid figure plays happily with some mathematical instruments in an image of natural rationality. The crested shield that faces him is Lotto's homage to the patron who commissioned the painting, Bishop Bernardo de Rossi. This is an allegory of virtue and vice, or reason and sensuality. The composite represents the two sides of our human nature, the rational and the bestial, and the picture's weighted visual embodiment of the two states invites us to draw our own moral conclusions. The figures by themselves, as simplified emblems of human dispositions, might have been enough for the painter's didactic purposes, as in the tradition of emblem books; but the contrasted landscapes give the meaning powerful sensational support. Details of natural features—such as the savagely broken tree, the storm clouds, the contrasted foregrounds where one side is cushiony grass and the other stony austerity—help to enact the picture's allegorical meaning at the same time as they lift it beyond the didactic functionalism of the emblem. There's a sensuous pleasure extending beyond and around the 'intellectual truths' that the allegory is meant to transmit, and this conforms with Aquinas's account of 'congenial' holy teaching.

The relationship between the sensuous or aesthetic appeal and the moral or intellectual meaning generated by landscape motifs is a vexed one, particularly in this early period when landscape is hardly ever other than a setting for the human drama. How much 'reading' of these landscapes is appropriate? The 'Book of Nature' was held to be a kind of panoramic text composed of divine hieroglyphs. All natural objects were sanctified not just because of God's immanence in the natural world, but because each in its principle of growth reveals a part of God's design. One of the finest scholars to confront these interpretative issues was Erwin Panovsky. He focused them memorably in his study of early Netherlandish painting, a period when medieval iconographic traditions and conventions were being adapted by painters who had felt the innovations of perspective introduced by fourteenth-century Florentine painters and theorists, and the pressures of naturalism that accompanied such developments: 'A way had to be found to reconcile the new naturalism with a thousand years of Christian tradition; and this attempt resulted in what may be termed concealed or disguised symbolism as opposed to open or obvious symbolism.'[11] But if the symbolism is concealed or disguised in naturalistic representations, how can one know whether or not, or to what extent, the object represented is charged with deliberate symbolic meaning? An apple tree might be simply an apple tree rather than the Tree of Knowledge of Good and Evil. A river might be just a river rather than an allegory of the Course of Human Life. Panovsky points out that, especially 'where

the principle of disguised symbolism was not as yet developed to perfection',[12] there is less of a problem in interpreting paintings where a motif is awkwardly and incongruously introduced in an otherwise fairly consistently naturalistic picture—its very incongruity betrays its symbolic or iconic function. But as 'disguised symbolism' became more sophisticated, the viewer could be less and less certain that he or she had understood the 'intellectual truth' of the depicted scene. In acknowledging this, Panovsky's answer is characteristically candid and authoritative:

There is, I am afraid, no other answer to this problem than the use of historical methods tempered, if possible, by common sense. We have to ask ourselves whether or not the symbolical significance of a given motif is a matter of established representational tradition … whether or not a symbolical interpretation can be justified by definite texts or agrees with ideas demonstrably alive in the period and presumably familiar to its artists … and to what extent such a symbolical interpretation is in keeping with the historical position and personal tendencies of the individual master.[13]

This admirable caution should be borne in mind in any hermeneutical endeavour. The problem facing the viewer of landscape scenery in early devotional paintings is one both of interpretative tact and scholarly erudition.

It is at this point that we might consider paintings from the Northern European Renaissance, where the relationship of landscape to narrative is often different from that figured in the work of the Italian masters, and where, indeed, landscape has often a greater licence to dominate the painting, religious or secular. This becomes particularly interesting in the case of the Danube School, an example of which we have seen in the case of Lucas Cranach. According to one recent scholar of this tradition, Christopher Wood, the first independent landscapes in the history of European art were painted by Albrecht Altdorfer (*c.*1480–1538), Cranach's contemporary. These are apparently finished paintings—in oil on parchment, attached to panels—not just sketches or studies for backgrounds of more ambitious compositions. The pictures are empty of living creatures, human or animal, and, as Wood observes, they 'tell no stories'. Wood's claim for Altdorfer's innovations—'He prised landscape out of a merely supplementary relationship to subject matter'[14]—is closely argued and densely documented in relation both to the historical record of landscape presence in contemporary pictures and to the theoretical principles at issue in deciding such questions as what the terms 'independent' or 'supplementary' mean in absolute or relative terms.

One of these early 'independent' landscapes is the well-known *Landscape with a Footbridge* [**17**]. It is the largest of Altdorfer's landscapes and the most enigmatic. In trying to make some kind of

17 Albrecht Altdorfer

Landscape with a Footbridge,
c.1516

narrative sense of this wholly depopulated view, Wood suggests that
the trees have an anthropomorphic structure and character, to compen-
sate, as it were, for the lack of signifying human presence in the picture:
and indeed the mop-headed treetop on the right does recall features of
the shaggy wild men in some of Altdorfer's other works. Wood also
suggests that the idiosyncratic architectural detail of the stone building
argues for its being based on a real building. So, is this landscape

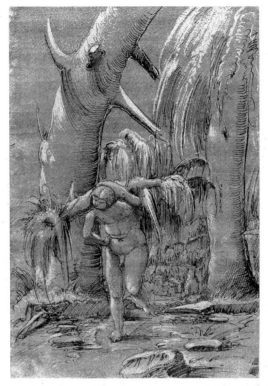

topography, or allegory, or some generic hybrid? Are we presented with 'disguised symbolism' to which we have lost the de-coding key? We know that Altdorfer produced pen and watercolour views of particular places and we know that he painted mythological and allegorical subjects. Like Dürer, he could enlist one practice in the service of the other. If this painting has an allegorical thrust to it, might we read its subject as the bridging of wilderness and civilization? If so, it might well be a more developed extension of the theme that appears in Altdorfer's earlier pen drawing *Wild Man* [**18**], where the savage trudges towards us with a huge tree trunk over his shoulder, heading away from the city in the background. If the London *Landscape* [**17**] is to be read metaphorically, then the shaggy-headed trees might indeed have assumed the narrative role traditionally belonging to human actors. The subject has obvious affinities with the popular Jerome representations.

However, we just don't have the evidence to confirm any of these readings one way or the other. Moreover, it is not clear that we are even asking the right questions. Had this been painted a century or two later, we might now be more relaxed in accepting it simply as a landscape study, an interesting view dominated by this curious bridge, perhaps a particular place, perhaps not. But because it is so early in date for an 'independent' landscape, we are anxiously on our guard against a naive or teleologically biased interpretation of it. The virtual non-existence of an independent landscape painting tradition at the beginning

of the sixteenth century exerts formidable pressure on our reception of these pictures, which we feel *ought* to have a narrative or hagiographical *raison d'être*.

Joachim Patinir and the 'world-landscapes'

A particularly rich and complex example of the kind of problem discussed above is evident in the work of the Flemish painter Joachim Patinir (*c*.1485–1524). His subjects are nearly always religious, but although the figure of the Madonna or saint occupies a foreground position, it is dwarfed by a vast panoramic landscape spreading away on all sides. Fields, farms and villages, cities, monasteries, bays full of shipping, great tracts of forest and mountain chains spread away to a very distant horizon. On a first glance at his painting *Landscape with St Jerome* [19], one might almost miss the tiny figure of the saint in his wattle-and-daub lean-to. The most striking feature of the painting is the breadth and reach of the landscape.

If the iconic figure, in whom devotional significance was traditionally so heavily invested, is now so subordinated to the landscape, how far is that landscape supplying a compensatory 'disguised symbolism' to guide the viewer to its religious meaning? Or is the little saint with his lion simply a pretext for an ambitious exercise in landscape painting? On closer inspection of the picture, fragments of a narrative emerge. These represent not so much disguised symbolism, as scenes from the life of Jerome anachronistically synchronized. There are three lions detectable: one with Jerome in the foreground; one charging at a donkey on the grassy hill on the right; and, as a minuscule detail, one in front of the monastery on the plateau behind Jerome's craggy lair (see detail on page 24). The depiction in one frame of a sequence of actions involving the same protagonist was a feature of Gothic religious paintings. But, in those instances, the space or spaces within which those actions were taking place were not presented with any serious degree of realism. (Or at least perspectival naturalism was less important than the impressing of the spiritual lesson on the mind of the viewer.) Arguably, that lesson gained expressive emphasis in inverse ratio to the mimetic realism of the presentation. But Patinir's landscape appears to be shaped by a painstaking attempt to give the illusion of a single view across a great tract of countryside at a particular moment. This is hard to reconcile with the depiction of a sequence of events that involves the appearance, in three different parts of the landscape, of the same lion. The separate parts of the landscape are theatres for separate scenes from the *Golden Legend* account of Jerome's life.

Patinir incorporates each of these scenes into his landscape. In the distance the caravan of wicked merchants can be seen just to the right of the pinnacle rocks. In front of the monastery Jerome with the lion pardons the kneeling merchants. In the right foreground the lion attacks

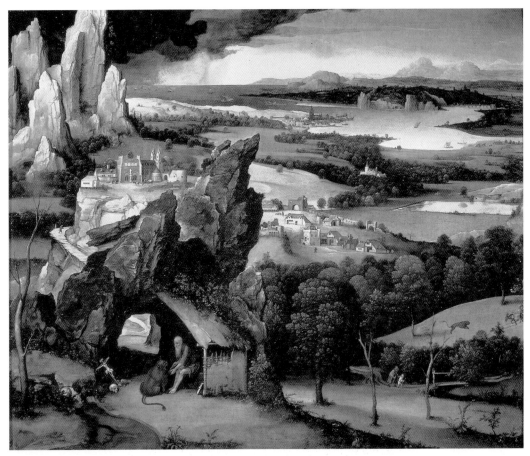

19 Joachim Patinir

Landscape with St Jerome,
c. 1515–19

the caravan being led by his friend the ass. Finally, in the immediate foreground, Jerome is tending the lion's paw. Thus one can piece together a story that highlights the virtues of the saint; and it is obvious that any single picture that is to include all these anecdotes would have to be fairly expansive. But the striking aspect in this narrative painting, especially when one compares it to the Venetian Jeromes, is the apparent superfluity of scenic detail: the reservoir in the middle ground on the right; the cluster of buildings in front of it; the chateau among the trees; the distant coastal town with cathedral, and so on. None of these is incorporated as a setting for narrative episodes. Why do we need so *much* landscape in order to rehearse the story of Jerome? Are we missing, in this proliferation of landscape motifs, clues to further interpretation of Jerome's story? Or are we seeing here, in these 'world-landscapes' a kind of breakthrough to the modern sensibility about landscape?

I want to turn to another painting by Patinir, *Landscape with Rest on the Flight into Egypt* [20]. Here I want to discuss one of the most detailed and extensive interpretations of the picture (as of other Patinir pictures). The analysis is by Reindert Falkenburg in his study *Joachim*

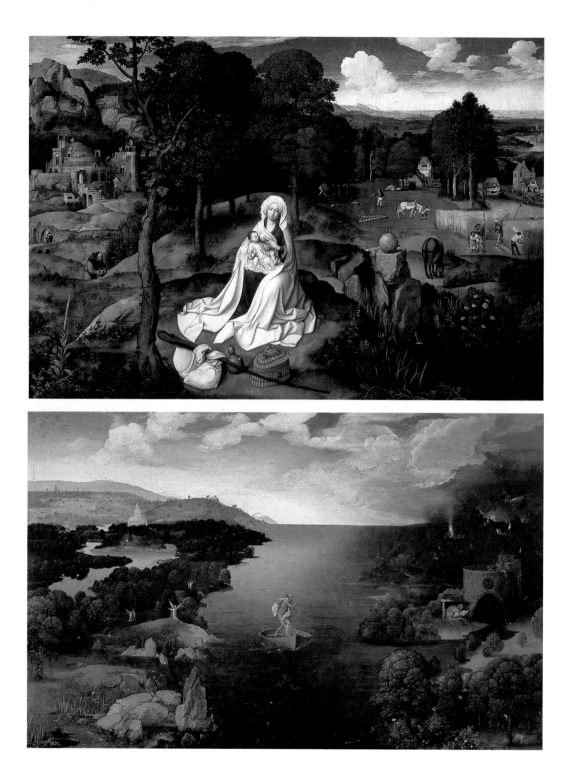

Patinir: Landscape as an Image of the Pilgrimage of Life.[15] *The Flight* presents us with another busily detailed landscape, although the view is not as extensive as in the *Jerome* and the central figure is much more dominant. Once again we have, included in the landscape, episodes relating to the story of the Flight into Egypt of the Holy Family. It is difficult for the modern secular viewer to grasp many of these, because they speak in what is now almost a dead language. Falkenburg stresses the continuing presence of the iconographic tradition in this painting which, at first glance, seems to lavish so much more attention on detailing the natural scenery for the sheer pleasure of its sensuous immediacy. As in the *Jerome*, we can piece together the relevant narrative from the human actions depicted and from some of the more obvious indicators of the event. The basket, flask, and staff which are so prominently displayed in the foreground are the traditional tokens of travel on the Flight, and as it were, quickly key us in to the subject of the painting. They belong to the story of the Flight, just as do the narrative incidents depicted in the landscape: the Miraculous Wheatfield on the right which, according to the apocryphal gospels, ripened overnight as the infant Jesus passed by; and, in the walled temple or city in the left background, the Fall of the Idols at Heliopolis when the Holy Family arrived at the end of their Flight. The narrative, with Family resting in mid-Flight in the centre, is arranged in a right-to-left sequence, starting with the Massacre of the Innocents on the far right. In this respect it is more coherently organized than the narrative elements in the Jerome. However, that is not all that is involved in the decoding of the imagery.

To the right and left of the Virgin are clusters of plants painted with scrupulous detail. Falkenburg, partly invoking the conjectures of other scholars, offers to interpret each of these according to Christian plant symbolism. Thus the Aaron's rod plant in the extreme left foreground, known as a specific against evil, might here symbolize the person of Christ. Beside it, to the left, is what looks like a greater celandine, an Easter and spring plant possibly signifying Christ's suffering. At the foot of the foreground tree is a flowering and fruiting strawberry, which 'can typify Paradise as well as Mary's virginity and motherhood' but can also allude to her humility—here, however, 'it is more likely that it belongs in the Christological context of the other plants in this corner of the painting and should be seen as emblematic of Christ's blood sacrifice',[16] and so on.

We are here dealing precisely with what Panovsky called 'disguised symbolism', and the question is where such deciphering comes to an end when we are confronted with Patinir's landscape pictures. Does almost every natural form betoken a Christian meaning? Do these pictures amount to much more than an arrangement, admittedly vivified by demands for the new perspective laws and a lively naturalism, of iconographic motifs? In other words, is it safer (that is, more

consonant with the original intentions of the painter) to think of it as, first and foremost, a compilation of essentially allegorical motifs, and to distrust, as a product of our secular illiteracy in Christian iconography, any reception of the picture that prioritizes it as an aesthetically pleasing arrangement of rural scenes?

One more Patinir painting might be considered—one in which it is the landscape as a total structure, rather than as a congeries of isolated scenes or motifs, which constitutes an allegory. *Landscape with Charon* [**21**] has strong affinities with Lotto's *Allegory* [**16**]. The figures in the boat are right in the centre of the channel that divides the picture in two. They have reached the confluence of two smaller channels: that to the right leads to the mouth of Hell, guarded by the three-headed Cerberus; that to the left leads to Paradise, where angels walk with the human souls. The organization of this landscape is altogether more schematic. As Falkenburg argues, drawing on the work of Panovsky and others, it seems that Patinir is here adapting a very familiar contemporary topos, the choice between life's two paths. The choice was given iconic form in many representations, showing the initiate at a fork in life's path. This was related to the Pythagorean concept of the letter Y (here inverted) as symbolizing the two possible paths: the main shaft of the letter signifies early age in its uncertainty; at the point of the fork, the left side leads to the blessed life, the right to damnation. Allegorical figures of Virtue and Vice might be depicted at the entrance of each path. The dilemma could be enacted by figures from classical mythology, as here with Charon and Cerberus, or by figures from the biblical world, as here with the angels. The imagery of the natural world in this painting subserves the allegorical design in economical ways. Thus, for instance, the rocky entrance to the Paradise channel contrasts with the seductively cushioned entrance to the channel opposite. The deer, rabbits, swans and peacocks of Paradise contrast with the baboon in the right foreground, an image of lascivious, bestialized nature.

We have looked at three of these 'world-landscapes', each using landscape to help in the telling of a story—by structural design (the inverted Y composition in *Charon* [**21**]), by distributing across a vast terrain a medley of synchronized narrative episodes in *Jerome* [**19**], by deploying the religious iconography of plants in the *Flight* [**20**]. Yet we may still feel that the real purpose of these paintings, the superfluous scale of their landscapes in relation to their narrative function, is to celebrate the awesome beauty of the natural world. The sheer grandeur of that natural theatre in which the story of Jerome occupies select sites in the foreground and middle ground is akin in spirit to the section in Leonardo da Vinci's *Paragone*, 'The painter is lord of all types of people and of all things':

If he [the painter] wants valleys, if he wants from high mountain tops to un-fold a great plain extending down to the sea's horizon, he is lord to do so; and likewise if from low plains he wishes to see high mountains, or from high mountains low plains and the sea shore. In fact, whatever exists in the uni-verse, in essence, in appearance, in the imagination, the painter has first in his mind and then in his hands; and these are of such excellence that they are able to present a proportioned and harmonious view of the whole that can be seen simultaneously, at one glance, just as things in nature.[17]

Patinir evidently relishes the power of possessing such a mighty tract of landscape in one painting, and, beside this extraordinary vista, in for-mal terms, the Jerome story is almost relegated to *parergon*.

The sense that we are being treated to a gratuitous virtuoso exercise in landscape painting is perhaps supported by the knowledge that Patinir in his own time was recognized as a master of landscapes: 'den gut Landschaftsmaler', as Dürer said of him. The known landscape specialist would very likely have been encouraged to exploit his partic-ular *métier*, notwithstanding the primarily devotional subject on which he might have been working. Collaborative working practices would bear this out. Patinir is known to have added landscape backgrounds to compo-sitions by other masters such as Quentin Massys (1465/6–1530) and Joos van Cleve (c.1490–1540). But we would still like to know the extent to which Patinir was responding to a new demand for landscapes. As Reindert Falkenburg has pointed out, we know little more about Patinir's patrons and customers than that a merchant by the name of Lucas Rem, who frequented Antwerp in the second decade of the six-teenth century while Patinir was working there, has his coat of arms on four of Patinir's paintings, from which one may assume that he bought them for his collection.

Max Friedlander in his classic study *Early Netherlandish Painting* suggests, without specific evidence, that Patinir's extraordinary land-scapes were a response to new contemporary demands on the religious painter:

That generation itself called out for a shift in the centre of gravity. ... The world was huge, man a mere grain of sand in it. Earth had begun to rivet the attention of scholars, explorers, travellers and poets—and it was expanding apace. ... This primacy and dominion of the soil, with its teeming multitudes, was in accord with the growing knowledge of the physical world.[18]

Such expansion of knowledge might well have made the world seem more accessible and encouraged painters to offer pictorial scope for ex-pansive exploration. It is also possible that the humanist impulse, which initiated a refocusing of attention and interest on the physical and emotional complexity of man, might have extended that interest to man's equally complex and rich physical environment. A new kind of anatomizing portraiture of the earth's surface would be a counterpart

to the new perceptions of the human being. All these possibilities simply enhance the sense of sheer enthusiasm for picturing the natural world which Leonardo expressed in his *Paragone*.

Still, one might ask why the same expansive artistic response to the new feeling for the earth was so much less in evidence in Italian painting of the same period, especially in Florentine painting; or was it? There remain baffling questions about the origins of the taste for landscape art. According to Otto Pacht, 'any unbiased investigation would show that it was the Italians who first designed individualized landscape settings and that it was their influence which stimulated similar experiments in the North where landscape painting fully established itself as an independent genre'.[19] Or was it the North that stimulated Italian tastes in independent landscape? Ernst Gombrich, in a pioneering essay on the rise of landscape in the Renaissance,[20] drew attention to comments in 1521 by the Venetian connoisseur Marc Antonio Michiel, who noted among the items in the collection of Cardinal Grimani 'molte tavolette de paesi' (many pictures of landscape). In this category, Michiel included works by Giulio Campagnola (*c*.1482–*c*.1518) and Giorgione's (*c*.1477–1510) *Tempest* [**29**], the latter being described as 'a small landscape [*paesetto*], on canvas, with a thunderstorm, a gipsy and a soldier'. Gombrich comments, 'Whatever else the painting may illustrate, for the great Venetian connoisseur it belonged in the category of landscape painting ...'. The existence of such a 'category' is itself significant. Gombrich relates the rise of landscape to Renaissance theories of art, characteristically arguing that landscape painting in its 'institutional aspect' emerged only when it found a way to become accommodated into academic conventions of art in the Renaissance:

It was precisely an art such as landscape painting which lacked the fixed framework of a traditional subject matter, that needed for its development some pre-existing mould into which the artist could pour his ideas. What had begun as fortuitous modes crystallized into recognisable moods, strains of sentiment which could be touched upon at will.

The demand for landscape painting came from the Renaissance South, so Gombrich argues. It may have been the Danube School or the Netherlandish painters, such as Patinir, who first produced landscape views ('fortuitous modes') around the turn of the fifteenth into the sixteenth century, but those artists were not consciously initiating a new genre. That, according to Gombrich, came as a result of certain kinds of market demand stimulated by Italian artistic theory. In the late fifteenth century, Alberti (1404–72) and Leonardo wrote enthusiastic appreciations of the pleasures afforded by landscape scenery for psychological recreation. The Flemish painters were recognized as having a particular flair for such scenery: 'a certain talent and discretion

is needed for [the depiction of] near and distant landscape which the Flemish seem to have rather than the Italians',[21] wrote the Italian author of one treatise on painting in 1509. The demand was being adumbrated. Gombrich concluded, 'it might be said that if such a kind of painting did not yet exist, it had to be invented'.

Gombrich's influential thesis on the 'rise of landscape' has been challenged in a number of ways, mainly on the grounds that it proposes exclusively art-historical explanations for developments that were enmeshed in a much broader conspectus of cultural changes: such as the growth of interest in empirical science and the attendant appetite for pictorial representations of the natural world; early capitalist attitudes towards the land, especially undeveloped land, and the erosion of certain habits of relating to the land under feudal systems of land tenure; or even the following disarmingly simple account by Christopher Wood, which raises as many questions as it purports to answer:

Landscape in the West was itself a symptom of modern loss, a cultural form that emerged only after humanity's primal relationship to nature had been disrupted by urbanism, commerce and technology. For when mankind still 'belonged' to nature in a simple way, nobody needed to paint a landscape.[22]

The lonely figure of the anchorite in a natural setting focuses just these forms of disruption: the drama is precisely this engagement between the primitive elements and the human spirit, where that human has made a choice about the location of that 'primal relationship'. The tradition of depicting Jerome in such a way as to explore the significance of landscape continued well into the period when it is conventionally assumed that landscape painting had established itself as an independent genre. In the 1630s Philip IV of Spain commissioned a number of paintings for his sumptuously palatial retreat Buen Retiro.[23] Prominent among the commissions were two series of landscapes, about 50 paintings in all, one consisting of pastoral scenes, the other of anchorites in panoramic natural settings. Claude Lorrain (*c*.1604/5–82) and Nicolas Poussin (1594–1665) were among the artists approached: Claude produced *Landscape with an Anchorite* and Poussin *Landscape with St Jerome*. The mix of these two types of rural scene and human subject, shepherds and anchorites and their deliberate association, in a lavish commissioning exercise, with the Buen Retiro ideal of civilized retreat, confirmed the new status of landscape art.

Landscape as Amenity

3

> Our minds are delighted in a particular manner with the pictures of pleasant landscapes, of havens, of fishing, hunting, swimming, country sports, of flowery fields and thick groves ... those who suffer from fever are offered much relief by the sight of painted fountains, rivers and running brooks.[1]
>
> Alberti, *Ten Books of Architecture*

> Viewing ... nature's scenery assuages from the soul all passions, frees it from all tensions, brings together its scattered powers, invites it to calm contemplation, and strengthens, enlivens, and refreshes it.[2]
>
> Ludwig Fernow, *Römische Briefe*

Awesome and beautiful landscapes can detoxify the mind and spirit. The word 'amenity' derives from the Latin adjective *amoenus*, meaning 'pleasant'. The *locus amoenus*, the 'pleasant place', was a phrase used in classical and Renaissance times to designate distinctively beautiful rural or garden retreats. The phrase has an obvious kinship with the ancient term 'pleasance', which referred to secluded pleasure grounds on a large garden estate. The therapeutic power of natural scenery, attested to in the above quotations from Alberti and Fernow, whether discovered in the natural world or artfully contrived for the gardens and parks of country estates, is the theme of this chapter's exploration of various versions of the *locus amoenus*.

The ideal 'pleasant place' had to be natural, or, if crafted, then crafted with predominantly natural materials, but it had also to be safe, partially domesticated and insulated from the world of public affairs. The idea and practice of small-scale gardening or large-scale 'landscaping' have always oscillated between the two extremes of full cultivation and untouched wilderness, and one could write an illuminating, if oblique, history of a nation's cultural development by examining its changing conception of the garden's scope, design and function. In the Renaissance, the garden was an important focus for thinking about the

tensions between those 'vast and all-comprehending Dominions of Nature and Art' as one writer put it in 1657.[3] In the poem by Wallace Stevens cited in Chapter 1 (see page 5), the jar—the work of art—'took dominion' over the wilderness of nature in a reprise of the ancient controversy over the relationship between the two forces or concepts. As E. W. Tayler has demonstrated, that relationship could be co-operative or antagonistic: 'These conflicting interpretations of the division—Nature and Art as complementary, Nature and Art as opposed—represent the two main alternatives for Renaissance thinkers.'[4] Nature could be thought of as raw wilderness, the deformed and uncontrollably prolific face of the fallen world: 'The best Nature without Art is but a Wilderness.'[5] But nature could also be thought of as representing the form of perfection, the ideal order: 'Nature is the Art of God', as Thomas Browne asserted.[6] As we saw in Chapter 2, Christian attitudes towards wilderness were similarly ambivalent. The apparent incompatibility of these two views of nature made the activity of gardening an intellectual challenge as well as a horticultural laboratory, the latter practice spurred by the importation into sixteenth-century Europe of a wealth of exotic plants from the near East and from the New World.

Cicero (106–43 BC) had written of 'another' or a 'second nature' (*alteram naturam*) created by the agricultural changes made by man that

23 Michelozzo di Bartolomeo
Photograph of the
Villa Medici, Fiesole,
commissioned *c.*1455

seemed to transform the the natural world.[7] Gardening in the Renaissance was sometimes thought of as introducing a 'third nature' arising out of the subtle integration of nature and art[8] so that the final result (in so far as a garden can ever represent 'a final result') seems to partake equally of both. The fusion so admired can, for us today, seem hard to credit in sixteenth-century gardens, where they survive, or in the pictorial records of such gardens—they seem so intent in marking off the cultivated areas from the extra-mural landscape as to suggest less integration than planned antithesis. Sometimes it seems as if the loose rhythms and contours of the outside world are there specifically to give a rugged, dishevelled frame to the controlled geometry of the formal garden, to throw it into sharp relief and to boast of the scale on which the owner can impose his civilized presence on the landscape. The fresco portrait of the Villa Caprarola [**22**], painted for the loggia of the Palazzina Gambara, Villa Lante, Bagnaia, depicts the estate in its hilly and thickly wooded landscape. The darkness of the surrounding country heightens the light on the central building and formal gardens, just as the rectilinear patterns of those walled enclosures and larger structures throw into relief the undulating, serpentine forms of the landscape features.

Alberti in *De re aedificatoria* (1485) had recommended situating the villa on a height so as to enhance its grandeur and also to afford views of the surrounding country. His advice had been anticipated a quarter of a century earlier in the construction of the Villa Medici at Fiesole [**23**] commissioned by Cosimo de' Medici for his son Giovanni. The hilltop site was chosen for its panoramic views, both of the countryside and of the city of Florence. This was, in its day, a very significant decision, according to architectural historian James Ackerman:

LANDSCAPE AS AMENITY 55

The extraordinary innovation in form and function at the Fiesole villa consists in the replacement of the economic values of the earlier Medici properties—income, security, the provisioning of the city palace—by ideological values that made an image of the landscape, exalting it as something other than the natural environment.[9]

Ackerman's identification of an important cultural change in the evaluation of land, subordinating its economic utility to its aesthetic value, corresponds with the kind of analysis of the ascendancy of 'landscape' in the early modern period offered by Denis Cosgrove (see pages 20–1). Land was increasingly valued as an aesthetic amenity—as landscape.

The opportunity for landscape vistas was also a determining factor in the siting and design of Lorenzo's villa at Poggio a Caiano (1480s). Again at this villa, designed by Guiliano da Sangallo (1443?–1516), the house was, as it were, raised from the ground by one storey so that the grand entrance was on the first floor. One reached this by curved, balustraded staircases that brought one on to an open promenade surrounding the square structure of the house. The Italian Renaissance villa, whether or not originally situated so as to command fine views of the country, often lifted its main reception rooms on to the first floor, around which ran an open promenade, as in the fresco of the Villa Caprarola [22]. Here a different view of the country and gardens is afforded from each of the five façades of the building. This design—the raised *piano nobile* and exterior terrace for promenading—encourages the practice of leisurely viewing of the landscape. Astutely sited country villas were residential belvederes.

The growth in popularity of landscape painting in the sixteenth century, where an expansive view of countryside began to predominate over any narrative elements, can be related to the contemporary growth of interest in villa life in Italy. Views of the countryside from the terrace or loggia of the *piano nobile*, or through the frame of a window, encouraged the pictorializing of landscape. Palladio's Villa Rotonda at Vicenza [24] was built in the early 1550s, and differed from many of the villas built earlier in the century in the respect that it had no connection with farming. It was built purely for pleasure, for a retired official of the papal court, Monsignor Paolo Almerico.[10] The priorities for siting it were therefore predominantly aesthetic. Palladio described the chosen site in his *I Quattro Libri*:

The site is one of the most pleasant and delightful that one could find because it is at the top of a little hill with an easy ascent and is bathed on one side by the Bacchiglione, a navigable river, and on the other is surrounded by the most agreeable hills which give the aspect of a great theatre: and all are cultivated and abound in most excellent fruits and the best vines. Thus, because it enjoys beautiful views on every side, some of which are limited, others more distant, and still others that reach the horizon, loggias have been made on all four sides.

Almerico's villa was a refined viewing station. The *locus amoenus*, as mentioned earlier, involved the sense of insulation from the harsher aspects of the natural world. So, among the refinements of the Villa Rotonda, the portico viewing stations shielded the landscape spectator from inclement weather or too fierce sunlight, by having lateral diaphragm walls, each pierced by an arch to allow ventilation.

The heightened interest in having access to fine views of the country is part of the general idealization of the rural world, intensified by the rapid growth of cities and the problems attendant on such growth. Those who bought land and villas in the Veneto did so at a time when land property came to be considered by the Venetian patriciate as a more secure investment than banking or trade, and when increased congestion, noise and atmospheric pollution in the cities were rapidly worsening. The contrasts between town and country are displayed in Titian's (*c.*1485–1576) *Pastoral Scene* [**25**]. The darkened, smoky city is set against the expansive, sunlit, pastoral tranquillity in the foreground, a calm slightly unsettled by the boar and the half-shrouded nude.

The country estate also offered a refuge from the frequent invasions of plague. Vilification of city life is evident in the various literary celebrations of life on a rural estate that appeared over the middle years of the sixteenth century. No doubt much of this literature conventionally rehearses the sentiments of Horace and of Juvenal (*c.*60–*c.*140) in relation to the miseries of urban life and the delights of rural retirement, but it need be no less strongly felt for that. A good example of such writing in praise of villa life and the opportunities for landscape pleasures is Agostino Gallo's *Le Dieci Giornale*, ostensibly recording a dialogue that took place in 1553. One of his speakers, Avogadro, launches a diatribe against the physical and moral pollutants of the contemporary city in order to throw into sharper relief the hedonistic and moral benefits of the countryside:

25 Titian
Pastoral Scene, c.1565

How can I express the satisfaction that we get from the pure air here, which is so refreshing to the spirit? We find it wonderfully stimulating and at the same time it soothes the brain, purges the mind, calms the spirit and strengthens the body. ...

Here you are free from bawling streetsweepers and garbage collectors, jostling porters and wine-carriers, bawds and whores reeking of musk, crooks and sorcerers who ensnare you, ... towns today are full of strife and stress, and not what they were in the happy days of our grandfathers and great-grandfathers. ...

Here we have complete peace, real freedom, tranquil security and sweet repose. We can enjoy pure air, shady trees with their abundant fruit, clear water, and lovely valleys; we can make use of the fertile farmland and the productive vines, as well as appreciating the mountains and hills for the view, the woods for their charm, the fields for their spaciousness and the gardens for their beauty ... it is impossible to reckon the value of the great sense of contentment we feel when we rest our eyes on the high mountains, the agreeable hills, the great diversity of trees, the green fields. [11]

Gallo suggests that cities were very different places from those in 'the happy days' of two or three generations ago. His list of rural pleasures here is a mix of economic satisfaction, of the way 'we can make use of the fertile farmland and the productive vines', and more purely aesthetic delight in the peaceful, restorative spectacle of nature in all her forms. He echoes Alberti's promotion of the pleasures of landscape pictures and the relief they can offer to those suffering from fever.

Alberti was speaking of *pictures* of landscapes. The country villa owner could realize views of rural scenery the town dweller could enjoy only in painted representations, or from pastoral poetry. Palladio's villa designs made a point of integrating architecture and landscape, so that the aesthetic value of landscape was part of the commercial value of the real estate selected for the rural retreats. When the urban dweller is also the villa owner—as happened increasingly in Renaissance Italy as the urbanized professional and merchant classes bought country estates— that interchange, or tension, between artificial and real landscapes becomes a more immediate experience and a more absorbing interest. The issue was highlighted in what was then the most celebrated villa description of all, Pliny the Younger's (*c*.61–*c*.112) description of his estate on the Tuscany–Umbria border. It was Guarino Guarini Veronese, the owner of a villa at Val Policella near Verona, who, in 1419, brought to light the letters of Pliny that contained these descriptions, both of the villa and of the views from it:

A great spreading plain is ringed round by mountains ... these hills are fully as fertile as the level plain and yield quite as rich a harvest. ... Below them the vineyards spreading down every slope weave their uniform pattern far and wide. ... Then come the meadows and cornfields ... meadows bright with flowers. ... It is a great pleasure to look down on the countryside from the mountain, *for the view seems to be a painted scene of unusual beauty rather than a real landscape*, and the harmony to be found in this variety refreshes the eye wherever it turns.[12] [my italics]

Pliny's way of suggesting the extraordinary beauty of the real landscape is to make it seem more the product of art than nature. This must be one of the first intimations of the Picturesque habit of using landscape paintings as the standard of beauty in assessing real scenery. In recommending the view of the landscape as one of the great benefits of villa life, Pliny's description confers a high value on the visual experience of landscape afforded by the villa.

As we have seen, Italian villa owners went to some trouble to ensure that their villas functioned well as belvederes. These villa owners were the patrons, and could see to it that their tastes in landscape could issue in commissions. Thus the view of real landscapes, seen through the villa window frames or loggia openings, could be supplemented by painted landscape views framed in alcoves in the halls, or *salone*, of the grand villas. In the Villa Barbaro, Maser, Paulo Veronese in (*c*.1528–88) painted a number of frescos of landscapes with romantic ruins [**26**]. On a more ambitious scale, the Camera delle Cariatide [**27**] at the Villa Imperiale, Pesaro, has an illusionistic landscape extending all round the room. It was painted around 1530 by Dosso and Battista Dossi (*c*.1497–1548).[13] The visual effect is that of being in an elaborate rustic loggia or pergola, rather larger than the actual room (which is

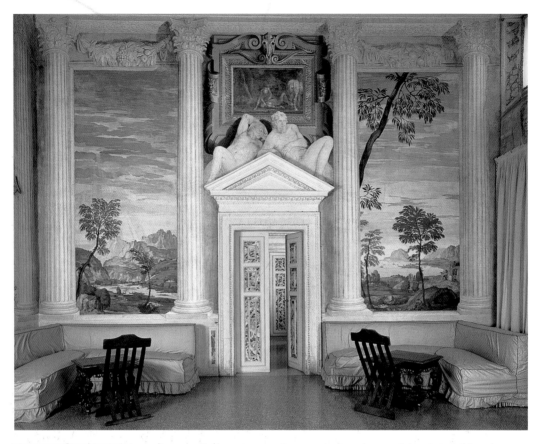

26 Paolo Veronese
Landscape frescos, 1560–62

quite small, just 4.85 × 6.2 metres) supported by caryatid columns. A broad landscape, naturalistically rendered, stretches beyond these out to the horizon. The whole design represents a weird interplay between exterior and interior, nature and artifice. The caryatids—women grafted on to tree roots—are images of a merging of nature and the human. Landscape is drawn into the experience of the house. The conventional polarities, nature and art, are confused in this visual illusionism. But they were already deliberately confused, as for instance in Pliny's account where the countryside viewed from his villa looked more like a beautiful picture than a real landscape. In the Camera delle Cariatide the beautiful picture looks like views, from four sides of the house, of a real landscape. In the Villa Rotonda, it will be recalled, Almerico had four loggias for viewing four stretches of beautiful countryside.

Each wall in the Camera is, in effect, a large panel painting, with the loggia arches symmetrically organized so as to divide up the view of the countryside beyond into smaller, partially framed vistas. But the imaged landscape is a continuous panorama, ignoring the corners turned in the room. It plays its own free forms and gently undulating contours against the geometry of the room/loggia. Unusually, the

transition from domestic interior to *trompe-l'œil* landscape is not graduated. There are no trim walks or flowerbeds at skirting-board level to mediate between house and landscape, as would have been the case in many contemporary villas, where one would walk out of the house into a garden that suggested, in its rectilinear enclosed forms, a series of exterior rooms, and thereby both offered a continuity with indoors and mediated the transition to the parkland and countryside beyond.

If villas were sited and architecturally designed so as to exploit, as one of their great amenities, the surrounding landscape views, so could the villa gardens themselves be organized as viewing stages for the natural scenery that lay beyond the estate. The Este Garden at Tivoli and the Orsini Park [28] at Pitigliano (begun about 1560) were two of many gardens that performed this function. Orsini Park was designed to offer the spectator particularly rugged and grand-scale views. It stretched along a high plateau and at one point, near the end of a promontory, there was a huge armchair carved in the rock. It faced a magnificent view of the valley and hills. In such designs the question of where garden gives way to natural landscape is hard to determine. The point is that the experience of the wider landscape becomes an integral part of the experience of the garden, just as both were integral to the experience of the country house.

27 Dosso and Battista Dossi
Camera delle Cariatide,
c.1530

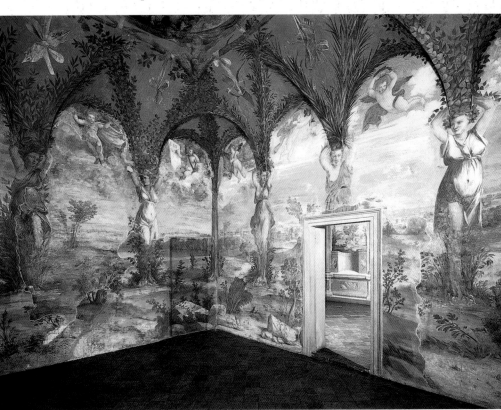

Renaissance villa culture demonstrates a variety of ways in which the relationships between domestic and the wild, art and nature, are negotiated so that landscape becomes absorbed into the total cultural experience of villa life—through the relation of house to garden and garden to environing landscape, through the importance of siting villas so as to optimize the vistas, through the paintings of landscape available within the villas. Commentators on villa life, from Pliny onwards, had stressed the therapeutic value of that more sustained exposure to real countryside enjoyed by the villa owner and his society. Instead of the vicarious enjoyment of rural retirement and pastoral idyll afforded by books and pictures, the authentic experience was now more widely available to patrician and plutocrat, and, according to some influential figures, should always be preferred. The point is made with some urgency by Leonardo da Vinci, in his efforts to promote the visual over the literary representation of the natural world:

What induces you, oh man, to depart from your home in town, to leave parents and friends, and go to the country-side over mountains and valleys, if it is not the beauty of the world of nature which, on considering, you can only enjoy through the sense of sight; and as the poet in this also wants to compete

with the painter, why do you not take the poet's descriptions of such landscapes and stay at home without exposing yourself to the excessive heat of the sun? Would that not be more expedient and less fatiguing, since you could stay in a cool place without moving about and exposing yourself to illness? But your soul could not enjoy the pleasures that come to it through the eyes, the windows of its habitation, it could not receive the reflections of bright places, it could not see the many flowers which with their various colours compose harmonies for the eye, nor all the other things which may present themselves to the eye.[14]

Leonardo's priorities are an echo of the writings of Petrarch, in particular (as we noticed in Chapter 2) his letters praising his country retreat in the Vaucluse and his more general celebrations in *De Vita Solitaria* (1346).

The literary impulse behind the new valuation of rural scenery and life is part of the history of villa culture and plays a crucial role in promoting landscape art. The Medici circle included a number of writers who celebrated idylls of rural life. Angelo Poliziano was a protégé of Lorenzo de' Medici and through his patronage was appointed to a chair at the Florentine university. There he wrote *Rusticus* (1483), a verse lecture on the bucolic poems of Hesiod and Virgil. The Neapolitan writer, Sannazaro, produced his enormously influential pastoral romance, *Arcadia*, in 1502 (though the authorized edition appeared two years later). The Venetian writer, Pietro Bembo, whose work included vernacular imitations of Petrarch's poetry, published *Gli Asolani* in 1505 with its elegant discourses on Platonic and sensual love, set in an idealized garden retreat at the palace at Asolo:

They reached a little glade of tender grass, all carpeted with many sorts of charming flowers. Beyond this the laurels, which here grew lawlessly in greater quantity than elsewhere, formed two groves of equal size, black with shade and reverent in their solitude; and deep between them harbored a delightful fountain, carved with consummate art out of the living rock with which the mountain closed the garden on this side.[15]

This is where they choose to hold their debate, a *locus amoenus* typical of the favoured rural retreats for courtly villa life in its mix of the wild and the cultivated.

These writings issued partly out of the renewed interest in the classical genres, the Roman agronomical texts, Virgilian pastoral and Horatian celebrations of retirement in the country. The literary milieux associated with villa life in Renaissance Italy encouraged the blending of these revived genres with both a strong vernacular inflection and a relish for natural scenery afforded by local settings. Courtly pastoral blended with *fête champêtre*, and philosophical dialogues on love were staged in rural or garden settings. The resurgence of interest in pastoral, georgic and Horatian modes in poetry, and their fostering in the villa culture of the period, is matched in painting, particularly in Venetian

landscapes. The pastorals of Giulio Campagnola and Titian belong to this world, as do perhaps the more enigmatic landscapes of Giorgione. One wonders, for instance, to what extent the controversial *Tempest* [**29**], with the soldier and the suckling mother antithetically positioned, might be an allegorical representation of ideas on the divided gender roles in *Gli Asolani*, with which the painting is contemporary:

So man and woman, though fated to bear different loads, each needs what the other carries to the hunt of life, being each too feeble to support more than his half of the common burden … How could we at the same moment give the people laws and children suck … or lying in repose on featherbeds at home, wear out a heavy pregnancy, and at the same time make war beneath the open sky with sword in hand and clad in armour?[16]

In a later imaginary dialogue, conducted in a villa setting, one of the speakers in Gallo's *Le Dieci Giornale* tempts his friend with a glimpse of delicious recreation on the villa's estate:

and what would you say if I told you that sometimes, at the same hour [late afternoon or early evening], we come across our ladies … strolling about the estate

29 Giorgione
Tempest, 1505–10

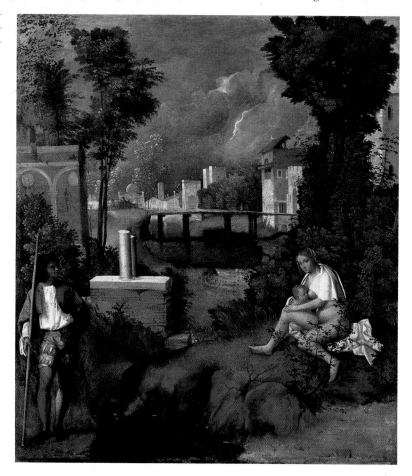

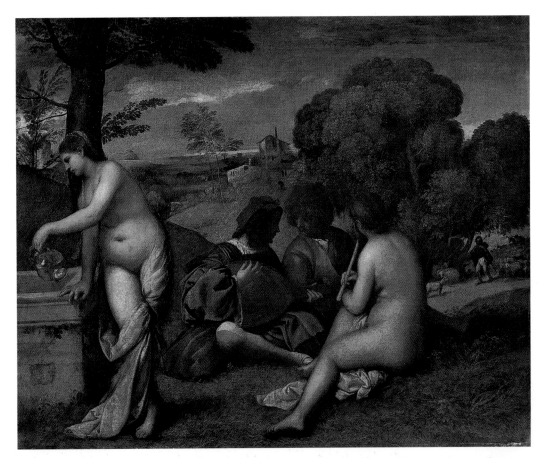

30 Giorgione or Titian

Le Concert Champêtre,
*c.*1510

... or chatting beside some pool or clear fountain? We greet them with proper ceremony and then we talk with them in a bantering way. ... Sometimes one of us sits down to play the lute or the viol or some other instrument of that sort.[17]

Such a scene might almost be a recollection of the main subject of Giorgione's (or Titian's?) *Le Concert Champêtre* [**30**], with the woman by the fountain basin and the young man with the lute. Harmonized with Giorgione's scene of courtly rural recreation is the pastoral detail of shepherd and flock in the sunlit middle ground. Both picture and passage illustrate the blend of revived classical pastoralism with contemporary Renaissance setting, and typify the idealized *locus amoenus*. Like Giorgione's *Tempest* [**29**], this painting has never been conclusively explained in terms of its subject matter. Is it Virgilian eclogue, the swains' singing contest, in a Venetian idiom? In the seventeenth century it was known as a 'Pastorale',[18] possibly the first recorded application to painting of the term usually associated with the literary genre. Or is it an allegorical celebration of Poetry, the female personification of which was often portrayed with a simple flute and sometimes with a pitcher of water as well? Or is it a hybrid composition, partly allegory, partly 'conversation' picture, partly pastoral?[19] There is no

reason why it should not embrace several sub-genres. Poetry, according to Boccaccio (1313–75), flourished in a country setting. The rural *locus amoenus* was her natural habitat:

If at any time ... [Poetry] leave her lofty throne, and descend to earth with her meinie of sacred Muses, she never seeks a habitation in the towering palaces of kings or the easy abodes of the luxurious; rather she visits caves on the steep mountainside, or shady groves ... There the beeches stretch themselves, with other trees, toward heaven; there they spread a thick shade with their fresh green foliage ... there, too, are clear fountains and argent brooks ... and there the flocks and herds, the shepherd's cottage or the little hut untroubled with domestic cares; and all is filled with peace and quiet.[20]

Giorgione's (or Titian's) *Le Concert Champêtre* can easily be associated with this affinity between the spirit of poetry and a pastoral landscape setting. It can also be associated with more contemporary sentiments of this kind. Sannazaro's *Arcadia* has already been mentioned in connection with the revival of pastoral—or one might say with the Renaissance refreshing of pastoral. *Arcadia* is a series of pastoral poems, modelled on Virgil's *Eclogues*, accompanied by prose passages, many of which develop elaborate landscape descriptions. The book was enormously popular: from its first authorized appearance in 1504 there was a new edition every two years, on average, throughout Sannazaro's lifetime (he died in 1530). The Prologue is significant in its emphasis on the higher pleasures of country retreats at the expense of cultivated gardens, an emphasis that raises again the issue of the tension between art and nature. However, in the Prologue the tension is not now the stark opposition of art and nature but a polarizing of the untouched natural world and that 'third nature' which is the garden's attempt to integrate and harmonize artifice and the wild. The point is made through a number of examples:

More often than not the tall and spreading trees brought forth by nature on the shaggy mountains are wont to bring greater pleasure to those who view them than are the cultivated trees pruned and thinned by cunning hands in ornamented gardens. And the birds of the woodland singing upon the green branches in the solitary forests give much more pleasure to him who hears them than do those birds that have been taught to speak from within their lovely and decorated cages in the crowded cities. And the wax-bound reeds of shepherds proffer amid the flower-laden valleys perhaps more pleasurable sound than do through proud chambers the polished and costly boxwood instruments of the musicians. And who has any doubt that a fountain that issues naturally from the living rock, surrounded by green growth, is more pleasing to the human mind than all the others made by art of whitest marble, resplendent with much gold.[21]

This pastoral manifesto takes us back into *Le Concert Champêtre* [30]. Patricia Egan in an article of 1959[22] observed of this painting that its placid landscape—seemingly a peaceful unity—contained several

carefully planned oppositions. The obvious one, between the clothed and the naked figures, is extended into contrasts between the stylish, expensively dressed boy on the left and the peasant dress of his tousle-haired, barefoot companion. The buildings behind them, according to Egan, are equally contrasted: the cluster of brown buildings to the right of this mass, with picturesquely asymmetrical roof slopes, is juxtaposed to a more elegant and seemingly symmetrical white building. To these oppositions we are prompted to add another, highlighted in the passage from *Arcadia*: the reed flute or recorder held by the seated woman is closely juxtaposed to the 'polished and costly boxwood instrument' played by the patrician youth. In fact, just as Sannazaro's Prologue was structured by art and nature oppositions, so this painting is similarly structured.

one gets great enjoyment in seeing a happy, fruitful and festive hillside, with a thousand retired recesses where it seems that quiet and felicity reside, and in hearing the rustic songs of simple villanelle and the sound of the waxed pipes of the shepherds.[23]

Villa culture, in its negotiation of the relations between garden and the wild, in its intra-mural landscapes and its belvedere designs, in its active sponsorship and general encouragement of literary and pictorial pastoral, provides a context in which the aesthetic appraisal of natural scenery begins to assert itself as a cultural activity; and within that context 'landscape' emerges as a topos and begins to constitute itself as an independent genre.

The close connections found in Renaissance Italy between literary pastoral, landscape painting, gardening, the *locus amoenus*, and planned landscape vistas, the promotion of land as an aesthetic asset, and the mediation between domestic and wilder areas of a country estate—all these became central concerns in Enlightenment thinking about nature. This chapter concludes with a very brief sampling of some of the directions in which this thinking led, and some of the ways in which post-Enlightenment landscape has been designed as an aesthetic amenity.

The garden in eighteenth-century England became a green laboratory for aesthetic experiments. Gardening as a philosophical enterprise was promoted by the new confidence in a benignly ordered and rational universe, a universe driven by mechanical laws increasingly accessible to human intelligence:

Nature, and Nature's Laws lay hid in Night:
God said, *Let Newton be!* and All was *Light*.[24]

Enlightenment belief in the essential benevolence and supreme efficiency of Nature led to its being appreciated as 'a god-govern'd machine'.[25] Intellectual curiosity about the natural world fostered a

revised and enlarged sense of what constituted aesthetic pleasure in natural scenery. Older prejudices against mountain wilderness led to striking distinctions between the cultivated land of a garden estate and the outlying regions untouched by cultivation and, hence, inhospitable. The portrait of Chatsworth [31], the home of the Duke of Devonshire in the heart of the Derbyshire hill country, illustrates the sharp division between cultivation and the wild, much as the fresco portrait of the Villa Caprarola had done. The exaggerated coarseness of the surrounding country, accentuated in the bestial coupling in the foreground, represents a version of the fallen world, and throws into greater relief the orderly paradise within the walls of Chatsworth. Charles Cotton's poem 'The Wonders of the Peake' (1681) echoes this:

> To view from hence the glittering *Pile* above
> (Which must at once wonder create, and love)
> Environ'd round with *Nature's* Shames, and Ills,
> Black Heaths, wild Rocks, bleak Craggs, and naked Hills,
> And the whole *Prospect* so informe, and rude?
> Who is it, but must presently conclude
> That this is *Paradice*, which seated stands
> In midst of *Desarts*, and of barren *Sands*?[26]

In nearly the same period the third Earl of Shaftesbury, among the foremost of those who promoted the view of the essentially benign nature of all creation, gave to one of the speakers in his philosophical dialogue *The Moralists* the following speech:

I shall no longer resist the Passion growing in me for Things of a *natural* kind; where neither *Art*, nor the *Conceit* or *Caprice* of Man has spoil'd their *genuine Order*, by breaking in upon that *primitive State*. Even the rude *Rocks*, the mossy *Caverns*, the irregular unwrought *Grotto's*, and broken *Falls* of Waters, with all the horrid Graces of the *Wilderness* itself, as representing NATURE more, will be the more engaging, and appear with a Magnificence beyond the formal Mockery of Princely Gardens.[27]

Shaftesbury's conviction that beneath the apparent random sprawl of wilderness lay a 'deep' order, finer than could ever be fabricated by human ingenuity, with all the resources of money and technology available, was an inspiration to rethinking landscape aesthetics. His work was explicitly invoked in the most substantial and innovative descriptive poem of the century, James Thomson's (1700–48) *The Seasons*; and *The Seasons* in turn inspired landscape poets, painters and garden designers in Britain and continental Europe:

I know no subject more elevating, more amusing; more ready to awake the poetical enthusiasm, the philosophical reflection, and the moral sentiment, than the works of Nature. Where can we meet with such variety, such beauty, such magnificence.[28]

Nature herself, in all her apparent imperfections, manifested the divine order. What might have been viewed as flaws or deformities in natural forms and forces might now be understood as necessary to the larger design of creation which only the deity comprehended in its totality.

In his verse *Epistle* (1731) to Richard Burlington, *On the Use of Riches*, Alexander Pope had recommended, in gardening terms, an 'artful wildness'. This oxymoronic prescription, introduced in order 'to perplex the scene', encapsulates the balance now favoured in the organization of landscape views. Over the middle and later decades of the century the intellectual interest in, and aesthetic pleasure to be derived from, nature in the wild tilted that balance more and more in favour of 'wildness' as the site of the *locus amoenus*. Burlington's protégé, William Kent (*c.*1685–1748), was a painter who had had some training in Rome under the former's patronage but, soon after his return to England, turned his limited painterly talents to garden design. In this capacity he was very successful in promoting the newer tastes in informal landscape design. His work on Lord Cobham's estate at Stowe, Buckinghamshire, constituted a classic text in landscape gardening. As against the older Dutch–English formal gardening practices—walled or box-hedged rectilinear patterning, topiary—Kent encouraged a greater sinuousness in the design of pathways and allowed a greater freedom for the natural forms of the landscape to predominate. The introduction of the ha-ha, or sunken fence, created a continuity between the inner garden and the natural landscape beyond, and effectively imported that landscape into the broad experience of the garden as one stepped out from the house. Kent's successor at Stowe, Lancelot

32 Anon
Heveningham Hall, c.1781

'Capability' Brown (1716–83), took that one stage further by obliterating most of the traces of the old formal parterre gardens, by carrying the lawn and trees right up to the house itself and by softening the transition from garden to parkland to the point where one could hardly tell where one ended and the other began. In effect, many of the great houses of England were now set *in a landscape*, not insulated from the landscape by the environing gardens [32]. Nature at large was the *locus amoenus*.

Views of the houses in their settings and views from the houses emphasized their confident occupation of what seemed to be natural landscapes—they belonged to England and England belonged to them. However, these were carefully managed scenes, designed to look natural, but actually contrived on a vast scale, with groupings of trees distributed with apparent randomness across the land and horizons planned as vistas, sometimes visually controlled with the placing of an eye-catcher. This was essentially the 'look' of a 'Capability' Brown landscape. Near the end of the eighteenth century, the Brownian landscape design came under attack from Picturesque theorists who urged a much greater freedom in gardening and a greater respect for the free organic growth of natural forms and for the way that time and accident shaped a landscape. This was not a matter of 'third nature' gardening in the old sense of a horticultural imposition of design, but of careful management of nature's spontaneous developments, an adumbration of a later century's landscape conservation. Thus, for example, Arthur

Young, the English writer on agriculture who had a sharp eye for the Picturesque potential of the countryside he travelled through, suggested specific ways in which the imposing natural scenery of the Cumberland lakes and mountains at Derwentwater might be slightly modified so as to rival and surpass, in terms of landscaping pleasures, the finest gardens that could be produced by man:

Winding paths should be cut in the rock, and resting-places made for the weary traveller: many of these paths must necessarily lead through the hanging woods, openings might be made to let in views of the lake, where the objects, such as islands, etc., were peculiarly beautiful. … It is amusing to think of the pains and expense with which the environs of several seats have been ornamented, to produce pretty scenes it is true, but how very far short of the wonders that might here be held up to the eye in all the rich luxuriance of nature's painting. What are the effects of a *Louis*'s magnificence to the sportive play of nature in the vale of *Keswick*![29]

Natural scenery had become a valuable commodity, an amenity. In France in the early nineteenth century a new market for the consumption of landscape imagery evolved in Paris, fostered partly, as Nicholas Green has persuasively argued,[30] by the nature of the redesigned commercial centres, by the Picturesque vogue and the popularity of scenic guides to Picturesque France, and by the various spectacles, such as the panorama and diorama, with their new technological powers for creating simulacra of natural scenery. This gave a special value to the semi-rural *banlieus*, those 'pleasant places' such as the forest of Fontainebleau, which the new railway system brought increasingly within reach of a day's excursion from the city. These were advantages that both the railway companies and estate agents were quick to exploit.

European capital cities had, of course, grown in relatively unplanned ways, before garden 'lungs' and the restorative power of natural scenery acquired the importance they assumed in the nineteenth century. New York was different: Central Park [**33**], right in the heart of the city, was planned as a natural landscape, on largely Picturesque principles, by Frederick Law Olmsted. It was designed to be emphatically all that the growing city was not. The grid-pattern layout of New York City and its geometrical blocks of buildings, the insistent rectilinear verticality and horizontality, inspired a diametrically opposite set of requirements for this *locus amoenus*, which was to be a sylvan retreat from the city. Instead of salvaging an oasis of geometrical order from the surrounding wilderness (as at Chatsworth, for example) Central Park preserves an oasis of mazy contours and rural surprises in the midst of a relentlessly rectilinear urban design.

The example of Central Park typifies the way in which the relationships between the domestic–urban and the rural have been constructed in oppositional terms. Efficient spatial organization is required in the

ENTRAL PARK.

Published by JOHN BACHMANN, 76 Nassau St New York.

PRINTED BY F. HEPPENHEIMER, 22 & 24 N. WILLIAM ST N.Y.

34 Bernard Lassus
Avenue and Ruined Portico
of Nîmes Theatre, Aire de
Nîmes-Caissargues, 1992

planning of house or city; but relief from that utilitarian regime is what
is required in the recreational enjoyment of nature. Nature becomes
the repository for anti-utilitarian values, and the aestheticizing of land
as landscape is a move to consolidate that cultural valuation of natural
scenery. These oppositions are largely culturally generated and, as we
have seen in the case of the centre–periphery, 'Argument–by-work'
discussions in earlier chapters, are susceptible to deconstructionist
analysis to the point where the binary oppositions begin to dissolve.
Such challenges to the traditionally confrontational city–country,
art–nature, domestic–rural relationship have always, in any case, been
inherent in the practice of gardening, which attempts to mediate be-
tween the two, and from which evolves the concept of 'third nature'.

In the later twentieth century, when in many western European
countries the sense increases that countryside is disappearing as the re-
sult of the endlessly invasive network of railways and motorways, some
designers are arguing that this old oppositional relationship is posi-
tively obstructive to further environmental development. Bernard
Lassus, the French landscape designer, has written of the 'desire of
urban culture to have a stable image of rurality from before the period
of its own industrialisation',[31] and has proposed new ways of organiz-
ing land space that are not confrontational in the old city–country di-
chotomy, whereby the motorway system is demonized much as
industrialization was demonized in its early phases. Lassus offers ways
of reintegrating the two. He has proposed 'a habitat that is linked to the
motorway but at the same time includes the rural within itself'; and
what he calls 'town-landscapes' would thus interpose 'as new structures
between motorways and "classic" towns on the one hand, and between
successive towns on the other'.

With such ideas of rapprochement in mind, he designed a motorway rest area near the Mediterranean town of Nîmes, the Aire de Nîmes-Caissargues [**34**]. The design plays with the old tensions in new ways. For instance, where the Renaissance villa or Georgian country house might be situated so as to take maximum advantage of views of uninterrupted countryside, the Aire, situated in the countryside, is orientated so as to take full advantage of the view of the city of Nîmes, from which it is pleased to draw most of its own local identity. In addition to its visual incorporation, Nîmes's own urban history is inscribed, by forms of elegant architectural allusion, into the landscaped site. Thus the surviving Doric colonnade of the nineteenth-century theatre in Nîmes (destroyed by fire) now terminates a long avenue of trees (itself carrying echoes of Versailles's grandeur), much as a classical ruin (authentic or folly) might have been situated to complete a vista in an eighteenth-century 'pleasance'. The Mayor of Nîmes greeted the Aire with the comment: 'You are bringing me a park for my town.' One- and two-storey belvederes (incorporating miniature maquettes of Nîmes's famous Tour Magne) were constructed to enhance for the resting motorist the Aire's views of landscape and cityscape [**35**], in which neither becomes aesthetically prioritized over the other.

A motorway amenity has become a postmodern *locus amoenus*.

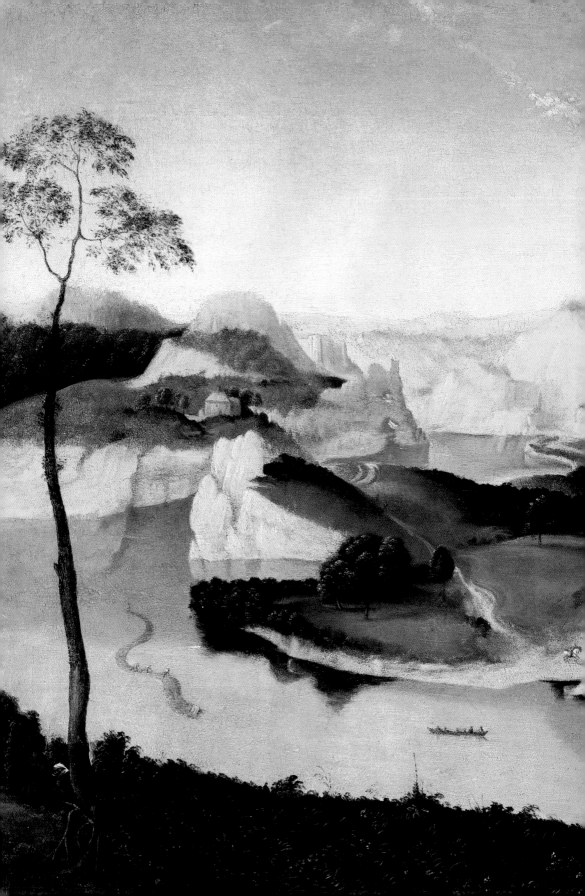

Topography and the *Beau Ideal*

4

Landscape pictures can be like maps—we value both for introducing us to places that we may otherwise not know. They are information and invitation. They can mediate the passage from what we know to what we don't know. Thus, in some instances, we move towards the landscape picture to begin to explore, and there, just on the far side of the threshold, tucked into the foreground inside the frame, the artist may be sitting, absorbed in recording the scene that is being revealed to us for the first time, and we move past him into new country [36]. We move towards an antique map and are introduced to the designer or publisher by assertive cartouche self-advertisement before we begin to explore the intricate cartographical details.

'Knowledge is power' is an old saying. Maps can offer us this sense of power, from which evolves a metaphorical vocabulary of possession: we may enjoy a 'commanding' view of a territory, whether it is a parish or a continent, identifying its boundaries, distinguishing its physical undulations; we may 'grasp' the relationship of its conspicuous landmarks to each other. We accumulate information the more we pore over it. Landscape 'prospects' can similarly give one a pleasurable sense of being monarchs of all we survey, as the view taken from a hilltop offers a wide panorama across a variegated country, or over the estate of a great country house, revealing to us its organization and its setting within the wider landscape, or over a battle scene featuring the strategically advantageous high ground and the principal access routes for military operations. Within one frame a landscape picture can modulate into a map, and a map can introduce and schematize a landscape. An instance of the former can be seen in Peeter Snayers's (1592–1667) monumental painting, *The Infanta Isabella* [...] *at the Siege of Breda* [37]. In the massed foreground, where spectators mix with battalions of soldiers, we are witnessing a historical event. That populous foreground dips steeply away to a level plain which becomes a map—a diagrammatic illustration, in cartographic shorthand, of the siege. An instance of the latter is El Greco's (1541–1614)

View and Plan of Toledo [**38**]. The map held up to us by the youth is carefully labelled and keyed to the principal buildings of the city. The city itself, in profile, set in its dramatic landscape, is represented with topographical fidelity.

36 Netherlandish School

Landscape: A River among Mountains, mid-sixteenth century

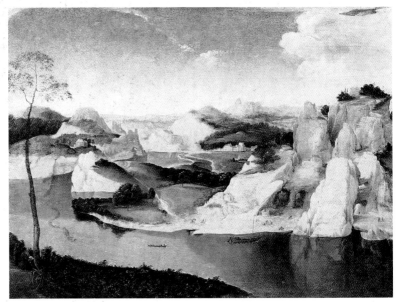

37 Peeter Snayers

*The Infanta Isabella Clara Eugenia at the Siege of Breda of 1624, c.*1630

38 El Greco
View and Plan of Toledo,
c.1610–14

As graphic, pictorialized sources of information that encourage us to expand our knowledge, enrich our sense of our physical environment, and perhaps even stretch our spiritual horizons, maps and landscape pictures have a close relationship. The first part of this chapter considers the nature of this relationship as it concentrates on a particular historical period, The Netherlands in the late sixteenth and seventeenth centuries, when topography in the art of the cartographer and the painter enjoyed a kind of symbiotic productivity. The second part of the chapter moves the focus of attention south, to Italy in the same period, where what seemed like a very different kind of landscape art was being developed —one that eschewed topographical fidelity in order to render scenes of idealized beauty. The constitution of and tensions between these two traditions, the Dutch and the Roman, are explored as issues with particular historical determinants. But those issues are pervasive beyond the boundaries of particular periods and locations inasmuch as the representation of landscape in art is always negotiating that gamut between particularization and generalization, portraiture of place and the idealization of the natural world. In the final section of the chapter we will consider one painting, Peter Paul Rubens's (1577–1640) *Het Steen* [**56**], as a marriage of the two landscape modes so often seen as antithetical.

Map and landscape

At what point does a landscape picture offer the kind of value we associate with maps? At what point can a map offer us the kind of pleasure we associate with a landscape picture? Leonardo da Vinci was both painter and cartographer. For him the painter, the naturalist and the

39 Leonardo da Vinci

Landscape (Arno Valley?),
1473

geographic surveyor were aspects of the single enquiring mind. As far as the painter is concerned, 'if he wants from high mountain tops to unfold a great plain extending down to the sea's horizon, he is lord to do so'.[1] Here are the ideas of knowledge, power and pleasure mixed in the sensation of the painter's lordly vision, and it is just such a mix that gives philosophical value to the art of representing the natural world. The landscape artist and the maker of maps of the physical geography of a region have this much in common. Leonardo tested this in a number of drawings, particularly in some cartographical sketches in the first two or three years of the sixteenth century. We might take a sequence of these, but start just a little earlier with his pen and ink landscape, believed to be of the Arno Valley [**39**]. Here is the high viewpoint, the level river valley unfolding to the horizon, the castle on the spur as a kind of surrogate of the viewer's commanding situation over the plain ('if he wants [this exhilarating viewpoint] … he is lord to do so'). Is the drawing a sketch of a possible setting for a larger painting? Is it a geological study (the scarp cliff on one side, the tumbling soft knolls on the other)? Is it an occasion for a technical experiment, in perspective management, or in the graphic rendering of tree forms with those strange radiating curves on the right hillside?

In 1501 and 1502 Leonardo was preparing maps for Cesare Borgia. In these the high viewpoint adopted in the Arno Valley sketch is now raised. Some of these drawings are halfway between a bird's-eye view and a relief map. The *Bird's-eye View of Western Tuscany* [**40**] still *just* retains an angled perspective view, in that we appear to be side on to the foreground mountains. But the configurations of hilltop towns and castles are beginning to dwindle into cartographic symbols. The next stage, as the viewpoint lifts to a wholly vertical one and pulls even further away from the earth's surface, is the relief map drawing [**41**] of

40 Leonardo da Vinci

*Bird's-eye View of Western
Tuscany, c.*1502

41 Leonardo da Vinci

*Bird's-eye View of Southern
Tuscany — Val di Cjiana,
c.*1502

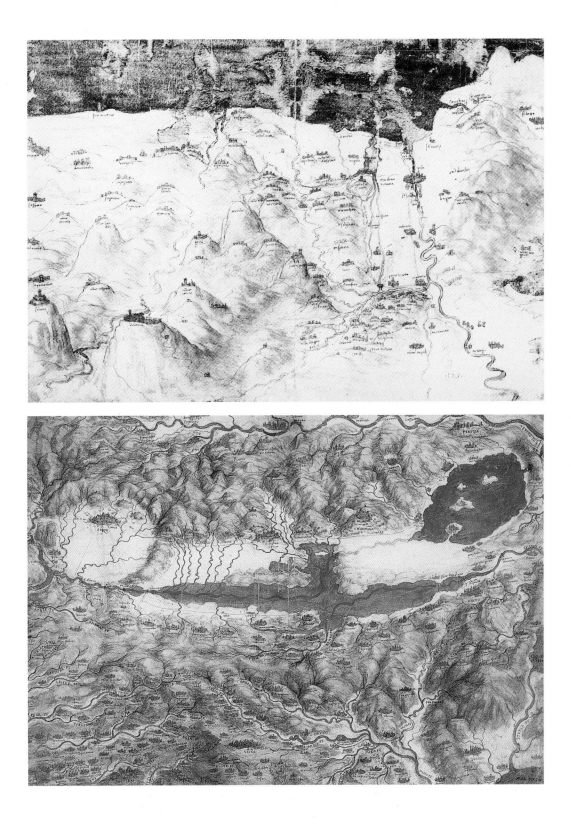

southern Tuscany, where the river and lake systems are diagrammatically exposed. We might say that, by this point, any aesthetic interest we may have had in the landscape has evaporated as the functional, instrumental design takes over. This is unequivocally a map, not 'art'. But at what point has it changed from one to the other? If we reverse the sequence and steadily lower the viewpoint, at what stage does a *landscape* satisfaction begin to inflect our response to the visual description? As we move back along this gamut do we ever entirely lose the kind of pleasure and interest in the view that we associate with map gazing?

The point of these questions is not to provoke direct answers, but to reinforce the sense that the work of the cartographer and of the landscape painter were at one time, and often still are, intimately related, in spite of our tendency to think of the former as a science and the latter as art. Arguably, we suspend such distinctions as we become absorbed in a landscape painting or photograph that offers a wide view. The eye travels across it, browsing, exploring, co-ordinating the various features, making sense of the space—much as it does in studying a map. It is only when we pull away from the productions themselves and think of the professional distinctions between map maker and painter that we find ourselves categorizing such distinctions.

The historical connection between map design and landscape art may best be seen in the work of Netherlandish artists and cartographers of the early seventeenth century. Hanging maps, landscape paintings and prints adorned the walls of houses in seventeenth-century Holland, particularly in the urban homes of newly rich mercantile classes, as can be seen in many interior scenes painted in this period. The contemporary demand for accurate and detailed maps can be explained in terms of their value for military operations, for documenting political change where national and regional boundaries were concerned, and for water control in a period when the physical extent of The Netherlands was undergoing expansion (drainage and reclamation in northern Holland increased the land mass by one-third between 1590 and 1650).[2] Rich and complex figurative maps and cityscapes testify to a lively interest in the environment of the home country. The art of the cartographer and topographical artist in the northern Netherlands was enhanced by the arrival in the country as a whole of many Flemish artists in 1585 and after, when Antwerp fell to the Spanish army. But the appetite for maps extended beyond their principally functional value. Spectacular wall maps, as well as smaller-scale landscapes, feature in several paintings by Jan Vermeer (1632–75), notably in the background to his *Art of Painting*.[3]

For a nation enjoying extensive trading links and consolidating its own national identity, maps and views of other countries and of The Netherlands would have had a special appeal. The curiosity of an expansionist nation about other countries generated a style of map

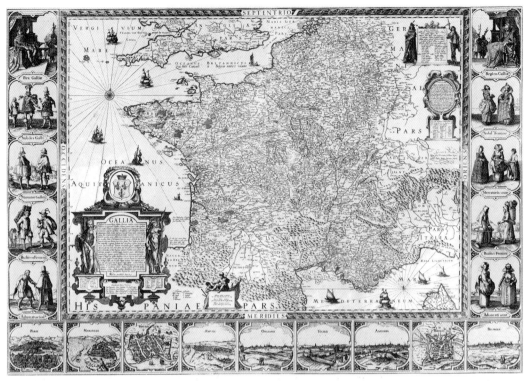

42 Claes Jansz. Visscher
Gallia, 1650
(with enlarged detail)

making that offered much more than simply cartographical information. What did the people of foreign countries look like, how did they dress, what did their cities look like, what were the distinctive natural features of their country? In responding to such demands, maps performed the function of mini-encyclopaedias. The map of France, *Gallia* [42], published by Claes Jansz. Visscher (1587–1652) is a good example. In the borders on either side of the map the various ranks of French people are depicted in characteristic dress, men on the left, women on the right. In the border along the base are depicted some of the major French cities, and it is to this feature that I want draw attention. Topography here takes different forms. Some of the information is in map form (Rochelle), some in bird's-eye view (Paris, Marseille), some in profile (Orléans, Bourges). Some, in other words, are extensions of the cartographic mode of the central map of France, others are landscape views that give an impression of the city set in its natural environment, much as one might see it as a traveller. The viewpoints run the full gamut that we witnessed in the Leonardo sequence of drawings (or compare El Greco's *View and Plan of Toledo* [**38**], where maps and profile cityscape are juxtaposed within one frame). The *Gallia* view of Bourges, for instance, might be detached, enlarged and developed a little and could then take its place as an independent framed view. Such views indeed constituted a specific kind of landscape or cityscape category in this period in Holland.[4] Willem Jansz.

43 Jacob van der Croos

View of The Hague, with Twenty Scenes in the Neighbourhood, 1661–63

Blaeu's 1608 Map of Holland featured a detailed profile of Delft as one of its border illustrations. Vermeer's *View of Delft* is only the best known of many such profile views of the city that, in their topographical role, have an affinity with mapping yet offer a scene that is more than information.

Claes Jansz. Visscher, as a prolific publisher of maps and topographical landscape prints, ran a successful commercial enterprise that married two rather different exercises. He was himself an able draughtsman and contributed some of the little townscapes that appear on his maps, as well as drawing small landscapes for his series of prints [**44**]. After his death in Amsterdam in 1652, his son, Nicolaes, took over the business. It was he who published the map scrupulously reproduced in the background of Vermeer's *Art of Painting*. Thus landscape views and maps were amalgamated in a number of ways: they were marketed together by a single commercial enterprise; they were incorporated together into single maps-and-views publications; and they were both used as decorative displays in Dutch homes. The construction of an elaborate composite design with a map as the central component, accompanied by a border of views of local and characteristic features of the mapped subject, suggests a continuity in informative aims between map and views—the mapping impulse extends beyond the map itself. The whole cartographic enterprise, as read from centre to periphery, modulates from diagrammatic topography to landscape views; but both ends of the scale may be thought of as topography—topography by different means.

An exercise in setting up the relationship between centre and periphery, possibly inspired by that particular structuring of diverse

forms of topographical information in the maps, is Jacob van der Croos's (1683–99) *View of The Hague, with Twenty Scenes in the Neighbourhood* [**43**]. Here the artist locates the relationship of urban centre to rural environs in iconic form, as the city is literally surrounded by its neighbourhood. In the large maps the border pictures had illustrated the specific topographical and social attributes of the country that was mapped in its entirety in the centre. In Croos's portrait of The Hague it is the scenic attributes of the city's local regions that are highlighted, even advertised. There is a serene, reassuring uniformity about the lateral landscapes. The ratio of sky to land is little varied in the 20 views. A spire, tower or windmill breaks the horizon line in nearly every picture, just as it does in the central view of The Hague. The city indeed is pictured as being only a larger version of the placid rural settlements that fringe it. So the contrast between city and village is not accentuated. But in an earlier tradition of seeing the local rural neighbourhood in relation to its city, this contrast is exactly what is stressed.

Pleasant Places and grand views

Visscher the map maker was also the publisher of several highly popular series of landscape prints in the first two decades of the seventeenth century. These consisted of a sequence of scenes within easy reach of some major city. The Antwerp publisher, Hieronymous Cock, had popularized the idea in a series of landscape prints featuring 'various cottages and country places shown carefully and clearly from the life' (*ad vivum expressa*), in 1559. A further series appeared a few years later, again *ad vivum*. In 1612 Visscher brought out a new edition and attributed the views to Pieter Bruegel (*c*.1525–69), incorrectly. The anonymous artist of these views is now known as the Master of the Small Landscapes; and 'small landscapes' might well represent the generic term for these collections of views of outlying rural spots—*regiunculae*—or 'little regions'. The scenes were from the region around Antwerp. Views of 'Pleasant Places' in the neighbourhood of Haarlem appeared in 12 plates in 1608 [**44**]. These were explicitly designed for a particular clientele: 'Here you may have a quick look at pleasant places, you art lovers who have no time to travel far.' How much of the appeal of landscape in art over the centuries is summarized in this short address! Visscher is clearly aiming at the wealthy and busy mercantile class, professionally locked into the life of the big cities and pleased to be reassured that such Pleasant Places were just a short ride from their homes. The sparsely populated country places depicted in these topographical views would indeed have been pleasanter than the rapidly developing, crowded cities (the urban population in Holland more than doubled between 1580 and 1610—precisely the period when the publishers began to exploit the new interest in these Pleasant Places). By 1622, over half the population of Holland were city dwellers, a

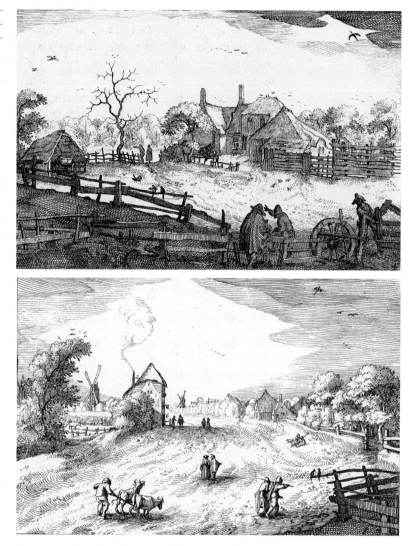

density unique in Europe at the time. The flourishing of landscape art in this period in The Netherlands owed a lot to this concentrated urbanization. It is possible that the tempting scenes represented in these views were offered as an incentive to wealthy families to buy property in the rural neighbourhood. The titling of so many of these series has more than a whiff of the estate agent's promotional texts.

No doubt there should be some allowance for picturesque exaggeration in these scenes, but their claims to topographical accuracy are stressed again and again. They are like fugitive vignettes from the borders of a Visscher map that have now taken on an independent status. In breaking away from their cartographic matrix, these landscapes both retain the trace of their topographical pedigree as well as taking us forward, straight into the mainstream tradition of Dutch landscape painting in this century.

Local portraiture celebrates both the old, picturesque, forgotten rural scenery and the flourishing new republic with portraits of those distinctive features in the landscape that were the source of Holland's wealth and emblems of its history—the ubiquitous windmills that pumped out the water in vast land-reclamation projects, the bleaching fields, the seaports crowded with trading vessels, the new canals, carefully naturalized, and then the ancient farms and the ruined castles that fell victim to the Spanish army in the years of struggle for political and religious independence. Seascapes, battle scenes and landscapes grew rapidly in popularity in the early decades of the seventeenth century. Specialist painters in these subjects constituted 26 per cent of the total number of newly registered Guild artists in Delft, in the period 1613–49—before that period they had constituted barely 15 per cent.[5] Landscapes, seascapes and battle scenes were images of the living history and topography of the new republic, and could be represented in maps as well as in paintings.

This celebration of the native landscape as the new republic asserts its identity involves both delineation of the contested and acquired territory, as the lavish maps of the period demonstrate, and images of the land and the way its people relate to it—economically, militarily, and recreationally—as the burgeoning of landscape painting testifies in this period. Both are forms of self-definition. In such a context, 'mere' topography can become positively heroicized. Furthermore, its claim to heroic status is reinforced by its resistance to adopting the traditional formal vocabulary of heroic landscape drawn from Italianate models and structures. Why speak in a borrowed foreign language when the domestic vernacular is part of the way in which one expresses one's identity? So, away with the conventional coulisses, the tripartite distancing, the three-colour range—they are as inappropriate to Dutch landscape in seventeenth-century Holland as cypresses and ruined temples.

However, to impute such consciously nationalistic motives to the landscape artists of the early Haarlem School would be a dangerous generalization. A contrary argument has it that it was the relative ignorance and insularity of the Dutch artists that explain their neglect of classical landscape structuring devices. These painters lacked a well-travelled, aristocratic patronage base; they were craftsmen and of a low social status which preserved them from the influence of cosmopolitan intellectuals; theirs was a bourgeois, market-led specialization in landscape and they practised with no theoretical inhibitions.[6] Indeed, a broader generalization argues that landscape painting in the West is inherently the product of an urbanized, mercantile culture, not an aristocratic one. However, in the case of one particularly innovative artist, Hendrick Goltzius (1558–1617), we know that he was fully conversant with foreign models of landscape beauty. He had travelled to Italy (in

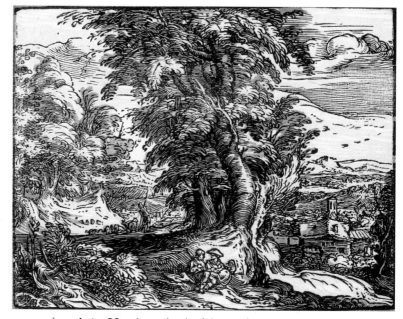

1590–91) and, in Haarlem, he had been drawn into a circle of cosmopolitan painters and writers, including Carel van Mander, whose 1604 treatise on painting, *Het Schilder-Boeck*, was very influential and much cited by successive writers on art in seventeenth-century Holland. Van Mander's chapter on landscape painting recommends traditional structuring and motif conventions: tripartite or quadripartite distances; a clearly defined foreground, with large tree trunks (*à la* Bruegel and Gillis van Coninxloo (1544–1607)); conspicuously differentiated, though fluently linked, recession bands; characters engaged in pleasing Arcadian or georgic activities:

Show how Tityrus, with his flute, entertains Amaryllis, his beloved among women, resting beneath an oak tree, while even his flock enjoys the pleasant sound. Show the countryside, town and water filled with activity.[7]

An example of this kind of landscape is Goltzius's woodcut of the 1590s, *Landscape with a Seated Couple* [**45**]. It displays prominent foreground tree trunks, pastoral dalliance, peaceful flocks, and strongly rhythmical co-ordination of distances of the kind one might find in Campagnola's distinctive landscape woodcuts.

Goltzius, however, deliberately moved away from this manner. In the first two or three years of the seventeenth century he produced some strikingly original drawings of the countryside around Haarlem. The lack of conventional structural orientation in his *Dune Landscape near Haarlem* [**46**] is disconcerting. Where does the eye focus, how is it to travel in this picture? Apart from a glimpse of dark slope on the right, there are no devices such as side-screen trees or cliffs or darkened foreground to channel the eye into a conspicuously lit middle distance.

46 Hendrick Goltzius
Dune Landscape near Haarlem, 1603

A winding road takes us a little way in, but then leaves us. There are no carefully marked distances, no single arresting motif. Beyond a certain point we give up trying to make aesthetic sense of the view in terms of those familiar landscape structures Goltzius had employed in earlier designs. This is a plotting of isolated settlements and woodland in a kind of spatial vacuum. It is like a map, both in the information it offers us (in imprecise gesture, of course), and in the mode of its picturing, as Svetlana Alpers remarks: 'In this drawing, as in the entire tradition of panoramic landscapes that follow, surface and extent are emphasized at the expense of volume and solidity.'[8]

The views of extensive landscapes and huge skies became a distinctive tradition in Dutch seventeenth-century paintings, particularly in the work of Philips Koninck (1619–88) and Jacob van Ruisdael (1628/9–82) in the 1650s, 1660s and 1670s. Ruisdael's chalk panoramic sketches of views of Haarlem are similar to Goltzius's drawing in their mapping out of the landscape and profile of the distant city; there are no coulisses and the level horizon line is about halfway up the picture. Ruisdael's sketches were preparations for his so-called 'Haarlempjes' (small views of Haarlem); he is reckoned to have produced about 45 such views of the city and its surrounds. The Haarlempjes are closely related to the popular *regiunculae* of the earlier part of the century, and those in turn related to map views. The striking difference between Ruisdael's paintings and the little drawings is the much enlarged ratio of sky to land. These are cloudscapes almost as much as they are landscapes, and it is in the interaction between these two 'scapes that the mapped countryside acquires a dramatic interest that lifts it away from

performing the principally topographical function served in the
Goltzius and Ruisdael sketches, where the sky is almost blank. A mag-
nificent example is the *View of Haarlem with Bleaching Grounds* [**47**].
The hard, straight line of the horizon, the fitful patches of very sharp
sunlight, the geometrical arrangements of the bleached linen, and the
squared mass of St Bavo's cathedral are all in dynamic contrast with the
plump, soft, densely toned cloud clusters.

 Though it has transcended the mapping mode in many respects,
this landscape painting retains the topographical and documentary
functions of the map. In those small peripheral panels on the large
maps, the viewer was sometimes offered a profile view of a city with
an extensive rural foreground in which the artist depicted the distinc-
tive local trade or industry on which the city's prosperity depended.
Essentially the same relationship is figured in Ruisdael's painting.
Haarlem's economic prosperity and international fame was based on
its linen-bleaching industry[9] and Ruisdael has connected the city and
its industry by, literally, highlighting the two and submerging the rest
of the landscape in shadow. The dramatic chiaroscuro enriches the
scene—gives it a grandeur—but serves also the kind of promotional,

locally informative function that we would expect from more utilitarian sources such as regional maps, city histories, and travellers' guide books. It gives broad heroic stature to a portrait of a particular place, but does so without assimilating the local to an idealized, generalized landscape.

'Map-work' and poetic landscape

The notion of much of Dutch landscape painting as 'mere topography', an old but enduring prejudice, with its implied disparagement of the utilitarian function of maps, is based on an undervaluation of maps, and a determined cultural distinction between 'art' and 'mapping'. The distinction is made in the interests of raising the aesthetic status of landscape painting, and this means subordinating the instrumental, informative role of landscape picturing. These prejudices have obscured or suppressed affinities between mapping and landscape painting that the early Dutch School would happily have acknowledged. Such prejudices have been challenged by some art historians since the late 1970s, but none the less remain still quite firmly entrenched.

As has been indicated in earlier chapters, the subordination of landscape painting in the hierarchy of genres was more or less habitual in Renaissance Italy—it was a poor relation, a dependant, a servant. 'It doth not appeare', wrote Edward Norgate in *Miniatura* (*c.*1639/40), 'that the ancients made any other Account or use of it but as a servant to their other peeces, to illustrate or sett of their Historicall paintings by filling up the empty Corners, or void places of Figures and story, with some fragments of Landscape.'[10] Landscape as mere record of place continued to be held in contempt by 'academy' orthodoxy over the next century and a half. In England, the prejudice was well expressed by Henry Fuseli, Professor of Painting at the Royal Academy, in 1801. He is speaking of 'that kind of landscape which is entirely occupied with the tame delineation of a given spot: an enumeration of hill and dale, clumps of trees, [etc.] ... what is commonly called views':

These, if not assisted by nature, dictated by taste, or chosen for character, may delight the owner of the acres they enclose, the inhabitants of the spot, perhaps the antiquary or the traveller, but to every other eye they are little more than topography. The landscape of Titian, of Mola, of Salvator, of the Poussins, Claude, Rubens, Elzheimer, Rembrandt, and Wilson, spurns all relation with this kind of map-work. ... The usual choice of the Dutch school, which frequently exhibits no more than the transcript of a spot, borders, indeed, nearer on the negative kind of landscape.[11]

Fuseli's list of those who may be delighted by such 'tame delineations of a given spot' corresponds closely to those categories of people for

whom maps might have a particular appeal, maps of an area with which they are particularly familiar, either as landowners or residents, or on which, as curious strangers, they might wish to become better informed. These 'transcripts', it is implied, have no more than a mere utility value; they are a 'kind of map-work'. In this context, the Dutch School is to be separated from the roll-call of painters who have raised landscape to poetic heights:

in the varied light of rising, meridian, setting suns; in twilight, night and dawn. Height, depth, solitude, strike, terrify, absorb, bewilder in their scenery. We tread on classic or romantic ground, or wander through the characteristic groups of rich congenial objects.

Landscape, it was thought, could not on its own offer spiritual or ethical inspiration in the way that representations of the Holy Family, the saints or the great heroes of ancient mythology could. It could not offer intellectual pleasure of the kind and degree prescribed by Aristotle (384–322 BC) in the *Poetics*: it could not instil philosophical truths. That was reserved for epic and tragic modes in literature and heroic, historical painting in art. The close affinities between painting and poetry in the hierarchizing of subject matter meant that landscape in painting was associated with the pastoral in poetry, both inferior genres (though superior to topographical views) but both granted a kind of restorative power and a glimpse of the ideal beauties of the natural world.

Classical pastoral and its Renaissance revival in Italian poetry and painting—which we observed in Chapter 3—does not chronicle the real experience of rural life and work, just as it is not interested in portraits of real places. Pastoral's enduring illusion of the natural grace and innocence of rural folk always had its critics. 'Is the countryside indeed that Arcadia of riches which the Italian poets today describe?' was the sardonic question put by Sforza Pallavicino in 1644: 'who more than the peasant is ruled by his appetites—the Golden Age is for those that have gold'.[12] The enduring popularity of Sannazaro's *Arcadia* (1504), Tasso's *Aminta* (1581) and Guarini's *Il Pastor Fido* (1590) was due largely to the way these idylls issued from, and played variations on, the sense of a profound difference between rural and urban, or courtly, ways of life. That Golden Age, with its eternal springtime, was eloquently invoked in Guarini's pastoral drama (here in Sir Richard Fanshawe's verse paraphrase of 1647):

Fair Golden Age! when milk was th'only food,
And cradle of the infant world the wood
(Rock'd by the windes); and th'untouched flocks did bear
Their dear young for themselves!
… to buy reall goods with honest toil
Amongst the woods and flocks, to use no guile,
Was honour to those sober souls that knew

No happiness but what from vertue grew.
Then sports and carols amongst Brooks and Plains
Kindled a lawful flame in Nymphs and Swains …
Base present age, which dost with thy impure
Delights the beauty of the soul obscure.

In many ways the idealized pastoral landscapes produced in seventeenth-century Italy could hardly be more different to some of the landscape paintings we have seen from the Dutch artists in the same period. Ruisdael's *View of Haarlem with Bleaching Grounds* [47] co-ordinates city with countryside, dramatizes their strong interdependency, and implies something larger about the vigour and prosperity of the nation as a whole. In Roman pastoral landscapes of the same period, the city, if it appears at all, is pushed into the far distance as a huddle of vague, generalized architectural forms. If any such forms feature in the foreground or middle distance they are usually seen in various states of overgrown, picturesque decay, slowly being assimilated into the world of nature. As urbanization invades the countryside and threatens its fabric, so there is a fascination with the reverse process as nature reclaims territory in the greening of ruins. The two worlds—one of innocence and a modest subsistence economy, the other sophisticated and commercially aggressive—are forced far apart, and it is on that accentuated separation that pastoral thrives.

Mapping co-ordinates cities with the rural environment; pastoral detaches the two. Mapping relishes topographical specificity and documentary record; pastoral idealizes and generalizes its subjects and settings. Mapping emphasizes the continuities of history; pastoral arrests history and mythologizes it: the 'Fair Golden Age' is sharply opposed to the 'Base present age'. Seventeenth-century Roman pastoral painting tried to elevate landscape according to the ideological principles suggested in this sequence of antitheses, and in so doing, it seems deliberately to distance itself from the Dutch landscape tradition. At the end of that century, Roger de Piles's influential *Cours de Peinture par Principes* (1708), addressed the subject of landscape, but had a very exclusive sense of what was important in landscape painting:

Among the many different styles of landskip, I shall confine myself to two; *the heroick* ['*heroique*'], and *the pastoral* or *rural* ['*pastoral ou champêtre*']; for all other styles are but mixtures of these.[13]

This distillation of all varieties of landscape painting to just two primary genres omits the topographical altogether. De Piles admires the landscape contributions of the northern Italian painters (particularly Titian) and the Flemish artists (particularly Rubens) but omits any mention of the realistic tradition in Dutch landscape painting. As Michael Kitson has observed, this omission is significant; for De Piles, like other writers on

48 Nicolas Poussin

*Landscape with Pyramus
and Thisbe*, 1650–51

49 Nicolas Poussin

*Landscape with Man killed
by a Snake*, 1648

this subject before him (for example: Giovanni Paolo Lomazzo in *Trattato dell'Arte de la Pittura* (1584); Carel van Mander in *Het Schilder-Boeck* (1604); and Edward Norgate in *Miniatura*), 'landscape was a genre in which the artist was assumed to use his imagination; he was not expected to depict real views from nature or views that looked as if they might be transcripts of actual countryside'.[14]

We might now look at these two categories of elevated landscape, the heroic and the pastoral or rural, before returning finally to the tensions between topography and the *beau ideal*.

Heroic landscape

Fuseli's distinction of the higher forms of landscape included the capacity of the depicted landscape scene to evoke strong emotional feelings, such as terror, and to conduct us into classical or romantic ground. The landscapes of Nicolas Poussin achieve just this effect, especially in his late works. In two paintings from this period he explores the terrifying impact of natural events on human life and integrates landscape with the human drama in subtle ways so as to elevate the genre. *Landscape with Pyramus and Thisbe* [48], painted for his Roman patron Cassiano dal Pozzo, portrays the climactic scene in a 'heroic' tragedy. Pyramus, mistakenly believing that his beloved Thisbe has been killed by a lion, kills himself in his grief and is here discovered by Thisbe who is then herself to fall on the sword that lies beside her lover. The anguish and violence of the tragic action in the foreground infect the whole landscape, and it is as if the cosmic resonance of this event now dwarfs the tragic pair. Poussin's letter on the painting is very revealing on this aspect:

I have tried to represent a land storm, imitating as well as I could the effect of a violent wind, of air filled with darkness, with rain, with lightnings and with thunderbolts which fall here and there, not without producing disorder. All the figures to be seen play their part in relation to the weather: some flee through the dust, and go with the wind which carries them along; others, in contrary fashion, go against the wind and walk with difficulty, putting their hands before their eyes. On one side a shepherd runs away and leaves his flock, seeing a lion, which, having already thrown down some oxherds, is attacking others, some of whom run away while others prick on their cattle and try to make good their escape. In this confusion the dust rises in whirlwinds. A dog some way off barks, with his coat bristling, but without daring to come nearer. In front of the picture you will see Pyramus, stretched out dead on the ground and beside him Thisbe, given over to her grief.[15]

As Anthony Blunt (1907–83) has pointed out, this letter suggests strongly that it was the management of the storm and its impact upon the scattered humans and animals that was Poussin's primary interest: the story of Pyramus and Thisbe, mentioned only at the end of this passage, acts as a pretext for an exercise in dramatic landscape. Storm

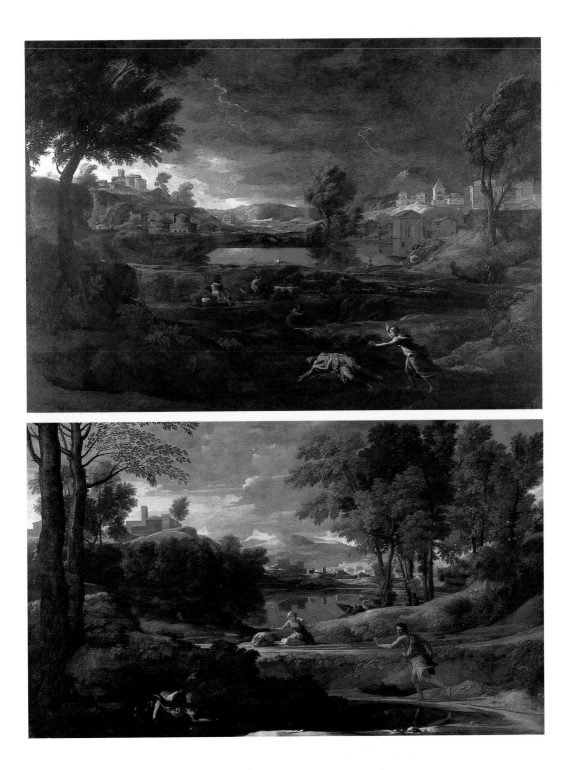

and savagery is presented 'not without producing disorder'. This odd double negative has the effect of making disorder seem a reluctant concession to the impact of violent wind, darkness, rain, thunder and lightning. That rhetorical oddness in the letter actually echoes one of the most striking things about the scene as a whole. There certainly is an eruption of chaos in the middle distance, but beyond that the landscape has a peculiarly static poise. The surface of the lake is unruffled, the flawless geometry of the buildings on either side seems impervious to the destructive energies of the storm. Although the lightning is severing the branch of a tree on the far side of the lake, that whole area seems hardly yet to carry the resonance of the foreground disasters.

The same contradictions or tensions are present in one of Poussin's best-known and most enigmatic paintings, almost contemporary with the *Pyramus and Thisbe*: *Landscape with Man killed by a Snake* [**49**]. As with the other picture, everything issues from the terrified moment of discovery of a corpse in the foreground which triggers a chain of reactions as we look further into the picture's distance. Recession managed through overlapping planes ensures that the woman cannot see the snake-wrapped corpse—her alarm can only be in response to the terror of the witness to the scene. In a few seconds' time the fishermen are going to be drawn into the horror. The secretary of the Parisian Academy, André Félibien, wrote about this picture in his 1685 study of the lives and works of distinguished painters and understood it to represent '*les effets de la peur*'.[16] His interpretation has some authority since he was personally acquainted with Poussin. So, to a great extent, both of these paintings are concerned with transmitting powerful emotional effects and exploring the extent to which landscape can play an expressive part in that experience. At the same time the serenity of parts of the landscape in these two paintings acts as a counterpoint to the sensational events—a serenity not just in the features depicted—the placid water surface, the immaculate cities, the clarity of the atmosphere, even in the dramatis personae who, in all their anguish and terror, have the carefully modelled poise of classical statuary—but in the conspicuous care taken in the organization of the composition, betokening the intellectual mastery of the artist. It is this intellectual quality that so distinguishes Poussin's work as a landscape painter and ensures the elevation of the genre. It is a quality that Joshua Reynolds (1723–92) encapsulated in his third annual *Discourse* (1770) to the students of the Royal Academy:

The *gusto grande* of the Italians, the *beau ideal* of the French, and the *great style*, *genius*, and *taste* among the English, are but different appellations of the same thing. It is this intellectual dignity, they say, that ennobles the painter's art; that lays the line between him and the mere mechanick.[17]

The 'mere mechanick' is elsewhere in the *Discourses* associated with the Dutch School. Among the symptoms of this 'intellectual dignity' are a respect for, and trained familiarity with, the art and literature of classical antiquity. Poussin is one of those artists who can thereby elevate a painting of the natural scene:

he transports us to the environs of ancient Rome, with all the objects which a literary education makes so precious and interesting to man. ... Like the history-painter, a painter of landskips in this style and with this conduct, sends the imagination back into antiquity; and, like the Poet, he makes the elements sympathise with his subject. (*Discourse* 13)

This is exactly what Poussin does in the *Pyramus and Thisbe* [**48**] and it endows a landscape scene with heroic dignity.

Pastoral

The other category mentioned by De Piles was the pastoral, or rural, style of landscape. This style became closely associated with Claude Lorrain, the French painter who settled in Rome in 1627. In Claude's pastoral landscapes, the Golden Age is rendered with a golden light that suffuses the distance and gilds both the foreground figures and the forms of the natural setting, as in his *Landscape with a Rustic Dance* [**50**].

Painters of pastoral or heroic landscape might accumulate a portfolio of 'transcripts of actual countryside', especially as the practice of sketching from nature became more common in the seventeenth century. But these isolated studies were essentially a means to a more elevated end once they were incorporated into finished oil paintings, when the specific topographical record was subordinated to a generalized and idealized pastoral or heroic landscape. This practice was understood by Reynolds to have been Claude's:

CLAUDE LORRAIN ... was convinced that taking nature as he found it seldom produced beauty. His pictures are a composition of the various draughts which he had previously made from various beautiful scenes and prospects.[18]

Claude was a prolific open-air sketcher, as his friend and biographer Joachim Sandrart recorded. The two used to go on sketching expeditions in the countryside around Rome. The chalk and wash drawing *An Artist Sketching* [**51**] may well be a memory of such jaunts. Claude's experience of sketching was combined with his close observation of a range of landscape modes: Flemish, Dutch, and German, as well as Venetian and Bolognese. For example, Domenichino's (1581–1641) *Landscape with Tobias laying hold of the Fish* [**52**] gave Claude the compositional model for his own *Landscape with Hagar and the Angel* [**53**]. The detailed similarities and differences between these two landscapes are worth noting. Both feature the framing trees arching their heads inwards, the winding passage from foreground to middle

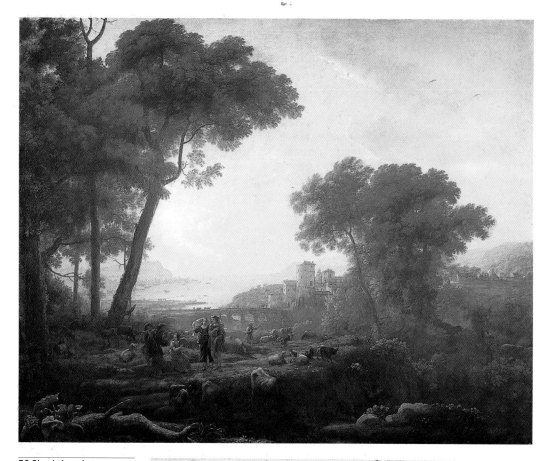

**50 Claude Lorrain
(Claude Gellée)**

*Landscape with a Rustic
Dance, c.*1640–41

**51 Claude Lorrain
(Claude Gellée)**

*An Artist Sketching, c.*1640

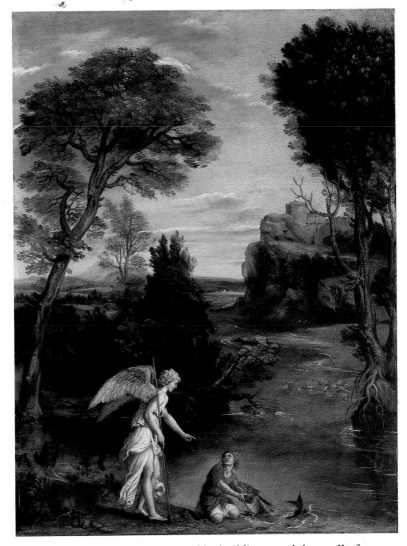

distance, the promontory crowned by buildings, and the swell of mountains in the distance. Their differences are significant in terms of the increasing dominance of the landscape motif over the narrative action. Claude's figures are greatly reduced in size and marginalized—almost literally they give way to the landscape. Foreground is more distinctly marked off from second distance, both by its darkness and by the lack of any continuity of motif to link the two, as the river had done in the Domenichino (the outstretched arms of Claude's angel make only a slight bridging gesture in this direction). But it is the brilliance of the light and the tonal richness in the middle distance that is so arresting in Claude's painting. They draw the eye quickly from the foreground and concentrate attention on the extraordinary atmosphere of serenity.

As he developed a distinctive style of his own, Claude came to be praised for his exquisite naturalism, as if he were rendering real scenery.

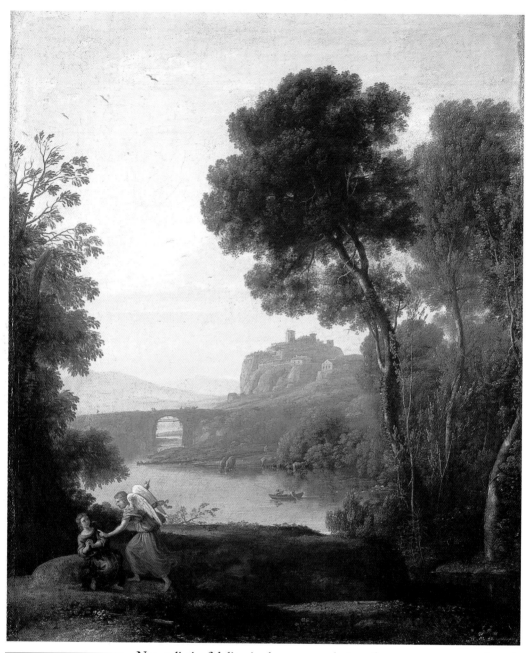

**53 Claude Lorrain
(Claude Gellée)**

*Landscape with Hagar
and the Angel,* 1646–47

Naturalistic fidelity is, however, relative: for our tastes nowadays it would be predominantly his sketches in pen and wash or chalk that merit this tribute. In his finished paintings, as his career advanced, the landscape became increasingly idealized, largely in response to the demands of patronage, which, from the late 1630s onwards, included the rich and powerful: those in the Papal entourage; French nobility; and the King of Spain. Although he did produce some landscapes with a close correlation to real views, Claude's topographical

**54 Claude Lorrain
(Claude Gellée)**

*Landscape with the Marriage
of Isaac and Rebekah*
('The Mill'), 1648

studies of, say, the Tiber Valley and Ponte Molle, Tivoli's Villa and Falls, become generalized motifs in his pastorals or biblical landscapes. In one of his best-known paintings, *Landscape with the Marriage of Isaac and Rebekah* (sometimes known as 'The Mill') [**54**], an unspecific Campagna setting includes a version of the Falls of Tivoli introduced as a decorative motif to enhance the richly variegated landscape setting. A random cluster of buildings, including a little antique temple, a brick tower and modern mill house, faces across the river the walls of a large imposing city, mostly in silhouette. It might be suggestive of Rome with the pyramid of Gaius Cestius and something resembling Castel St Angelo, but such specificity is discouraged. Upriver from the city is another version of the Ponte Molle. The accent is on the late afternoon light and its mellow influence over the whole of this miscellaneous landscape—soldiery, cowherd, fisherfolk, shepherds, dancing peasantry, family groups at rest and play. The whole amounts to an anthology of pastoral motifs of the kind listed by Alberti, at the sight of which 'our minds are cheered beyond measure'. It works to reconcile not only obviously discordant elements, such as the soldiers and shepherds, but also more elusive tensions: vitality and repose are combined in the foreground festivities, work and play; the antique past is a benign neighbour to the

**55 Claude Lorrain
(Claude Gellée)**

*Landscape with Narcissus
and Echo*, 1644

industrious present in that conglomeration of waterside buildings, the mill and the busy laundresses.

This gilded motley affords great sensuous pleasure and is a good example of just what it was that made Claude's landscapes so popular. It is pure pleasure, not information—landscapes graced by the presence of biblical or Ovidian figures. Many of Claude's mythological scenes derive from his reading of Ovid's (43 BC–c.AD 17) *Metamorphoses* and are infused with erotic power. *Landscape with Narcissus and Echo* [**55**] is one example. The androgynous Narcissus dotes over his reflection in the secluded forest pool, while the nymph Echo peers longingly at him from her concealment in the trees. The languorous nymph in the foreground strikes the erotic keynote somewhat stridently, and probably more so than Claude intended (his *Liber Veritatis* version shows the nymph fully draped and the nude is probably a later repainting).[19] The sinuous lines of the reclining nymph, by whom Narcissus is wholly unmoved, are translated into landscape terms, in the soft, rounded contours and textures of the tree foliage, low bushes and grassy banks encircling the pool. The warmth, stillness and voluptuousness of the landscape as a whole is expressive of the erotic charm of the story, and it seduces the spectator into the idyllic world. Claude and Poussin represent the poetry

of landscape, the elevation of a lowly genre from mere portraiture of place to ideal models of human happiness or heroic dignity.

The idealization of place

This chapter has shown a straining in opposite directions of two landscape modes, the faithful portrait of a particular place, and the generalized, idealized representation of rural beauty; between map and 'art', between Netherlandish and Franco-Italian traditions in landscape. We have also seen that these polarities are not as sharply antithetical as they might seem and that it is in many cases Renaissance and neoclassical academic art criticism alone that wants to draw sharp distinctions where, in practice, these seldom exist.

We might conclude with a landscape painting that offers to dissolve these differences in a variety of ways. Rubens's portrait of his own house in its landscape setting, *Autumn Landscape with a View of Het Steen in the Early Morning* [56], was painted shortly after he had bought the estate in 1635. He was in his late 50s and had a few years before retired from a hectic diplomatic career as an official emissary of Spain. Het Steen, about three hours' ride to the south of Antwerp, was bought precisely with the idea of genteel rural retirement in mind. The Netherlands continued to be ravaged by war and plague, as Rubens described in a despairing letter to a friend, but nothing of this appears in the landscape painted probably just a year later.

In thinking about the value and status of this picture as both topography and idyll, we may recall Fuseli's contemptuous attitude towards views of particular places:

that kind of landscape which is entirely occupied with the tame delineation of a given spot: an enumeration of hill and dale, clumps of trees, shrubs, water, meadows, cottages, and houses; what is commonly called views. These, if not assisted by nature, dictated by taste, or chosen for character, may delight the owner of the acres they enclose, the inhabitants of the spot, perhaps the antiquary or the traveller, but to every other eye they are little more than topography.

Well, Rubens is indeed the owner of the acres enclosed by much of this view, as well as the inhabitant of the spot; but, in the following sentence, Fuseli lists Rubens among those few European landscape painters who for him transcend the kind of 'map-work' he so despises and associates with 'the Dutch School'. So what has Rubens done to raise this portrait of a place to high art? The building is recognizably the Dutch-gabled, moated manor house of Het Steen, the stream with the little wooden bridge corresponds to the Baerebreek, the town on the horizon would be Malines with the tower of St Rombout's Cathedral against the skyline. The landscape is uncompromisingly a Lowlands one: flat, moist, riddled with streams, a windmill, cattle pastures bordered by lines of willow.

56 Peter Paul Rubens

Autumn Landscape with a View of Het Steen in the Early Morning, c.1636

Each of these features is as approximately true to the topography of the estate as is consistent with Rubens's sense of the cultural significance of that estate. Het Steen represents for Rubens a set of values, not just a Brabant address; and it is that set of values, not just a pictorial estate map, that is transmitted in the painting. But in representing that idealization of country life, *Het Steen* has not betrayed the particularities of place. It is 'uncompromisingly' Lowlands in its physical geography, but also in the sense that it has not adopted a repertoire of Italianate, Claudean motifs nor structural devices to dignify a local site by association with a classicizing Arcadianism or Horatian celebration of rural retirement. For example, the structure is not dependent on a formula of three well-marked distances with coulisses, a middle-ground promontory and stretch of bright water, a mountainous horizon. Rubens's topography is mapped in the vernacular. The colour scheme employed to create recession is derived from the practice of Rubens's Antwerp predecessors, Patinir and De Momper (1564–1634/5): warm browns and russets, heightened with touches of red for the foreground, green for the middle distance and a purply blue for the background. The directional lines into the landscape are not reliant on conventional side screens, but form a complex arrangement of diagonals and wedges: a strong line starts from the crouching fowler and parallel gun barrel, runs out along the line of trees starting at the footbridge, and carries through to the horizon. This is crossed by another line starting from the woven straggle of branches to the right of the central stump: that line carries along the far curve of the stream to the front of the house. Rubens uses the low-lying natural features of his

own countryside as vectors in the firm structure of his landscape. A system of low-gradient diagonals is much more appropriate for the landscape type chosen by Rubens, and had already become a kind of hallmark of Dutch landscape painting in the pioneering work of Pieter van Santvoort (1603–35) and Pieter de Molyn (1595–1661) in the 1620s.

So in terms of technique, as well as in the choice of motifs for his landscape, Rubens is underscoring the local, national identity. For this well-travelled, well-read man of the world his home is not just the sheltered manor house; it is the opportunity to inhabit an idea that is both inseparable from a particular place and yet larger than any particular place can embody.

Framing the View

5

A landscape picture is familiarly an image of the outside world adorning the walls of our indoor world. Those whose rooms do not allow window views of rural distances can acquire printed or photographic versions to supply what is missing; arguably, the more we live in towns, the higher the value of such artificial views of what we can no longer see through our windows. As one English writer put it, surveying the popularity of landscape paintings in the late eighteenth century:

the draughtsman was driven into the recesses of the mountains, for the subjects of his pencil. From thence he brought home scenes, not only suitable to his art, as being more capable of receiving its higher touches, than less broken scenery … but at the same time, such as were acceptable to his customers; as forming an agreeable contrast with the ordinary scenery in the environs of cities … indeed, at all times, and every where, one great end of Landscape painting is to bring distant scenery—and such more particularly as it is wild and not easily accessible—under the eye, in a cultivated country, and an embellished site: and not to expose itself, by a faint imitation of the views which are seen from the windows of the room, for which the representations are intended as furniture.[1]

One framed landscape replaces another, the simulacrum substitutes for the real, while both may make us aware of the degree to which we feel we have become distanced from 'nature'. In our domestic interiors we become increasingly conscious of 'outside' and 'inside', of separate worlds. The open window to that outside world, beyond the towns, gives us not only, if we are lucky, a glimpse of countryside—a section of garden, orchards, fields, woodland, hills—it also gives us light and fresh air. The associations between access in our domestic lives to these vital natural resources and the aesthetic benefits of a good view give landscape imagery a special status. You cannot paint or photograph light and fresh air, but you can represent the forms spontaneously brightened and invigorated by those essential things: the gleam of sunlight on a river or the bright reticulations of shadow and light through leaves and branches, trees bending in the breeze that stirs the lake

Detail of 57

surface into ripples. Immaterial light and air, which are precious commodities in our domestic-interior lives, are, as it were, metonymically represented in landscape pictures by the material forms they touch, illuminate and vivify. The wonderfully vivid freshness communicated in Ansel Adams's *Tenaya Creek* photograph [**3**] is a good example.

The framing of views of the natural world, on painted canvas and photographic prints, or through viewfinders, windows, doorways and arches, is the subject of this chapter. I will be looking at a range of pictures from very different periods and traditions, with the intention of examining the psychological impressions made when landscape is mediated by an interior, where that interior intrudes into the picture to define the boundaries of the chosen scene or scenes. The presence of an interior determines our relationship with that landscape, which is so often inflected by our sense of the duality 'indoors' and 'outdoors'.

This issue is exemplified in complicated ways in the painting by Antonello da Messina (*c.*1430–79), *St Jerome in his Study* [**57**]. The outside world illuminates the interior through several apertures: the three high windows bringing light into the vaulted upper space; the two or three lower windows giving views of the hilly landscape; and the foreground archway through which we see all this. Thus, through an architectural frame, shaped like an altarpiece painting, we penetrate into an interior until we reach more recessed frames that draw us again into the outside world.

The painting is a virtuoso exercise in perspective, scrupulously organizing the lines of the meticulously detailed floor tiling, the delicate colonnade on the right, the raised study area in the centre. A vertical line passes down from the centre of the crown of the archway, more or less through the column bisecting the central window, passing through Jerome's open book down to the central vertical line of the tiling, from either side of which the bands of tile gradually fan out to reinforce the one-point perspectival design. Everything is meticulously parallel to the picture plane: archway, study spaces, rear wall, Jerome himself in his side-on position, the peacock, partridge and half-sketched cat. Only the lion, conspicuously, breaks the pattern.

Much the same compositional geometry continues in the landscape beyond, through the left-hand window. River, rowing boat, the sunlit walls of the town or monastery, and adjacent enclosed garden, and the road passing in front of these all run parallel to the picture plane and are cut by diagonals echoing the line of perspective that started at the foreground archway: the slant of the oar, the road leading up towards the hills. Hardly anything in the painting is allowed to disturb this austere geometry, except the folds, sweeps, and more rounded contours of Jerome's figure and clothing—a disturbance formally designed to arrest attention on the subject of the painting. That relief from the rectilinear principle is echoed in the landscape's rolling, rounded

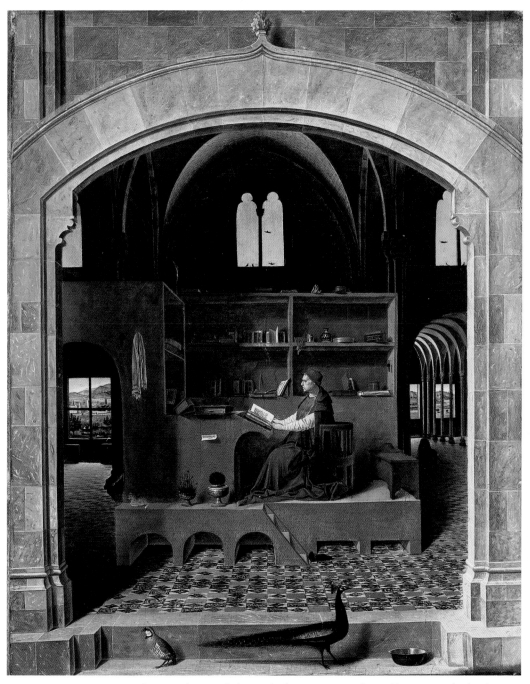

57 Antonello da Messina

St Jerome in his Study,
c.1474

forms, glimpsed through those two windows. Interestingly, both windows are divided: the large left-hand window with its mullion and transom grid breaks up the landscape into four framed views, and the right-hand window is interrupted by the columns. In the left window the horizontal division neatly separates the green, comfortable, populated river landscape from what looks like barren hill country above.

The view of the outside in this painting, the landscape (such as it is) with its looser, rounder contours, is subordinated to the discipline of the interior which itself is a projection of the orderly mind of the scholar saint who is the chief focus. Framing predominates as a series of frames, explored as the eye moves into the picture through successive openings, past the figure of the saint, to right and left, drawn towards the muted sources of light from the rear. In all of this, the interior is clearly distinguished from the exterior: against this ruled complex of spaces, landscape functions distantly as the relatively unruly 'outside' that will not disturb the composure of Jerome's study. The mind is in full control.

By contrast, consider the framing strategies and the outside–inside duality in Christoffer Eckersberg's (1783–1853) *A Pergola* [**58**]. Eckersberg, a Danish painter, was part of the artistic circle around the sculptor Bertel Thorvaldsen (1768/70–1844) in Rome in the second decade of the nineteenth century and produced a number of Italian landscapes in this period. In *A Pergola*, 'inside' and 'outside' are confused, and indeed that confusion may well be the experience the painter is aiming to represent. The viewer's position is presumably within a walled garden, where the sunlight filters through the leafy mesh of the pergola, giving a sensation of shade that contrasts with the intense heat sensed in the open landscape beyond. The sunlight through the pergola is softened and mellowed so that it harmonizes with the pale terracotta of the wall. As one moves from one space to another in the picture, there is a consistent interplay between the natural and the cultivated, the inside and the outside, the relaxed and the formal, the free and the trained. As in da Messina's painting [**57**], the viewer is positioned dead centre and the principal architectural features are parallel to the picture plane, starting with the pergola uprights and cross beams, then the high wall and arch, beyond that to the low wall and sarcophagus (if that is what it is), and then out to the long flank of the sun-baked farm building in the distance. The perspective lines on pavement and pergola are carefully calculated and the principal frame of the archway is emphatic and hard edged. One frame opens on another and, unlike the da Messina painting, natural forms live in harmony with the architecture; a gentler version of the exterior countryside flourishes under a benign, relaxed rule within the confines of the enclosed garden.

For northern Europeans especially, there is a fascination with the relaxing of sharp distinctions between inside and outside, landscape and domestic interior. So much of the northerner's life is passed inside buildings that it differs a great deal from the experience of the Mediterranean where inside and outside interpenetrate more easily. Such considerations might help to explain why landscape art seems originally to have been a northern European initiative.

The motif of the window view, sometimes including a gazing figure, has been associated with specifically northern European Romantic preoccupations, the longing to escape confinement, the inducement to liberate the imagination to explore the vast regions of light. The motif, as one critic has put it, 'brings the confinement of an interior into the most immediate contrast with the immensity of space outside … the window is like a threshold, and at the same time a barrier'.[2] The effect of a window frame around a landscape is to accentuate the sense of distance, cultural as well as visual, which that outside world acquires. Novalis (the pseudonym for the German Romantic von Hardenburg (1772–1801)) wrote, 'Everything at a distance turns into poetry: distant mountains, distant people, distant events; all become romantic.' Such distancing and framing by an interior can glamorize even the most unassuming kinds of landscape.

Take the example (from the period identified with this Romantic fascination for the motif) of the German painter Friedrich Wasmann's

(1805–1886) *View from a Window* [**59**]. The frame is rendered as drab, daubed bands of dark and lighter brown with just enough detail on the left to suggest an opened casement, the angled top and bottom lines of which guide the eye out into the landscape, the base of the casement frame running parallel to the line of the road. Once beyond the rectangle of the window there are no strict horizontals or verticals. Instead this is a composition of dramatically steep diagonals and restless, rolling contours. The brushwork which was dragged along in straight bands to represent the frame now loosens up and slithers freely in defining the forms and rimming them with the bright, low sunlight. The colouring of the further landscape is almost preternaturally rich and romantic in its glowing primrose sky and lapis lazuli sea of hills, heightened by the dull umbers of the interior of the viewing room. Inside throws the outside into brighter relief.

The relationship between domestic interior and romantic landscape is echoed in the centrally pictured cottage on the foreground slope. If *we* have a sumptuous view, what must the uninterrupted view be like from the far side of the cottage? What is life like when you are *part* of such a landscape? The lack of any topographical information in the painting's title enhances its Romantic values, its dreamlike aura. In this respect it differs from the detailed, expansive view of the Bay of Naples and Vesuvius taken from a window in the town of Quisisana [**60**] by Norwegian painter Johan Christian Dahl (1788–1857). The window frame is less intrusive in this composition, though stressed in the title. Through the window and over the rooftops of the neighbouring houses, we are given a scale by which to take the

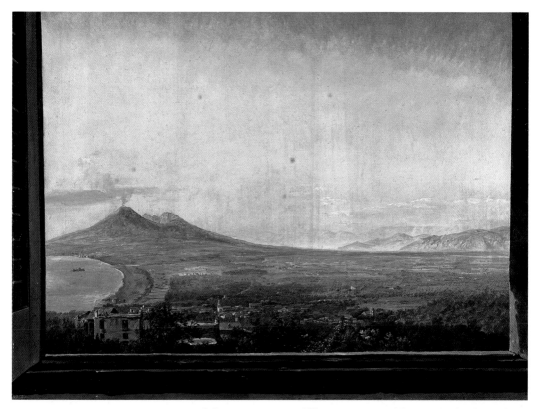

60 Johan Christian Dahl

View from a Window at Quisisana, 1820

measure of the giant cone of Vesuvius, smouldering in the late after-noon light. The blue remoteness of the volcano is enhanced by the contrast with the neat symmetry of the frame and the glimpse of trim shutters on the left.

Dahl's painting is more a tourist's record of a celebrated landscape than a glimpse of Romantic possibilities. This is another implication of the window view: it authenticates the landscape. A picture frame is an ornamental addition to a completed painting of any kind, but the in-clusion of a window frame border in the total painting enhances the sense that this is a real view—a visual anecdote, as it were—an authentic part of one's experience *here*. The window frame serves another purpose. Its boundaries help to limit the lateral stretch of the landscape, which has a panoramic sweep. Both the high viewpoint and the physical topography of the area deprive the viewer of natural borders: the eye from, say, a hilltop at this level could sweep uninterruptedly to left and right in this vast, continuous landscape, but here the window's useful boundaries provide a ready-made frame. The window is parallel to the picture plane, and we must be no more than a metre away from the sill. Any further forward and we would be turning our head left and right as the landscape increasingly assumed a panoramic curve. As it is, at a little distance from the window, this becomes one view, 'front on'—the inclusion of the frame in the painting is telling us just that. The

convenience for the painter is considerable. This view of a real Neapolitan scene belongs in the room where this particular window is; once painted, it becomes portable, and the same view can adorn a room anywhere else in the world.

Books of advice to painters frequently stressed the desirability of selecting a view that could be taken in without turning the head. The seascape painter Claude-Joseph Vernet (1714–89) endorsed this in this a letter of *c.*1765:

Il faut … prendre, pour sujet de votre dessin ou de votre tableau, ce que le même coup d'oeil peut embrasser, sans remuer ni tourner la tête; car, chaque fois qu'on tourne pour voir un object qu'on n'apercevait pas, ce sont tout autant de tableaux nouveaux qui demanderaient le changement de la forme des objets, celui de leurs plans, et par consequent celui de la perspective.[3]

The rigid restriction to the single glance, so conveniently enforced by the window frame, has interesting implications for landscape representation. Vernet argues that the consequences of disregarding his advice are not simply that the principal focus of a composition would have to be awkwardly expanded in order to include whatever visual information a slight turn of the head would add, but that the principal view would change its value—a value dependent on the fixed, limited perspective. Thus, to return to Dahl's *View*, if the painter had moved closer to the window the view would have included (as one looked from left to right) more of, respectively, the Bay of Naples and the hinterland, as well as more of the foreground below. It would cease to be 'a view', perhaps; it would be unpicturable, unless one devised a panoramic

61 Eric Ravilious
Train Landscape, 1940

representation. As it is, this becomes a portable souvenir and the artist is relieved of further responsibility for selection and demarcation.

Had Dahl and Wasmann retired further from the window frame, the landscape would have been modified in other ways than simply by shrinkage of extent. The relationship between interior and exterior would have become more insistently the subject of the picture. This is the case in Eric Ravilious's (1903–42) watercolour *Train Landscape* [61]. This perplexing scene gives three framed views of an English landscape from within a third-class railway compartment. It is, of course, one continuous landscape outside, divided up by the carriage window frames into a triptych. The landscape itself is unremarkable except for a white horse. Cultivated fields occupy the foreground, and a prehistoric relic marks the open, ancient downland. This homely view of a patiently enduring English landscape no doubt had a particular poignancy at the time it was painted (the second year of World War II). All this is seen from within the trim, modern world of the train interior. The two worlds are not quite as antithetical as one might suppose: the design and, to some extent, the texture of the carriage cloth chime with the field patterns outside. The effigy of the old animal mode of transport is ironically framed from within the new machine mode. As in the Messina painting of Jerome in his study [57], the loose, free lines of the distant landscape are interrupted, controlled into smaller units by the restricted perspective from the fussy, airless compartment interior. We are sealed off from that outside world in our comfortable, upholstered, symmetrically organized interior. The only window that could be opened is obtrusively closed, as the full length of the leather release belt demonstrates. The tabs on the blinds, intruding into the tops of the frames, are easily reached if one wanted to obliterate that outside world altogether.

What is particularly unsettling about this picture is that there is no suggestion of any movement that would normally have the effect of blurring the contours of the exterior world. We are now very used to seeing landscape move rapidly past us through the window frames of train compartments or cars, so that the frame hardly controls a stable composition as it does through a house window. But the car, train or carriage passenger can enjoy a linked sequence of landscapes from that point of view. We imagine ourselves, by an odd transference, as seated in a stationary interior with the world rushing past outside for our amusement, as at the exhibition of a moving panorama when the spectator is in fact stationary and watching a giant continuous landscape or cityscape scroll by.

The perception in such circumstances of landscape scenery as a spectacle, a commercial amenity, becomes a kind of habit. So it was for the eighteenth-century Picturesque tourists as they travelled in their carriages through England's Lake District, armed with their Claude glasses [62]:

62
A Claude glass

A succession of high-coloured pictures is continually gliding before the eye. They are like the visions of the imagination; or the brilliant landscapes of a dream. Forms, and colours, in brightest array, fleet before us; and if the transient glance of a good composition happen to unite with them, we should give any price to fix, and appropriate the scene.[4]

The traveller here, William Gilpin, has two frames to mediate his landscapes: the carriage window and his Claude glass. He is not looking out of the carriage window but into the framed mirror reflection of what the window offers to his view. So he sees the world outside as 'a succession of … pictures', waiting to be fixed and appropriated; in other words, the world outside has already been reduced to a frameable possession. Gilpin's pictorial processing of the experience of natural scenery, extravagantly artificial as it might seem, is a version of the way many of us continue to perceive landscape, as our experience of it is increasingly mediated by frames of one kind or another: the window, the camera viewfinder, the television set, the cinema screen.

Gilpin used the Claude glass as a kind of portable frame with additional optical advantages. The glass was a convenient, miniaturized version of the larger convex studio mirror sometimes used by painters. Encased in a wallet, the convex glass (oval, circular or rectangular) admitted into the frame a fair expanse of landscape, but the reflected image was, of course, condensed and warped, so that lateral verticals in the original scene appeared slightly bowed in the sides of the mirror. The modern wide-angle camera lens can give the same effect. Through this device nature could be viewed instantly, accommodated in a frame; sometimes in both an internal as well as an external frame. If the artist found the right viewpoint, he or she might be able to use foreground trees or the side of a building to act as framing side screens, through which the eye could wander to the middle and far distance. The convexity could give a slight inward curve to these foreground verticals so that, in seeming to lean in and enclose the central view, they acted as convenient natural coulisses to supplement the mirror's own frame.

Tourists equipped with Claude glasses could pass through countryside 'taking pictures' in the way the modern tourist does with a camera, and return home with a series of 'fixed' and 'appropriated' landscape pictures mediated through frame and viewfinder. This is what the tourists are doing in Paul Sandby's (1730/1–1809) painting *Roslin Castle, Midlothian* [63]. Sandby depicts the picturing activity of gentlefolk as they use the box *camera obscura* to take pictures of the peasant woman and child on the bridge, with perhaps the shepherd and flock in the background. For these amateur artists, the landscape is processed, by lens and mirror, to throw on to the rectangular ground-glass surface an image that one of the ladies is tracing.

What the eighteenth-century gentry enjoyed as a sophisticated connoisseur activity has become fairly habitual for the modern tourist. The 1977 *documenta 6* exhibition in Kassel, Germany, featured a gigantic installation, the *Rahmenbau* [**64**], consisting of two frames erected at Schöne Aussicht (beautiful view), a terrace overlooking a park and valley. The frames, according to one description, gave shockingly different views: 'A green landscape viewed through the large frame as a wide valley was transformed by the small frame into urban sprawl dominated by chimneys.'⁵ The same writer quotes one of the artists involved in the exhibit, Laurids Ortner, as commenting on the habit of framing:

The *Rahmenbau* frames a random stretch of landscape. Our concern is first, to make the viewer aware that he does not react to or become aware of daily objects that surround him constantly, unless they are specially 'framed'. Secondly, we wanted to turn his attention especially toward the urban landscape and show the observer that here a landscape has developed of which he has not yet become fully conscious.

The Claude glass image flattened the features in a landscape of any depth, much as binoculars do, so that, as Gilpin observed, they look 'something like the scenes of a playhouse, retiring behind each other'.[6] This brings us to consider another kind of framing, the proscenium arch. As with the window views, the theatre audience (after the introduction in the early nineteenth century of gas lighting) gazed from within a darkened room through the proscenium frame into a brightly lit world organized to draw the eye into its middle and upstage areas, much as the landscape artist would direct the passage of the spectator's eye. This is evident in the seventeenth-century set design, by an unknown Italian artist, *Landscape with Rustic Houses and Waterfall* [**65**]. The historian of stage design, Donald Oenslager, in describing this sketch, suggests the analogy with the little window-view landscapes in Renaissance painting, such as those we have seen in da Messina's painting:

The artist tried to create order out of many unrelated elements by aligning his wings in perspective on the stage floor. Thus he incorporated many locales in one scene—a rustic house, a rocky forest, a waterfall, a fence with garden gate, a *tempietta*, and, atop the opposite precipice, a villa. The composite scene debouched into an open landscape with a fortified hilltown above a river

receding in the distance, quite reminiscent of those charming views seen through the windows of Renaissance paintings.[7]

This eclectic landscape is the setting for an unknown pastoral play, according to Oenslager: 'this composite scene served the fluid action of pastoral plays such as Tasso's *Aminta* and Guarini's *Pastor Fido*'. The scene is an *omnium gatherum* of landscape motifs. The downstage wings, emerging from the proscenium sides, reinforce the lateral framing of the theatre structure with, on the right, a darkened cliff face and overhanging tree, bending inwards as would be the desired effect in a Claude glass view, and on the left, rustic houses built against and rising from the cliff, following the vertical of the slender tree next to them. The rest of the set is organized on strong intersecting diagonals. Along the ground on the right a clearly visible line marks out the basic structural plan. The perspective line is carried along these paths and continued in the background by the zigzagging river.

Such a strongly perspectival set design, if carried out, would be most appreciated by those with seats in the middle of the auditorium, the position assumed by the particular scenographer as he laid out his plan. Seats far to the right or left of centre—the cheaper seats—would find parts of the middle ground and background obscured. The full picture, all the visual information for the sequence of dramatic episodes, would be available only to those who could afford the best seats. No such exclusivity applies to the spectator of a landscape painting where the viewpoint from a commanding central position is available to anyone.

66 Nicolas Poussin
Orpheus and Eurydice,
*c.*1650

Whether such traditions of stage design influenced the seventeenth-century Roman landscape painters—Claude and the Poussins in particular—or whether the painters influenced the scenographers is hard to determine. But the advantage of a framed design of this kind was unarguably felt by both in giving a disciplined structure to a landscape scene. One critic has drawn attention to specific theatrical correspondences in a painting by Nicolas Poussin, *Orpheus and Eurydice* [66], arguing that no other landscape painting by Poussin so clearly resembles a theatre stage:

The spectator is just the right distance away and has the central viewpoint usually enjoyed from the best seat in the auditorium. ... the resemblance to a stage is such that the middleground and background could almost be envisaged as a two-dimensional backdrop intended to produce a three-dimensional effect: the castle could be a text-book example of how to render volume on a flat surface. This trick endows the figures in the foreground with a kind of physical freedom, a plasticity that convinces by contrast with the 'painted picture' look of the background.[8]

The scene of Orpheus and Eurydice is played out downstage against a painted backdrop. It is not only the middle ground and background that suggest two-dimensional stage scenery. Poussin has also organized his repoussoir trees as stage wings. When one adds the dark clouds over the top of the picture and the strong shadow running all along its base, we are presented with another version of the interior framing technique. This intensifies the strong bright light in which the dramatic action is played out, and corresponds to the ideal sought by stage lighting.

The stage designer is constructing a landscape of two-dimensional trees, castles, and hills within a three-dimensional framed space. Landscape painters sometimes used stage models in constructing their imaginary landscapes, figuratively and literally (Philippe Jacques de Loutherbourg (1740–1812) and Thomas Gainsborough (1727–88), for example). Views of landscape through a window or viewfinder, captured in a Claude glass or organized as a stage set, suggest how persistent is the habit of framing a view of the natural world, of seeing it in rectangular sections. I want to close this review of some of the ideas and practices of framing the landscape with two examples of the play between the real and the artificial which is stimulated by the habit of framing.

The playhouse, the window frame and the ideally proportioned rectangular view are brought together in one formerly celebrated natural site in England's Lake District. Near Grasmere, on the Rydal Hall estate, are two waterfalls of modest size. The smaller of the two, Lower Rydal Fall [67], is a drop of about 20 feet. The water falls from a narrow rim in a thickly wooded area, is divided in its fall by a large protruding rock, and tumbles into a wider pool, overhung with trees, before veering to the left into a smaller channel and out of sight. On

67 Joseph Wright of Derby
Rydal Lower Fall, 1795

68 Anon
Rydal Falls from the
Summerhouse

the poolside bank, directly opposite the falls was (and still is) a small seventeenth-century stone hut, a summerhouse [68], the entrance to which was gained by a path to its rear, so designed that as the visitor approached the falls and listened to the noise of the water growing louder, his view was blocked by the little hut. Once inside, and when the door had been closed, the shutters on the large window facing the pool were thrown back and there, perfectly framed, was a view of the tree-shaded falls, the pool in the foreground, and above, in the background, a glimpse of the little rustic stone bridge crossing the upper stream.

Whatever the original purpose of the little hut, by the later eighteenth century it had become an ideal viewing chamber. The dark interior and the large window threw into strong picturesque relief this little landscape, ideally proportioned to its frame. William Mason, the poet and biographer of Thomas Gray (1716–71), noted with satisfaction the sense of scale:

Here Nature has performed every thing in little that she usually executes on her largest scale; and on that account, like the miniature painter, seems to have finished every part of it in a studied manner; not a little fragment of rock thrown into the bason, not a single stem of brushwood that starts from its craggy sides but has its picturesque meaning, and the little central stream dashing down a cleft of the darkest-coloured stone, produces an effect of light and shadow beautiful beyond description. This little theatrical scene might be painted as large as the original, on a canvas not bigger than those which are usually dropped in the Opera-house.[9]

Nature had constructed her landscape in such a way as to ensure its value as an aesthetic commodity. It hardly needed any artistic modification. The principal motifs were sufficiently concentrated in the composition to make distortions of the Claude glass unnecessary. All that was needed was to put a frame around the living scene; and that is, in effect, what the summer-house offered. The scene was thereby processed and was poised in status between natural landscape and artefact: a 'living picture'.

The window view, as we noticed earlier, in the *View* of the Bay of Naples [60], helps to determine the scope and boundaries of a potentially limitless landscape. The frame determines the single glance that Vernet and others insisted was so important to the selection of landscape subject. One can enlarge or contract the view slightly by moving towards or back from the window. Minute attention to calculations of the chosen view featured in many treatises on perspective. One such, which also has some interesting advice on framing the view, was Arnaud Cassagne's *Traité Pratique de Perspective* (1873): '*The assemblage of objects destined to form a picture should be easily embraced at a glance.*'[10] This meant that the artist had to choose very carefully the proper distance to take up from the object to be represented. Too near and the

artist would have to turn the head from left to right to catch the extremities of the chosen view, too far and the intervening air would give too vague a form to the objects of study. The best distance 'should be *at least equal to twice the total base of the subject*'.[11] The Rydal viewing chamber conforms very closely to these stipulations on distance and the single glance; furthermore, in providing a frame that prevents any lateral stretching of the view, it corresponds to another important recommendation by Cassagne:

To judge the distance properly in drawing from nature, the artist will derive great assistance from the use of a small frame, of wood or cardboard, divided in the middle by a very fine thread or horse-hair, which divides the space into four equal parts and at the same time indicates the centre.[12]

The illustration of this technique imposes a grid over the village scene [69] (much as the left-hand window frame in Messina's *Jerome* [57]

69 Cassagne
Two diagrams, 1873

was organized by the intersecting vertical and horizontal bars), focusing the chosen subject, preparing it to become a painting. The other illustration, the tower in the landscape, interposes a huge two-dimensional representation between artist and subject in order to demonstrate the point about the proper distance. In somewhat surreal fashion it also provokes questions about the relationship between copy and original; this brings us to René Magritte's (1898–1967) *La Condition Humaine* [**70**].

It is likely that Magritte knew Cassagne's diagrams and that the idea in several of Magritte's paintings, where a canvas intervenes between the viewer and the landscape which is the subject of the canvas, was suggested by these.[13] In this teasing version of the relationship between nature and artifice, where the manipulative, processing implications of the frame are concerned, the window and curtains frame a landscape which is partially obscured by an easel-mounted canvas depicting precisely that portion of the landscape it blocks from view. Like several of the landscape views exemplified in this chapter, this is a glimpse of the outside world from an interior. The ruled lines and drab colouring of the interior, including the apparatus of easel and canvas, enhance the softened, organic forms and iridescence of the exterior scene. But that interior/exterior play is complicated by the further element of the canvas painting. In a reversal of the usual distinctions, the real landscape is framed (by the window), and the painted landscape is not. But that distinction between the real and the painted collapses. Both landscapes are painted, of course: Magritte has made no distinction between his manifestly painterly handling of what one can see of the 'real' landscape and the painterly handling of its canvas representation. The two landscapes are consistent and continuous with each other in technique as well as in their positional relationship. So can one talk of *two* landscapes here? Can one sustain the usual hierarchical distinctions between the 'real' one and the 'artificial' one, between 'exterior' and 'interior', when the artificial looks just as real as the scene it represents, and when the landscape inside the room is indistinguishable from the landscape outside?

Magritte's own remarks on the painting raise explicitly the issue of inside/outside:

In front of a window seen from inside a room, I placed a painting representing exactly that portion of the landscape covered by the painting. Thus, the tree in the picture hid the tree behind it, outside the room. For the spectator, it was both inside the room within the painting and outside in the real landscape. This simultaneous existence in two different spaces is like living simultaneously in the past and in the present, as in cases of deja vu.[14]

The representation of the simultaneous existence of the landscape in two different spaces is designed to baffle, to deconstruct, those familiar

70 René Magritte
La Condition Humaine, 1933

distinctions and orientations on which landscape views from interiors depend, as this chapter has shown. Landscape is supposed to be that which lies outside our familiar domestic living spaces—as in the distinction between Jerome's study area and the rolling hill scenery glimpsed through his windows. Landscape is conventionally that which we bring into our interiors in the form of copies only—framed pictures. This distinction generates, or is produced by, a range of associated distinctions which we take for granted in considering landscape in art: such as, domestic versus wild, art versus nature, manufactured versus organic, copy versus original. Magritte's picture, with its teasing reflexivity, deliberately subverts these habits of perception: 'given my desire to make the most ordinary objects shock if at all possible, I obviously had to upset the order in which one generally places them'.[15] The shock of defamiliarization, which was crucial to the Surrealist venture, lies less in the objects represented than in the disposition of those objects in entirely new relationships, in their recontextualizing. Magritte's remarks on *déjà vu* as the momentary experience of living simultaneously in the past and the present is another example of such dislocation and the resultant collapse of binary opposites. Thus, in *La Condition Humaine*, Magritte disturbs a whole tradition of cultural conventions.

Looked at from another point of view, the painting may be seen as less subversive than it is parodic of what Magritte regards as the bourgeois–picturesque valuation of landscape and its representation in art. To what extent has that valuation prioritized the artificial over the real and accepted the former as the landscape of real, palpable value, not only in commodity terms? Have we come to recognize the aesthetic merits of landscape only when it can be accommodated in a frame of some sort? The often-remarked use of the same word, 'landscape', to designate both a stretch of countryside and an artistic representation of that countryside suggests that an elision of a conceptual kind has taken place.

A familiar way of describing realism in art and literature is to invoke the analogy of the mirror or the window. The realist writer supposedly offers the reader a view of life through a wholly transparent window pane, without distortion, without manipulative mediation. But what has happened to the window view in *La Condition Humaine*? Our view of the real world outside is blocked by the painting, and yet it is not blocked because the painting does what the Realist agenda requires: it reproduces all that the eye could see were the canvas to be removed. We can virtually ignore the fact that it is a canvas and treat it as part of the window. Viewed thus, the right edge of the easel painting, with its pinheads securing the bare canvas to the stretch frame, becomes just a white vertical strip unaccountably taped on to the window pane, and the portion of easel and clamp floating in the blue sky might be a typical Surrealist intrusion of something alien.

Art here prevents us from seeing nature: it physically impedes our view of what the window allows us to glimpse. This is Magritte's literalizing of a cultural change in our perception of landscape. Or is 'nature' simply an idea we need to construct for that which is *beyond* the painted, framed object? Perhaps the 'original' has in some respects never been other than a construction, a fabric of our perceptions determined by cultural conventions and changing human needs. To what extent does the formal framing of a view of the natural world—the window view of Romanticism as much as the framed, painted landscape—not just enhance but produce the sense that there is such a thing as unframed landscape? Is that sense of a real, wild landscape beyond the frame just as much an illusion as the framed, painted view of it? And is *that* unanswerable question, graphically posed in Magritte's painting, what he means when he entitles it 'The Human Condition'?

'Astonished beyond Expression'

Landscape, the Sublime, and the Unpresentable

6

The Picturesque view of nature is one that appreciates landscape in so far as it resembles known works of art. At the same time, Picturesque taste favours natural scenery for its untouched status, its remoteness from the world of art and artifice—it delights in the results of accident, the traces of the agency of time and organic growth, it celebrates what is alien and wild and spontaneous. As Picturesque taste, drawing on models of landscape beauty from Italian and Dutch seventeenth-century painting, absorbs and reproduces its favourite material in paintings and garden design, what was strange and wild becomes increasingly familiarized and commodified. Uncultivated natural scenery is, as it were, domesticated—it is accommodated within our daily experience both as an artistic experience and as a tourist amenity; it is aesthetically colonized.

What has just been described, with reference to the Picturesque, belongs to a period of changing tastes in the later eighteenth century in Britain. But in its broader implications it is not necessarily historically specific. It is a paradigm we may recognize as part of common experience: that is, we recognize the extent to which art, as it explores through images the further reaches of experience, becomes part of the process whereby intimidating novelty graduates into safe familiarity. The novice soon outlives the thrill of the nursery slopes.

The formulae derived from Picturesque conventions reduce novelty and variety to secure uniformity. The Picturesque makes different places seem like each other. It encourages us to edit out diversity, eccentricity, startling departures from the standard. It chooses to reassure, not to shock. Over time, its homogenizing habit dulls with sameness and familiarity, and the spirit longs for novelty and freshness, even shock. In landscape art there are a number of ways to challenge these tendencies of the Picturesque, two of which I will focus on in this chapter. Artists can search out more remote, pictorially uncharted, regions of the earth to portray or they can refigure the familiar. In the latter case, the stimulus and disturbance would be felt not so

Detail of 74

much in the subject as in the mode of treatment. In this chapter I want to concentrate on both strategies, and to demonstrate them with reference to Romantic landscapes in art and literature and to theories about the *avant garde*. This will be traced principally in painting, but also in other forms of spectacle, such as the panorama.

'A sort of delightful horror'

The seventeenth-century Italian painter, Salvator Rosa (1615–73), acquired a reputation as a specialist in wild, turbulent landscapes [71]. Originals or painted copies of his work, as well as hundreds of prints, were bought by Grand Tourists and became increasingly familiar in the collections of the great houses in northern Europe in the eighteenth century. Among the connoisseur and cultivated classes Rosa's name became almost proverbial for the terror induced by awesome mountain scenery: 'Precipices, mountains, torrents, wolves, rumblings, Salvator Rosa', exclaimed Horace Walpole (1717–97) in a letter during his crossing of the Alps in 1739. He and Thomas Gray stayed at the small village of Echelles, from which they took the steep mountainous road up to La Grande Chartreuse monastery. It gave them their first experience of the high Alps, as Gray recorded in a letter:

I own I have not, as yet, anywhere met with those grand and simple works of art that are to amaze one … but those of Nature have astonished me beyond expression. In our little journey up to the Grande Chartreuse, I do not remember to have gone ten paces without an exclamation, that there was no restraining: not a precipice, not a torrent, not a cliff, but is pregnant with religion and poetry. There are certain scenes that would awe an atheist into belief … [it is] one of the most solemn, the most romantic, and the most astonishing scenes I ever beheld.[1]

Walpole described the scene to their mutual friend Richard West:

But the road, West, the road! winding round a prodigious mountain, and surrounded with others, all shagged with hanging woods, obscured with pines, or lost in clouds! Below, a torrent breaking through cliffs, and tumbling through fragments of rocks! Sheets of cascades forcing their silver speed down channelled precipices, and hasting into the roughened river at the bottom! Now and then an old foot-bridge, with a broken rail, a leaning cross, a cottage, or the ruin of an hermitage! This sounds too bombast and too romantic to one that has not seen it, too cold for one that has. … We staid there [Grande Chartreuse] two hours, rode back through this charming picture, wished for a painter, wished to be poets![2]

Walpole's breathless, broken sentences and exclamation marks express his struggle to convey the sensations of that journey, and he virtually gives up near the end as he invokes the help of poetry and painting. The challenge here is twofold: the mind coping with shocking new experiences; and, as Gray explicitly announces, struggling to give

71 Salvator Rosa

*Landscape with Soldiers
and a Huntsman,*
?mid-seventeenth century

articulate expression to the ineffable. Coherent syntax all but collapses under the strain. Walpole makes little attempt to compose an overall picture (Gray does this better); he simply provides an inventory of the materials of sublime scenery. The descriptive process is miniaturized in that aforementioned opening sentence of his letter the day before: 'Precipices, mountains, torrents, wolves, rumblings, Salvator Rosa …'. The addition of Rosa's name at the end is a gesture, as if to say: 'You know the kind of landscape he paints … well, that's what we saw first hand.' It is a kind of shorthand, which became increasingly convenient as a means of conveying impressions of certain types of scenery. Johann Ludwig Aberli, a printmaker in Berne in the late eighteenth century who specialized in views of Swiss scenery, recalled a journey into the Alps made in 1774: 'On our travels it sometimes happened that both of us would cry out at the same time: *Salvator Rosa! Poussin! Saveri! Ruisdael!* or *Claude (Lorrain)!*, according to whether the subjects before our eyes reminded us of the manner and choice of one or other of the masters named.'[3] This is the characteristic gesture of the Picturesque: almost as a reflex it accommodates the experience of such scenery to familiar pictorial conventions. Rosa's inspirational versions of sublimity, his vocabulary of sublime motifs, touched a number of American artists, most notably Thomas Cole (1801–48). As a kind of homage, Cole produced a loose, vivacious sketch, *Salvator Rosa Sketching Banditti* [**72**],[4]

72 Thomas Cole

*Salvator Rosa Sketching
Banditti, c.*1832–40

which is a compendium of the familiar motifs of criss-crossing, shattered trees, gloomy caves, massive rock faces and the *banditti* with whom, according to legend, Rosa associated. The figure of the sketching artist, hard to make out, is tucked at the foot of one of the trees.

The experience of the Sublime is, almost by definition, one that subverts order, coherence, a structured organization—just as we witnessed in Walpole's attempts to describe the Chartreuse. It bypasses the rational mind and concentrates its force directly on the emotions. The conditions favourable for inducing the experience of the Sublime appear to be wholly inimical to the values associated with the so-called Age of Reason in which it was enthusiastically articulated. Obscurity and darkness, the near loss of visual and intellectual control over one's environment, are strange properties to celebrate in the En*light*enment; but these are undoubtedly the attractions of the Sublime as Edmund Burke proposed in his *Enquiry into the Origin of our Ideas of the Sublime and Beautiful,*[5] a book that had an immense influence on aesthetics in Europe and North America in the later part of the century. Reason is overpowered:

the mind is so entirely filled with its object, that it cannot entertain any other, nor by consequence reason on that object which employs it. Hence arises the great power of the sublime, that far from being produced by them, it anticipates our reasonings, and hurries us on by an irresistible force.[6]

The first-century AD treatise *On the Sublime*, attributed to Longinus, emphasized the extent to which 'the effect of elevated language is, not to persuade the hearers, but to entrance them ... sublime passages exert an irresistible force and mastery ... a well-timed stroke of sublimity scatters everything before it like a thunderbolt.'[7] Longinus's simile is significant. The natural world's analogy to his literary sublime is the kind of overpowering scenery that Walpole confronted in the Alps, or it might be violent storms, erupting volcanoes, or thunderous waterfalls. All these impress the spectator with their power to crush the human being: 'I know of nothing sublime which is not some modification of power,' wrote Burke. The highest manifestation of sublime power is the intervention of the deity in human affairs. This is absolute power. By analogy there is a sublimity in forms of ancient despotic power; and there may well be an inverse correlation between the Georgian Englishman's self-congratulatory experience of living under a mixed political constitution and the new appetite for the Sublime with its implications of raw autocratic power.

The Sublime is also a strongly gendered aesthetic through its rugged, primitive, patriarchal associations. Its antithesis, in Burke's account, is a model of beauty that is recognized by the senses as having a fragile delicacy, an alluring smoothness of contour, and a submissiveness—all of which are exemplified in the female form and in the cultural expectations of what is 'properly' feminine. Translated into landscape terms, the Sublime becomes associated with Salvator Rosa's

73 Edgar Degas
Landscape, c.1892

world of dark, elemental violence, gypsies, and bandits; and the beautiful is associated with Claude's languorous and voluptuous pastoral scenes. A good example of the latter is the painting *Narcissus and Echo* [**55**] where the contours of the foreground nymph are echoed in the landscape motifs. A fanciful extension to this aesthetic is Edgar Degas's (1834–1917) virtuoso pastel assimilating the female body to the the softly undulating forms of landscape [**73**].

Burke listed, among the sources of the Sublime, power, obscurity, privation, vastness, infinity, difficulty, and magnificence. It is worth dwelling on these for a moment. All suggest experiences that rob us of control: we are prey to forces many times stronger than us (power), we cannot see properly (obscurity), we are deprived of our usual co-ordinates (privation refers to '*Vacuity, Darkness, Solitude and Silence*'), we cannot sense any reassuring boundaries of things (infinity). Many of these sources are dramatically present in Rosa's paintings. They were also recognized as being components in the complex experience of the Sublime when the spectator confronts directly the more awesome forms and forces of nature.

For the Sublime to be attractive as an experience (rather than simply painful in its terror), there needs to be some reassurance that, in the face of overwhelming power, the person is not in actual mortal danger:

if the pain is not carried to violence, and the terror is not conversant about the present destruction of the person, as these emotions clear the parts, whether fine, or gross, of a dangerous and troublesome incumbrance, they are capable of producing delight; not pleasure, but a sort of delightful horror, a sort of tranquillity tinged with terror.[8]

In landscape terms, this 'delightful horror' can be induced by a well-calculated modulation from security to horrific danger, as the philosopher David Hartley described:

If there be a precipice, a cataract, a mountain of snow, etc in one part of the scene, the nascent ideas of fear and horror magnify and enliven all the other ideas, and by degrees pass into pleasures, by suggesting the security from pain.[9]

Both Burke and Hartley recognize the complexity of this sensation of the Sublime and both resort to the kind of oxymoron used by the critic John Dennis 60 years before, when he tried to convey his feelings in crossing the Alps:

we walk'd upon the very brink, in a literal sense, of Destruction; one Stumble, and both Life and Carcass had been at once destroy'd. The sense of all this produc'd different motions in me, viz., a delightful Horrour, a terrible Joy, and at the same time, that I was infinitely pleas'd, I trembled.[10]

The position of being both spectator and potential victim/participator is crucial to the full experience. It is a matter of being taken as close to disaster as is compatible with still retaining the sense that one is not

74 Philippe Jacques de Loutherbourg

An Avalanche in the Alps, 1803

actually in danger ('the brink of Destruction'); it is both destabilizing and reassuring, the two feelings in dynamic tension. The effect is conveyed well in Philippe de Loutherbourg's *An Avalanche in the Alps* [**74**].

Thomas Cole produced several paintings of Niagara Falls which, as one recent critic has remarked, embodied nearly all those qualities which eighteenth-century visitors associated with the Burkean Sublime: *vast, powerful, magnificent* waterfall, its outlines *obscured* by mist, *difficult* to get to, a seemingly *infinite* succession of waters, creating an incessant roar, the sense of profound *solitude* in awareness of the surrounding wilderness, inspiring *terror* in the observer.[11] One visitor to the Falls in 1787 invoked both orators and painters in his attempt to convey the sensation of this sublime spectacle: 'it may be well said to be the real sublime and beautiful conveyed in the Language of Nature infinitely more strong than the united Eloquence of Pitt, Fox and Burke even if we give them the Assistance of Loutherbourg to help them'.[12] These expressions of helplessness (similar to Walpole's in the Alps) are a measure of the overpowering scale of these spectacles. The inability descriptively to encompass such phenomena, linguistically or pictorially, is the best tribute one could pay to their sublimity: it is a way of dramatizing human powerlessness, and the sensation of powerlessness is one of the key experiences of the Sublime. But strategic incoherence becomes a cliché after a while, no matter whether or not it is still authentically the experience of the Sublime.

New experiences which challenge the capacity of the spectator to articulate a response are new also in the sense that they impact upon an old language, whether verbal or visual, which has neither the resources nor the flexibility to stretch to the new. The Irish poet Thomas Moore (1779–1852), writing from Niagara in 1804, raises this issue of the impotence of language:

It is impossible by pen or pencil to convey even a faint idea of their magnificence. Painting is lifeless; and the most burning words of poetry have all been lavished upon inferior and ordinary subjects. We must have new combinations of language to describe the Falls of Niagara.[13]

The Burkean Sublime provided a word custom-made for such experiences, but this does not amount to 'new combinations of language'. It is not clear quite what Moore means by this phrase. Presumably he has in mind not so much new linguistic coinages as new organizations of language, radical dislocations of the conventional structures. Writers resorted to a range of rhetorical devices, such as Walpole's extended, headlong inventories of amazing sights, a rapid accumulation designed to leave the reader as breathless and disorientated as the spectator describing them. Another tactic was a more intensive use of metaphorical language, devices to aggrandize the experience of the Falls by calling in, through simile, an extra armoury of Sublime effects that are not physically present in the scene but are made legitimate adjuncts through metaphorical language: the torrent 'smokes', 'thunders', explodes 'like cannon-fire', and so on.

75 Anon
View of Niagara Falls, 1697

Such rhetorical reinforcements to scenic description do not easily find counterparts in pictorial representations of the Falls. None the less artists devised various strategies for accentuating the Sublime. In one of the earliest and most wisely disseminated pictures of Niagara, the engraving *View of Niagara Falls* [**75**],[14] the rather stilted and tame ribbons of falling water and the splashes at their base are given emotional force by the gestures of the foreground figures. Three of these have their arms outstretched in wonder at the whole sublime scene. The fourth, still climbing to the platform, has his ears covered so as to denote what the painting cannot otherwise reproduce, the mighty roar of the Falls. Block out these figures and the emotional impact of the scene is much diminished. However, their presence also has the odd effect of diminishing the scale of the depth of the Falls. This is more successfully conveyed by the details on the lower right of the picture: the winding road down and the minute figures standing in wonder at the base of the Falls. Moore's forlorn remark that 'Painting is lifeless' takes little account of the strategies that landscape artists can employ to give emotional vitality to their subject.

The savage splendour of such natural sites can be enhanced metonymically too. Niagara is an Indian name and on Indian territory. Several early paintings make this territorial identity explicit: for instance H. Füssli's (1755–1829) *View of Niagara Falls* [**76**], taken, it seems, from almost exactly the same spot as **75**. To Füssli's European eye the primitive power of the Falls is inseparable from the indigenous primitive inhabitants of the region: both represent forms of natural savagery, each reinforcing the other. The Indian brave sits like the tutelary genius of the Falls. The contemporary political significance of

76 Heinrich Füssli
View of Niagara Falls, c.1776

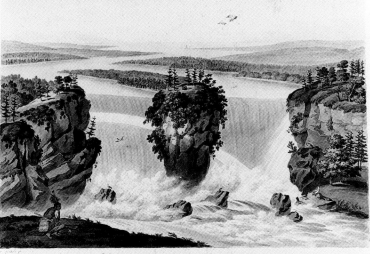

Vue de la Cascade du Niagara en Amérique,
dans le pays des Iroquois.

the Indian is accented by his military equipment, the rifle and toma-hawk, and these weapons play their part in the total effect of the Sublime in this scene.

The gesticulating figures in the Hennepin engraving [**75**] help to mediate the experience of the Falls. Their actions raise the level of delightful horror as they invite us at one remove to share in the experi-ence of the scene and to feel, as if by contagion, the sensations they are undergoing. William Henry Bartlett's (1809–54) steeply vertical com-position, *View Below Table Rock* [**77**],[15] pushes us much closer to the Falls and gives us a more immediate sensation of the awful precipice. The dark cliff, the overhang of Table Rock and the black hollow just below the lip of the Falls and behind the sheet of water contrast violently with the dazzle and glare of the water and spray. The dramatic chiaroscuro corresponds to Burke's 'suddenness' as a cause of the Sublime (by this he means any form of violent transition, whether aural or visual). The picture is designed to engulf the spectator, to make it seem as if there is no escape. There is no secure, level foreground, of the kind presented in the Hennepin and Füssli views [**75** and **76**], no viewing area parallel to the picture plane, by which we can graduate our entry into the picture. Instead, the human figures with whom we might identify are struggling on two broken diagonals which begin to cut across the dominant verticals and horizontals that control the compositional structure. This, together with the unnerving closeness to the Falls, destabilizes the spectator and renders much more alarming the sense of the Sublime.

'It is impossible by pen or pencil to convey even a faint idea of their magnificence', Thomas Moore had written of the Falls. This was a technical challenge taken up in new ways in the early nineteenth century. Niagara Falls became the subject of a range of commercial spectacles in Europe and America in the late eighteenth and early nineteenth centuries. The painter and scenographer Philippe de Loutherbourg designed a Niagara scene for his Eidophusikon in London in the 1780s. The Eidophusikon was a kind of miniature theatre, about 6 feet wide and 8 feet deep, with wings and flats, sound and lighting, in which landscapes, cityscapes, scenes from epic literature and so on were displayed. This device, and the dioramas and panoramas that developed rapidly in Paris and London over the next few decades, literally gave a new dimension to the pictured Sublime in landscape terms. The dissatisfaction with the limitations of two-dimensional painting or verbal descriptions of scenes such as Niagara Falls be-comes, as we have seen, part of the ritualized response of visitors to such sites; it is a form of impotence that inversely accentuates the power of the Sublime.

Robert Burford, who took over the ownership of the Leicester Square Panorama in London in 1826, exhibited a panorama of the Falls

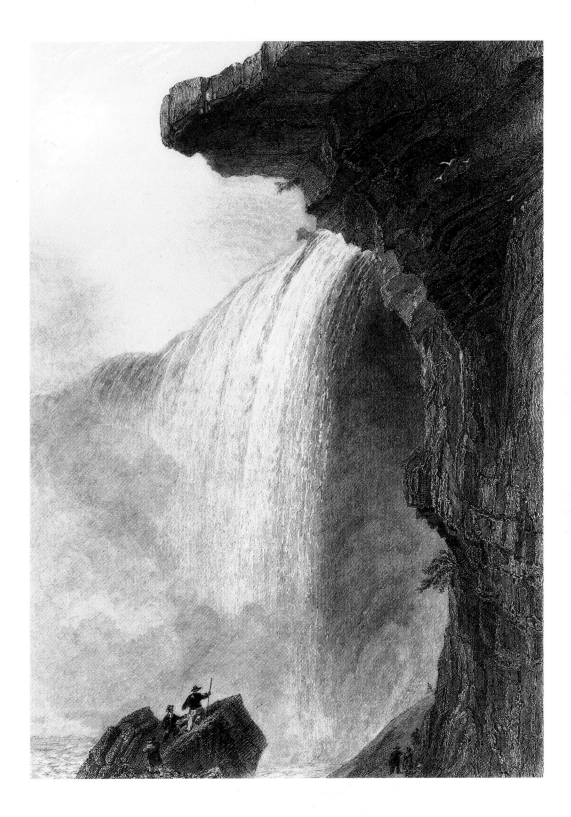

in 1833. He had been to the Falls in the autumn of 1832 and made a number of sketches from the Table Rock viewpoint. He based the panorama painting on these sketches and presented a 360-degree sweep of the Falls and the surrounding country. The descriptive catalogue offered to visitors to the Panorama made the point that the Falls 'surpass in sublimity every description which the power of language can afford'; it was 'indispensable', he argued, to be able to exhibit 'at one view' the various parts of the scene. The catalogue quotes in support another visitor to the Falls, a Captain Basil Hall:

All parts of the Niagara are on a scale which baffles every attempt of the imagination, and it were ridiculous therefore to think of describing it; the ordinary means of description, I mean analogy, and direct comparison, with things which are more accessible, fail entirely in the case of that amazing cataract, which is altogether unique; yet a great deal, I am certain, might be done by a well-executed Panorama.[16]

Hall dismisses the efficacy of simile and analogy as reductive devices to familiarize what is 'unique' (these are the old Picturesque mechanisms). The Panorama was new technology and offered to replicate the experience of the Sublime much more closely than any medium had done before. The panorama paintings were detailed, high-definition transcripts from nature, at least in aspiration. Ideally, they were substitutes for the original scene itself, far exceeding the power of words or painting to reproduce that original. Robert Barker, generally credited with being the inventor of the Panorama, claimed that it was an 'IMPROVEMENT ON PAINTING, Which relieves that sublime Art from a Restraint it has ever laboured under'.[17] In 'unlimiting the bounds of the Art of Painting',[18] Barker and his invention captivated even those painters whom one might have thought to have been among the staunchest purists. Joshua Reynolds was reported as acknowledging that the Panorama was 'capable of producing effects, and representing nature in a manner far superior to the limited scale of pictures in general'.[19] Jacques-Louis David (1748–1825) saw one of Pierre Prévost's panoramas in Paris and remarked 'Really, one has to come here to study Nature!'[20]

Painterly verisimilitude on a colossal scale was one of the great innovations of the Panorama. The controlled viewing environment was another. One important constituent of the Burkean, sensationist Sublime is the power of the spectacle wholly to occupy the mind and senses so as to exclude anything else. As John Dennis put it, the Sublime 'commits a pleasing rape upon the very soul'.[21] This happened at Niagara: the vast spectacle, the sense of terrific power and the deafening roar of the Falls shut out any other distractions and sensorily engulfed the spectator. This is what the Panorama could do, by extending the facsimile visual field and enveloping the spectator.

In a gallery of landscape paintings, the spectator is strongly aware of frames marking off the edge of the chosen view. The landscape, however expansive the original, is so organized and delimited as to be taken in at one stationary view, with perhaps the full scale suggested rather than represented. A triptych where a continuous landscape extends across all three panels can give the impression of a more spacious, unfolding expanse of land, especially if the side panels are slightly angled in towards the spectator. But the painted Panorama wholly surrounds the spectator. There are no lateral edges to cut off the view, and the top and bottom edges of the Panorama are concealed, shaded off at the top, perhaps, and intercepting the spectator's sight of the bottom with a paling or wall. Such elimination of any discernible frame to the view enhances the sense that the spectator is actually at the original site.[22]

Panorama and diorama technology worked hard to complete such an illusion of authenticity. Louis Daguerre's (1789–1851) diorama view of 'Mont St Gothard', taken from the town of Faido, was exhibited in 1830. *The Spectator* reviewed it (24 April), saying: 'This beautiful representation of one of the grandest scenes in nature has the effect of bringing the reality before the eye so vividly as to excite those emotions and raise up those associations which a contemplation of the actual scene would produce in the mind; such truth, force and feeling is there in the picture.'[23] For his 'View of Mont Blanc taken from the Valley of Chamonix', Daguerre imported from Chamonix a complete chalet and its outhouses. A live goat was tethered in a shed, and the sounds of alpenhorn and singing accompanied the spectacle. Where did nature end and art begin? Daguerre remarked:

It is just for this mixture of nature and art that many critics blame me; they say that my live goat, my chalet and my real fir trees are illegitimate aids for the painter. That may well be so! My only aim was to produce the most complete illusion; I wanted to rob nature, and therefore had to become a thief. If you visit the valley of Chamonix you will find everything as it is here: the chalet with projecting eaves, and the tools you see here, even the goat down there, I brought back from Chamonix.[24]

This 'complete illusion' of a landscape is more than simply a transcription of the original: it is partly also a transplanting of the original. Nature has been 'robbed' to achieve the illusion. To add to a landscape painting three-dimensionality, sound and movement, blurs the distinction between artefact and nature in ways that Daguerre's contemporaries found disconcerting. Art and landscape materially feed off each other to produce a complex amalgam, a kind of grafting.

Hardly anything remains from the great age of the panoramas, but one interesting survivor is the Bourbaki Panorama in Switzerland, painted by Edouard Castres (1838–1902) in the nineteenth century and much restored since. During a recent restoration, the Panorama was

studied by the Canadian photographer, Jeff Wall. The huge photo-graph *Restoration* [**78**] exposes some of the technology of panorama spectacle: the railed viewing area beneath the circular, curtained canopy, and the continuation of the depicted drama from the two-dimensional painting on to a three-dimensional 'set', with its litter of army equipment and broken line of fencing on the snow. Jeff Wall speculated that the Panoramas were 'an experimental response to a deeply-felt need, a need for a medium that could surround the specta-tors and plunge them into a spectacular illusion'.[25] He also pointed out the irony that the Panorama, which catered for a need to represent what the traditional framed canvas could not represent, was itself incapable of being experienced in representation in any other medium.

Indeterminacy and the Sublime

I want now to pick up some of the implications, as far as the represen-tation of the landscape Sublime is concerned, of the ineffable nature of the experience—that sense that the Sublime is identified precisely when words fail to measure up to the scale of the experience. How does one represent that which, almost by definition, is unrepresentable, is 'beyond expression'?

The Picturesque had employed a vocabulary of appropriation and commercial transformation in negotiating its relationship with the nat-ural world: natural materials were processed into aesthetic commodities —'landscapes'. The Sublime eludes the impulse to consume in the sense just described: it is pictorially unframeable, and it cannot be framed in words. The Sublime is that which we cannot appropriate, if only be-cause we cannot discern any boundaries. If anything, it appropriates us. The vocabulary associated with the experience is one of surrender to a superior power—the very reverse of the Picturesque. In the act of surrender we acknowledge the feebleness of our powers of articulate

expression and representation. We surrender ourselves, or at least the self that is constituted by language is dissolved:

> Stand then upon the summit of the mountain, and gaze over the long rows of hills. Observe the passage of streams and all the magnificence that opens up before your eyes; and what feeling grips you? It is a silent devotion within you. You lose yourself in boundless spaces, your whole being experiences a silent cleansing and clarification, your I vanishes, you are nothing, God is everything.[26]

This passage is from the second of Carl Gustav Carus's *Nine Letters on Landscape Painting* (composed between 1815 and 1824). Carus was the friend, informal pupil, and, later, champion of Caspar David Friedrich (1774–1840). The date of composition of this passage is within a year or two of his mentor's enigmatic painting, *Wanderer above the Sea of Mist* [**79**]. The experience described by Carus belongs not to us, the spectators, but to the figure on the summit of the foreground rocks. It is difficult to accept this man as our surrogate, as has so often been claimed for Friedrich's *Rückenfiguren*. The potential force of that sea of mist on us—'you lose yourself in boundless spaces … your I vanishes'—is impeded by the very assertive *contre-jour* pyramidal mass of rock, with its pinnacle completed by the dark figure. *We* cannot have the sublime experience open to the figure, mainly because of the very presence of that figure. The figure is not a conduit to the Sublime, as in Picturesque landscapes the leaning and pointing marginal shepherd might be—it dominates the scene. All lines converge on the figure. The arresting urbanity of the man's clothing and slim cane marks him off as something wholly alien to this environment. The strongly interventionist *contre-jour* effect is reinforced by the man's sartorial *contre-ambience*.

The relationship of the urbane *Rückenfigur* to the misty mountainous landscape in Friedrich's painting is an experiment in the accessibility of the Sublime. In this respect it has an interesting relationship with

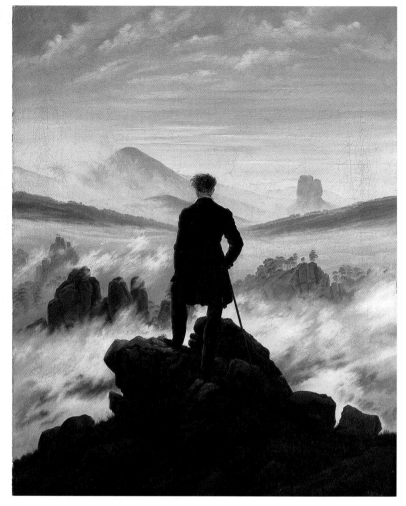

a 1795 poem by Friedrich von Schiller (1759–1805), 'Der Spaziergang' (The Walk). The poem uses the idea of a walk as both a literal experience of the world in all its sensuous and social being, and metaphorically as a means of revisiting various stages in the evolving relationship between the social state and the state of nature. The walk thus has its moments of epiphany, attached to specific stages in the poet's journey through the landscape. He travels from the benign pastoral scenes so familiar to him and ascends to a very different kind of world:

Before me, heaven
With all its Far-Unbounded!—one blue hill
Ending the gradual world—in vapour!
 Where
I stand upon the mountain-summit, lo,
As sink its sides precipitous before me …
 Wide Ether o'er me—
Beneath, alike, wide Ether endless still!

He is drawn into a reverie-like survey of past stages in civilization, from which he emerges to take stock again of his position:

> But where am I—and whither would I stray?
> The path is lost—the cloud-capt mountain-dome,
> The rent abysses, to the dizzy sense,
> Behind, before me! …
> Only the raw eternal MATTER, whence
> Life buds, towers round me—the grey basalt stone,
> Virgin of human art, stands motionless and lone …
> Am I indeed alone, amidst thy charms,
> O Nature—clasped once more within thy arms?[27]

The poet is the philosopher-gazer, the product of a sophisticated civilization, in search of a broad perspective on the human relationship to the natural world and to the originating state of nature. As such he is well represented in the trim but windswept figure in Friedrich's painting, where much of the imagery of the poem is deployed. The gulf—literalized in the painting—between the human and the vast world of nature fascinated the Romantics. As Schiller remarked, 'nature is for us nothing but the uncoerced existence, the subsistence of things on their own, being there according to their own immutable laws'.[28]

The Sublime as an intellectual challenge incorporates this sense of the unattainable 'other' out there, imaged as the natural world with its own 'immutable laws', careless of humans, manifesting itself occasionally in those more sensational impacts on the human world which have traditionally constituted the Sublime—storms, volcanoes, earthquakes, avalanches and so on. The Sublime is often rendered as melodramatized 'otherness'. The sensationist Sublime, as we have noted it in Burke, that unknowable source of power way beyond our control, is philosophically modified in the work of Kant and Schiller so that it assumes

a more emphatically ethical dimension. It stimulates the mind and spirit to enlarge their intellectual and moral capacities. For Kant the term designates that which cannot be represented. In one sense Burke had anticipated this sense of indeterminacy in his account of the Sublime. Among the circumstances contributing to the terrifying Sublime, according to Burke, are obscurity, vacuity, darkness, solitude and silence, all of which bewilder the senses of sight and sound, and more generally stress the absence of any determined forms. The deprivation of clear contours and co-ordinates generates fear as it stimulates the imagination to recover familiar configurations. Burke's examples range from the mighty to the minuscule. The inspiring gloom of great cathedral interiors can stimulate the Sublime just as, in a lower key, incomplete pictures:

The imagination is entertained with the promise of something more, and does not acquiesce in the present object of the sense. In unfinished sketches of drawing, I have often seen something which pleased me beyond the best finishing.[29]

Friedrich's eerie *The Monk by the Sea* [**80**] is a virtual compendium of Burkean 'privations'—darkness, solitude, silence, obscurity. There is something appalling in its emptiness, in its utter lack of any consoling, reassuring presences. As a 'landscape' (or 'seascape') it appears systematically to have removed all motifs that might have acted as props, to guide the eye and determine the experience to be gained from the picture. Infra-red examination of the painting as well as contemporary accounts of its several stages of composition reveal that Friedrich did just that. A glimpse of moon was eliminated, as were two sailing boats.[30]

A review of the painting appeared in the *Berliner Abendblätter* on 13 October 1810: 'since in its uniformity and boundlessness, it has no foreground but the frame, the viewer feels as if his eyelids had been cut off'. The remark implies that we cannot exercise any control over what the painting offers to us: its boundlessness horrifies us. We react to it in terms of what is missing from it, the terrible emptiness. Within this luridly tinted vacuum, there isn't even a narrative offered. It is a portrait of near-nothingness, its power residing in its accumulation of negatives, absences. This privative character is precisely the force of the Sublime. Ironically, if one were to make a photographic negative of this picture and reverse the chiaroscuro, it would resemble a very familiar landscape structure: darkened foreground, brightly lit middle distance (the sea), deeper-toned background rising to a darker upper sky.

At least in the *Monk* we can distinguish land, sea, and sky—the constituent elements have some definition. In August Strindberg's (1849–1912) extraordinary seascape, *Lonely, Poisonous Mushroom* [**81**], even these categories have become uncertain. Strindberg knew Friedrich's paintings, but the picture is more particularly related to an experience described in an 1890 novel, *By the Open Sea*:

Now when there was nothing to catch the eye in either land or sea, just the blue vault above him, he felt free, isolated like a cosmic speck, floating in the air, subject to nothing but the law of gravity.[31]

The experience of emptiness in the face of a landscape with no distinguishing material features is felt as liberating: it almost dematerializes the person experiencing it. In the painting this sense of buoyant freedom is not so apparent. The presence of the poisonous mushroom, the only material object in the whole scene, taints the atmosphere in a sinister way, without at all giving definition to the space it occupies.

A firm and determined outline gives stability to objects, it defines their relationship to each other and to the space in which they are situated. The Sublime, with its emphasis on obscurity, vacuity and indeterminacy, destabilizes and disorientates: in terms of landscape art it seeks to represent less the objects that strike the viewer than the sensations experienced by the viewer—or it is a combination of the two? Kant's investigation of the 'negative pleasure' that constitutes the Sublime emphasizes the subjective status of sublimity: 'it cannot be contained in any sensuous form':

In what we are wont to call sublime in nature there is such an absence of anything leading to particular objective principles and corresponding forms of nature, that it is rather in its chaos, or in its wildest and most irregular disorder and desolation, provided it gives signs of magnitude and power, that nature chiefly excites the idea of the sublime.[32]

The forms of nature, objectively portrayed, are not only inadequate but inappropriate as a means of representing the Sublime. The French philosopher of postmodernism, Jean-François Lyotard, has applied Kantian notions of the Sublime to twentieth-century manifestations

of the avant-garde in art. That which cannot be represented, because of its indeterminacy, asks for a new language. When Gray, awestruck by the Alps, confessed to having been astonished 'beyond expression', did he mean that the language then available to him was inadequate, or that no possible language could convey the sensations and ideas then coursing through his mind? 'I cannot express' is, of course, an appropriately expressive formulation of the 'negative pleasure' peculiar to the Sublime. Something like this point is made by Lyotard in a reference to the 'father of the sublime': 'Longinus even goes so far as to propose inversions of reputedly natural and rational syntax as examples of sublime effect'.[33] But how does a landscape painter 'invert' his or her 'reputedly natural and rational syntax' of graphic representation? Friedrich's *Monk* [80] goes a long way towards realizing this inversion. The question leads Lyotard to consider, as an example of avant-gardist experimentation with expressive painterly language, the case of Paul Cézanne's (1839–1906) later work: 'the task of having to bear witness to the indeterminate'.

Cézanne wrote of his persistent search in later life 'for the expression of those confused sensations that we bring with us at birth', sensations anterior to our familiarity with pictorial representations of the scenes that trigger such sensations:

The Louvre is the book in which we learn to read. We must not, however, be satisfied with retaining the beautiful formulas of our illustrious predecessors. Let us go forth to study beautiful nature, let us try to free our minds from them, let us strive to express ourselves according to our personal temperaments.[34]

'Retaining the beautiful formulas of our illustrious predecessors' is just the kind of habit we identify with the Picturesque, as the opening of

this chapter suggested. These formulae are instruments of control which the Sublime wrenches from our grasp and which Cézanne invites us to relinquish in order to re-educate our sensibility. That re-education involves an openness to new languages. Cézanne's striving to find a new language to express primitive sensations led to an abandoning, perhaps even an inversion, of the language of the 'book' of the Louvre. Outline, modelling, chiaroscuro disappear. Sensations don't have boundaries or volume or spatial location:

Now, being old, nearly 70 years, the sensations of colour, which give light, are the reason for the abstractions which prevent me from either covering my canvas or continuing the delimitation of the objects when their points of contact are fine and delicate; from which it results that my image or picture is incomplete.[35]

Cézanne's move towards recording sensations in paint is seen in terms of those negatives, of his enlisting those privations that have been definitive conditions in framing an aesthetic of the sublime: the 'incomplete' is the finished result; 'abstractions' are a kind of negative—they involve the sense of *removal, withdrawal*, the deprivation of whatever was *concrete*. His late oils and watercolours strive to represent these sensations—'perception at its birth', in Lyotard's words—as he confronts landscapes with which he has been familiar for a long time. Conventional systems of co-ordination and delineation are suppressed, deliberately *ab*stracted. They sometimes remind one of a child's toy kaleidoscope: translucent flakes of colour scattered into vague patterns on a depthless bright ground [82]; 'If only we could see with the eyes of a newborn child!' Cézanne is recorded as saying in 1902; 'Today our sight is a little weary, burdened by the memory of a thousand images.'[36]

This chapter began with images of terrifying Alpine crevasses and it closes with a view of a calm Provençal river bank. The defamiliarization called for by Cézanne is related to the Romantic Sublime, though it lacks the afflatus and rhetorical flourish that had come to characterize the Sublime. The Sublime had long been associated with the threat to self-preservation experienced at a safe distance. So here, with the work of the avant-garde, a comparable aesthetic disturbance is associated by Lyotard with a radical destabilization:

The art-lover does not experience a simple pleasure, or derive some ethical benefit from his contact with art, but expects an intensification of his conceptual and emotional capacity, an ambivalent enjoyment. Intensity is associated with an ontological dislocation. The art-object no longer bends itself to models, but tries to present the fact that there is an unpresentable.

The inexpressible, 'unpresentable' properties of landscape, its power to dislocate and renew vision, are not confined to the great scenic spectacles of the world. The Sublime happens anywhere, once the film of familiarity is lifted or pierced.

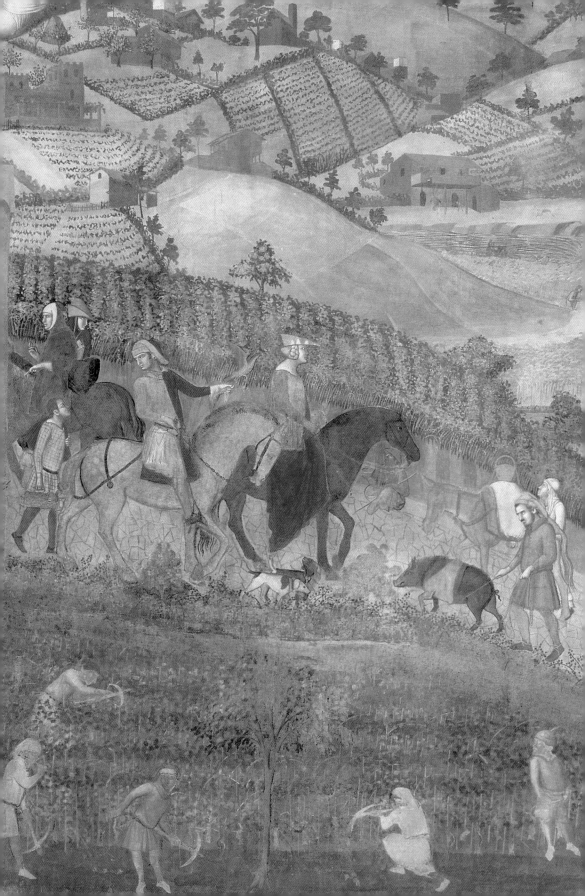

Landscape
and Politics

7

Landscape—construed and represented pictorially as a refuge from the pressures of city, court, and political life—is an ancient practice, and one observed in several contexts throughout this book. Early Christian anchorites and Renaissance humanists celebrated the experience of solitude and spiritual refreshment afforded by pastoral retreats. Life in the country as compared to the burgeoning cities seemed simplified, less subject to rapid and convulsive change, free from crowds, noise and pollution, and in tune with natural processes. Landscape in art was nourished by the strengthening of these views and, in the early modern period, found patronage and a more open market for images that represented and reinforced the values associated with these prejudices. Countryside, for the Enlightenment and later periods, represented the world as it used to be, before urbanization and industrialization, and consolidated the myth of a natural order from which modern humanity had strayed.

The promotion of a sense of a widening cultural divide between city and country suppressed the economic and political realities of their mutual dependency: the country fed the city and the city stimulated the economy of the country. The shepherds idealized in pastoral poetry and painting tended their flocks with a view to profitable sales of wool and meat at local town markets. The rural idyll deliberately masks the commercial cycle that connects town and country, as we noted in contrasting the landscape *beau ideal* with some of the Dutch topographical works. It frames portraits of happy self-sufficiency, of subsistence rather than capitalist farming, of insulation from the effects of foreign wars, contested national frontiers, and the endless internal disturbances in the distribution of power and wealth. It freezes history in some kind of Golden Age.

In this chapter we shall be examining some of the ways in which landscape in art reinforces such utopianism, or where landscape imagery has been narrowly read so as to produce the utopian vision of a world innocent of history and political meaning.

Detail of 83

83 Ambrogio Lorenzetti

*Good Government in the
Country*, 1338–40

NASCE · EL MERITA COLOR COPERA) BENE · 7 AGLINOVI OR 'OEBITE PENE

PHILOSOPHIA

Ambrogio Lorenzetti's (active 1319–48) frescos on the walls of Siena's Palazzo Pubblico were painted in the period 1338–40. On the long west wall of the palace's Sala della Pace are depicted scenes representing Good Government [**83**] as it affects city and countryside. On the opposite wall, landscapes and city scenes display the effects of Tyranny and Bad Government. On the west wall painting, the city gates lead straight out into the country. In the near and middle distance, lake and low-lying farmland begin to give way to masses of small round-topped hills that stretch their undulations to the horizon. Kenneth Clark has referred to this scene, and to its antithetical Bad Government equivalent opposite, as 'the first surviving landscapes, in a modern sense'.[1] By 'modern sense' Clark means that Lorenzetti's landscapes have a 'factual', naturalistic value considerably in advance of their time: until around 1500 the predominant landscape interest for painters, as far as Clark is concerned, lay in its symbolic value. By seizing on this fourteenth-century masterpiece as a kind of starting point in the evolutionary history of western landscape art, we are already recontextualizing it. We are giving it the kind of independent 'landscape art' status which, in making it part of a grand progressivist narrative, conspires with the utopianist view of landscape to loosen its connections with another kind of history.

Lorenzetti's purpose here was, in accordance with his overall design of the Sala della Pace frescos, to exemplify Good Government in the countryside. That countryside, Siena's tributary *contado*, is represented not in order to celebrate an independent rural idyll, with its implied denigration of urban life, nor as a precocious virtuoso exercise in naturalistic landscape painting. Scenes of rural life and labour are to be related to the scenes of busy commerce within the city, and both realms are understood to be prospering as a single integrated beneficiary of an efficient and benign political dispensation.

This ideological integration is graphically underpinned in a number of ways, in the picture's deployment of its component motifs, in its narrative elements and in its organization of perspective and lighting. Denis Cosgrove has drawn attention to the geography of cultivation in the *contado* of the typical city state of this period as one of 'zones of slackening intensity of production away from the city':

Beyond the intensive zone lay more extensive patterns of landscape … less fully integrated into urban commercial life. More strictly feudal organization often survived here on large ecclesiastical and older aristocratic estates.[2]

Thus an early capitalist, 'urban-centred linkage with a commercialised countryside' co-existed with more ancient feudal systems of land tenure, social relations and economic activity. Lorenzetti's fresco, in foregrounding the former and marginalizing the latter, contributes to the propagandist promotion of the newer order. Tensions between

capitalism and feudalism are schematically articulated in the imagery of thriving city state and isolated rural estates.

The populousness of the city and immediately neighbouring *contado* is striking. The easy flow of traffic between town and country is depicted in the foreground movement of people from all ranks of life. Nobles on horseback, coming through the city gate on their way to a falconry expedition in the country, pass peasants and merchants with well-laden donkeys, on their way to markets within the city. Further along the road, heading away into the country, two more, richly pan-niered beasts precede a man preoccupied (or so it seems) with counting his profits from recent trade within the city. The interpenetration of city and country, the sense that the two are co-ordinated entities, is also reinforced in formal terms. John White[3] has drawn attention to the way in which both figures and architecture, in city and rural scenes, di-minish in spatial recession not from the spectator's point of view, but from the point of view of the city itself. Thus the travellers along the foreground road, which is parallel to the picture plane, diminish in size from left to right. The reapers in the middle distance are the same size as the sower in the foreground, because they are equidistant from the *city*, though not from the viewer; and the figures over on the right (the man leaning on a wall by the small arcaded building, for example) are smaller than their counterparts at a similar distance into the picture space in the centre (the threshers, for instance). The lighting scheme too emphasizes the centrality of the city as it ignores the natural light source (coming from the right of the painting) and radiates from the heart of the city centre out into the countryside and strikes the left-hand flanks of the rural buildings.

The west wall fresco in the Sala della Pace represents city and coun-try as having common interests and sharing in the benefits of Good Government. This is an image of the idealized earthly city state. Landscape art, as a separate genre, emerges as this sense of a shared in-terest between town and country comes under pressure, as early urban-centred capitalism develops new relations with land and endows it with exchange value. If Lorenzetti's city-commissioned fresco is rightly seen as an intervention affirming the value of city–country integration, one might infer from this an awareness of growing disharmony in that relationship.

In spite of what seems a new realism, Lorenzetti's method is recog-nizably that of the emblem traditions, in which sometimes elaborately detailed landscape scenes are made into vehicles for simple moral or political axioms. For example, the rising sun warming a landscape can stand for the benign influence of an enlightened monarch, as in J. W. Zincgreff's [**84**] emblem of 1619, to which is applied the following text: 'Prince, let your mercy reign everywhere, as far as your eye can see.'[4] In such instances the landscape carries explicit political significance.

However, such explicitness is not the primary focus of the present study. Landscape in art can express a set of political values, a political ideology, when it is least seeming to invoke political significance. The very concept should make us wary of assuming that any representation of countryside is wholly without a programmatic content. We have already noted the origins of the word 'landscape' in the German word *Landschaft*, designating the land immediately adjacent to a town and understood as belonging to the town, rather like the Italian *contado*. It defines its identity against that of the town with which there is a mutual dependency. Etymologically and conceptually 'landscape' has, from the start, been ineradicably implicated in urban and political life, in property and commercial relations. Again, this remains so even when the image seems most innocent of such connections. In a natural landscape, any kind of marker of human presence and human usage—a bridge, a road, a milestone, a castle, an isolated monument—inflects that landscape, connects it however vestigially with the insignia of human control and organization.[5] Pictures of wild scenery, without a trace of cultivation or human presence, and without any declared emblematic intent, appeal largely *because* they dramatize that landscape's own untrammelled liberty. Such landscapes constitute a gesture of defiance to what is felt to be an oppressive, expansionist civilization, and are therefore infused with political meaning. Images of landscape, pastoral or sublime, are images of retreat, refuge, retirement. They are places where political life emphatically is *not*, and therefore remind us of what is absent. The landscapes of St Jerome, juxtaposing wilderness and fruitfulness, desert and distant city, have their relevance here.

Landscape, property, and nationhood

Joseph Addison wrote in *The Spectator* (23 June 1712): 'A spacious Horizon is an Image of Liberty.' This carries force in two senses: in

terms of sheer spatial geography, it conveys the sense of expansive freedom to roam; it also suggests that the mind is liberated by the apparent absence of territorial boundaries inscribed on that geographical space. There is, as it were, a political freedom superadded to the physical expansiveness of that view. But of Addison's remark one wants to ask, Liberty from what? We can answer this by returning to Lorenzetti's fresco [83] and its juxtaposition of city and country. In the city, the horizon is barely half a mile from the foreground figures. In the country, it is miles and miles away. In the city there is an organized restriction of space for a greater density of population—architectural compartments help to structure the lives of the citizens. But beyond the city gates, there is a dramatic contrast: people are dispersed across a vast terrain, the contours of which are meandering and rounded. The modulation from life organized in smaller compartments to the sense of a greater freedom of space can be seen in the movement from the city to the country. From the conglomeration of boxed spaces within the city we move to nearby hills that are partly cultivated in rectangular strips; but beyond those, apart from a few hilltop castles, the vast sea of hills rolls away towards a vague horizon. 'The health of the eye seems to demand a horizon. We are never tired, so long as we can see far enough', wrote Ralph Waldo Emerson in *Nature* (1836).[6]

Landscape may include signs of property divisions but, in the Romantic mind, it will transcend these. Landscape often *is* that which transcends human interference, which repairs division and unifies segregated territory. John Barrell has argued that, in eighteenth-century Britain, the capacity to read the landscape as a whole, to be able to relate particulars into a comprehensible unity, marked out the 'liberal mind'. This capacity was also, by analogy, what qualified the 'man of taste' for political responsibility: 'In so far as the representation of panoramic prospects serves as an instantiation of the ability of the man of "liberal mind" to abstract the general from the particular, it was also understood to be an instantiation of his ability to abstract the true interests of humanity, the public interest, from the labyrinth of private interests which were imagined to be represented by mere unorganized detail.'[7] Barrell is, incidentally, assessing the credentials of the *man* of taste, and marking out the intellectual ground exclusive to this social and cultural categorization. Why not *woman* of taste too? The question focuses again the degree to which landscape is bound up with issues of property and territorial control, the masculine 'command' of a view. Women were credited with an aptitude for sensitive miniaturist portraits of cottages, village scenes, flowers, but were held to lack the intellectual virility to be able to organize a spacious, multifarious landscape.

The intellectual (and political) privileging of the neoclassical holistic reading of landscape may be compared with its more Romantic, Transcendentalist counterpart. Emerson's well-known reflections on

landscape and ownership are made in the context of what he called the 'occult relation between man and the vegetable', a primitive kinship almost suffocated by the advance of civilization and Enlightenment materialism:

The charming landscape I saw this morning, is indubitably made up of some twenty or thirty farms. Miller owns this field, Locke that, and Manning the woodland beyond. But none of them owns the landscape. There is a property in the horizon which no man has but he whose eye can integrate all the parts, that is, the poet. This is the best part of all these men's farms, yet to this their land-deeds give them no title.[8]

'He whose eye can integrate' corresponds to the Enlightenment intellectual as characterized by Barrell. Both can transcend local particulars, co-ordinate, and unify. For Emerson it is matter of transcending the superimposed ownership boundaries and the perspective of the real-estate agent who understands land only as a map of private properties.

What might be seen as a triumphal realization of Transcendentalist thinking in relation to landscape, particularly in relation to Emerson's morning view quoted above, was the project completed in 1976 by Christo (b. 1935) and Jeanne-Claude (b. 1935): *Running Fence* [85]. This was a white fabric fence, 5.5 metres high and nearly 40 kilometres long, stretching across two counties north of San Francisco. Permission had be given by about 60 different ranch-owners for the fence to cross their property, and it was allegedly the first work of art to be submitted to an Environmental Impact Report.[9] *Running Fence* defied property boundaries as it swept across the landscape of rolling hills before dipping down into the Pacific Ocean. For the two weeks of its existence, this fence, with its bridal delicacy of appearance, unified segregated properties, dissolved county boundaries and married sea and land. It was understood as a parody of that most formidable political barrier, the Iron Curtain, behind which Christo lived until his emigration to the West in 1957.[10]

The extent to which landscape can be, and has been, the medium for the propagandist transmission of national identity can be exemplified in many ways. Post-Waterloo France, as Nicholas Green has argued, was engaged in the construction of a national identity centred on the land and on the regions; the state's promotional role in this, in its cultural policies and purchases of landscape paintings during the Third Republic, was very marked.[11] At the beginning of this century the 'Group of Seven' painters in Canada had an emphatically nationalist agenda in their work. One of them, Lawren Harris (1885–1970), spoke of the 'cleansing rhythms' of the north: 'the top of the continent is a source of spiritual flow that will ever shed clarity into the growing race of America, and we Canadians being closest to this source seem destined to produce an art somewhere different from our southern fellows—an art more spacious, of a greater living quiet, perhaps of a more certain

85 Christo and
Jeanne-Claude
Running Fence, 1972–76

conviction of eternal values'.[12] The spiritual purity of the nation is therefore imaged in its landscapes.

The issues of nationhood, and of boundaries and frontiers, both geographical and cultural, are peculiarly intense in the experience of the nineteenth-century American landscape artists—photographers and painters—especially among those who confronted wilderness as the frontier moved west. The challenge was that of portraying landscapes with no markers of European civilization, no equivalent historical associations. Thomas Cole, the American painter who felt a special responsibility for creating landscape paintings that would have a distinctively heroic national identity, addressed the issue in his 'Essay on American Scenery' (1836):[13]

You see no ruined tower to tell of outrage—no gorgeous temple to speak of ostentation; but freedom's offspring—peace, security, and happiness … And in looking over the yet uncultivated scene, the mind's eye may see far into futurity. Where the wolf roams, the plough shall glisten; on the gray crag shall rise temple and tower—mighty deeds shall be done in the now pathless wilderness.

This is liberty from the historical past, from tradition. Here are landscapes that have never been overlooked by the emblems of feudal or ecclesiastical power. Cole's celebration, as several critics have observed,[14] is ambivalent. His utopian vision looks forward to forms of secure, enlightened democracy, and yet he, like so many of his contemporaries in Europe, is acutely aware of the patterns of growth and decay to which empires, like humans, are subject. This cyclical process he portrayed in a sequence of five paintings, *The Course of Empire* [**86** and **87**], which

traced the transformation of wilderness to civilization and back to wilderness as a kind of 'progress' sequence.

In the same year as he wrote his Essay, Cole painted *View from Mount Holyoke, Northampton, MA, after a Thunderstorm—The Oxbow* [**88**]. Where *The Course of Empire* envisioned the cyclical process of the growth and decay of civilization in sequential, narrative fashion, *The Oxbow* compresses the dialectic between wilderness and cultivation into a single image, diagonally split. The storm is passing away to the left and opening up, on the right, a placid, sunlit scene of farmland in the river valley. The valley settlements have been wrested from the wilderness, a savage region of which occupies the stormy left side of the picture. The two worlds are connected by the passing storm clouds and, significantly, by the artist's umbrella as it leans out over the cliff edge. The artist depicts himself at work just below this, barely visible in the dense vegetation. The artist's presence in the wilderness intensifies and complicates the relationship between civilization and the wild already patterned in the diagonal division of the picture. The prominently sited umbrella and accompanying artistic paraphernalia acquire a kind of emblematic significance, like the cartouche representations of the cartographer and his tools that often adorned maps. They are instruments of territorial control. Indeed the umbrella has the look of a furled flag announcing possession of a piece of new land.

In another respect Cole has taken possession of the landscape. *The Oxbow* view is adjusted to a traditional landscape template, derived from the landscape types of the Sublime and the Beautiful, associated with Salvator Rosa and Claude Lorrain respectively. The sunlit valley with its

gentle contours and spatial recession, managed by alternating bands of light and dark until the eye reaches the horizon mountains, corresponds with the Claudean schema. The high-country wilderness, with its confusion of different kinds of vegetation, the broken stumps, the ravaged, criss-crossed foreground trees, and the ragged storm clouds overhead are typical Rosa-esque motifs. These New World landscapes have been rendered in Old-World formulae, a procedure that represents a kind of cultural colonization of the new territory. For Cole the wilderness he celebrates is gloriously free from the art of the Old World, just as, politically, his new country has won independence from its imperial master:

The painter of American scenery has, indeed, privileges superior to any other. All nature here is new to art. No Tivolis, Ternis, Mount Blancs, Plinlimmons, hackneyed and worn by the daily pencils of hundreds; but primaeval forests, virgin lakes and waterfalls.[15]

And yet, paradoxically, the nature that 'is new to art' is mediated by structural models which had become as 'hackneyed' as the famous sites of the Old World.

The issue of 'pictorial colonization', and its political implications, has been an interesting aspect of post-colonial rethinking of supposedly 'native' styles of picturing landscape. Amy Meyers has argued that British and American artists from the late sixteenth century onwards adopted Old-World ordering systems in their illustrative documentation of New-World landscapes, native settlements, indigenous flora and fauna, and topographical records of cities and country seats. The sixteenth-century artist John White, in his meticulous drawings of insects, 'assimilated the strange forms of a New World into a structure of understanding long established for the forms of the Old'.[16] White's eighteenth-century successor, the artist–naturalist Charles Willson Peale (1741–1827), established a natural history museum in which he organized the exhibited forms of native American fauna on the principles of European classification. Meyers argues the analogy with American topographical landscapes of the eighteenth century. In the example of John Smibert's (1688–1751) *View of Boston* [89], the town of Boston looks like the standard profile view of a city so familiar on ornamental European maps (see for instance [42]). Here it looks oddly as if it has been pasted on to the background of this landscape of green hills and waterways. It gives the impression not of a city that has grown up from the land but of one that has been superimposed on it. It might be any European city. That it is not, has to be emphasized pictorially by the foreground group. The British colonist with a magisterially sweeping gesture indicates his territory to the wondering group of Indians. It is further emphasized, of course, by the imposition of the English town name 'Boston' on this New World city.

Francis Pound's revisionist study of New Zealand landscape paint-ing, *Frames on the Land* (1983), takes the same kind of line. As his title suggests, he examines the extent to which early New Zealand painting adopted traditional European structuring schema in representing the new experience of this landscape and its native (Maori) peoples. His examples are intended to show how stylistic conventions traditionally associated with certain categories of landscape—'Ideal', 'Sublime', 'Picturesque', and so on—inform paintings of even the most distinctively New Zealand landscapes and thereby undermine twentieth-century art-historical claims about the contribution such paintings make to the formation of a distinctively New Zealand national identity. Pound's thesis was in turn subjected to a critique, by W. J. T. Mitchell,[17] which suggested that the colonial 'framing' conventions, once recognized as playing a major mediating role in familiarizing new territory, were themselves insufficiently subjected to examination: 'A historical, as distinct from a historicist, understand-ing of this sort of painting would, in my view, not simply retrieve their conventionality but would explore the ideological use of their conven-tions in a specific place and time.' Mitchell's essay is richly suggestive of the ways in which landscape is employed 'as a technique of colonial representation', and he poses a question that has major implications for thinking historically about the broader political significance of landscape art:

Is it possible that landscape, understood as the historical 'invention' of a new visual/pictorial medium, is integrally connected with imperialism? Certainly the roll call of major 'originating' movements in landscape paint-ing—China, Japan, Rome, seventeenth-century Holland and France, eigh-teenth- and nineteenth-century Britain—makes the question hard to avoid.

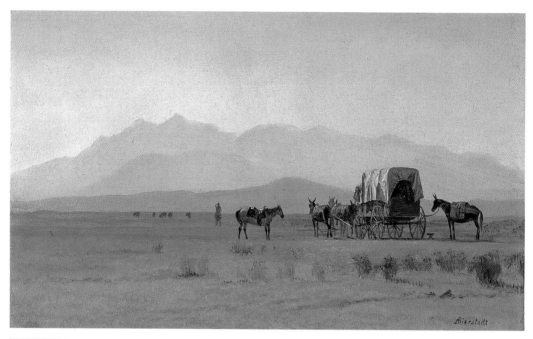

90 Albert Bierstadt

*Surveyor's Wagon in the Rockies, c.*1859

Cole's explicit agenda (rather than, perhaps, his artistic practice) in representing American natural scenery is made very much in the context of America's sense of wanting to break with dependency on the cultural colonialism left behind in the wake of political independence. Barbara Novak has written that 'Cole's career coincided with the discovery of the American landscape as an effective substitute for a missing national tradition.'[18] (Cole was himself one of the initiators of the rise of landscape in nineteenth-century America.) The sense of national identity was linked to a kind of internal imperialist drive, the move westwards, and the appropriation of territory from the Native Americans.

We might compare Cole's somewhat derivative rendering of the confrontation between civilization and the uncharted wilderness with work by his near contemporary, Albert Bierstadt (1830–1902). Bierstadt's *Surveyor's Wagon in the Rockies* [**90**] removes the props that had given structural support and aesthetic orientation to Cole's *Oxbow* scene. There are no framing devices; the surveyor has moved into the landscape from the right, halted the wagon and walks forward to scan the line where the plains end and the Rockies rear up. The landscape is neither Rosa-esque wilderness, nor has it the softness and voluptuous vegetation of Claude's landscapes. There is little here to enable one to get one's bearings, and in that respect the management of the landscape view deftly dramatizes the surveyor's predicament. That lone human figure is nearly lost to our view: he is so thinly painted (like the distant buffalo, a mere smudge of brown) as to be semi-transparent, partially absorbed into this apparently infinite

landscape to which he has to give topographical identity. The Rockies are rendered as layered silhouettes of flat washes (in spite of the fact that this is an oil painting), quite without solidity or volume, as if they too were blank features waiting to receive the map maker's inscriptions, to have their peaks and canyons named, to have passes shaped for wagon routes and tunnels cut for the railroad. *The Surveyor's Wagon* marks the first stage of the conversion of wilderness to real estate.

In 1859 Bierstadt had accompanied the surveying expedition led by General Frederick W. Lander. Four years later he produced one of his most magnificent landscapes, *The Rocky Mountains, Lander's Peak* [91]. Like Cole's *Oxbow* this picture combines river valley settlement and mountain wilderness, but its formal modifications to the antithesis are interesting. The settlement is an Indian one and its presence hardly disturbs the natural order: there are, for instance, no field grid patterns to mark off this territory from the wilderness, and the subdued, earthy colours in which the Indians and their tepees are painted assimilate them easily to their natural habitat. On the far side of the valley a brilliantly lit waterfall thunders down. The darkened ground beyond that gives way to the full grandeur of the Rockies, and rises to the snowy peak in the centre. The modulation from domesticated foreground to Sublime background is swift and dramatic. 'Representing the sublime range which guards the remote West, its [*Rocky Mountains*] subject is eminently national', wrote H. T. Tuckerman in 1867.[19] In a painting of the same title, executed in the same year, Bierstadt chooses a vertical format and eliminates the human subject altogether, offering what Barbara Novak has called a 'virgin space': 'Man has not yet entered

91 Albert Bierstadt

The Rocky Mountains, Lander's Peak, 1863

Eden. ... The spectator, with no surrogate to license his entry into the picture, is all eyes.'[20] This disregards two factors: first, even if no European or American settler has trodden that valley floor, the artist's gaze has penetrated this 'virgin space'; second, the picture is titled *Lander's Peak*, so the territory is already on the map. The most prominent and sublimely inaccessible feature in this allegedly pristine landscape has already been appropriated as a memorial to the man whom Bierstadt accompanied on his surveying expedition to the Rockies four years before. The same peak monumentally dominates the populated valley in Bierstadt's other painting of the same title, as if it were an allegory of the domination by the European settler of the indigenous peoples of America, a new political dispensation naturalized in the language of landscape.

The natural order and the social order

Various strategies evolved to depoliticize views of the natural world. One of these was the Picturesque aesthetic which we have already encountered in other contexts. This might best be introduced by an episode from Jane Austen's (1775–1817) *Northanger Abbey* (published in 1818) in which the naive heroine, on a walk in the countryside around Bath, is being inducted into the mysteries of the Picturesque by the more worldly Henry Tilney:

He talked of fore-grounds, distances, and second distances—side-screens and perspectives—lights and shades; — and Catherine was so hopeful a scholar, that when they gained the top of Beechen Cliff, she voluntarily rejected the whole city of Bath, as unworthy to make part of a landscape. Delighted with her progress, and fearful of wearying her with too much wisdom at once, Henry suffered the subject to decline, and by an easy transition from a piece of rocky fragment and the withered oak which he had placed near its summit, to oaks in general, to forests, the inclosure of them, waste lands, crown lands and government, he shortly found himself arrived at politics; and from politics, it was an easy step to silence.[21]

The curve of the run of topics, from Picturesque connoisseurship to politics, is a shift from a subject with which the whole company can engage (given a little coaching) to one that is exclusive to men (in Jane Austen's society, politics was a middle- and upper-class male preserve). The cult of the Picturesque, with its mix of jargonized connoisseurship, cultivated sensibility and development of sketching skills, opened opportunities for women to involve themselves in aesthetic debates about landscape. It was part of a young gentlewoman's acquisition of accomplishments, hence Catherine's eagerness to learn, and Henry's willingness to instruct. The appraisal of landscape, principally in terms of its formal and affective qualities, excluded appraisal of it in economic or political terms. The man

credited with having inaugurated the vogue for Picturesque description and tourism, Revd William Gilpin, made this kind of distinction clear in the opening paragraphs of his first tour description, *Observations on the River Wye*:

We travel for various purposes; to explore the culture of soils; to view the curiosities of art; to survey the beauties of nature; to search for her productions; and to learn the manners of men; their different polities, and modes of life.

The following little work proposes a new object of pursuit; that of not barely examining the face of the country; but of examining it by the rules of picturesque beauty: that of not merely describing; but of adapting the description of natural scenery to the principles of artificial landscape.[22]

Picturesque tourism—unlike travel to learn about other cities, or varieties of agricultural practice, or the new factories—is a leisurely pursuit that attends specifically to the degree to which the landscape corresponds to pictures of landscape. To that end it assumes a licence sometimes to shut off altogether consideration of an economic or political kind; and it is thereby legitimated as an intellectual province for women. Thus, a page or two later in the second edition of Gilpin's Wye *Observations*, he judges that the 'scenes of habitation and [the clothing] industry' around Stroud spoil the Picturesque beauty of the wooded valleys: 'A cottage, a mill, or a hamlet among trees, may often add beauty to a rural scene: but when houses are scattered through every part, the moral sense can never make a convert of the picturesque eye.'

Urbanization, industrialization, parliamentary acts of enclosure, government forestry policies, the impact on the rural poor of legislation against vagrancy and poaching—all of these could be excluded from consideration when the landscape was to be appraised according to Picturesque principles. Aesthetic valuation was substituted for valuation in terms of real estate or farming potential—and yet these are inseparable. The great estates of the landed gentry in eighteenth-century Britain ideally combined the ornamental with the economically profitable, as Alexander Pope (1688–1744) had urged in his *Epistle to Burlington* on the *Use of Riches* (1731). John Harris the Younger's portrait of Dunham Massey Hall in Cheshire [**92**] shows the colossal scale of the oak plantations:

> rising Forests, not for pride or show,
> But future Buildings, future Navies grow:
> Let his plantations stretch from down to down,
> First shade a Country, and then raise a Town.[23]

The landscape—and the English landscape in particular—was shaped by economic forces, so it was entirely natural that Henry Tilney should follow that sequence of topics, from picturesque withered oak, to

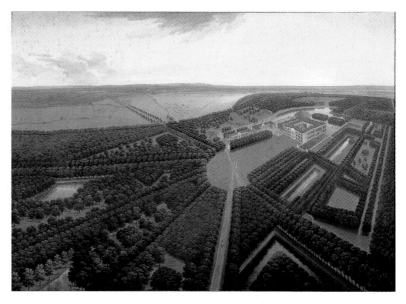

forests and their enclosure, to crown land, to government policy. But, in drifting away from Picturesque discourse, from the purely aesthetic valuation of land, he left most of his audience behind.

The portrait of Dunham Massey shows the estate in relation to the surrounding landscape. The symbols of power and control are inscribed on the land, in ways that resemble the pictorial strategy in Lorenzetti's *Good Government* [83] and the emblem by Zincgreff [84]. The light is at its most intense in the area around the house; and from there the great avenues radiate, like lines of power, through the estate and far out into the countryside. It stamps its authoritative presence on the landscape.

A more harmonious relationship between those who hold political and economic power and the landscape is suggested in Johann Zoffany's (1733–1810) portrait *John, 3rd Duke of Atholl and Family* [93]. Here the family is seen at rest and play in the setting of its park in the Scottish Highlands. The family members are aligned with the forms of the natural world while at the same time clearly demonstrating dynastic alignments. The young heir, next to his father and separated already from the women of the family, has a posture that is parallel both to the Duke and to the seated mother. She in turn is parallel to the apple tree and both are figures of rich fertility. The children are wholly at ease with the creatures of nature, the swan, fish and pet lemur, and the younger children play with fruit and flowers. They are quite literally, as well as metaphorically, at home in the natural world. The parkland stretches away behind them and rises into mountain peaks. Where the estate ends is designedly vague, and in that respect a contrast to the Dunham Massey portrait [92]. A section of wall and bridge on the far right quite unobtrusively reminds

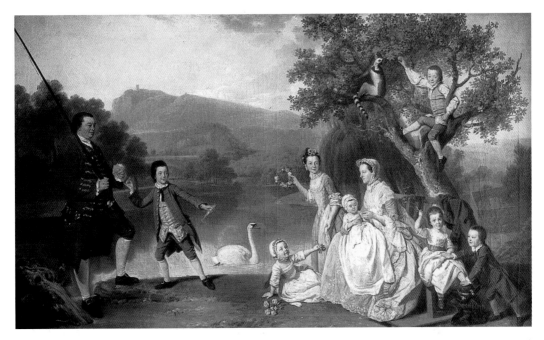

93 Johann Zoffany
John, 3rd Duke of Atholl and Family, 1767

the viewer that at least the middle ground of this apparently natural setting is private parkland.

Although this is not landscape painting so much as a 'conversation piece' in a natural setting, the hierarchical relations between the figures, the ownership of land, and the relation between figures and the natural world become a matter for consideration when we are confronted with what seems more obviously a 'landscape' picture, when the human presence is clearly subordinated to the rural scene. Richard Wilson's (1713/14–82) *Extensive Landscape with Lake and Cottages* [**94**] is typical of hundreds of eighteenth-century British landscape paintings. In relatively formulaic manner, its framing trees and shadowed foreground guide the eye into a sunlit middle ground, with the cottage and lake scenery, and then up to the horizon with the eye-catching church presiding peacefully over the happy scene. In 1982 a major exhibition of Wilson's paintings was accompanied by a catalogue with a substantial revisionist interpretation of such scenes. Its author, David Solkin, in developing a Marxist reading of Wilson's landscapes, offered an interpretation of this painting in terms of what he perceived as its expression of the prevailing 'aristocratic myth'. According to that myth, the social inequalities in Georgian England were divinely ordained but could be represented so as to constitute an overarching system of social harmony. It was in the interests of the land-owning aristocracy to believe that the peasantry were content with their station in life and with the labour enjoined on them under this dispensation. The *Extensive Landscape*, according to Solkin, has exactly this myth as its governing agenda:

Wilson offers the viewer a glimpse into a paradise of peace and plenty, where contented peasants and prosperous picnickers, neat cottage and a modest country house, co-exist in perfect harmony. This artifice of an ordered unity emerges from and depends upon a series of contrasts: between human beings of obviously different stations and their respective habitations, between a mountainous escarpment and a low-lying plain ... between areas of light and shadow. ... [Wilson] has resolved another important opposition, that between labour and leisure, by blending the one imperceptibly into the other. Here work for the peasants seems tantamount to a form of relaxation, while the standing gentleman looks away from his playful companions to make a responsible survey of his well-run world.[24]

Hierarchy is reinforced vertically in the disposition of buildings in the landscape: church on the horizon, down to porticoed mansion, down to the lowly cottages in the vale.

The reading of such benign pastoral scenes as essays in the artificial resolution of class tensions has been very influential since the late 1970s or so, and has alerted us to the politically manipulative strategies of artists whose ostensible subjects are portraits of rural life and scenery innocent of political meaning.[25] Such readings can seem, at times, over-pressed and insufficiently allowing for the influence on such landscape painting of other factors. Thus, for instance, in the Wilson painting, what Solkin identified as the controlling series of contrasts—light and shade, escarpment and plain, gentry and peasantry—might equally have a contemporary philosophical rationale as a political one. The concept of *discordia concors* was one that underpinned key topographical poems in seventeenth- and eighteenth-century England. This held that the elements in creation had initially to be separated and antithetically established before being structured in harmonious relation to each other. Thus, as Sir John Denham's poem, *Cooper's Hill* (1668), expresses it:

94 Richard Wilson
Extensive Landscape with Lake and Cottages, c.1744–45

Wisely she [Nature] knew, the harmony of things,
As well as that of sounds, from discord springs …
While driness moysture, coldness heat resists,
All that we have, and that we are, subsists.
While the steep horrid roughness of the Wood
Strives with the gentle calmness of the flood:
Such huge extreams when Nature doth unite,
Wonder from thence results, from thence delight.[26]

The structure of contrasts in *Extensive Landscape* [**94**] conforms with this ancient idea of what constitutes the principle of harmonious creation in nature and what sustains its vitality, the dialectical tension between antithetical forms. *Discordia concors* is not incompatible with the political interpretation of this landscape painting; to some extent it may be seen as a metaphysical endorsement of it. In fact the aesthetic justification of social and economic distinctions as a manifestation of *discordia concors* was cast in landscape terms by one theorist of the Picturesque later in the century:

A good landscape is that in which all the parts are free and unconstrained, but in which, though some are prominent and highly illuminated, and others in shade and retirement; some rough, and others more smooth and polished, yet they are all necessary to the beauty, energy, effect, and harmony of the whole. I do not see how a good government can be more exactly defined.[27]

A varied landscape, in which the component 'parts' relate to each other in terms of energizing contrasts rather than egalitarian levelling, is the desired model of beauty, and the analogy is made with the political dispensation. Both are seen as representing the natural order of things, and both were opposed to alternative models of government and gardening, such as, respectively, the newly republican France in the 1790s, and the austerely formal French gardens of the eighteenth century.

Part of this dialectic concerns the relation of the human figures to the landscape, and here again the political re-reading of English landscape painting has stimulated new perspectives. In studying the depiction of the labourer in Constable's paintings of the second and third decade of the nineteenth century, John Barrell has argued that Constable's attempt to recreate an older image, in the idealized georgic mode, of the fertile land of East Anglia could not be reconciled with what the painter knew to be the contemporary conditions of life for East Anglian labourers. Agricultural depression in the years following Waterloo provoked rioting among labourers desperate for work. Constable's mill-owning family in Suffolk was acutely aware of these crises. His paintings over the period 1814–24 (including *Boat Building*, *View of Dedham* and *The Hay-Wain*), in order to render the working East Anglian landscapes as he wanted them to be, and to some extent as he remembered them from his childhood, diminish and distance the

figures and facial expressions of the labourers so that they seem almost naturalized as part of the landscape—backs turned, heads down or faces hidden by hat brims as they bend to their tasks of reaping, digging, and ploughing. Barrell remarks: 'if they obtruded more, if they became less symbolic, more actualised images of men at work, we would run the risk of focusing on them as men—not as tokens of a calm, endless, and anonymous industry, which confirm the order of society'.[28]

The subordination of the human figure in landscape painting to mere *staffage* is an old practice. Once the landscape is emptied of historical narrative or biblical subjects and only the native inhabitants, as it were, are left to 'animate' the natural scene, then we expect them to be reduced to little more than accessories: the landscape is the main subject. But Barrell is suggesting more deliberate motives on Constable's part for the virtual reification of the rural labourer in these paintings. We might look more closely at one of these: *The Hay-Wain* [**95**].

Kenneth Clark responded to the painting as 'an eternally moving expression of serenity and optimism'.[29] For Barrell, 'The landscape is still, an image of stability, of permanence; the stability of English agriculture seems to partake of the permanence of nature in this image of luxuriant meadowland.'[30] This is famously a portrait of real places, Willy Lott's cottage, the mill stream on the Stour, a real 'wain' (based on a drawing of a Suffolk harvest waggon), particular trees in their setting, a particular time of day (*Landscape: Noon* was the painting's original title), a moment when the clouds open up to let the sun drench the distant meadow where the reapers are working. The naturalistic concern matches the topographical obsession in Constable, and we have long been used to thinking of the painting as one of the high points of (in Kenneth Clark's phrase) 'the natural vision'. However, pictorial naturalism may imply, but does not ensure, social realism. *The Hay-Wain* was painted in Constable's London home, in a very different world both from the Suffolk farmlands of his childhood, and from the contemporary scenes there of poverty and rioting among the labourers. In 1823 he wrote to his close friend, Archdeacon Fisher, who had strong ties with Suffolk parishes and some proprietorial interest in the land there:

Though I am here in the midst of the world I am out of it—and am happy—and endeavour to keep myself unspoiled. I have a kingdom of my own both fertile & populous—my landscape and my children—[31]

Constable is able to keep himself 'unspoiled' by distancing himself both from the larger social world of London and the troubled conditions of life in Suffolk, and by inhabiting the naturalistically rendered utopia of his painted England. This 'kingdom of my own' was a version of England that Constable shared enthusiastically with Fisher. How ironic then are the reasons given by Fisher, who had first option on

buying *The Hay-Wain*, for eventually having to relinquish his claim to this English rural idyll: 'Let your [...] Hay Cart go to Paris [...] I am too much pulled down by agricultural distress to hope to possess it.'[32]

Constable's paintings have been seen as 'portable icons', constituting a wholly deliberate contribution to the construction of English national identity as fecund, domesticated and profoundly stable.[33] The political instrumentality of landscape in art has been apparent in other contexts in this book, for instance in seventeenth-century Dutch landscape painting. In late nineteenth-century France, we see it again in the highly manipulative activities of State patronage towards the land-scape genre. Selected Salon landscapes were purchased by the State and placed in provincial museums partly in order to foster a sense of national identity throughout France.[34]

Landscape art, as this chapter has tried to convey through various examples, has from early on been implicated in nationalist, imperialist and socio-economic ideologies, and often most potently so when, su-perficially, least touched by suggestions of any political agenda. This is not a matter of past history only. The heightened consciousness in the western world about the environment in the late twentieth century makes us increasingly aware of what, in different ways, has always per-tained: landscape is a political text.

Nature as Picture
or Process?

8

Today our sight is a little weary, burdened by the memory of a thousand images … We no longer see nature; we see pictures over and over again.

Cézanne in conversation, 1902

J. M. W. Turner's (1775–1851) painting, *Snow Storm* [**96**], was exhibited at the Royal Academy in 1842. It carried an inordinately long title: *Snow Storm—Steam-Boat off a Harbour's Mouth making Signals in Shallow Water, and going by the Lead. The Author was in this Storm on the Night the Ariel Left Harwich.* Turner's concern personally to authenticate the experience has thrown up a number of problems. The *Ariel* was a Dover, not a Harwich, paddle steamer, and Turner, as far as is known, had not been to that part of East Anglia for many years. His reported account of the circumstances of the painting is as follows:

I did not paint it to be understood, but I wished to show what such a scene was like: I got the sailors to lash me to the mast to observe it; I was lashed for four hours, and I did not expect to escape, but I felt bound to record it if I did. But no one had any business to like the picture.[1]

Given that Turner was in his late 50s at this time, one may be reasonably sceptical about his capacity to withstand the elements for as long as he claimed. The painting was famously reviled by the critical press as a mass of 'Soapsuds and whitewash'. 'What would they have?' muttered the exasperated Turner, 'I wonder what they think the sea's like? I wish they'd been in it.' As Turner's comments showed, the defence against its being bad art is that it is 'nature'. This is an odd turnaround from the neoclassical academic view that nature's material forms need some correction by the artist. 'We no longer see nature; we see pictures', as Cézanne observed.

If Turner's words are accurately reported, the stress is clearly on authenticity, even at the risk of unintelligibility: 'I wonder what they think the sea's like?' The implication is that the experience itself of this

96 J. M. W. Turner

Snow Storm—Steam-Boat off a Harbour's Mouth making Signals in Shallow Water, and going by the Lead. The Author was in this Storm on the Night the Ariel left Harwich, 1842

ferocious natural process, a storm at sea, can be transmitted only in a new and foreign language. To some it seemed as if Turner had not only abandoned all conventions and familiar vocabulary of realistic land-scape or seascape representation, but had gone elsewhere for his paint-ing materials—'Soapsuds and whitewash', 'here he uses his whole array of kitchen stuff'. The *Athenaeum*'s review of 14 May 1842 (from which the above quotation is taken) complained of utter disorientation: 'Where the steam-boat is—where the harbour begins, or where it ends—which are the signals, and which the author in the *Ariel* … are matters past our finding out.' The narrative account, unreadable from the painting, ironi-cally has to be supplied at some length in the title where 'The Author' asserts he was 'in this Storm'. Being *within* the storm at sea, he could not, of course, command a view *of* it, as a painter might have done from a distant vantage point on shore, where harbour line might be clearly distinguished from sea, and the sea from the storm-tossed boat.

Turner's concern to embed himself in the experience of the play of natural forces, and to let that experience dictate the terms on which the landscape image is constructed, is a new development in the relation-ship between the artist and the natural world. It advances one step further those moves towards a more sustained practice of open-air painting, which European landscapists had undertaken over the

previous 60 years or so, in order to immerse themselves in the same el-
ements they were recording. Such practices, especially when taken to
such extremes as Turner's account suggests, were often the butt of
satirists, as Carl Johan Lindström's drawing (*The French Painter* [**97**]:
'Il faut faire la nature en ravage') illustrates. Fresh breezes and natural
daylight were substituted for airless studio and artificial lighting. This
much more intimate engagement with nature modifies considerably
the language and meaning of landscape. Turner's *Snow Storm* is an ex-
treme example of the way in which the new relationship destabilizes
the whole idea of 'landscape'. A less tempestuous disturbance of the
settled landscape is caught in Pierre Auguste Renoir's (1841–1919)
exhilarating *Le Coup de Vent* [**98**], where the slurred brushwork seems
itself to have been driven by the gust of wind and generates a wonder-
fully zestful and rhythmical counterpoint to the landscape forms over
which it plays. The idea of nature as a congregation of forces of growth
and decay, a site of constant energetic movement and change, under-
mines the conception of landscape as a fixed, stable arrangement of
natural forms ordered by the artist at a distance—a physical distance,
in terms of both a prospect viewpoint and a studio finishing.

What we are concerned with in this chapter is the attempt to trans-
mit the experience of nature as a constantly changing organism, not as
a kind of grand-scale still life. Landscape is a living environment, not
'*nature morte*'. Several problems face the Romantic and Post-Romantic
artist who takes on this vitalist challenge, and some aspects of it are
taken up in other chapters (as, for instance, the late twentieth-century
Land Art practitioners whose work is sometimes in itself a dramatic
act of recognition of the ephemerality of natural objects). Landscape

representation had been predominantly the record of surfaces only. Could it possibly tell us about 'deep' history, the subcutaneous life of the world as an organism? If so, could that be made aesthetically compelling as a work of landscape art? An interesting case in point is the picture *Ravenscar, Yorkshire* [**99**] by the British photographer Joe Cornish. Cornish has remarked that, among his approaches to photographing landscape, 'is a search for forms which reflect the primal force of nature':

These can be found on beaches, canyons, glaciers, wind-driven snow, sandy deserts, and of course, from plants and flowers. By bringing out the pattern, rhythm or shape which reflects nature's energy, the photographer can offer a fresh vision and insight into the subject.[2]

The Ravenscar view illustrates this ambition well. The sea and the wind, here deceptively serene and devoid of energy, have over thousands of years shaped this bay, sculpted the cliff face, worn smooth the boulders on the beach, and ribbed the great stretches of sand. This is an awesome 'history' subject for an artist; but it is landscape as natural history, not landscape subserving episodes of heroic human history.

The particular issues addressed in this chapter are as follows: the demands on the landscape artist to acquire a more scientific understanding of his subject; and the problems of how to express, both as subjective experience and as objective fact, the continual changefulness of living nature. We are interested in modes of representing both the subjective sensational effect on the artist of the forms and energies of the natural world, and the more objective insight into nature as an organism. That the two concerns touch each other at several points can be illustrated by the following remarks attributed to Paul Cézanne:

All that we see dissipates, moves on. Nature is always the same, but nothing of her remains, nothing of what appears before us. Our art must provide

some fleeting sense of her permanence, with the essence, the appearance of her changeability.[3]

This paradoxical double sense of the natural world as both ephemeral and unchanging, as that which requires the landscape artist to fuse both vitality and stability in representing the experience of nature, became sharpened in the early nineteenth century by the discoveries of geological time. Charles Lyell's *Principles of Geology* (1830) was, in the words of its subtitle, an 'Attempt to Explain the Former Changes of the Earth's Surface by Reference to Causes now in Operation'. The physical world is understood as subject to, or as constituted by, a continuous process of decay and generation. Geological history is not a narrative that we now look back on as a largely completed inscription on the earth's material form: it is our present environment. We continue to alter it and we continue to be altered by it. Johann Gottfried Herder argued, two centuries ago, that environment moulded personality, that the structure of the earth shaped the ways in which we thought. Carl Ritter reinforced these views in the 1830s: 'The very productions of the soil have been interwoven, as it were, into the texture of the human mind.'[4] Timothy Mitchell has remarked of this period that the 'concept of environmental determinism was merged with geology and gradually assumed the rank of unquestioned, conventional wisdom'.[5]

Geologists and the cultural thinkers (particularly the Romantic vitalists) of early nineteenth-century Europe increasingly stressed the belief that humans were not as detached from natural processes in the world around them as they might have supposed. Their contentions coincided with the promotion of open-air painting. One of the earliest advocates for this practice, Claude-Joseph Vernet, insisted on the authority of nature: 'You must do exactly what you see in nature; if one object is confused with another, be it in form or in color, you must

99 Joe Cornish
Ravenscar, Yorkshire, 1997

render it as you see it; for, if it is good in nature it will be good in paint-ing.'[6] This is similar to Turner's insistence on the value of the authen-ticity of the direct experience of nature, at the risk of being accused of bad painting. The sense of the increasing detachment of the human being from natural processes could be arrested, and possibly reversed, in a number of ways: particularly by the more sustained direct contact with nature in open-air painting; and by a more intensive re-perceiving of the organic natural world at work, in movement.

Once out of the studio, the landscape painter becomes more alert to the instability of the physical environment, its moody changefulness of complexion and countenance. Turner's *Snow Storm* provoked a series of critical attacks, as we have seen, and these in turn provoked John Ruskin (1819–1900) into his magisterial defence of Turner, *Modern Painters*, the first volume of which appeared in 1843. Ruskin attacked the acade-mic tradition of generalizing and idealizing landscape forms and fea-tures, and, in line with calls from Goethe and others, argued for the landscape painter's greater attention to the specifics of the natural world: 'every class of rock, earth, and cloud, must be known by the painter, with geologic and meteorologic accuracy'.[7] The five volumes of *Modern Painters* proceeded to inform the landscape painter at great length on precisely these matters and to compare Turner's fidelity to the 'Truth' of nature with the practices of the revered old masters of landscape.

Ruskin's attack on Claude in the Preface to the second edition of *Modern Painters* is an eloquent example of the way in which the new priorities are affirmed. He chooses as his example of Claude's typical practice a painting we have already featured, *Landscape with the Marriage of Isaac and Rebekah* [54]. He picks his way contemptuously through the details of Claude's Campagna, noting what he sees to be the mis-handling of pastoral motifs ('a man with some bulls and goats tumbling headforemost into the water, owing to some sudden paralytic affection of all their legs'), the incongruity of introducing dancing peasants (who would surely frighten any cattle driven so near them) into the same scene as Roman soldiery, the weir constructed for no apparent purpose, the city ('at an inconvenient distance from the water-side'), and so on.

This is, I believe, a fair example of what is commonly called an 'ideal' land-scape; *i.e.*, a group of the artist's studies from nature, individually spoiled, se-lected with such opposition of character as may insure their neutralizing each other's effect, and united with sufficient unnaturalness and violence of associ-ation to insure their producing a general sensation of the impossible.

Ruskin then offers the reader a verbal picture of what he feels to be the true character of the Roman Campagna 'under evening light':

Let the reader imagine himself for a moment withdrawn from the sounds and motion of the living world, and sent forth alone into this wild and wasted

plain. The earth yields and crumbles beneath his foot, tread he never so lightly, for its substance is white, hollow, and carious, like the dusty wreck of the bones of men [a footnote adds at this point: 'The vegetable soil of the Campagna is chiefly formed by decomposed lavas, and under it lies a bed of white pumice, exactly resembling remnants of bones']. The long knotted grass waves and tosses feebly in the evening wind, and the shadows of its motion shake feverishly along the banks of ruin that lift themselves to the sunlight. Hillocks of mouldering earth heave around him, as if the dead beneath were struggling in their sleep; scattered blocks of black stone, four-square, remnants of mighty edifices, not one left upon another, lie upon them to keep them down. A dull purple poisonous haze stretches level along the desert, veiling its spectral wrecks of massy ruins, on whose rents the red light rests, like a dying fire on defiled altars. The blue ridge of the Alban Mount lifts itself against a solemn space of green, clear, quiet sky. Watch-towers of dark clouds stand steadfastly along the promontories of the Apennines. From the plain to the mountains, the shattered aqueducts, pier beyond pier, melt into the darkness, like shadowy and countless troops of funeral mourners, passing from a nation's grave.[8]

I have quoted this at length because in this description Ruskin is embodying a new programme for landscape painters. His purpose is 'to insist on the necessity, as well as the dignity, of an earnest, faithful, loving study of nature as she is'. Claude has not attended to the true character of his chosen landscape. That true character can be discerned only by an artist who, first of all, establishes himself *in* that particular setting, and who, second, has some reverence for and understanding of the geological composition of that particular landscape and how time, weather, and human agency have together modified this material. In other words, the artist must know this particular landscape intimately, both intellectually and emotionally. The Campagna landscape is the product of centuries of natural processes. Ruskin's description of it links imperial history with the natural attributes of the territory so as to suggest that they are hardly divisible. The human presence there is organically incorporated with the natural scene. The landscape is movingly rendered as 'a nation's grave' to which all the motifs are making their funereal contribution. This is historical landscape of a very distinctive kind. It is telling a human story linked to a strong sense of specificity of place; and this particular sense Claude has conspicuously failed to communicate.

Ruskin was ambivalent about the usefulness of anatomical studies for the figure painter and sculptor, but one might well suggest that he is recommending an analogous practice for landscape representation. If, in order to grasp the form and dynamics of the human body, the artist has traditionally been expected to study some anatomy, why should a similar educative requirement not be made of the student of landscape? The understanding of how the forms and movements of muscle, bone, and sinew animate the human body has a counterpart in Ruskin's prescribing to the landscape artist an understanding of how vegetable,

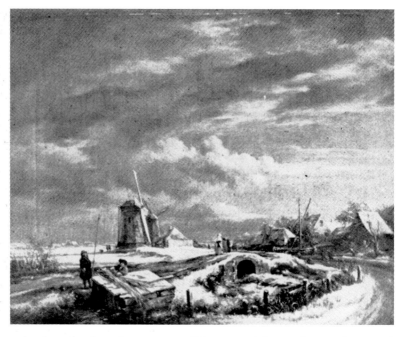

animal, and mineral processes of decomposition and growth control the surface forms of the painter's subject. In effect this was the substance of *Modern Painters*.

'*We see nothing truly till we understand it.*' This was John Constable in the third of his lectures on the history of landscape painting (9 June 1836), enunciating a principle that Ruskin would certainly have endorsed. Constable's observation prefaces his discussion of Ruisdael's paintings. He sees Ruisdael as two painters, the master naturalist and the grandiloquent allegorist, and in distinguishing the two he speaks first of *Winter* ('Copy after Jacob van Ruisdael') [**100**], a copy he has made of the other artist's *Winter Landscape* (itself in the Philadelphia Museum of Art's John G. Johnson Collection):

This picture represents an approaching thaw. The ground is covered with snow, and the trees are still white; but there are two windmills near the centre; the one has the sails furled, and is turned in the position from which the wind blew when the mill left off work; the other has the canvas on the poles, and is turned another way, which indicates a change in the wind. The clouds are opening in that direction, which appears by the glow in the sky to be the south (the sun's winter habitation in our hemisphere), and this change will produce a thaw before the morning. The occurrence of these circumstances shows that Ruysdael *understood* what he was painting. He has here told a story.[9]

The story told is one of a change in weather and the human response to that change. The imminent thaw, the shifting direction of the wind, the clearing of the clouds—these affect the lives and work of those who live beneath this vast sky to which they submit (the ratio of sky to land is significant). The processes of change in its slightest nuances and in

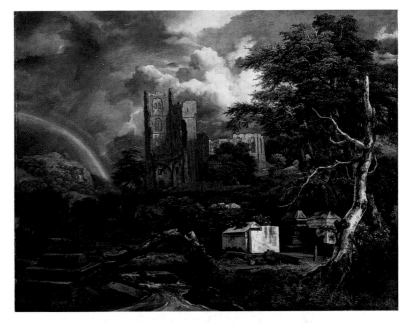

its influences on human life, a further version of that integration of the human and natural world, constitute a new subject for landscapists, a new narrative, and one that is widely accessible. In the passage immediately following the above description, Constable compares the winter scene with an allegorical landscape, generally supposed to refer to Ruisdael's *The Jewish Cemetery* [**101**]. Ruisdael did two versions of this subject; one is in Detroit and the other in Dresden. Goethe (1749–1832), in an essay of 1816, praised the symbolic and poetic power of the painting. The Detroit version came to England about 1815 and was published in an 1835 catalogue by John Smith, who wrote of the artist's evident intention 'in this excellent picture … to convey a moral lesson of human life'.[10] Constable disagreed with this high valuation, arguing that Ruisdael had 'attempted to tell that which is out of reach of the art':

In a picture which was known, while he was living, to be called 'An Allegory of the Life of Man' (and it may therefore be supposed he so intended it), there are ruins to indicate old age, a stream to signify the course of life, and rocks and precipices to shadow forth its dangers. But how are we to discover all this?

Why is Ruisdael's enterprise here supposed to be 'out of reach of the art'? Allegorical painting, whether or not through landscape imagery, had been a familiar enough mode in European art for several centuries, and it can hardly be said that Ruisdael's symbolism of ruins and rainbows in this picture is making undue demands on the interpretative skills of the viewer, especially of one, like Constable, so familiar with traditions in landscape painting. Constable himself, when his picture

of *The Glebe Farm* was being engraved for publication in *English Land-scape*, said he had added a ruin: 'for, *not* to have a symbol in the book of myself … would be missing the opportunity'.[11] And elsewhere in *English Landscape* he calls the rainbow the 'Mild arch of promise'.[12] And yet Constable suggests in his lecture that Ruisdael is employing a kind of dead language, a symbolic vocabulary lost to the present generation.

Arguably, the 'story' commended by Constable in Ruisdael's winter landscape is more abstruse in the significance of some of its details than that of *The Jewish Cemetery*, unless, like Constable, the spectator is a countryman. Constable, as a miller's son, would have had a special alertness to the significance of the positioning of the windmills in rela-tion to signals from the changing cloud patterns. But would a city dweller be able to read *that* story, rather than the allegorical one? Each requires a certain kind of erudition. However, Constable is one of a number of artists and critics in this period who both sense, and help to promote, a change of language in landscape art. Philipp Otto Runge, the friend of Caspar David Friedrich, believed that 'as Egyptian images were no longer comprehensible, so too were Renaissance masterpieces now only empty signs'.[13]

Scientific knowledge and close observation of natural phenomena were increasingly urged on the landscape artist. Goethe was recorded as having declared in 1831:

A landscape painter should possess various sorts of knowledge. It is not enough for him to understand perspective, architecture, and the anatomy of men and animals; he must also have some insight into botany and mineralogy, that he may know how to express properly the characteristics of trees, plants, and the character of the different sorts of mountains. It is not, indeed, neces-sary that he should be an accomplished mineralogist, since he has to do chiefly with lime, slate and sandstone mountains, and only needs know in what forms they lie, how they are acted upon by the atmosphere, and what sort of trees thrive, and are stunted upon them.[14]

In the same year, Carl Gustav Carus wrote:

How expressively and powerfully does the history of mountains speak to mankind, how sublimely it presents to mankind the divine essence in direct relationship to god, in that it seems all at once to deny every transitory vanity of earthly existence. And how clearly this history reveals itself through certain strata and mountain types, so that even the untrained viewer arrives at some sense of this history. Artists are at liberty to accentuate such aspects and by so doing provide, in a higher sense, a historical landscape.[15]

Carus coined the term *Erdlebenbildkunst* ('depiction of the earth's life') in order to identify an art of landscape that differed from traditional landscape modes.[16] 'Historical landscape' in this sense was a landscape art that represented the natural history of the earth, not the cultural and social history that relegated landscape to pedestal or backdrop. But

the cultural and the geological could also be fused in a newly accented kind of history painting. We see this in the set of landscape paintings of Greek scenes by the German artist Carl Rottmann (1791–1850), under commission from King Ludwig, for example *Sikyon and Corinth* [**102**]. The painting recalls that sub-genre of landscape that portrays ruins as emblems of mutability and the vanity of human wishes, a kind of *memento mori*. What distinguishes Rottmann's painting from that conventional topos is the new attention to *Erdlebenbildkunst*. The eroded ruin of Corinth as a presence is shrunk to a single small detail on the plateau, visually assimilated into the larger land mass from which it originally emerged, and this is rendered in close naturalistic detail. The drama of geological time is just as much—if not more—the subject of the painting as the ancient acropolis. Over thousands of years, dwarfing in time the history of Corinth, the foreground river has cut the gorge deeper and deeper, and exposed the cliff face and the rock strata that, themselves, tabulate geological time.

Carus, Rottmann, and Constable, in their different ways, promote the status of landscape painting so that, in its own terms, as an educative and spiritually elevating genre, it becomes equivalent to 'history' painting of the highest order, but without relying on the insistent presence of heroic human narrative. Landscape is itself a language accessible to everyone; neither spectator nor landscape artist has to be learned in Greek mythology, ancient history or antique iconographic codes.

Constable's exemplary *Winter* [**100**] landscape dramatizes a particular moment, but it is one from which the spectator can infer both a preceding and a succeeding narrative. The status of landscape in art

has, since the Renaissance, been continually changing: from being a relatively inert background to a dramatic human event, in which our interest is on the *human* story, it is becoming in itself the dramatic focus. Nature's processes are being depicted in ways that substitute for the human drama, and yet continue to imply, if not to incorporate, the human dimension. Thus, in Turner's *Snow Storm* [96], it is the fore-grounded mesmeric violence of the snowstorm that is the heroic subject of the painting, not the pitching paddle steamer, devoid of human figures to register the ferocious effects of the storm. It is the spectator who is now in the eye of the storm and, like the artist, sucked in to the natural drama by the force of the vortex composition.

Another Turner landscape that concentrates on natural processes, *Frosty Morning* [103], appears to have more human narrative incident than Constable's *Winter*. In the foreground in the cold dawn light, an old man and a child watch some men at work. A coach, with its lamps still lit at the end of the night ride, approaches from the left background. However, Turner's primary subject here has little to do with the figures; it is about time and change. Reading from left to right, it depicts the passage from night to dawn, and the warming of the earth as the sun thaws the ground frost. As Jack Lindsay remarked, 'This ability to express the movement of time is one of Turner's great qualities.'[17] The confirmation that the passage of time and the natural processes of sunrise and thaw were the chief subjects comes in the quotation from James Thomson's poem *The Seasons*, which Turner associated with the painting when it was exhibited: 'The rigid hoar frost melts before his beam'. Turner is capturing a moment of transition (perhaps reinforced in the foreground companionship of childhood and old age), just as Constable had identified a moment of transition in Ruisdael's *Winter Landscape*. To achieve this within one picture is a considerable intellectual and technical challenge for the landscape artist. The older

tradition of calendar landscapes dramatized the seasonal or diurnal cycles
with a number of individual paintings which were to be linked in a se-
quence—winter, spring, summer, autumn, along with dawn and sunset
—but to suggest the transition between two of these in a single, natu-
ralistic painting is another matter. Both here and in another dawn land-
scape, *Morning amongst the Coniston Fells* [**104**], Turner is concerned to
make the transition from night to day felt as a dynamic experience: we
watch it happening, like a linear narrative, as we read the pictures, from
left to right in *Frosty Morning* [**103**], and from bottom to top in *Coniston*,
where the brilliant morning sun has yet to penetrate the base of the fore-
ground slope. Like *Snow Storm* [**96**], though obviously with less vio-
lence, this is an assault on the senses. *Coniston* is designed to confront
the spectator with the magnificent eruption of dawn light, as it tosses its

magnificence high on to the gilded clouds and then runs like gleaming rivulets of lava down the slopes. The volcanic rendering gives the experience an apocalyptic grandeur, reinforced by the quotation accompanying the painting when it was first exhibited—Turner adapted some lines from *Paradise Lost* (Book V), Adam and Eve's hymn to the morning:

> Ye mists and exhalations that now rise
> From hill or streaming lake, dusky or grey,
> Till the sun paints your fleecy skirts with gold,
> In honour to the world's great author, rise!

The lines and the painting express movement as the sun warms the earth and dispels the morning mists, contrasting dusky grey with gold. The painting is almost iconic, as it invites us to make the transition from dark to light. Nature's processes are given heroic grandeur, equivalent to the highest form of history painting.

In the case of both of these paintings, Turner has enlisted poetry to enhance the meaning of the picture. The quotations from Thomson and John Milton (1608–74) are not simply decorative extensions to the picture's caption—verbal ormolu around the painting—they are functionally essential to the experience of the landscape. They help to do what painting finds hard to do in a single picture: convey movement and process in one frozen moment. Note how the titles themselves insist on the priority of the natural processes by placing them at the beginning: *Snow Storm* ...; *Frosty Morning*; *Morning amongst*

'Truth to Nature' can mean two things: the anatomist's understanding and accurate, sympathetic rendering of 'deep' nature; and what might be called the *emotional* truth to nature. Turner's *Snow Storm* is perhaps the fusion of both. We have considered some aspects of the former truth; now we turn to the subjective.

Painting or sketching in the open air had, since the Renaissance, been regarded as essentially a means to a higher end: studies of nature executed 'in the field' were preparations for the finished picture in the studio, where the studies would be modified and synthesized in the larger project. The practice of a number of pioneering painters in Italy in the 1770s and 1780s—Vernet, Pierre-Henri de Valenciennes (1750–1819), Thomas Jones (1742–1803), and the watercolourists Francis Towne (1739/40–1816) and John Robert Cozens (1752–97)—helped to change the conventional subordination of open-air painting to studio painting. Watercolour landscapes had for three centuries been executed in the open air, for topographical, botanical or other purposes, but these were regarded as 'drawings', rather than 'paintings', with certain implications about the inferior hierarchical status attached to the choice of watercolour as a medium. Cozens's watercolours, however, caused some puzzlement:

[His drawings] are, for composition, keeping, and effect, superior to any thing of the kind. They have a peculiar excellence, in which they resemble painting; for the effect is not, as is usually the case, produced from outlines filled up, but is worked into light, shade, and keeping, by a more artful process, the masses being determined in the first making out.[18]

As watercolour began to challenge 'painting', so oil painting executed in the open air loosened its associations with the kind of formal 'finish' expected from studio work, and approximated to what had traditionally been the mode of watercolour sketching.

Pierre Auguste Renoir had a studio constructed for him, at Les Collettes in Provence, which was a compromise between outside and inside. It was a 'sort of glassed-in shed', set among the olive trees, into which the light came from all directions, but could be controlled by adjusting the cotton curtains. This 'outside studio' was a novel way of meeting Renoir's prescription for exposure to both inside and outside:

A little work must be done in the studio in addition to what one has done out of doors. You should get away from the intoxication of real light and digest your impressions in the reduced light of a room. Then you can get drunk on sunshine again.[19]

Open-air studies of nature had a degree of privacy and intimacy, like keeping a diary; neither intended for publication, both encouraging a more spontaneous rhythm of work in recording fleeting impressions, whether visual or emotional. This greater flexibility enabled painters to catch transient effects of light and weather. Valenciennes's two studies of Rocca di Papa [**105** and **106**], executed a year or two before his departure from Italy, show the same scene under different cloud conditions. The mist and cloud are reshaping the contours of the solid features, suggesting an eerie malleability. As Valenciennnes remarked:

It is good to paint the same view at different times of day, to observe the differences that light produces on the forms. The changes are so palpable that one has trouble recognizing the same objects.[20]

To develop a greater responsiveness to, and understanding of, nature's volatility involves not only more sustained open-air practice but also training oneself, as an artist, in what one might call an active passivity. To allow those fleeting changes to make fresh impressions on the sensibility, one needs to unlearn those educated responses that tend to intervene, edit, interpret the sensations. Jean-Baptiste Camille Corot (1796–1875) made this point emphatically:

We must never forget to envelope reality in the atmosphere it had when it burst upon our view. Whatever the site, whatever the object, the artist should submit his first impression.[21]

**105 Pierre-Henri
de Valenciennes**

*Rocca di Papa in the Mist,
c.1782–84*

**106 Pierre-Henri
de Valenciennes**

*Rocca di Papa under Clouds,
c.1782–84*

So too did Cézanne:

If we could only see with the eyes of a new born child![22]

Painting from nature is not copying the object, it is realising one's sensations.[23]

The high value placed on a primitive sensational response to the natural world did not preclude a sophisticated technical sense of how to draft those responses without compromising their primitive freshness. Authenticity in landscape art, in these terms, is a transcription not of 'nature', but of subjective responses. It often involved a process of sustained direct contact with the chosen site, famously, for example, in the case of Cézanne's Mont Sainte-Victoire landscapes, or Monet's series paintings of the 1890s; and it meant bit by bit, in the face of the site, sloughing off the conventional 'picturing' habits. It meant saturating oneself in the site so that it ceases to be just a visual field, ceases perhaps to be a 'landscape', but becomes a complex of sensations, of light, colour, smell, sounds, tactile experience. It becomes an environment.

Here it might be useful to take stock of distinctions between some of these cognate terms—landscape, nature, environment. The following descriptions are useful:

Nature is the entire system of things, with the aggregation of all their powers, properties, processes, and products—whatever follows natural law and whatever happens spontaneously.

Landscape is the scope of nature, modified by culture, from some locus, and in that sense landscape is local, located. … Humans have both natural and cultural environments; landscapes are typically hybrid.

An environment does not exist without some organism environed by the world in which it copes. … An environment is the current field of significance for a living being.[24]

The experience of nature as process rather than picture depends on shifting the emphasis from 'landscape' to 'environment'. Landscape is an exercise of control from a relatively detached viewpoint. Environment implies a mutually affective relationship between the 'organism' and its environing 'current field of significance'. The geographer Denis Cosgrove has argued that the painter's 'scenic' sense of landscape is incompatible with the subjective experience of landscape because the painter is an outsider, detached from that which has become his motif. But when a landscape becomes an environment, the relationship must change: the scenic sense would then be only one of many ways in which what was landscape becomes holistically the current field of significance. The interaction between landscape and artist now becomes more complex.

It may help to have such distinctions in mind when we come to consider the *Grainstack* [**107** and **108**] series painted by Monet in 1890–91. He records in his letters that he worked with painful slowness 'on a series of different effects'. He was aiming for 'instantaneity': 'I'm increasingly obsessed by the need to render what I experience.'[25] The stacks stood in a field behind his house at Giverny. They were familiar neighbours, as were the houses whose shapes are discernible in the

107 Claude Monet

Grainstack, 1890–91

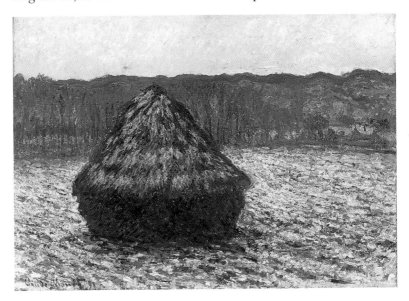

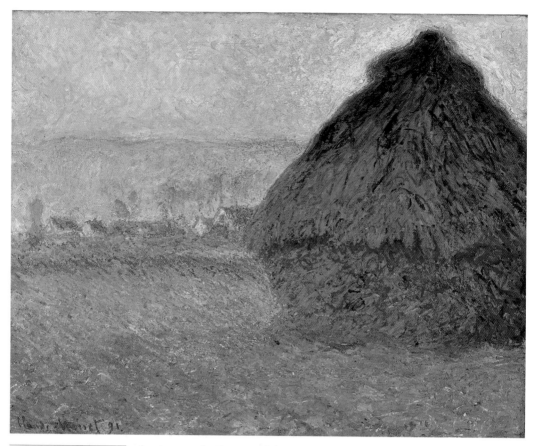

108 Claude Monet
Grainstack (Sunset), 1891

background of many of the *Grainstack* paintings. So the subject was already part of Monet's home environment, his current field of significance. The series traces the effects of different times of day and seasonal changes on these stacks as they weather down in the months following the grain harvest. *They* are seen interacting with *their* environment: stiffened and frosted in the snow, glowing in the warmth of a sunset. They assume an amiable and rather foolish stolidity as one looks at them from painting to painting. Monet shifts his viewpoint, moves around the field, gets to know them better. So sometimes [**107**] they stand clear, proud of the line of trees or scattering of houses at the far edge of the field: there they are, solid objects, with volume and weight, storage amenities for the rural economy. Sometimes [**108**] they are transfigured into dense masses of—what? Something oddly immaterial: flat polygonal patches with short, curled scribbles of paint, rippling with a mysterious energy. A preternatural brilliance trembles around the edges, and almost begins to consume the pyramidal top. Colour spills all over the ground in shimmering rivulets of magenta, saffron, rose-pink, sapphire.

These seem impossible colours, until one remembers that Monet's Truth to Nature is subjectively experiential. 'The shadow cast by the

olive trees is often mauve. It is in constant motion, luminous, full of gaiety and life.'[26] So wrote Jean Renoir in his biography of his father, Pierre Auguste. It reminds us that there are different kinds of truth. The emotional truth to nature is a subjective truth authenticating sensory experiences which, objectively, cannot be verified. Mauve, vivacious shadows are a fact of sensory perception. So too are grainstacks that dematerialize into writhing, vibrating storage units of colour.

Monet has, by adopting the series format, altered his landscape into an environment, in a way that can become apparent only when one has a chance to see ten or so paintings from this series together. It becomes pointless to talk about ten juxtaposed *Grainstack* pictures as ten 'landscapes': they relate to each other as facets, or transcribed experiences, of a single 'environment'. The artist has lived with them, day after day, week after week, not in order to produce, by the end, one painting of this scene. A series can document natural processes as well as the perceptual processes of the artist immersed in the motif. The interplay between the various *Grainstack* pictures undermines the sense of 'picture'. The series lets in what the single 'landscape' would have to edit out— that is, the elusive vitality of change.

The discussion so far has suggested the incompatibility of the two kinds of 'truth'. But the effort to engage more intimately with nature, to understand her workings, and to respond to the sensations generated by feeling landscape as a living environment, can take a physico-aesthetic form, a mix of close scientific observation and aesthetic codification of organic processes. A particularly interesting case is that of the English poet Gerard Manley Hopkins (1844–89). Hopkins coined a technical terminology—'inscape' and 'instress'— to express his sense of distinctive generic design in natural objects, whether it was the patterns in the breaking of waves on the shore, or a sunset, or the configured relation of leaves to twigs and twigs to branches. He noted in his journal (19 July 1866):

I have now found the law of the oak leaves. It is of platter-shaped stars altogether; the leaves lie close like pages, packed, and as if drawn tightly to. But these old packs, which lie at the end of their twigs, throw out now long shoots alternately and shiny leaved, looking like bright keys. All the sprays but markedly these ones shape out and as it were embrace greater circles and the dip and toss of these make the wider and less organic articulations of the tree.[27]

His enigmatic term 'inscape' has an interesting relation to 'landscape', in the context of our discussion in this chapter. Inscape is what emerges when 'landscape' is penetrated, intellectually and emotionally (Hopkins might prefer to say 'spiritually'), when the organic material forms of the natural world are understood as manifesting certain laws of energy. In seeing the way in which the boughs and twig sprays of chestnut trees plunged and crossed one another when the wind shook

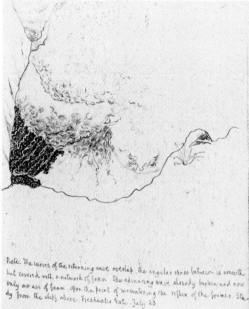

Note. The curves of the returning wave overlap, the angular space between is smooth but covered with a network of foam. The advancing wave already broken and now only a mass of foam upon the point of encountering the reflux of the former. Sta-dg from the cliff above. Freshwater Gate. July 23

Shanklin, Isle of Wight
1866
the diameter is 6½ in.

109 Gerard Manley Hopkins
'Study from the Cliff above Freshwater Gate, July 23', 1863

110 Gerard Manley Hopkins
'Shanklin, Isle of Wight', 1863

them, Hopkins noted, 'Observe that motion multiplies inscape only when inscape is discovered, otherwise it disfigures' (14 May 1870). The discovery of the 'law' of 'inscape' recorded in his journals, in both prose and drawings, is a revelation of new beauties, but it took hard work and constant observation, rather in the manner of the dedicated open-air painter. In a journal entry of 1872, he remarked:

About all the turns of the scaping from the break and flooding of the wave to its run out again I have not yet satisfied myself. The shores are swimming and the eyes have before them a region of milky surf but it is hard for them to un-pack the huddling and gnarls of the water and law out the shapes and sequence of the running. ... Looking from the cliff I saw well that work of dimpled foamlaps—strings of short loops or halfmoons—which I had studied at Freshwater years ago.

His Freshwater study of 1863 [**109**] shows an attempt to 'law out' the patterns of breaking waves, part stylization and part naturalism. Once the 'law' is discovered, then affinities between different natural features can be represented. Thus his study of trees at Shanklin [**110**] renders their rippling movement under wind gusts in much the same formal terms as he would render waves and foam. In one sense Hopkins is re-newing the landscape vision, reanimating the response to the natural world that 'landscape' conventions have ossified. In this respect he shares the same kind of agenda as Ruskin's *Modern Painters*.

A poet, of course, has recourse to metaphor in order to render one thing in terms of different things, and thereby disclose unexpected affinities. For the artist this is not available. The stylization of move-

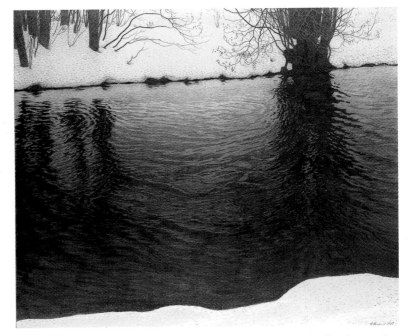

ment in natural objects leads in one direction, towards the decorative mannerisms of Art Nouveau, as for instance in the beguiling *Winter Evening by a River* [**111**], by the Swedish painter Gustav Fjaestad (1868–1948). Here the water's mysterious eddies become almost an abstract plotting of natural energies, like randomly sprinkled iron filings driven into nearly symmetrical whorls by the approach of a magnet. Or, perhaps, like the chaotically destructive snow, wind, and water in Turner's *Snow Storm* [**96**], which convert that picture into a near-abstract diagram of force fields.

This chapter started with a quotation from Cézanne,[28] urging the landscape artist to shed the over-familiar repertoire of pictures and explore the unmediated experience of nature. We have considered instances of artists who, in different ways, try to meet that challenge. They get to know nature with a greater scientific depth of understanding and with a greater intimacy. But their efforts do not result in what one might expect from such a project—a more refined naturalism. In curious ways their more intimate understanding of nature's processes results in their work's seeming to become less naturalistic—more abstract, more mannered—than the landscapes of their more conventional predecessors.

We have been concentrating on those landscapes produced by nineteenth-century artists, because that is the period when open-air painting became established practice and when the great advances in geological understanding were popularized. It was also the period of the invention of photography. Photography, in due course, became the chief instrument of pictorial naturalism. But it could neither

adequately record the subjective relation of the observer to the natural scene nor convey the sense of nature as living process. The tensions between photographed and painted landscape were the subject of a recent study of Cézanne by Pavel Machotka, *Cézanne: Landscape into Art*. Machotka juxtaposes reproductions of Cézanne's landscape paintings with site photographs that, as precisely as possible, represent the viewpoint, time of day, and season when the motif was under study by Cézanne. The project yields some fascinating results in terms of correctives to some art-historical assumptions about Cézanne's practice, but it also raises questions about the relative value for the understanding of landscape of photographic record and painted image. Such questions become focused, in this study, particularly when the author comes to consider the ten canvases depicting Mont Sainte-Victoire, painted between 1902 and Cézanne's death in 1906. Machotka suggests that the appeal of Sainte-Victoire had several dimensions: it was a magnificent natural feature in the Aix landscape, which any visitor would acknowledge; in local–historical terms it was a symbol of Marius's victory over the Teutons and the Ambrones; for 'Cézanne the painter of narrative scenes [the early *L'Enlèvement* is cited], it could also serve as a personal symbol for attainment or culmination'; for Cézanne the landscape painter, 'it would be above all a motif: an object responsive to subtle quotidian and seasonal changes, and inviting continual, even restless, play of the logic of organized sensations'. (The last phrase is a quotation from Cézanne's letters.) The mountain was charged with further personal significance when Cézanne had his studio constructed at Les Lauves, in full view of Sainte-Victoire, morning, noon and evening.

In the context of these observations on the complex of values associated with this site, Machotka reproduces a 1930s photograph of Sainte-Victoire [112] taken from the same vantage point as Cézanne's *Le Mont Sainte-Victoire vu des Lauves* [113]:

112 John Rewald
Mont Sainte-Victoire, *c.*1930s

113 Paul Cézanne
*Le Mont Sainte-Victoire
vu des Lauves,* 1902–06

What photographs seem particularly inadequate to document is this *complex experience.* They do convey rather precise information within their frame and moment in time, but until one has seen the motif itself, extended in depth and breadth, one will not feel its attraction, nor sense the effect of change of season or point of view, nor grasp how pressing is the translation of deep space on to the flat plane of the canvas.[29] [my italics]

A single photograph cannot *live with* the site nor register a sense of the environmental energies playing upon the sensibility of the person who exists within that landscape and who is trying to express in graphic terms those complex impressions. This sense of the rhythmical energies of the landscape is expressed, or rather asserted, in a strikingly non-naturalistic vocabulary of slanting and vertical patches of colour: the foreground diagonals inclining up to the left, the middle ground patches, where recession accelerates, standing perpendicular to the horizon, and the mountain's strong diagonal veering up to the right, as a counterbalance to the foreground. None of this vitality is registered in the scrupulously topographical photograph. That 'complex experience' of landscape is exactly what has concerned us in this chapter, and Machotka's juxtaposition of photograph and painting of the same view perhaps says more than many words can on the issue.

Landscape into Land

Earth Works, Art, and Environment

Landscape in art, as conventionally conceived and executed, is a framed representation of a section of the natural world, a cropped view, selected and reduced so that it can be a portable memento of an arresting or pleasing visual experience of rural scenery. The first chapter of this book argued that land becomes landscape once this kind of conceptual process has begun, and some way before any material reproduction of the image has been generated. The implication is that landscape art doesn't happen in nature; landscape art is an abstraction from, an appropriation of, nature such that, once the process has issued in an art object, one might say (pointing to the land) 'there is the original', and (pointing to the painting or photograph) 'here is the artist's representation'. The distinction bestows a mystique on the 'original', a different kind of value on the artefact, and generates a tension or a dialectic between the two. It also renders both artist and spectator as detached observers of nature. The process terminates in what is perceived as a profound distinction—'art' and 'nature'. That dialectic is part of the condition of landscape art and, since the Renaissance, has given a wonderful energy and complexity to western traditions in representing landscape, in literary as much as in visual forms.

In the twentieth century the distinction between art and nature has become increasingly problematized. The shifting, evanescent borderline between the two has also become the locus for some of the most exciting artistic activity in the last third of this century, exemplified in the work of artists who, in most cases, had a very sophisticated awareness of such debates and who were examining, in radical terms, the function and value of their own activities as artists.

The investigation of the point at which land becomes landscape raises questions about where the artistic engagement with the site begins and ends. Open-air painting in the late eighteenth and nineteenth centuries had taken the artist out of the studio to a more intimate and sustained confrontation with the site. But it was usually assumed that such an engagement was part of a process: it was a deliberate excursion

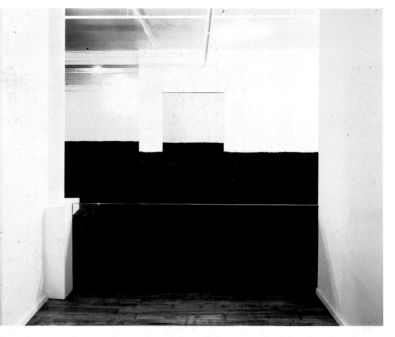

in order to enhance the authenticity of the record of the site, but it was understood usually to be an excursion *from* the studio and eventually *back into* the studio, and what eventually emerged from the studio would find its way on to the walls of public galleries or private homes. That indoors–outdoors duality, determining the constitution of landscape as that sense of something beyond our domesticating reach, has been a refrain through much of this book as we considered the different forms in which artists have interpreted and engaged with landscape since the Renaissance: the *parergon* to the Argument, the window frame, the *camera obscura*, the belvedere, the landscaped garden, the *trompe l'œil* landscape panels, and so on. Just as *parergon* is implicated in *ergon*, and just as the frame is implicated in the totality of the landscape representation (in a sense it is that which defines it as a 'landscape'), so the art gallery may be seen as a further kind of frame, since it helps to constitute the work—say a landscape painting—which it is ostensibly simply clearing space for. The photograph by Karen Knorr [1] in the first chapter bears on this sense of the inflection given by the exhibiting space. Like the exhibition catalogue, though less explicitly, the gallery contextualizes and mediates the framed representation of the landscape which the painter or photographer has already manipulated in order to produce the image he or she wanted. In a further framing, the gallery itself is contextualized within its broader culture, given social meaning, and manipulated by political and economic forces. In the 1960s the gallery seemed, to a number of artists, to be less a desirable showcase opportunity than a corrupt, and corrupting, instrument of a fundamentally philistine capitalism.

From the 1960s onwards, the prioritizing of the art object as material commodity, too susceptible to the corruptive manipulations of the art market, gave way to a prioritization of the process, to the raw materials used by the sculptor, to the artist's developing ideas and their implementation, to the activity of art making. A quite deliberate dirtying up of the art gallery became one of the expressions of these new priorities, sometimes quite literally, in the dumping of natural materials from the land—rocks, trees, earth—on to the floors of the gallery rooms. 'Earth is the material with the most potential because it is the original source material',[1] said the sculptor Michael Heizer (b. 1944). Walter De Maria's (b. 1935) *New York Earth Room* [**114**] consists of 250 cubic yards of earth, at a depth of nearly two feet, spread over 3,600 square feet of gallery floor. This is the very stuff of which landscapes are composed and shaped. Here it is eerily blank and passive, simply submitting to the formal matrix of the floor and walls of the gallery. It has the forlorn air of a caged wild animal, or rather that may be one of the cultural meanings it provokes. In an ironic commentary on 'landscape', it is framed and boxed land in its starkest material form. The title, *Earth Room*, juxtaposes the old dialectical antagonists. What shock or pathos it elicits in the viewer is generated by the clash of values and meanings associated with those dualities we have constructed: art and nature.

The importation of raw materials into the demure, clean spaces of the art gallery is matched in Anselm Kiefer's disturbing work [**115**]. He produced a series of books, *Märkische Sand*, in 1977 and 1978, consisting of photographed German landscapes, plains and wheatfields, with allusions to Nazi spoliation of the land (the title refers to a marching song in Hitler's army). Sand then creeps onto the edges of these pages

115 Anselm Kiefer
Märkische Sand IV, 1977

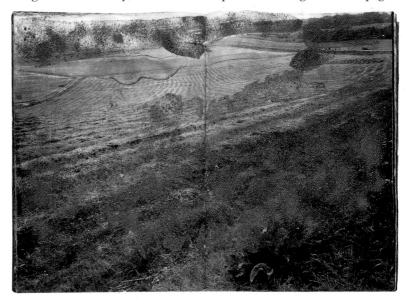

and bit by bit moves across to smother the image of the landscape, in a startling textual re-enactment of historical vandalism.

We talk about a 'work of art' and, usually, we are referring to the completed art object. But the presence of the word 'work', the reminder of the effort and concentration and application needed to produce the object, deserves more attention. The 'art' issues from the 'work', so why not concentrate on the work processes themselves? From the mid-1960s Earth Art and Land Art were forms of response to this kind of thinking, and exercised a reverse pull on the detachment associated with the mimetic tradition of landscape representation. It is in this sense that the present chapter suggests the reversal of the opening chapter's title, and explores the conversion of landscape into land, sometimes as an explicit act of restoration.

Landscape art has often intersected with sculpture and with the active modelling of the land, most notably in gardening. Several practitioners of Earth Art over the last third of this century have associated themselves, theoretically and in practice, with landscape gardening, and their installations, 'displacements', or otherwise 'marked sites' are designed to be experienced within the context of the landscape environment. So distinctions between sculpture and the arts of landscape often become invisible. The trace of these artists' engagement with landscape may exist on the site itself, as a substantial or minimal modification of the material components of that site; as such, it cannot, of course, be removed from that site. That is why so much Earth Art or Land Art can be disseminated only in photographs or photographs with text, or sometimes just text. In many cases, the site itself has *become* the place where the original landscape is now irrecoverable because its shape has been manipulated, however minimally, by the artist.

Photographic records of these 'marked sites', such as many of those reproduced in this chapter, make the worked section the chief focus, and photographs, of course, offer a purely visual and two-dimensional focus. But Earth Art of this kind needs to be experienced *in situ*. Some of these artists have shot film of the making of these earth works, both as a record and as a carefully edited experiment in perception of the work. At one stage Robert Smithson (1938–73) apparently had it in mind to construct an underground cinema beneath his *Spiral Jetty* [**119**], at Salt Lake, so that he could show his film of the making of this earth work.

The work of the Earth Artist cannot easily be identified with this or that particular object which the hands of the artist have made, but more with the relationship between that object (sometimes a mere re-arrangement of on-site stones, for instance, or a line drawn on the desert floor) and the otherwise untouched site. The 'landscape art' in this case *is that relationship*. If we continue to think in the nature–art dialectical manner, then such a work of art may be seen as a portrait of a

dialectic, and it would have to be expressed in some such concatenated terminology as 'unassuming-artefact-in-natural-setting'—except that the 'artefact' may also be a construct of 'natural' materials. Where does one end and the other begin? The issue corresponds to elements in deconstructionist thinking about the relation of text to context, where distinctions between the two (as between art and nature) are held to be culturally constructed rather than essential and absolute. Text can be defined as such only by reference to the *con*text from which it is artificially separated. Text depends for its supposedly independent identity on its relationship to that which it is *not*; but a dependant cannot be said to have a fully separate, autonomous existence. Everything therefore is 'text'; or everything is 'context': '*Il n'y a pas de hors-texte*', in Derrida's striking assertion. As with text and context, there is a co-extensiveness, a continuity between other binaries, between nature and artefact, between Land Art and land, between landscape and the gallery.

Earth Art and Land Art have taken many forms: minimalist and ephemeral intervention in the site itself, the larger-scale sculptural earth work involving heavy construction equipment, the largely unmediated installation in an art gallery of materials gathered from a landscape site, the landscaped reclamation or planned naturalization of industrial wasteland, acts of conservation of natural land that involve decisions about *what* traditional usages of the land are to be retained, and so on. All of this suggests a new kind of interest in getting one's hands dirty by entering into altogether more intimate relations with the raw materials of the original. They are acts of intervention. The language some of these artists have used to describe their work with the natural world can reveal an urgency to be able to identify with natural processes, by exploring an almost symbiotic kinship:

The earth's surface and the figments of the mind have a way of disintegrating into discrete regions of art. Various agents, both fictional and real, somehow trade places with each other—one cannot avoid muddy thinking when it comes to earth projects. ... One's mind and the earth are in a constant state of erosion, mental rivers wear away abstract banks, brain waves undermine cliffs of thought, ideas decompose into stones of unknowing.[2]

This meditation by Robert Smithson, one of the best-known practitioners of Earth Art in the 1960s and 1970s, dramatizes in metaphorical language the exchange or interchangeability between the artist's mind and the materials of the natural world with which he works. That distance or detachment associated with representational landscape art, the selection and framing off of a view of landscape, has just about disappeared in such accounts. Smithson is explicit about this impulse towards a more visceral landscape art, and it is sometimes set in opposition to what he sees as enervated forms of artistic production within European cultural traditions. He regretted the Cubists' development of Cézanne's experimental landscape art 'into a kind of empty

formalism': 'we ... have to reintroduce a kind of physicality; the actual place rather than the tendency to decoration which is a studio thing, because the Cubists brought Cézanne back into the studio'.[3] Smithson's own site-specific earth works are his response to what he perceived as the mistaken directions taken in landscape art.

The kind of physicality in this relationship with the natural world is exemplified in the work and writing of the Italian sculptor, Giuseppe Penone (b. 1947), whose early work was associated with the 'Arte Povera' school of the late 1960s. In the woods in Garessio, south of Turin, in 1968, Penone constructed a shallow, rectangular, concrete basin in the dry section of a stream bed, and then diverted the stream so that it flowed into and over the container. His description of what he regards as the necessary physical and mental immersion in the raw material of his site is symptomatic of the new intensity of intimacy with the natural world:

In order to make sculpture the sculptor must first lie down, flatten himself on the ground letting his body sink, lowering himself without haste, gently, little by little, and finally having reached a horizontal position, concentrating his attention and his efforts upon his body, which pressed against the ground allows him to see and feel the things of the earth; he can then open his arms to fully enjoy the coolness of the ground and attain the necessary degree of peace for the accomplishment of the sculpture.[4]

This engagement with the natural materials, more or less at the source from which they originate, leads to various experiments involving the assimilation of the artist's self with the organic world. In a bizarre literalizing of what might be called the hands-on approach to the natural world, Penone grasped a sapling with his hand (again in the Garessio woods) and at the point of contact fastened a cast-iron model of his hand to the tree [116]. Over the next ten years the iron hand maintained its grip and the tree grew round it, bulging into a scar where the hand seemed to choke its growth.

The language adopted by Penone and Smithson to express an exchange between the artist's mind and the materials of the natural world, where one is seen in terms of the other, is akin to Smithson's sense that 'the landscape is co-extensive with the gallery'. The oppositional nature of the two is illusory, a cultural conspiracy. In order to explore this renegotiated relationship, Smithson developed a form of landscape art he called 'Non-sites':

I was sort of interested in the dialogue between the indoor and the outdoor and ... I developed a method or a dialectic that involved what I call site and non-site. The site, in a sense, is the physical, raw reality—the earth or the ground that we are really not aware of when we are in an interior room or studio or something like that—and so I decided that I would set limits in terms of this dialogue (it's a back and forth rhythm that goes between indoors and out-

doors), and as a result I went and instead of putting something on the landscape I decided it would be interesting to transfer the land indoors, to the non-site, which is an abstract container.[5]

In the summer of 1968 Smithson went down into the slate quarries at Bangor-Pen Angyl, Pennsylvania [**117**], and there, as 'all boundaries and distinctions lost their meaning in this ocean of slate',[6] he experienced what he described as minor swoons and vertigos. In the face of what he called this 'Wreck of Former Boundaries', he collected slate chips for a 'non-site' installation, a shallow trapezoidal container in which the site-specific slates were deposited. These dislocated raw materials, wrenched from their boundary-less 'ocean' matrix and now sitting as a boxed 'non-site' in an art gallery, must (if one could imagine a sentient slate) have much the same sense of disorientation as the artist had on the original site. The title *Non-Site* [**118**] is of course very different from a title like '*Slate Chips*': *Non-Site* is specifically relational, and directs the spectator to the 'site' itself, thus setting up the 'back and forth rhythm that goes between indoors and outdoors'.

Smithson's monumental work, *Spiral Jetty* [**119**], is one of the first and best-known examples of Earth Art in America. It runs off the land, as a 1,500-foot, counter-clockwise coil, out into the Great Salt Lake, Utah (Smithson bought a 20-year lease on the area) and is composed of earth, black rock, salt crystals, and red algae. He selected his site without, apparently, any sense of the shape his work of art would take. That came to him in apocalyptic manner:

As I looked at the site, it reverberated out to the horizons only to suggest an immobile cyclone while flickering light made the entire landscape appear to quake. A dormant earthquake spread into the fluttering stillness, into a spinning sensation without movement. This site was a rotary that enclosed itself in an immense roundness. From that gyrating space emerged the possibility of the Spiral Jetty.[7]

The hallucinatory experience is similar to that which he describes at the slate quarries—swoons and vertigos. But in this instance, 'My

117 Virginia Dwan
'The Bangor Quarry', 1968

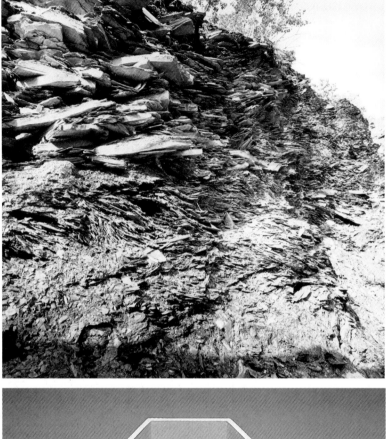

118 Robert Smithson
Non-Site, 1968

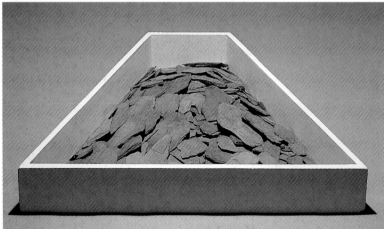

dialectics of site and nonsite whirled into an indeterminate state', and the materials *from* the site were sculpted into this vast configuration *on* the site, rather than packed, transported away and installed in a gallery 'non-site'. *Spiral Jetty* is a work that responds to the particular landscape in which it evolved, its configuration, its strange light and its distinctive colouring, as well as to the proximity of a derelict oil well.

The sculptor Michael Heizer has from time to time erroneously been seen as working within or at an angle to landscape art traditions. By his own account,[8] he has always been hostile to landscape art and its preoccupation with scenic beauty. His formidable early work, *Double Negative* [**120**], a 240,000-ton 'displacement in rhyolite and sandstone' in the Nevada Desert, may be seen (though that was not part of the original intention) as in some respects an 'anti-landscape' work, literalized in physical, *sub*terranean terms. Two deep cuts down into the desert floor, on the rim of a natural cliff face, take one below the naturally contoured integument that conventionally constitutes 'landscape'. This work of 'negative sculpture' places the spectator 50 feet below ground level in a cool, earthen chamber of strong verticals and diagonals, the sheer-cut walls exposing the sedimentary layers of rock that compose the desert. This combination of the sculpted, abstract geometry of the cuts and the geophysical interest emphasizes the departure from traditional landscape aesthetics.

Heizer's artistic orientation towards land as material, and specifically towards the desert site, is partly to be traced to his family's long-rooted connection with Nevada and, more immediately, to his father's life-long anthropological interest in the Great Basin region. There is a continuity between his family's roots, his father's written study 'Massive Stone Transport of the Ancients', Heizer's own artistic

119 Robert Smithson
Spiral Jetty (under construction), 1969–70

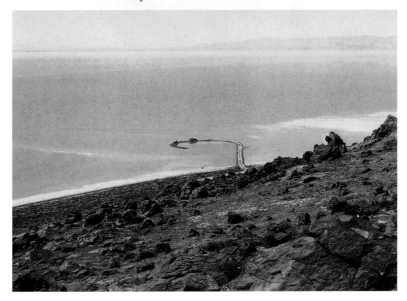

absorption in megaliths and their history, and his feel for the desert site: in his own words, 'Place is material: material is place.' Nowhere is this more apparent than in his 1969 work *Displaced/Replaced Mass* [121] at Silver Springs, Nevada. The title suggests a further variation on the dialectic between natural and human agencies in the shaping of the landscape. Three holes, dug in the clay floor of the Nevada desert and lined with concrete, acted as receptacles for three huge granite blocks, dynamited from 9,000 feet up in the Sierra mountains. Granite was the original material of what is now the desert. It was 'displaced' thousands of years ago by natural geological action, tectonic break-up

120 Michael Heizer
Double Negative, 1969

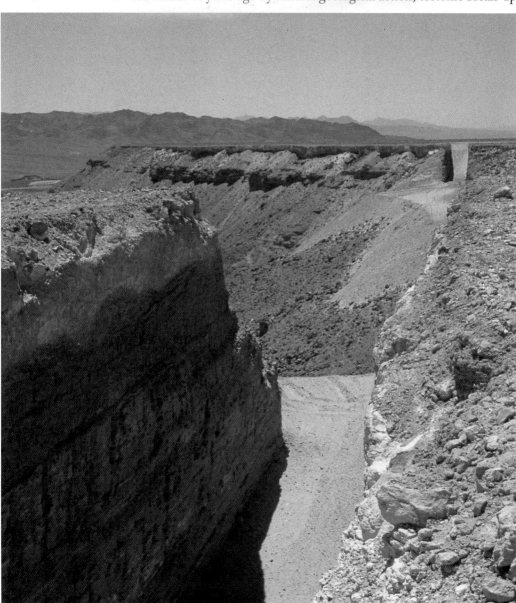

121 Michael Heizer

Displaced / Replaced Mass,
1969

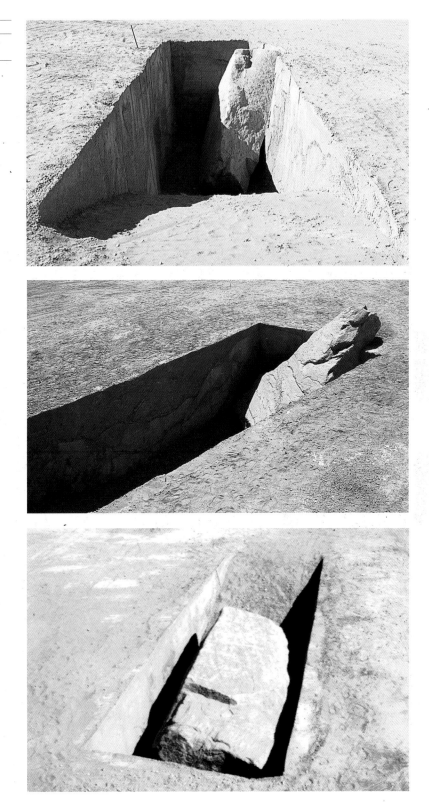

in the Great Basin, which caused the uplift of the granite to at least 9,000 feet. Heizer's work, therefore, 'replaced' the material. It is a weird act of restoration, a kind of reversal in megalithic terms of the minimalist site/non-site displacements of Smithson, though it was never intended as a way of engaging with Smithson's work. Heizer has spoken of his sculptural work as a kind of language to re-establish dialogue with the earth. The intimacy and intensity of this dialogue, often consciously resonant of the imprints on the land of Pre-Columbian cultures, manifests itself in digging deep down, as in *Double Negative*, and confronting the spectator with the raw material of earth and rock. In such cases, meaning must be excavated, rendered in 'negative sculpture', rather than carried in beguiling transcriptions of the beauty of the earth's surface. That imperative is lost in aerial or ground-level photographs where the specific site is viewed in the context of the surrounding desert or hills, and thereby assimilated to 'landscape'.

Heizer's restorative gesture is analogous to Smithson's own project (never carried out), *Floating Island* [**122**]. A huge rectangular barge was to be filled with trees, rocks and other plants, arranged as a miniature landscape. All the materials were to be indigenous to Manhattan so that, as the island float was tugged around the present island of Manhattan, citizens and visitors to the metropolis could enjoy a mobile exhibition of how their landscape used to be. In this vision the city itself becomes the art gallery. Geological reconstruction combines with more familiar landscape dialectics. The city was to have been confronted not only with the view of what it has itself displaced, but with the drifting image of an old pastoral dream, luring one into the possibility of a recoverable world of beauty and natural simplicity.

Mutability was both the theme and destiny of many of the pioneer Earth Art works. Now 30 years old, many of them have aged, natural-

122 Robert Smithson
Floating Island, 1970

ized, and been modified in various ways: desert sand has filled up and virtually obliterated the pits in *Displaced/Replaced Mass*, and the *Spiral Jetty* is submerged by the waters of the lake.

Earth Art, on this scale, provoked strong opposition both from traditionalists in the world of art criticism, and from contemporary Land Artists. Robert Smithson took issue with the traditionalist–environmentalist Alan Gussow,[9] who, in a book entitled *A Sense of Place: Artists and the American Land*, made clear what his priorities were in landscape art:

What these [traditional landscape] artists do is make these places visible, communicate their spirit—not like the earth works artists who cut and gouge the land like Army engineers. What's needed are lyric poets to celebrate it.

Gussow and others associated the Earth Artists with a kind of macho aggression in which the violation of the earth with huge mechanical diggers was seen as a raw assertion of male authority over Mother Earth. Smithson argued that his art was 'a direct organic manipulation of the land', akin to cultivation and to the work of the great landscape gardeners of the past. Frederick Law Olmsted, the designer of Central Park [33], was, according to Smithson, 'America's first "earthwork artist"'. Smithson also associated himself and his work with ancient forms of Earth Art, the Mesa Verde cliff dwellings, and the thousands of artificial hills made by Native Americans over the centuries.

The clash between Gussow and Smithson epitomizes the conflicts at the heart of landscape art in the last third of this century. Gussow's sense of the delicacy and sacrosanctity of the natural world makes him recoil from the Earth Artists' tearing at the fabric of nature. Nature, especially in the American experience, *used* to be that robust 'other', there to be tamed and cultivated. It was the fruitful provider, it was Mother Earth on whose strength and fertility the human community depended. Now it is a fragile, anorexic dependant, to be protected and 'managed'. The late twentieth century has a sharpened sense of human alienation from the natural world and a hunger for more intimate familiarity with that receding domain. It also has a sharpened environmentalist sense of the fragility of that eco-system. These anxieties burden the artist in his or her negotiation of that dialectic between civilization and the wild, technological progress and the natural world, the gallery and the landscape. Urbanization, mining, the dumping of waste, atmospheric pollution—all play a part in sculpting the modern landscape, alongside the more benign artistic contributions of the park and garden designers and the Earth Artists. The coming together of the two, the engagement of the landscape artist with sites scarred by industrial working (as in Smithson's various land-sculptural reclamation projects) or suffocated by urban development, accentuates the tensions between landscape and art gallery: it isn't the gallery that

123 Christo and Jeanne-Claude

Surrounded Islands, Biscayne Bay, Greater Miami, Florida, 1980–83

needs the old emollient images of utopian landscape art; it is our wrecked environment that needs the landscapists' direct intervention.

One intervention of this kind, and one of the most extraordinary works of art ever to have been realized—extraordinary both in scale and in conception—is the installation by the Bulgarian-born artist, Christo, and the French-born artist Jeanne-Claude, *Surrounded Islands*, Biscayne Bay, Greater Miami, Florida (1980–83) [**123**]. Eleven man-made islands lie in the bay surrounded by Greater Miami. Sheets of pink polypropylene fabric extended out 200 feet from each island, the perimeter following the contours of each island—60 hectares of fabric in total. The work of art remained for two weeks before it was removed. Twenty-four-hour monitoring of the installation was added to the staggering costs of the project—costs paid by the artists themselves. The cityscape was transformed. From the air, the radiant beauty of the pink-petalled islands acted as kind of aesthetic reclamation of the relentlessly urbanized and smog-dimmed environment. It created a macrocosmic version of Monet's garden of water-lilies in the centre of a metropolis.

If Gussow, in his antagonism to Earth Art, represents the more traditionalist view of the proper role of the landscape artist ('to celebrate it' and to 'communicate [the] spirit' of places), a different line of attack comes from within more recent developments in Land Art. The English artist Richard Long (b. 1945) has been concerned to distance himself from the American pioneers of Earth Art:

My interest was in a more thoughtful view of art and nature, making art both visible and invisible, using ideas, walking, stones, tracks, water, time, etc, in a flexible way. ... It was the antithesis of so-called American 'Land Art', where an artist needed money to be an artist, to buy real estate to claim possession of the land, and to wield machinery. True capitalist art.[10]

Long's revulsion at a 'capitalist art' that appropriates and transforms remote tracts of land is in tune with leftist, post-colonial, and 'green' thinking in Britain from the 1960s onwards. To many who belonged to the student generation of the 1960s, the acquisition of real-estate property as a preliminary to the making of a work of art was anathema. Long has said: 'I like the idea of using the land without possessing it'; or again, 'My outdoor sculptures and walking locations are not subject to possession and ownership.'[11] The anti-capitalist values chime with the anti-colonialist feeling that developed in post-war Britain. An old imperial power withdrawing from political occupation of colonial territory, and having qualms about the residual cultural heritage it has long superimposed on the native traditions, nuances those acts of territorial intervention that Earth Art and Land Art practise. Such political and cultural anxieties harmonize again with environmental ones, where the exploitation of natural resources and the industrial appropriation of dwindling wilderness have an analogous relationship to colonialism. For Long there is, in addition, the sense of growing up in a country where desert and wilderness sites, of the kind and scale favoured by the early American Earth Artists, are simply not available. As the sculptor Carl André (b. 1935) observed, the British landscape is already 'one vast earthwork'.[12]

Long's work employs what he calls 'the vocabulary of universal and common means': walking ('my art is the act of walking itself'),[13] wind, stones, sticks, water, roads, circles, lines. These materials are used less to represent landscape than to embody a distillation of his experience of the land. Long has described this experience as a simplifying of life:

Like art itself, [walking] is like a focus. It gets rid of a lot of things and you can actually concentrate. So getting myself into these solitary days of repetitive walking or in empty landscapes is just a certain way of emptying out or simplifying my life, just for a few days or weeks, into a fairly simple but concentrated activity. ... So my art is a simplification.[14]

The simplification is exemplified in Long's text pieces, such as *Wind Line, A Straight Ten Mile Northward Walk on Dartmoor, 1985* [**124**]. The column of directional arrows is the straight track of the walk represented as the experience of journeying through crossing easterly winds. This text piece might be compared with those paintings of surges of wind included in earlier chapters of this book, Poussin's *Pyramus and Thisbe* [**48**], for example, or Renoir's *Le Coup de Vent* [**98**], where one is drawn into the pictured landscape space in order, partly, to share the

WIND LINE

A STRAIGHT TEN MILE NORTHWARD WALK ON DARTMOOR

1985

124 Richard Long

Wind Line, A Straight Ten Mile Northward Walk on Dartmoor, 1985

sensations of disturbance. That disturbance is registered in Renoir's painting in the blurring brushstrokes that efface the stable landscape features, as if produced by a camera with a slow shutter action. Long's text has a minimalist austerity that does not invite participation of that kind. It is almost provocatively non-illusionistic. It uses simple, standard wind direction markers in order to convey just one feature in the experience of a unique and, presumably, solitary walk. It graphically enacts the concentration Long so cherishes as one of the fruits of his walking.

Long dwells on the idea of emptying—'empty landscapes', 'emptying out … my life'. What is an empty landscape? Something of that sense is conveyed in *Wind Line*. Above the written text and to either side of the thin column of arrows (on either side of the path of the walk?) there is a blank. White space. Textual silence. Long's photographs of some of his walked landscapes convey this experience of emptiness in more conventionally representative ways. *Walking a Line in Peru* [**125**] is formally analogous to *Wind Line*, with the walked path of the earth line, traced as a scar on the photograph, dividing the composition precisely in two. The geometrical ruling, cutting right across the lines of the shallow, sinuous desert channels, accentuates the sense of emptiness that lies either side of it in the Nazca Desert. The line is the only artefact perceptible in all this vast picture space, it is an inscription and itself constitutes an expressive emblem of those prized qualities in Long's Land Art, pure simplicity, and concentration.

How do you transmit to others the experience of a walk in such a landscape? How do you bring it into the art gallery? Long exhibits text pieces, photographs, sometimes natural materials from the region walked, foot and hand prints. This is not landscape representation, even though the materials may represent part of the experience of that landscape. It is not a recreation of that environment, and it is

125 Richard Long

Walking a Line in Peru, 1972

126 Andy Goldsworthy
Jack's Fold, 1996

important to distinguish it from that kind of endeavour. Smithson's site and non-site works which dramatize an art–nature dialectic and, in their different ways, Long's mud hand-print circles on gallery walls and his assemblages of stone or pieces of wood on gallery floors call attention to what the gallery cannot contain—a landscape. In these works, what is conventionally outside makes an intrusion; and the sense that a tray of rocks or a mud splash on a wall doesn't *belong* in a gallery provokes a revaluation of prejudices about outside and inside.

A work that offers further variations on this theme is Andy Goldsworthy's *Jack's Fold* [126]. This was the outcome of a major landscaping project initiated by England's Cumbria County Council in 1993, entitled *Sheepfolds*. As originally conceived it entailed the construction of up to 100 dry-stone sheepfolds on or near to historically identified sheepfold sites, where often the dilapidated remains of the older structure could be found. The term 'landscaping' used above needs to be qualified. This is a project difficult to categorize. It is part restoration, part Land Art, part craft revival, and is emphatically linked to the community environment. It is an attempt to re-historicize, in social and economic terms, a landscape—the English Lake District—that has become increasingly an aesthetic and recreational amenity. We might dwell briefly on this transformation of the Lakes into a set of 'landscapes' for the tourist, before discussing *Jack's Fold*.

Special 'Outdoor Leisure' Ordnance Survey maps provide the tourist with recommended viewpoints. One of the most popular is the view of Derwentwater from Ashness Bridge, postcards of which sell in their tens of thousands over the summer season. Let us examine this formulaic landscape view more closely.

The postcard of Derwentwater from Ashness Bridge [127] shown here combines in one picture all the elements—a little stream, rocks, woodland, lake, islands, mountains, sky—and organizes them into a fine composition of sweeping diagonals: one diagonal runs from the left foreground stream bed past the arch of the bridge and up the hillside in the middle distance; the other runs from the right foreground across to the bridge and then up the line of trees to the top left margin.

127 Salmon Cards
Derwentwater from
Ashness Bridge

DERWENTWATER

It is a compendium of general landscape elements, but given particular local identity by the inclusion of regionally specific architectural additions. The feature situated at the intersection of these diagonals is the picturesque old packhorse bridge, much reinforced by the National Trust (a British conservation organization) to enable it to bear modern traffic, though the postcard view manages to eliminate any sign of cars and to minimize the appearance of the road. The bridge is built of much the same stone as the rocks in, and bordering, the stream, and, like the line of dry-stone wall running up the mountainside just beyond it, is almost wholly naturalized in its setting: the construction of both these utilitarian items was a matter simply of shaping and arranging natural materials that lay to hand. Everything in this landscape seems placidly natural, although everything is carefully 'managed' by the conservation bodies entrusted with the preservation of this region as a beauty spot.

The packhorse bridges, the dry-stone walls, and the old sheep-folds—now almost iconic features in the English Lake District—were functional structures for a working people, the hill sheep farmers. The sheepfolds and pinfolds were also places for social contact within the working environment: they were not art objects, although local pride in the craft of dry-stone walling made them partly that. They have, however, become picturesque antiques as far as most of the summer tourists are concerned (a little like the horse brasses and warming pans that decorate the walls of English pubs, they have almost become museum pieces). A Cumbrian sheepfold could well become an art object, a memento of the ancient worked landscape, were it to be housed in an art gallery. That is exactly what happened when Andy Goldsworthy constructed *Jack's Fold* in a south-east England art gallery in 1996. The stones were brought from a boundary wall in Cumbria (and have since returned there), and the fold was built partly inside the gallery room and continued outside, on an adjacent grass plot. Unlike the sand, slate chips, bricks, and earth displayed in galleries by Smithson, De Maria and Long, the materials of *Jack's Fold* are assembled to demonstrate a functional purpose associated with the working landscape where they

originated. But, as Goldsworthy remarks, the gallery installation is only a pause in transit:

This particular sheepfold is obviously not going to have a practical use in this context, so its use here is more to provoke feelings and ideas about what was here before. … In terms of the gradual erosion of the sheepfold, that really is part of the broader coming to terms with things that change. Things are continuously in a state of change or flow and everything, even stone, has a sense of movement about it.[15]

Goldsworthy's stress on change reminds us that landscape in art has so often functioned to transmit an apparently timeless world, a direct contrast to the disturbing discontinuities of urban living. Edenic or Arcadian landscapes were insulated from time and change; but even when the 'soft' primitivism of those worlds was discredited, an idealized post-lapsarian world persisted in the imagination, a world in which, although the seasons revolved and life cycles moved from decay to renewal, there remained a sense of continuity and pattern that amounted to a principle of stability. The Ashness landscape [**127**] is preserved to offer a similar kind of reassuring experience. Late twentieth-century artists who have worked with the land—like Smithson, Heizer, Long, and Goldsworthy—have as a part of their agenda the need to remind us that nature is constant change. They do this explicitly in their writings, but they do it also in the more universal language of their art, by challenging the distinction between landscape and gallery, outdoors and indoors, art and nature, and insisting on a rediscovered continuity. *Jack's Fold* is, in many respects, closely analagous to Heizer's *Displaced/Replaced Mass* [**121**]: both are interventionist acts of restoration.

Goldsworthy's sheepfold is designed as a means of asserting a continuity of several kinds: a continuity of craft traditions, a continuity between an older Cumberland culture and the present day, and a continuity of place. The sheepfold brings Cumbria to England's south-east, it is then disassembled and returns north 'with the memory of having been in the south to take back to Cumbria'. This is a deliberate act of cultural reorientation, designed to stir awareness not only of the relation of artefact to environment, but of very different environments to each other. (What could be more of a contrast than that between the landscape of the Cumbrian fells and a municipal art gallery in south-east England?) This is related to another kind of reorientation that involves the way in which the gallery visitor actually views the sheepfold. Goldsworthy aimed to build the fold high enough so that it felt like a room within a room, 'so that you can walk from the interior of the gallery into another interior space'.[16]

We have already had occasion to remark on the way in which many of these artists have a heightened sense of the part played by the gallery environment in inflecting or supplementing the experience of the work

of art, especially where the art object is the importation into the gallery space of relatively unmediated material from the outside natural world (De Maria's *Earth Room* [114], for example). Earth Art and Land Art raise acute questions about the position of the spectator in relation to the work of art. The more intimate, tactile engagement with the land that is so distinctive of this kind of art, whether the artist's intervention is a bulldozer or a footprint, challenges the position, both perceptual and cultural, of the viewer. Landscape has traditionally been something from which we are sufficiently detached to be able to recognize it as 'landscape'—a view of countryside. Earth Art would have us pulled in to the reshaped natural site, dissolving the distance between viewer and art object, provoking new perceptual experiences.

The issue was raised in a particularly provocative way in the film-work of the Canadian artist, Michael Snow. In 1969 he proposed to the Canadian Film Development Corporation a project to record a piece of wilderness on a grand scale: 'I wanted to make a gigantic landscape film equal in terms of film to the great landscape paintings of Cézanne, Poussin, Corot, Monet, Matisse.'[17] An intricate camera apparatus was constructed to enable the camera eye to rotate vertically and horizontally a full 360 degrees and this was transported to an area of wilderness in north-eastern Canada. Snow's ambition to rival the landscape achievement of Cézanne, Poussin, and Corot prompts one to compare, as one critic has aptly suggested,[18] the photograph of Snow beside his elaborate camera apparatus, surrounded by his motif [129], with similar records of the older landscape masters at their work [128].

Five days of filming and many more days of editing produced *La Région Centrale*, a 3-hour version of which went on limited release. The experience of landscape generated by this film is unlike that offered by any other work of landscape art that we have so far considered. Snow described the camera as 'like a bodyless eye—an eye floating in space'.[19] We have had aerial viewpoints before, of course, but this is something different: 'the whole film is meant to work on your sense of gravity'. Sky, horizon, close-up rocky terrain, seas of mountains, horizon, clouds, sky, sunrise, sunset—the stock images of landscape art flow slowly and relentlessly through the frame, top to bottom, side to side, on and on and on. Foreground, middle distance, background—the old stable co-ordinates—it is impossible to hang on to these for long before one slips into a new mode of perception as the motifs are stirred together into a new order. 'It starts out *here*, respecting the gravity of our situation but it more and more sees as a planet does. Up downs up, down ups down, up ups up.'[20] *La Région Centrale* takes the grand elemental materials of landscape and reorchestrates then in surreal ways: 'within the terms of my work I had in the back of my mind great religious works like Bach's *St Matthew Passion*, B Minor Mass, *St John Passion, Ascension* oratorio'.[21]

The reorientation of perception is enhanced by the prolonged absence of any human element: sometimes, when the sun is low, the shadow of the revolving camera apparatus is visible, but otherwise there is little trace of human presence. This was a deliberate part of the experience. Wilderness *is*, almost by definition, that which is untouched by human presence (Long's 'empty' landscapes?), and wilderness in its psychological as well as geographical sense is what Snow wished to convey:

The film will become a kind of absolute record of a piece of wilderness ... a record of the last wilderness on earth, a film to be taken into outer space as a souvenir of what nature once was. I want to convey a feeling of absolute aloneness, a kind of Goodbye to earth which I believe we are living through. ... It will preserve what will increasingly become an extreme rarity: wilderness. Perhaps aloneness will also become a rarity.[22]

This quasi-eschatological vision brings together a number of issues that have perennially haunted discussions of landscape in art: vanishing wilderness and the end of nature, the representation of landscape as 'souvenir'. In the eighteenth century the Grand Tourist in Italy commissioned copies of Claude's Campagna landscapes to take home to northern Europe. The twentieth-century tourist took home snapshots or postcards of beautiful natural scenery. Now, as green regions and solitude become endangered amenities, we prepare celluloid souvenirs

129

Photograph of Michael Snow
beside the camera during the
filming of *La Région Centrale*,
1969

of the planet, to take with us as we say goodbye to a denatured and overcrowded earth.

'I feel horror at the thought of the humanizing of the entire planet', wrote Snow. For the last 500 years western landscape art has been like a barometer of anxieties over the balance of power between nature and culture. We have come to realize that nature—that 'out there', that 'other'—is not necessarily perpetually self-renewing. It is more like ourselves than we ever feared. When it is not offering us dreams of green spaces as utopian as ever the most artificial pastoral managed to be, landscape art in our time comes burdened with guilt.

'I recorded the visit of some of our minds and bodies and machinery to a wild place,' wrote Snow, 'but I didn't colonise it, enslave it. I hardly even borrowed it.'

Notes

Chapter 1

1. Knorr, Karen, *Marks of Distinction* (London: Thames & Hudson, 1991), p. 127.
2. Gombrich, E. H., *Art and Illusion* (London: Phaidon Press, 1960), p. 254.
3. Derrida, Jacques, *The Truth in Painting*, trans. G. Bennington and I. McLeod (University of Chicago Press, 1987). See esp. Ch. 1, sections II and III.
4. Clark, Kenneth, *Landscape into Art* (London: John Murray, 1949), p. 74.
5. *Ibid.*
6. Adams, Ansel, *Examples: The Making of 40 Photographs* (Boston and London: Little, Brown and Company, 1983), pp. 79–80.
7. *Ibid.*, p. 81.
8. Mitchell, W. J. T., 'Imperial Landscape', in W. J. T. Mitchell (ed.), *Landscape and Power* (University of Chicago Press, 1994), p. 5.
9. Warnock, S. and Brown, N., 'Putting Landscape First', *Landscape Design* (March 1998), pp. 44–6.
10. Lassus, Bernard, 'The New Spirit of the Place, or Taming the Heterogeneous' (1993), in Stephen Bann (trans.), 'The Landscape Approach of Bernard Lassus', *Journal of Garden History* (London and Washington DC: Taylor & Francis, April–June 1995), p. 105.
11. Green, Nicholas, *The Spectacle of Nature: Landscape and Bourgeois Culture in Nineteenth-century France* (Manchester University Press, 1990), p. 31.
12. Clarke, Graham, *The Photograph* (Oxford University Press, 1997), p. 90.
13. See: Kellert, S. R. and Wilson, E. O. (eds), *The Biophilia Hypothesis* (Washington DC: Island Press, 1993), Chs 3 and 4.
14. Cosgrove, Denis, *Social Formation and Symbolic Landscape* (University of Wisconsin Press, 1998 [first pub. Croom Helm, 1984]), p. 19.
15. Berger, John, *A Fortunate Man* (London: Writers' and Readers' Publishing Cooperative, 1976), pp. 13, 15.

Chapter 2

1. Wood, Christopher, *Albrecht Altdorfer* (London: Reaktion Books, 1993), ch. 2.
2. Talbot, Charles, 'Topography as Landscape in Early Printed Books', in S. Hindman (ed.), *The Early Illustrated Book* (Washington DC: Library of Congress, 1982).
3. Snyder, James E., 'The Early Haarlem School of Painting', *Art Bulletin* 42 (1960), p. 45, n. 32.
4. See: Williams, George, *Wilderness and Paradise in Christian Thought* (London: Harper, 1962), p. 18.
5. St Jerome, Letter CXXV, in H. Wace and P. Schaff (eds), *A Select Library of Nicene and Post-Nicene Fathers of the Christian Church*, second series, vol. 6 (Michigan: Wm B. Erdmans, 1954). (All subsequent quotations from Jerome are from this edition.)
6. Augustine of Hippo, *City of God* 19, 2, in Cuthbert Butler, *Western Mysticism* (London: Constable, 1922; 2nd edn, 1926), p. 164.
7. Petrarch, *The Life of Solitude*, trans. J. Zeitlin (University of Illinois Press, 1974), Book II, Tractate 1, Ch. 2.
8. See: Meiss, Millard, 'Scholarship and Penitence in the Early Renaissance: the Image of St Jerome', *Pantheon* 32 (1974), pp. 134–40.
9. St Jerome, Letter XXII, to Eustochium, *op. cit.*, p. 24.
10. St Thomas Aquinas, *Summa Theologiae*, trans. and ed. Thomas Gilby (London: Eyre & Spottiswoode, 1964), I, Ia, I art. 9, pp. 33–4.
11. Panovsky, Erwin, *Early Netherlandish Painting* (Cambridge, Mass.: Harvard University Press, 1966), I, p. 141.
12. *Ibid.*, p. 142.

13. *Ibid.*, pp. 142–3.

14. Wood, *op. cit.*, p. 23.

15. Falkenburg, Reindert, *Joachim Patinir: Landscape as an Image of the Pilgrimage of Life* (Amsterdam: John Benjamins, 1988).

16. *Ibid.*, p. 31.

17. da Vinci, Leonardo, *The 'Paragone'*, Sect. 13, in J. P. Richter (ed.), *The Literary Works of Leonardo da Vinci* (1883 (rev. 1939); 3rd edn, London: Phaidon, 1970), I, p. 38.

18. Friedlander, Max, *Early Netherlandish Painting* (Leyden & Brussels: Sijthoff, 1973), 9, Pt 2, p. 99.

19. Pacht, Otto, 'Early Italian Nature Studies and the Early Calendar Landscape', *Journal of the Warburg and Courtauld Institutes* 13 (1950), pp. 13–47.

20. Gombrich, Ernst, 'The Renaissance Theory of Art and the Rise of Landscape', in *Norm and Form: Studies in the Art of the Renaissance* (London: Phaidon, 1966), pp. 107–21.

21. Lancilotti, Francesco, *Trattato di Pittura* (1509), quoted in W. S. Gibson, *'Mirror of the Earth': The World Landscape in Sixteenth-Century Flemish Painting* (Princeton University Press, 1989), p. 40.

22. Wood, *op. cit.*, p. 25.

23. Brown, J. and Elliott, J. H., *A Palace for a King: The Buen Retiro and the Court of Philip IV* (Yale University Press, 1980), pp. 125–31.

Chapter 3

1. Alberti, Leon Battista, *Ten Books of Architecture* (*c.*1452), trans. Leoni, 1986, p. 192.

2. Fernow, Ludwig, *Römische Briefe [...] 1793–1798*: see Timothy F. Mitchell, *Art and Science in German Landscape Painting* 1770–1840 (Oxford: Clarendon Press, 1993), p. 60.

3. Rand, William, 'Dedicatory Epistle', in *The Mirrour of the Nobility & Gentry: Being the Life of the renowned Nicolaus Claudius Fabricius, Lord of Peiresk* (London, 1657). Cited in E. W. Tayler, *Nature and Art in Renaissance Literature* (Columbia University Press, 1964), p. 25.

4. Tayler, E. W., *op. cit.*, p. 29. I am indebted to Tayler's discussion of the subject; see esp. Ch. 1, 'Renaissance Uses of Nature and Art'. There is also a useful survey of the various meanings of Art and Nature in A. J. Close, 'Commonplace Theories of Art and Nature in Classical Antiquity and in the Renaissance', *Journal of the History of Ideas* 30, October–December 1969, pp. 467–86.

5. Gracian, Baltasar (Maxim XII), *The Courtiers Manual Oracle* (1647, English trans., London: A. Swalle, 1685), p. 9.

6. Browne, Thomas, *Religio Medici* (1642), in G. Keynes (ed.) (London, 1928), p. 23.

7. Cicero, *De Natura Deorum*, trans. H. C. P. McGregor (Harmondsworth: Penguin, 1972), p. 185.

8. Lazzaro, Claudia, *The Italian Renaissance Garden: From the Conventions of Planting, Design, and Ornament to the Grand Gardens of Sixteenth-century Central Italy* (Yale University Press, 1990), pp. 8–10.

9. Ackerman, James S., *The Villa: Form and Ideology of Country Houses* (London: Thames & Hudson, 1990), p. 106.

10. *Ibid.*, p. 78.

11. Gallo, Agostino, *Le Dieci Giornale* (1566), in Ackerman (trans.), *op. cit.*, Appendix, pp. 129–30.

12. Pliny the Younger, Ep. V, vi, in *Letters and Panegyricus* I, trans. Betty Radice (London and Cambridge, Mass.: Harvard University Press, 1969), pp. 339–41.

13. Gibbons, Felton, *Dosso and Battista Dossi: Court Painters at Ferrara* (Princeton University Press, 1968), see esp. pp. 76–85.

14. da Vinci, Leonardo, *The 'Paragone'*, Sect. 13, in J. P. Richter (ed.), *The Literary Works of Leonardo da Vinci* (1883 (rev. 1939); 3rd edn, London: Phaidon, 1970), I, p. 162.

15. Bembo, Pietro, *Gli Asolani*, trans. R. Gottfried (Indiana University Press, 1954), p. 14.

16. *Ibid.*, pp. 94–5.

17. Ackerman, *op. cit.*, p. 131.

18. The term was used by Charles Lebrun in his inventory of Louis XIV's collection. See Francis Haskell, 'Giorgione's Concert Champêtre and its Admirers', in F. Haskell, *Past and Present in Art and Taste* (Yale University Press, 1987), pp. 141–53.

19. See, *inter alia*, the discussion by David Rosand, 'Giorgione, Venice, and the Pastoral Tradition', in R. Cafritz, L. Gowing, and D. Rosand (eds), *Places of Delight: The Pastoral Landscape* (Washington DC and London: The Phillips Collection and Weidenfeld and Nicolson, 1988).

20. Boccaccio, *Genealogia Deorum Gentilium* (completed *c.*1370s), in Charles G. Osgood, *Boccaccio on Poetry* (Princeton University Press, 1930), pp. 24, 26.

21. Sannazaro, Jacopo, *Arcadia* (1504), trans. Ralph Nash (Detroit: Wayne State University Press, 1966), p. 29.

22. Egan, Patricia, 'Poesia and the Fête Champêtre', *Art Bulletin* 41 (December 1959), pp. 303–13.

23. *La Villa: Dialogo di M. Bartolomeo Taegio* (Milan, 1559), trans. in J. Ackerman, *op. cit.*, p. 111.

24. Pope, Alexander, 'Epitaph intended for Sir Isaac Newton, in Westminster Abbey' (1730).
25. Cooper, Anthony Ashley, Third Earl Shaftesbury, 'The Moralists', from *Characteristics* (1711), Treatise V, Pt II, Sect. 5.
26. Cotton, Charles, 'The Wonders of the Peake' (1681): extract in J. Dixon Hunt and P. Willis, *The Genius of the Place: The English Landscape Garden 1620–1820* (London: Paul Eleck, 1975), p. 95.
27. Cooper, *op. cit.*, Pt III, Sect. 2.
28. Thomson, James, Preface to 2nd edn of *Winter. A Poem* (1726), in J. L. Robertson (ed.), *The Complete Poetical Works of James Thomson* (Oxford University Press, 1908), pp. 240–41.
29. Young, Arthur, *A Six Months Tour through the North of England* (London: W. Strahan, 1770), pp. 155–56.
30. Green, Nicholas, *op. cit.*
31. Lassus, Bernard, 'The New Spirit of the Place, or Taming the Heterogeneous' (1993), in Stephen Bann (trans.), 'The Landscape Approach of Bernard Lassus', *Journal of Garden History* (London and Washington DC: Taylor & Francis, April–June 1995), p. 105.

Chapter 4
1. da Vinci, Leonardo, *The 'Paragone'*, Sect. 13, in Richter, *op.cit.*, I, pp. 38, 54.
2. de Vries, Jan, 'The Dutch Rural Economy and the Landscape: 1590–1650', in Christopher Brown, *Dutch Landscape: The Early Years: Haarlem and Amsterdam 1590–1650* (London: National Gallery, 1986), pp. 79–86.
3. Vermeer's painting is the starting point for Svetlana Alpers's fine essay, 'The Mapping Impulse in Dutch Art', in *The Art of Describing—Dutch Art in the Seventeenth Century* (London: John Murray, 1983). My discussion of the affinities between maps and Dutch landscape paintings owes much to the stimulus of this essay.
4. See: *The Dutch Cityscape in the 17th Century and its Sources* (Amsterdams Historisches Museum and Art Gallery of Ontario, 1977).
5. Montias, J. M., *Artists and Artisans in Delft: A Socio-Economic Study of the Seventeenth Century* (Princeton University Press, 1982), pp. 145–6.
6. Price, J. L., *Culture and Society in the Dutch Republic During the 17th Century* (London: Batsford, 1974); see esp. Ch. 6, 'Painting—the Artist as Craftsman'.
7. Brown, *op. cit.*, p. 42.
8. Alpers, *op. cit.*, p. 139.
9. Stone-Ferrier, Linda, 'Views of Haarlem: A Reconsideration of Ruisdael and Rembrandt', *Art Bulletin* LXVII (1985), 3, pp. 417–36.

10. Norgate, Edward, *Miniatura [...]* (1648–49): eds J. M. Muller and J. Murrell (New Haven and London: Yale University Press, 1997).
11. Fuseli, Henri, 'Invention', Lecture IV, in R. N. Wornum (ed.), *Lectures on Painting, by the Royal Academicians* (London: H. G. Bohn, 1848), pp. 449–50.
12. Pallavicino, Sforza, *Del Bene* (1644), quoted and trans. in Helen Langdon, *Claude Lorrain* (Oxford: Phaidon, 1989), p. 13.
13. de Piles, Roger, *Cours de Peinture par Principes*: first English trans., in *The Principles of Painting* (London: J. Osborn, 1743), p. 124.
14. Kitson, Michael, 'The Seventeenth Century: Claude to Francisque Millet', in Alan Wintermute (ed.), *Claude to Corot: The Development of Landscape Painting in France* (New York: Colnaghi; in association with the University of Washington Press, 1990), p. 14.
15. Jouanny, C. (ed.), *Correspondance de Nicolas Poussin* (Paris, 1911), p. 424; quoted and trans. in Anthony Blunt, *Nicolas Poussin* (1967; London: Pallas Athene, 1995), p. 297.
16. Félibien, André, *Entretiens sur les vies et les ouvrages des plus excelents peintures anciens et modernes* (1685; 1725 edn), Cit. IV, pp. 63, 150; see Sheila McTighe, 'Nicolas Poussin', in Wintermute, *op. cit.*, pp. 54–6.
17. Reynolds, Joshua, *Discourses on Art* (London: Collier-Macmillan, 1966), p. 44.
18. *Ibid.*, p. 65.
19. See: M. Roethlisberger, *Claude Lorrain: The Drawings* (catalogue) (University of California Press, 1968), p. 222.

Chapter 5
1. Marshall, William, *A Review of the Landscape* (London: G. Nicol, 1795), pp. 255–6.
2. Eitner, Lorenz, 'The Open Window and the Storm-tossed Boat: An Essay in the Iconography of Romanticism', *Art Bulletin* (1955), pp. 281–90. (The quotation from Novalis is on p. 286.)
3. Vernet, Claude-Joseph, Letter of c.1765: trans. in P. Conisbee *et al.*, *In the Light of Italy: Corot and Early Open-Air Painting* (Washington, New Haven, and London: Yale University Press, 1997), p. 112.
4. Gilpin, William, *Remarks on Forest Scenery* (London: R. Blamire, 1791), II, p. 225.
5. Binder Johnson, Hildegard, 'The Framed Landscape', *Landscape* (1979), 23 (2), pp. 26–32.
6. Gilpin, *op. cit.*, p. 227.
7. Oenslager, Donald, *Stage Design: Four Centuries of Scenic Invention* (London: Thames & Hudson, 1975), p. 35.

8. Lagerlof, M. R., *Ideal Landscape: Annibale Caracci, Nicolas Caracci, Nicolas Poussin and Claude Lorrain* (Yale University Press, 1990), p. 213.

9. Mason, William (ed.), *The Poems of Mr Gray. To which are prefixed Memoirs of his Life and Writings* (London: J. Dodsley, 1775), p. 366 (n.).

10. Cassagne, A., *Practical Perspective applied to Artistic and Industrial Design*, trans. G. Murray Wilson (Paris: A. Fouraut, 1886), p. 17.

11. *Ibid.*, p. 18.

12. *Ibid.*, pp. 19–20.

13. Whitfield, Sarah, *Magritte*, Exhibition Catalogue, South Bank Centre, London, 1992 (no pagination, see text entry for Cat. No. 50).

14. Magritte, René, 'The Lifeline' (1938), in Harry Torczymer, *Magritte: Ideas and Images*, trans. Richard Miller (New York: Harry N. Abrams Inc., 1977), p. 216.

15. *Ibid.*, p. 215.

Chapter 6

1. Gray, Thomas, letters: to Richard West, November 1739; to Mrs Gray, October 1739: J. Beresford (sel.), *Letters of Thomas Gray* (Oxford: Oxford University Press, 1925), pp. 44–5, 39.

2. Walpole, Horace, letter: to Richard West: 30 September 1739: in P. Cunninham (ed.), *The Letters of Horace Walpole* (Edinburgh: John Grant, 1966), I, p. 27.

3. Alberli, J. L., 'Foreword', *Collection de quelques vues dessinees en Suisse d'apres nature* (1782), quoted in Pierre Chessex (trans.), *Images of the Grand Tour: Louis Ducros, 1748–1810* (Geneva: Editions du Tricorne, 1985), p. 17.

4. See: Wallace, Richard, *Salvator Rosa in America: Exhibition Catalogue* (Wellesley College Museum, Wellesley, Mass., 20 April–5 June 1979).

5. Burke, Edmund, *A Philosophical Enquiry into the Origin of our Ideas of the Sublime and Beautiful* (2nd edn: 1759), p. 110.

6. *Ibid.*, pp. 95–6.

7. Longinus, *On the Sublime*, Ch. 1, trans. T. S. Dorsch, Classical Literary Criticism (Harmondsworth: Penguin, 1965), p. 100.

8. Burke, *op. cit.*, p. 257.

9. Hartley, David, *Observations on Man, His Frame, His Duty, and His Expectations* (London: S. Richardson, 1749), I, p. 419.

10. Dennis, John, *Critical Works*, ed. E. N. Hooker (Baltimore: Johns Hopkins University Press, 1939–43), II, p. 380.

11. McKinsey, Elizabeth, *Niagara Falls: Icon of the American Sublime* (Cambridge University Press, 1985), p. 33. I am indebted to McKinsey's excellent study.

12. Cometti, Elizabeth (ed.), *The American Journals of Lt John Enys* (Syracuse University Press and Adirondack Museum, 1976), p. 138.

13. Moore, Thomas, letter from Niagara (24 July 1804): quoted in McKinsey, *op. cit.*, p. 41.

14. Hennepin, Louis, *A New Discovery of a Vast Country in America* (London, 1698), p. 24 facing.

15. Willis, N. P., *American Scenery* (London: G. Virtue, 1840), I, p. 26 facing.

16. [Robert Burford], *Description of a View of the Falls of Niagara* (London, 1833), p. 4 (fn.).

17. Hyde, Ralph, *Panoramania! The Art and Entertainment of the 'All-Embracing View'* (London: Trefoil Publications, 1988), p. 21.

18. *Ibid.*, p. 24.

19. *Ibid.*

20. Gernsheim, H. and A., *L. J. M. Daguerre: The History of the Diorama and the Daguerrotype* (London: Secker & Warburg, 1956), p. 6.

21. Dennis, John, *The Grounds of Criticism in Poetry* (1704), Ch. 4, reprinted in A. Ashfield and P. De Bolla (eds), *The Sublime: A Reader in Eighteenth-century Aesthetic Theory* (Cambridge University Press, 1996), p. 37.

22. Hyde, Ralph, *op. cit.*, pp. 57–8.

23. Quoted in Gernsheim, *op. cit.*, p. 24.

24. *Ibid.*, p. 30.

25. Wall, Jeff, interview, in T. de Duve, A. Pelenc, and B. Groys, *Jeff Wall* (London: Phaidon, 1996) p. 129.

26. Carus, Carl Gustav, *Nine Letters on Landscape Painting*, quoted and trans. in J. L. Koerner, *Caspar David Friedrich and the Subject of Landscape Painting* (London: Reaktion Books, 1990), p. 194.

27. Schiller, Friedrich, 'The Walk' ('Der Spaziergang') (1795), in *Poems and Ballads of Schiller*, trans. Lord Lytton (London: Routledge, 1887), pp. 141–50. I am grateful to Maurice Raraty for directing my attention to this poem.

28. Schiller, Friedrich, 'On Naïve and Sentimental Poetry', in W. Hinderer and D. O. Dahlstrom (eds), *Friedrich Schiller: Essays* (New York: Continuum, 1993), p. 180. (Original text pub. 1800.)

29. Burke, Edmund, *op. cit.*, p. 138, Pt II, Sect. xi.

30. Mitchell, Timothy, *Art and Science in German Landscape Painting, 1770–1840* (Oxford: Clarendon Press, 1993), pp. 121–3.

31. *Dreams of a Summer Night: Scandinavian Painting at the Turn of the Century*, Catalogue (London: Hayward Gallery, 1986).

32. Kant, Immanuel, *The Critique of Judgement*, trans. J. C. Meredith in *Analytic of the Sublime* (Oxford University Press, 1952), pp. 91–2.

33. Lyotard, 'The Sublime and the Avant-Garde' (1984), in Andrew Benjamin (ed.), *The Lyotard Reader* (Oxford: Blackwell, 1989) pp. 196–211.

34. Letter to Emile Bernard, Aix 1905, in John Rewald (ed.), *Paul Cézanne: Letters*, trans. Marguerite Kay (London: Bruno Cassirer, 1941), p. 250.

35. *Ibid.*, 23 October 1905, p. 251.

36. Bordy, Jules, *'Cézanne à Aix': L'Art Vivant* (Paris, 1926): reprinted in Richard Kendall (ed.), *Cézanne by Himself* (London: Macdonald Orbis, 1988), p. 296.

Chapter 7

1. Clark, Kenneth, *Landscape into Art* (London: John Murray, 1949), p. 6.

2. Cosgrove, Denis, *Social Formation and Symbolic Landscape* (University of Wisconsin Press, 1998 [first pub. Croom Helm, 1984]), p. 80.

3. White, John, *The Birth and Rebirth of Pictorial Space* (London: Faber & Faber, 1957), Ch. 6. See also the challenge to this analysis in J. M. Greenstein, 'The Vision of Peace: Meaning and Representation in Ambrogio Lorenzetti's Sala della Pace Cityscapes', *Art History* 11, No. 4, December 1988, pp. 492–509.

4. Zincgreff, J. W., *Emblematum Ethico—Politicorum Centuria* (Frankfurt, 1619).

5. See: Warnke, Martin, *Political Landscape: The Art History of Europe* (London: Reaktion Books, 1994), Chs 1 and 2.

6. Emerson, Ralph Waldo, *Nature* (1836), in G. Clarke (ed.), *The American Landscape: Literary Sources and Documents* (Sussex: Helm Information Ltd, 1993), II, p. 7.

7. Barrell, John, 'The Public Prospect and the Private View: the Politics of Taste in Eighteenth-century Britain', in Simon Pugh (ed.), *Reading Landscape: Country–City–Capital* (Manchester University Press, 1990), p. 29.

8. Emerson, *ibid.*, p. 5.

9. Baal-Teshuva, Jacob, *Christo and Jeanne-Claude* (Cologne: Taschen, 1995), p. 49.

10. Tiberghien, Gilles A., *Land Art* (Princeton Architectural Press, 1995), p. 204.

11. See: Green, Nicholas, *The Spectacle of Nature: Landscape and Bourgeois Culture in Nineteenth-century France* (Manchester University Press, 1990), and John House (ed.), *Landscapes of France: Impressionism and its Rivals* (London: Hayward Gallery, 1995).

12. Harris, Lawren, 'Revelation of Art in Canada: A History', *The Canadian Theosophist* (1926), pp. 85–6; quoted in Brian S. Osborne, 'The Iconography of Nationhood in Canadian

Art', in D. Cosgrove and S. Daniels (eds), *The Iconography of Landscape* (Cambridge University Press, 1988), pp. 162–78.

13. Cole, Thomas, 'Essay on American Scenery' (1836), in Graham Clarke (ed.), *The American Landscape: Literary Sources and Documents* (Sussex: Helm Information Ltd, 1993), II, pp. 337–47.

14. See, for example, Stephen Daniels, *Fields of Vision: Landscape Imagery and National Identity in England and the United States* (Cambridge: Polity Press, 1993), Ch. 5.

15. Cole, Thomas, quoted in Clarke, *op. cit.*

16. Meyers, Amy R. W., 'Imposing Order on the Wilderness: Natural History Illustration and Landscape Portrayal', in E. J. Nygren (ed.), *Views and Visions: American Landscape before 1830* (Washington: Corcoran Gallery of Art, 1986), pp. 105–31.

17. Mitchell, W. J. T., 'Imperial Landscape', in W. J. T. Mitchell (ed.), *Landscape and Power* (University of Chicago Press, 1994), p. 23.

18. Novak, Barbara, *Nature and Culture: American Landscape and Painting 1825–1875* (1990; rev. Oxford University Press, 1995), p. 20.

19. Tuckerman, H. T., *Book of the Artists* (New York and London, 1867), p. 395.

20. Novak, *op. cit.*, p. 189.

21. Austen, Jane, *Northanger Abbey* (first pub. 1818; Harmondsworth: Penguin English Library, 1972), pp. 125–6.

22. Gilpin, William, *Observations on the River Wye, and Several Parts of South Wales, &c. relative Chiefly to Picturesque Beauty* (London: R. Blamire, 1782), pp. 1–2.

23. Pope, Alexander, *Epistle to Burlington* (1731), lines 187–90.

24. Solkin, David H., *Richard Wilson: The Landscape of Reaction* (London: Tate Gallery, 1982), p. 26.

25. Particularly fruitful and influential have been the following works: John Barrell, *The Dark Side of the Landscape* (Cambridge University Press, 1980); Ann Bermingham, *Landscape and Ideology* (London: Thames & Hudson, 1986). Michael Rosenthal's study, *Constable: The Painter and his Landscape* (New Haven: Yale University Press, 1983), is also a valuable re-reading of his subject.

26. Denham, Sir John, *Cooper's Hill* (1668), ll. 203–4, 207–12.

27. Price, Sir Uvedale, *Essay on the Picturesque* (1796), I, p. 39 (n.).

28. Barrell, John, *The Dark Side of the Landscape: The Rural Poor in English Painting 1730–1840* (Cambridge University Press, 1980), p. 149.

29. Clark, Kenneth, *op. cit.*, p. 77.

30. Barrell, *op. cit.*, pp. 148–9.

31. Letter from Constable (in London) to Fisher, 9 May 1823; in *John Constable's Correspondence*, ed. R. B. Beckett (Suffolk Records Society, 1968), VII, p. 116.

32. Letter from Fisher to Constable, January 1824; *ibid.*, VI, p. 151.

33. Helsinger, Elizabeth, *Rural Scenes and National Representation: Britain, 1815–1850* (Princeton University Press, 1997).

34. House, John, *op. cit.*, p. 25.

Chapter 8

1. The reported account was told to Ruskin by the Revd William Kingsley and was published in *Modern Painters* V (1860), IX, Ch. xii, para. 4, fn. 1. See also John Gage, *J. M. W. Turner: 'A Wonderful Range of Mind'* (Yale University Press, 1987), pp. 67–8.

2. Cornish, Joe, 'Recognising the Landscape', *National Trust Magazine* 85 (Autumn 1998), pp. 38–41.

3. Quoted in Joachim Gasquet, *Cézanne* (Paris, 1926); reprinted in R. Kendall (ed.), *Cézanne by Himself* (London: Macdonald, 1988), p. 302.

4. Ritter, Carl, lecture 14 April 1836; quoted in Timothy Mitchell, *Art and Science in German Landscape Painting 1770–1840* (Oxford: Clarendon Press, 1993), p. 141.

5. Mitchell, *op. cit.*, p. 6.

6. Vernet, Claude-Joseph, Letter *c.* 1765; quoted and trans. in P. Conisbee *et al.*, *In the Light of Italy: Corot and Early Open-Air Painting* (Washington, New Haven, and London: Yale University Press, 1997), p. 112.

7. Ruskin, John, *Modern Painters* (London: George Allen, 1906), I, p. xxxviii, 'Preface to the Second Edition'.

8. *Ibid*, I, pp. xli–xlii.

9. Constable, John, Lecture III (delivered at Royal Institution, London, 1836), in R. B. Beckett (ed.), *John Constable's Discourses* (Suffolk: Suffolk Records Society, vol. XIV, 1970) p. 64.

10. Slive, Seymour and Hoetnik, H. R., *Jacob van Ruisdael* (New York: Abbeville Press, 1981), p. 71.

11. Beckett, R. B., *John Constable's Correspondence* (6 vols, 1962–68), IV, p. 382; cited in L. Parris, I. Fleming-Williams, and C. Shields, *Constable: Paintings, Watercolours & Drawings* (London: Tate Gallery, 1976), p. 156.

12. *Ibid.*, p. 164.

13. Runge, Philipp Otto, *Hinterlassene Schrifte*, I, ed. D. Runge (Hamburg, 1840–1), p. 7; trans. in Mitchell, *op. cit.*, p. 70.

14. *Conversations of Goethe with Eckermann and Soret*, trans. John Oxenford (London: Bell & Sons, 1906), p. 562.

15. Carus, Carl Gustav, *9 Letters on Landscape Painting* (1831): quoted and trans. in Timothy Mitchell, *op. cit.*, p. 152.

16. In the discussion of Carus and Rottman I am indebted to Timothy Mitchell's stimulating study, *op. cit.*

17. Lindsay, Jack, *J. M. W. Turner: His Life and Work* (New York: Harper & Row, 1966), p. 148.

18. [Joseph Pott], 'An Essay on Landscape Painting' (London, 1782), p. 67.

19. For an account of the studio at Les Collettes, see: Jean Renoir, *Renoir, My Father*, trans. R. and D. Weaver (London: Collins, 1962), pp. 400–1; for Renoir on the 'intoxication of real light', see Michael Howard (ed.), *The Impressionists by Themselves* (London: Conran Octopus, 1992), p. 192.

20. Valenciennes, *Elements*, p. 409; quoted and trans. in Peter Galassi, 'The Nineteenth Century: Valenciennes to Corot', in Alan Wintermute, *Claude to Corot: The Development of Landscape painting in France* (New York: Colnaghi, 1990), p. 244.

21. Courthion, P., *Corot raconté par lui-même et par ses amis* (Geneva, 1946), p. 89.

22. Cézanne, Paul, reported conversation in Jules Bordy, 'Cézanne à Aix', *L'Art Vivant* (Paris, 1926), quoted in Kendall, *op. cit.*, p. 296.

23. Emile Bernard, 'Paul Cézanne', *L'Occident*, Paris, July 1904: trans. in L. Gowing, *Watercolour and Pencil Drawings by Cézanne* (London, 1973).

24. Rolston, Holmes III, 'Does Aesthetic Appreciation of Landscapes need to be Science-based?', *British Journal of Aesthetics* 35, No. 4 (October 1995), p. 379.

25. Monet, Claude, letter to Gustave Geffroy (7 October 1890), in Howard, *op. cit.*, p. 201.

26. Renoir, Jean, *op. cit.*, p. 30.

27. Hopkins, Gerard Manley, journal entry (19 July, 1866), in H. House and G. Storey (eds), *The Journals and Papers of Gerard Manley Hopkins* (Oxford University Press, 1959), p. 146.

28. *Cézanne in Conversation:* Kendall, *op. cit.*, p. 296.

29. Machotka, Pavel, *Cézanne: Landscape into Art* (New Haven: Yale University Press, 1996), p. 115.

Chapter 9

1. Heizer, Michael, 'Interview, Julia Brown and Michael Heizer', in Julia Brown (ed.), *Sculpture in Reverse* (Los Angeles: Museum of Contemporary Art, 1984), p. 14.

2. Smithson, Robert, 'A Sedimentation of the Mind: Earth Projects', *Artforum*, September 1968; reprinted in Nancy Holt (ed.), *The Writings of Robert Smithson: Essays*

with Illustrations (New York University Press, 1979), p. 82.

3. Smithson, Robert, 'Fragments of a Conversation' (1969), *ibid.*, p. 168.

4. Penone, Guiseppe, quoted in Jessica Bradley, *Guiseppe Penone* (National Gallery of Canada, Ottawa, 1983), p. 18.

5. Smithson, Robert, 'Earth' (Symposium at White Museum, Cornell University, 1970); reprinted in Holt, *op. cit.*, p. 160.

6. Smithson, Robert, 'A Sedimentation of the Mind: Earth Projects', *Artforum*, September 1968; reprinted in Holt, *op. cit.*, pp. 89–90.

7. Smithson, Robert, 'The Spiral Jetty', in Gyorgy Kepes (ed.), *Arts of the Environment* (England: Aidan Ellis, 1972); reprinted in Holt, *op. cit.*, p. 111.

8. Much of the following information about Michael Heizer's work comes from private conversations with the artist.

9. Smithson, Robert, 'Frederick Law Olmsted and the Dialectical Landscape', *Artforum*, February 1973; reprinted in Holt, *op. cit.*, pp. 122–3.

10. Long, Richard, quoted in Suzi Gablick, *Has Modernism Failed?* (London: Thames & Hudson, 1984), p. 44.

11. Long, Richard, quoted in R. Fuchs, *Richard Long* (New York and London, 1986), p. 236. (Unless indicated otherwise, subsequent quotations from Long are from the same source.)

12. André, Carl, interviewed in December 1968, *Avalanche*, Fall 1970.

13. Long, Richard, 'Entretien avec Claude Gintz', *Art Press*, June 1986, p. 7.

14. Long, Richard, quoted in William Malpas, *Land Art, Earthworks, Installations, Environments, Sculptures* (Worcestershire: Crescent Moon Publishing, 1997), p. 90.

15. Goldsworthy, Andy, interview with Matthew Shaul, in *Andy Goldsworthy 'Jack's Fold'* (University of Hertfordshire, 1996), p. 10.

16. *Ibid.*, p. 14.

17. Dompierre, Louise, *The Michael Snow Project: The Collected Writings of Michael Snow* (Ontario: Wilfred Laurier University Press, 1994), p. 53.

18. Sloan, Johanne, 'Millennial Landscapes' (unpublished doctoral thesis, University of Kent at Canterbury, 1998).

19. Dompierre, *op. cit.*, p. 79.

20. *Ibid.*, p. 59.

21. *Ibid.*, p. 58.

22. *Ibid.*, p. 56.

List of Illustrations

The publishers would like to thank the following individuals and institutions who have kindly given permission to reproduce the illustrations listed below.

1 Karen Knorr: *Pleasures of the Imagination: Connoisseurs*, 1986. Ciba chrome print, 115 × 115 cm. Courtesy the photographer/Interim Art, London.

2 Wolf Huber: *Landscape with Golgotha*, c.1525–30. Pen with watercolour and gouache on paper, 31.7 × 44.8cm. Universitätsbibliothek, Erlangen.

3 Ansel Adams: *Tenaya Creek, Dogwood, Rain, Yosemite National Park*, 1948. Photograph. Courtesy of the Ansel Adams Publishing Trust. All RightsReserved.

4 Joel Meyerowitz: *Broadway and West 46th Street, New York*, 1976. Photograph. Courtesy Joel Meyerowitz Photography & Film, New York.

5 Claude Monet: *Meadow with Poplars*, 1875. Oil on canvas, 54.5 × 65.5 cm.Courtesy, Museum of Fine Arts, Boston. Bequest of David P. Kimball in Memory of his wife, Clara Bertram Kimball.

6 Humphrey Repton: watercolour from the 'Red Book' for Longleat, 1804. Reproduced by permission of the Marquess of Bath, Longleat House, Warminster.

7 Vitaly Komar and Alex Melamid: *America's Most Wanted Painting*, 1994 (above), and *Denmark's Most Wanted Painting*, 1995–97 (below). Digitized images. Dia Center for the Arts, New York/Komar & Melamid Studio.

8 German Master (Lucas Cranach?): *Landscape*, c.1510. Pen on paper, 26.7 × 19.6 cm. Städelsches Kunstinstitut, Frankfurt-am-Main/photo Ursula Edelmann.

9 Lucas Cranach: *St Jerome*, 1509. Woodcut, 33.5 × 22.6 cm. © The British Museum, London.

10 Albrecht Dürer: *Little Pond House*, c.1497. Brush drawing with watercolour and body colour, 21.3 × 22.5 cm. © The British Museum, London.

11 Albrecht Dürer: *The Virgin and the Long-tailed Monkey*, c.1497–98. Engraving, 19.1 × 12.2 cm. Kupferstichkabinett, Berlin/Staatliches Museen zu Berlin Preussischer Kulturbesitz/photo Jörg P. Anders.

12 Giovanni Bellini: *St Francis in the Desert*, c.1480. Tempera and oil on poplar panel, 124.4 × 141.9 cm. The Frick Collection, New York.

13 Giovanni Bellini: *St Jerome in the Wilderness*, c.1450. Tempera on panel, 44.8 × 35.8 cm. Barber Institute of Fine Arts, Birmingham/photo The Bridgeman Art Library, London.

14 Giovanni Bellini: *St Jerome*, c. 1471–74. Predella panel (from the Pesaro Altarpiece). Oil on panel, 40 × 42 cm. Museo Civico, Pesaro/photo Scala, Florence.

15 Lorenzo Lotto: *St Jerome in the Wilderness*, 1506. Oil on panel, 48 × 40 cm. Musée du Louvre, Paris/photo The Bridgeman Art Library, London.

16 Lorenzo Lotto: *Allegory of Virtue and Vice*, 1505. Oil on panel, 56.5 × 42.2 cm. National Gallery of Art, Washington DC. Samuel H. Kress Collection.

17 Albrecht Altdorfer: *Landscape with a Footbridge*, c.1516. Oil on parchment, 41.2 × 35.5 cm. The National Gallery, London.

18 Albrecht Altdorfer: *Wild Man*, 1508. Pen and white heightening on red grounded paper, 21.6 × 14.9 cm. © The British Museum, London.

19 Joachim Patinir: *Landscape with St Jerome*, c.1515–19. Oil on panel, 74 × 91 cm. Museo del

Prado, Madrid/photo The Bridgeman Art Library, London.

20 Joachim Patinir: *Landscape with Rest on the Flight into Egypt*, c.1520–24. Oil on panel, 121 × 177 cm. Museo del Prado, Madrid/photo The Bridgeman Art Library, London.

21 Joachim Patinir: *Landscape with Charon Crossing the River Styx*, c.1520–24.Oil on panel, 64 × 103 cm. Museo del Prado, Madrid/photo The Bridgeman Art Library, London.

22 Raffaellino da Reggio: fresco, c.1570, showing the Villa Farnese, Caprarola, from the loggia of the Palazzina Gambara of the Villa Lante, Bagnaia. Photo The Bridgeman Art Library, London.

23 Michelozzo di Bartolomeo: Villa Medici, Fiesole, Florence, commissioned c.1455. Photograph, c.1910. Photo Alinari, Florence.

24 Andrea Palladio: Villa Rotonda (Villa Capra), begun 1550, Vicenza. Photo Scala, Florence.

25 Titian: *Pastoral Scene*, c.1565. Pen and brown ink, and black chalk, heightened with white gouache, 19.6 × 30.1 cm. The J. Paul Getty Museum, Los Angeles, CA.

26 Paolo Veronese: Landscape frescos, c.1560–62, Sala dell'Olimpo, Villa Barbaro, Maser. Photo Paolo Marton, Treviso.

27 Dosso and Battista Dossi: Camera delle Cariatide, c.1530, Villa Imperiale, Pesaro. Photo Scala, Florence.

28 Orsini Park, Pitigliano, begun c.1560: the viewing platform. Photo Ralph Lieberman, Williamstown, MA.

29 Giorgione: *Tempest*, 1505–10. Oil on canvas, 68 × 59 cm. Galleria dell' Accademia, Venice/photo The Bridgeman Art Library, London.

30 Giorgione or Titian: *Le Concert Champêtre*, c.1510. Oil on canvas, 109.9 × 137.8 cm. Musée du Louvre, Paris/photo Réunion des Musées Nationaux.

31 Unknown artist: *Chatsworth, Derbyshire*, 1707–11. Oil on canvas, 290 × 316 cm. Private Collection/photo Country Life Picture Library, London.

32 Heveningham Hall: engraving, c.1781. Photo Country Life Picture Library, London.

33 John Bachmann: View of Central Park, New York, 1863. Lithograph. The New York Historical Society.

34 Bernard Lassus: Avenue and Ruined Portico of Nîmes Theatre, Aire de Nîmes-Caissargues, 1992. Photo Malcolm Andrews.

35 Bernard Lassus: Belvedere and Distant View of Nîmes, Aire de Nîmes-Caissargues, 1992. Photo Malcolm Andrews.

36 Netherlandish School: *Landscape: A River among Mountains*, mid-sixteenth century. Oil on wood, 50.8 × 68.6 cm. The National Gallery, London.

37 Peeter Snayers: *The Infanta Isabella Clara Eugenia at the Siege of Breda of 1624*, c.1630. Oil on canvas, 200 × 265 cm. Museo del Prado, Madrid/photo The Bridgeman Art Library, London.

38 El Greco: *View and Plan of Toledo*, c.1610–14. Oil on canvas, 132 × 228 cm. Museo del Greco, Toledo/photo Institut Amatller d'Art Hispànic, Barcelona.

39 Leonardo da Vinci: *Landscape* (Arno Valley?), 1473. Pen and ink drawing, 19 × 28.5 cm. Galleria degli Uffizi, Florence/photo Alinari.

40 Leonardo da Vinci: *Bird's-eye View of Western Tuscany*, c.1502. Pen and ink, and wash, over black chalk, 27.5 × 40.1 cm. The Royal Collection © Her Majesty Queen Elizabeth II.

41 Leonardo da Vinci: *Bird's-eye View of Southern Tuscany—Val di Cjiana*, c.1502. Pen and ink and watercolour, 33.8 × 48.8 cm. The Royal Collection © Her Majesty Queen Elizabeth II.

42 Claes Jansz. Visscher: *Gallia*, 1650. Engraving. Bibliothèque Nationale, Paris.

43 Jacob van der Croos: *View of The Hague with Twenty Scenes in the Neighbourhood*, 1661-63. Oil on canvas, 62 × 123 cm (centre panel), 17.5 × 32 cm (border panels). Hague Historical Museum.

44 Claes Jansz. Visscher: *Plaisante Plaetsen*, 1608. Etchings, 10.2 × 16.5 cm. The British Museum, London.

45 Hendrick Goltzius: *Landscape with a Seated Couple*, from a set of landscapes, probably 1592–95. Chiaroscuro woodcut in ochre-sepia, olive and black, 11.4 × 14.7 cm. National Gallery of Art, Washington DC, Rosenwald Collection.

46 Hendrick Goltzius: *Dune Landscape near Haarlem*, 1603. Drawing, 8.7 × 15.3 cm. Museum Boijmans Van Beuningen, Rotterdam.

47 Jacob van Ruisdael: *View of Haarlem with Bleaching Grounds*, c.1670. Oil on canvas, 62.5 × 55.2 cm. The Professor Dr L. Ruzicka Foundation © 1999 Kunsthaus Zurich. All rights reserved.

48 Nicolas Poussin: *Landscape with Pyramus and Thisbe*, 1650–51. Oil on canvas, 192.5 × 273.5 cm. Städelsches Kunstinstitut, Frankfurt/photo Ursula Edelmann.

49 Nicolas Poussin: *Landscape with Man killed by a Snake*, 1648. Oil on canvas, 119.4 × 198.8 cm. The National Gallery, London.

50 Claude Lorrain (Claude Gellée): *Landscape with a Rustic Dance*, c.1640-41. Oil on canvas,

114 × 147 cm. By kind permission of the
Marquess of Tavistock and the Trustees of the
Bedford Estate, Woburn Abbey.

51 Claude Lorrain (Claude Gellée): *An Artist
Sketching*, c.1640. Black chalk with dark brown
wash on white paper, 21.4 × 32.1 cm. © The
British Museum, London.

52 Domenichino (Domenico Zampieri):
Landscape with Tobias laying hold of the Fish,
c.1615. Oil on metal, 45.1 × 33.9 cm. The
National Gallery, London.

53 Claude Lorrain (Claude Gellée):
Landscape with Hagar and the Angel, 1646–47.
Oil on canvas, 52.7 × 43.8 cm. The National
Gallery, London.

54 Claude Lorrain (Claude Gellée): *Landscape
with the Marriage of Isaac and Rebekah* ('The
Mill'), 1648. Oil on canvas, 149.2 × 196.9 cm.
The National Gallery, London.

55 Claude Lorrain (Claude Gellée): *Landscape
with Narcissus and Echo*, 1644. Oil on canvas,
94.6 × 118 cm. The National Gallery, London.

56 Peter Paul Rubens: *Autumn Landscape
with a View of Het Steen in the Early Morning*,
c.1636. Oil on wood, 131.2 × 229.2 cm.
The National Gallery, London.

57 Antonello da Messina: *St Jerome in his
Study*, c.1474. Oil on wood, 45.7 × 36.2 cm.
The National Gallery, London.

58 Christoffer W. Eckersberg: *A Pergola*,
1813–16. Oil on canvas, 34 × 28.5 cm. Statens
Museum for Kunst, Copenhagen/photo
Hans Petersen.

59 Friedrich Wasmann: View from a
Window, 1832–33. Oil on paper, 24.1 × 19.2 cm.
Kunsthalle, Hamburg/photo Elke Walford.

60 Johan Christian Dahl: *View from a Window
at Quisisana*, 1820. Oil on paper, 42.8 × 58.6 cm.
Rasmus Meyers Samlinger, Kunstmuseum,
Bergen/photo Geir S. Johannessen.

61 Eric Ravilious: *Train Landscape*, 1940.
Watercolour on paper, 44.1 × 54.8 cm. City of
Aberdeen Art Gallery and Museums. © The
Estate of Eric Ravilious. All rights reserved,
DACS 1999.

62 A Claude glass. Science Museum, London/
photo Science & Society Picture Library.

63 Paul Sandby: *Roslin Castle, Midlothian*,
c.1780. Pen and brown ink with watercolour
and body colour over pencil, 45.8 × 62.9 cm.
Yale Center for British Art (Paul Mellon
Collection), New Haven, CT.

64 Haus-Rucker-Co: *Rahmenbau*. Installation
at documenta 6, Kassel, 1977/photo Herkunff
(Stadtmuseum, Kassel).

65 Unknown (Italian) artist: *Landscape with
Rustic Houses and Waterfall*, seventeenth
century. Pen and bister, and watercolour,

27 × 35.1 cm. Pierpont Morgan Library,
York/photo Art Resource.

66 Nicolas Poussin: *Orpheus and Eurydice*,
c.1650. Oil on canvas, 120 × 200 cm. Musée du
Louvre, Paris/photo The Bridgeman Art
Library, London.

67 Joseph Wright of Derby: *Rydal Lower Fall*,
1795. Oil on canvas, 57.2 × 76.2 cm. Derby
Museum and Art Gallery.

68 Rydal Falls from the Summerhouse.
Photograph by David Lyons. The
Wordsworth Trust, Dove Cottage, Grasmere.

69 A. Cassagne: diagrams from *Traité
Pratique de Perspective* (1889 edition). The
British Library (7855.cc.35), London.

70 René Magritte: *La Condition Humaine*,
1933. Oil on canvas, 100 × 81 cm. National
Gallery of Art, Washington. Gift of the
Collectors Committee.© ADAGP, Paris,
and DACS, London, 1999.

71 Salvator Rosa: *Landscape with Soldiers and a
Huntsman*, ?mid-seventeenth century. Oil on
canvas, 142 × 192 cm. Musée du Louvre,
Paris/photo Réunion des Musées Nationaux.

72 Thomas Cole: *Salvator Rosa Sketching
Banditti*, c.1832–40. Oil on panel 17.8 × 24.1 cm.
Courtesy, Museum of Fine Arts, Boston, Gift
of Maxim Karolik for the M. and M. Karolik
Collection of American Paintings, 1815–1865.

73 Edgar Degas: *Landscape*, c.1892. Pastel on
paper, 42 × 55 cm. Collection Jan and Marie-
Anne Krugier-Poniatowski, Geneva.

74 Philippe Jacques de Loutherbourg:
An Avalanche in the Alps, 1803. Oil on canvas,
109.9 × 160 cm. © Tate Gallery, London.

75 Anonymous: *View of Niagara Falls*, 1697.
Engraving from Louis Hennepin, *New
Discovery of a Vast Country in America*
(London, 1698). Houghton Library,
Harvard University, Cambridge, MA.

76 H. Füssli: *View of Niagara Falls*,
c.1776. Etching and watercolour, 34.3 × 43 cm.
Royal Ontario Museum, Toronto.

77 W. H. Bartlett: *View Below Table Rock*,
1837. Engraving from N. P. Willis, *American
Scenery* (London, 1840). Houghton Library,
Harvard University, Cambridge, MA.

78 Jeff Wall: *Restoration*, 1993. Transparency
in lightbox, image 119 × 490 cm.
Kunstmuseum, Lucerne.

79 Caspar David Friedrich: *Wanderer above the
Sea of Mist*, 1818. Oil on canvas, 94.8 × 74.8 cm.
Kunsthalle, Hamburg/photo Elke Walford.

80 Caspar David Friedrich: *The Monk by the
Sea*, 1809. Oil on canvas, 110 × 171.5 cm.
Nationalgalerie, Berlin/Staatliche Museen
zu Berlin Preussischer Kulturbesitz/photo
Jörg P. Anders.

81 August Strindberg: *Lonely, Poisonous Mushroom*, 1892. Oil, 47.5 × 45 cm. Private Collection.

82 Paul Cézanne: *Le Pont des Trois Sautets*, c.1906. Watercolour, 40.8 × 54.3 cm. Cincinnati Art Museum. Gift of John J. Emery (1951.298).

83 Ambrogio Lorenzetti: *Good Government in the Country*, 1338–40. Fresco. Palazzo Pubblico, Siena/photo Scala, Florence.

84 J. W. Zincgreff: emblem from *Emblematum Ethico-Politicorum Centuria* (1619). The British Library (636.g.21(2)), London.

85 Christo and Jeanne-Claude: *Running Fence*, Sonoma and Marin Counties, CA, 1972–76. Fabric and poles, 5.5 m (h) × 40 k (l). © Christo 1976/photo Jeanne-Claude.

86 Thomas Cole: *The Course of Empire: The Savage State*, n.d. Oil on canvas, 99.7 × 160.6 cm. The New York Historical Society.

87 Thomas Cole: *The Course of Empire: Consummation*, c.1836. Oil on canvas,130.2 × 193 cm. .The New York Historical Society.

88 Thomas Cole: *View from Mount Holyoke, Northampton, MA, after a Thunderstorm — The Oxbow*, 1836. Oil on canvas, 130.8 × 193 cm. The Metropolitan Museum of Art. Gift of Mrs Russell Sage, 1908 (08.228)/photo © 1995 The Metropolitan Museum of Art, New York.

89 John Smibert: *View of Boston*, 1738. Oil on canvas, 76.2 × 127 cm. Child's Gallery, Boston/photo American Art Review.

90 Albert Bierstadt: *Surveyor's Wagon in the Rockies*, c.1859. Oil on paper mounted on masonite, 19.7 × 32.7 cm. St Louis Art Museum. Gift of J. Linnberger Davis (158:1953).

91 Albert Bierstadt: *The Rocky Mountains, Lander's Peak*, 1863. Oil on canvas, 186.7 × 306.7 cm. The Metropolitan Museum of Art, Rogers Fund, 1907 (07.123)/photo © 1985 The Metropolitan Museum of Art, New York.

92 John Harris the Younger: *Dunham Massey, Cheshire*, c.1750. Oil on canvas, 170 × 172.7 cm. The National Trust Photographic Library/ photo Angelo Hornak.

93 Johann Zoffany: *John, 3rd Duke of Atholl and Family*, 1767. Oil on canvas, 91.4 × 160 cm. Blair Castle, Pitlochry, Perthshire.

94 Richard Wilson: *Extensive Landscape with Lake and Cottages*, c.1744–45. Oil on canvas, 81.3 × 124.5 cm. Photo Christie's Images, London.

95 John Constable: *The Hay-Wain* ('Landscape: Noon'), 1821. Oil on canvas, 130.2 × 185.4 cm. The National Gallery, London.

96 J. M. W. Turner: *Snow Storm — Steam-Boat off a Harbour's Mouth*, 1842. Oil on canvas, 91.4 × 121.9 cm. © Tate Gallery, London.

97 Carl Johan Lindström: *The French Painter*, 1828–30. Pen and watercolour, 19.3 × 25.8 cm. Nationalmuseum, Stockholm/photo Statens Konstmuseer.

98 Pierre Auguste Renoir: *Le Coup de Vent*, c.1878. Oil on canvas, 52 × 82.5 cm. Fitzwilliam Museum, University of Cambridge.

99 Joe Cornish: *Ravenscar, Yorkshire* (view from Boggle Hole Beach). Photograph, 1997. The National Trust Photograph Library, London.

100 John Constable (after Jacob van Ruisdael): *Winter*, 1832. Oil on canvas, 58.1 × 70.8 cm. Trustees of the Will of H. G. Howe deceased, on loan to the Minories, Colchester.

101 Jacob van Ruisdael: *The Jewish Cemetery*, 1655–60. Oil on canvas, 142.2 × 189.2 cm. Detroit Institute of Arts. Gift of Julius H. Haass in memory of his brother Dr Ernest W. Haass.

102 Carl Rottmann: *Sikyon and Corinth*, 1836–38. Encaustic on plaster, 157 × 200 cm. Bayerische Stadtgemäldesammlungen/photo The Bridgeman Art Library, London.

103 J. M. W. Turner: *Frosty Morning*, 1813. Oil on canvas, 113.7 × 174.6 cm. © The Tate Gallery, London.

104 J. M. W. Turner: *Morning amongst the Coniston Fells, Cumberland*, 1798. Oil on canvas, 122.9 × 89.9 cm. © Tate Gallery, London.

105 Pierre-Henri de Valenciennes: *Rocca di Papa in the Mist*, c.1782–84. Oil on paper, 15.1 × 28.5 cm. Musée du Louvre, Paris/photo Réunion des Musées Nationaux.

106 Pierre-Henri de Valenciennes: *Rocca di Papa under Clouds*, c.1782–84. Oil on paper, 14.4 × 29.7 cm. Musée du Louvre, Paris/photo Réunion des Musées Nationaux.

107 Claude Monet: *Grainstack*, 1890–91. Oil on canvas, 65.7 × 92.1 cm. Art Institute of Chicago. Restricted Gift of the Searle Family Trust; Major Acquisitions Centennial Endowment; through prior acquisition of the Mr and Mrs Martin A. Ryerson and Potter Palmer Collection; through prior bequest of Jerome Friedman (1983.29)/photo © 1998 The Art Institute of Chicago. All rights reserved.

108 Claude Monet: *Grainstack (Sunset)*, 1891. Oil on canvas, 73.3 × 92.6 cm. Courtesy, Museum of Fine Arts, Boston. Juliana Cheney Edwards Collection.

109 Gerard Manley Hopkins: 'Study from the Cliff above Freshwater Gate, July 23', 1863.

Pen drawing. From the *Journals and Papers of Gerard Manley Hopkins*, ed. H. House and G. Storey (Oxford, 1959). © The Society of Jesus, 1959, by permission of Oxford University Press.

110 Gerard Manley Hopkins: 'Shanklin, Isle of Wight', 1866. Pen drawing. Bodleian Library, Oxford (MS.Eng.Misc.a.8, f.104r). From the *Journals and Papers of Gerard Manley Hopkins*, ed. H. House and G. Storey (Oxford, 1959). © The Society of Jesus, 1959, by permission of Oxford University Press.

111 Gustav Fjaestad: *Winter Evening by a River*, 1907. Oil on canvas, 150 × 185 cm. Nationalmuseum, Stockholm/photo Statens Konstmuseer.

112 Mont Sainte-Victoire, *c.*1930s. Photograph by John Rewald.

113 Paul Cézanne: *Le Mont Sainte-Victoire vu des Lauves*, 1902–06. Oil on canvas, 65 × 81 cm. Philadelphia Museum of Art. Gift of Mrs Louis C. Madeira.

114 Walter De Maria: *New York Earth Room*, 1977. Courtesy the artist. Copyright © Dia Center for the Arts, 1980/photo John Cliett.

115 Anselm Kiefer: *Märkische Sand IV*, 1977, pp. 26–27. Linseed oil and sand on bound original photographs and fibrous wallpaper, cardboard cover and original photographs. 42.5 × 60 × 5 cm. Private Collection/photo courtesy the artist.

116 Giuseppe Penone: *The Tree will Continue to Grow except at this Point*. Installation, Garessio, 1968–78. Courtesy the artist (Marian Goodman Gallery, New York).

117 The Bangor Quarry, 1968. Photograph by Virginia Dwan.

118 Robert Smithson: *Non-Site* (Slate from Bangor, PA), 1968. Slate, wood, 15.2 × 101.6 × 81.3 cm. Photo courtesy of Dwan Gallery Archives. © Estate of Robert Smithson/ VAGA, New York, and DACS, London, 1999.

119 Robert Smithson: *Spiral Jetty* (under construction), Great Salt Lake, Utah,

1969–70. Mud, salt crystals, rocks. L of spiral 457.2 m; W of spiral 4.6 m. Photo Gianfranco Gorgoni/© Estate of Robert Smithson/ VAGA, New York, and DACS, London, 1999.

120 Michael Heizer: *Double Negative*, 1969. Mormon Mesa, Overton, Nevada. 243,900 tonnes displacement in rhyolite and sandstone, 457.2 × 15.2 × 9.1 m. Museum of Contemporary Art, Los Angeles/photo courtesy the artist.

121 Michael Heizer: *Displaced/Replaced Mass*, 1969. Silver Springs, Nevada, commissioned by Robert Scull. Three granite rocks. Weight: 30.5, 73.2 and 43.7 tonnes, 30.5 × 243.8 × 2.89 m. Photos courtesy the artist.

122 Robert Smithson: study for *Floating Island to Travel around Manhattan Island*, 1970. Pencil drawing, 47 × 59.7 cm. Collection of Joseph E. Seagram & Sons, Inc., New York/ © Estate of Robert Smithson/ VAGA, New York, and DACS, London, 1999.

123 Christo and Jeanne-Claude: *Surrounded Islands*, Biscayne Bay, Greater Miami, Florida, 1980-83. 585,000 square metres of fabric floating around 11 islands. © Christo, 1983/photo Wolfgang Volz.

124 Richard Long: *Wind Line, A Straight Ten Mile Northward Walk on Dartmoor*, 1985. Courtesy the artist (Anthony d'Offay Gallery, London).

125 Richard Long: *Walking a Line in Peru*, 1972. Photograph courtesy the artist (Anthony d'Offay Gallery, London).

126 Andy Goldsworthy: *Jack's Fold*, 1996. Installation at Margaret Harvey Gallery, University of Hertfordshire, St Albans. Photo courtesy the artist.

127 Derwentwater from Ashness Bridge: postcard by The Salmon Studios, Sevenoaks.

128 Desavary: J.-B.-C. Corot at work. Photograph, n.d. © Archives Photographiques, Paris © CNMHS.

129 Michael Snow beside the camera during the filming of *La Région Centrale*, 1969. Photo Joyce Wieland.

Bibliographic Essay

The literature on landscape and its relation to art in the West is vast and diverse. Discussions of landscape in art have increasingly drawn on a range of disciplines beyond art history: geography (both physical and human), sociology, psychology, aesthetic philosophy, economic, political and cultural history, imaginative literature, and environmental sciences. The list continues to expand as the richness and complexity of the subject intensifies and as it is re-embedded in contexts beyond pure art history. This bibliography concentrates almost wholly on those titles available in English and is designed to represent the diversity of writings on the subject as well as to indicate key texts on particular national landscape traditions and on some of the principal individual landscape artists. There is always an overlap between the various bibliographic categories offered, a further reflection of the interdisciplinary character of studies of landscape and art.

The idea of landscape:
cultural and political approaches

Debates about the significance of landscape as a cultural construction have produced a number of stimulating studies in the last decade or two, including the following monographs and collections of essays. In these, which cover a broad span of periods and western national traditions, the political, cultural, and economic forces shaping the idea of landscape are discussed: **D. W. Meinig** (ed.), *The Interpretation of Ordinary Landscape* (Oxford, 1979); **Denis Cosgrove**, *Social Formation and Symbolic Landscape* (Croom Helm, 1984; Wisconsin, 1998); **Denis Cosgrove** and **S. Daniels** (eds), *The Iconography of Landscape* (Cambridge, 1988);

Simon Pugh (ed.), *Reading Landscape: Country–City–Capital* (Manchester, 1990); **Stephen Daniels**, *Fields of Vision: Landscape Imagery & National Identity in England and the United States* (Cambridge, 1993); **W. J. T. Mitchell** (ed.), *Landscape and Power* (Chicago, 1994); **Martin Warnke**, *Political Landscape: the Art History of Europe* (London, 1994). In **B. Bender** (ed.), *Landscape: Politics and Perspectives* (Rhode Island and Oxford, 1993), the primacy of the European 'viewpoint' is challenged. See also **Stuart Wrede** and **William Howard Adams** (eds), *Denatured Visions: Landscape and Culture in the Twentieth Century* (New York, 1991). **Simon Schama's** compendious and absorbing study, *Landscape and Memory* (London, 1995), is a major contribution to the cultural contextualising of landscape art.

Landscape and environmental aesthetics

A classic study in this field, with a magisterial survey of the ways in which humans have deliberately shaped their physical surroundings across the centuries and in all parts of the world, is **Geoffrey and Susan Jellicoe's** *The Landscape of Man: Shaping the Environment from Prehistory to the Present Day* (London, 1975). Also of interest is **N. Newton**, *Design on the Land: the Development of Landscape* (Cambridge, Mass., 1971). The convergence of a number of disciplines related to landscape studies—among others, art history, cultural geography, architecture, aesthetic philosophy, and cultural anthropology—has produced a new field of study, focused in **Arnold Berleant's** *The Aesthetics of Environment* (Philadephia, 1992). The geographer **Jay Appleton** was early in this field with his exploration of habitat theory in *The Experience*

of Landscape (London and New York, 1975) and The Symbolism of Habitat: An Interpretation of Landscape and the Arts (Seattle and London, 1990). Several of the writers mentioned in the preceding section, **Stephen Daniels** and **Denis Cosgrove** inter alia, are geographers, and their work on landscape is addressed in **Steven Bourassa**'s The Aesthetics of Landscape (London and New York, 1991). A good specialist study of one distinguished figure in this field is **A. Fein**, Frederick Law Olmsted and the American Environmental Tradition (New York, 1972). Several essays in the collection The Biophilia Hypothesis, ed. **S. R. Kellert** and **E. O. Wilson** (Island Press, 1993) also address the issue of environmental aesthetics. There is an interesting speculative essay by **Holmes Rolston III**, 'Does Aesthetic Appreciation of Landscapes Need to be Science-based?', British Journal of Aesthetics 35, No. 4 (October, 1995), pp. 374–86. See also **A. E. Bye**, Art into Landscape; Landscape into Art (Arizona, 1983) and **Brenda Colvin**, Land and Landscape (London, 1970). The argument that scenic values are an essential part of the cultural life of nations is made forcefully in **Christopher Tunnard**, A World with a View: An Inquiry into the Nature of Scenic Values (New Haven and London, 1978).

Gardening, country estates, and landscape design

One of the most wide-ranging and stimulating introductions to garden history in the West, as well as one of the most handsomely illustrated, is **M. Mosser** and **G. Teyssot** (eds), The Architecture of Western Gardens: A Design History from the Renaissance to the Present (Cambridge, Mass., 1991). The Journal of Garden History (1981–) is a continuing focus for debate about the subject as well as being a valuable record of historical research. See also **J. Dixon Hunt**, Gardens: Theory, Practice, History (London, 1992). On Italian gardens see **Claudia Lazzaro**, The Italian Renaissance Garden: From the Conventions of Planting, Design and Ornament to the Grand Gardens of Sixteenth-Century Central Italy (New Haven and London, 1990) and **G. Masson**, Italian Gardens (London, 1961). For an excellent study of the development of the country villa and the significance of landscape settings, see **James S. Ackerman**, The Villa: Form and Ideology of Country Houses (London, 1990). The relationship between the British country house and its garden or parkland is exhibited in **John Harris**'s scholarly pictorial record,

The Artist and the Country House: A History of Country House and Garden View Painting 1540–1870 (London, 1979). On English landscape gardening see the valuable anthology of contemporary sources in **J. Dixon Hunt** and **P. Willis** (eds), The Genius of the Place: The English Landscape Garden 1620–1820 (London, 1975). **J. D. Hunt**'s study of the garden as the nexus of various cultural practices is seen in The Figure in the Landscape: Poetry, Painting, and Gardening during the Eighteenth Century (Baltimore, 1976). On French gardens see **K. Woodbridge**, Princely Gardens: The Origin and Development of the French Formal Style (London, 1986) and **D. Wiebenson**, The Picturesque Garden in France (Princeton, 1978). Particular studies of gardening traditions in other European countries include **C. M. Villiers Stuart**, Spanish Gardens (London, 1929) and **G. A. Jellicoe**, Baroque Gardens of Austria (London, 1932). On the landscaping of public parks, see **G. F. Chadwick**, The Park and the Town: Public Landscape in the 19th and 20th Centuries (London, 1966) and **G. Eckbo**, Urban Landscape Design (New York, Toronto and London, 1964). On the particular contribution of Bernard Lassus, see 'The Landscape Approach of Bernard Lassus—II', trans. and introduced by **Stephen Bann**, Journal of Garden History 15 No. 2 (April–June 1995), pp. 67–106.

The Sublime and the Picturesque

Standard early accounts of the Sublime and the Picturesque are **Walter J. Hipple Jr**, The Beautiful, the Sublime and the Picturesque in Eighteenth-century British Aesthetic Theory (Carbondale, Ill., 1957), and **C. Hussey**, The Picturesque: Studies in a Point of View (London and New York, 1927). See also **Samuel H. Monk**, The Sublime (Michigan, 1962) and **Malcolm Andrews**, The Search for the Picturesque: Landscape Aesthetics and Tourism in Britain, 1760–1800 (Aldershot and Stanford, 1989). **Andrews**'s The Picturesque: Sources and Documents (Sussex, 1994; three vols) anthologizes discussions of the Picturesque from the eighteenth century to middle-nineteenth century. A trenchant analysis of the Picturesque and the limitations of the distancing, pictorializing mode is contained in **John Barrell**, The Idea of Landscape and the Sense of Place 1730–1840 (Cambridge, 1972). The cultural and political ramifications of the Picturesque are explored and extended in **S. Copley** and **P. Garside** (eds), The Politics of the Picturesque: Literature,

Landscape and Aesthetics since 1770
(Cambridge, 1994). The latter collection
includes a suggestive essay by **David Punter**
on tensions between the Picturesque and the
Sublime. **Immanuel Kant**'s 'Analytic of the
Sublime' is in his *The Critique of Judgement*,
trans. **J. C. Meredith** (Oxford, 1952). See also
the essay by **Jean-François Lyotard** on 'The
Sublime and the Avant Garde' (1984) in
A. Benjamin (ed.), *The Lyotard Reader*
(Oxford, 1989).

Landscape representation, frames, and panorama technology

Kenneth Clark's *Landscape into Art* (London,
1949) retains an impressive authority as the
pioneering modern introduction to landscape
painting in the western tradition. The story
of the evolution of open-air painting is told in
Peter Galassi (ed.), *Corot in Italy: Open-Air
Painting and the Classical Landscape* (New
Haven, London, 1991). On the sense of frame
as constitutive of the picture, whether of
landscape or other subjects, three essays
are of particular interest: **W. Ayreshire**,
'The Philosophy of the Picture Frame',
International Studies (June 1926); **Hildegard
Binder Johnson**, 'The Framed Landscape',
Landscape 23 (1979), No. 2, pp. 26–32; **Alain
Roger**, 'Le Paysage Occidental: Retrospective
et Perspective'; *Le Débat* (May–June 1991), No.
65, pp. 14–28. Several essays in the same issue
of *Le Débat* explore problems of definition and
representation of landscape. See also **Vaughan
Cornish**, *Scenery and the Sense of Sight*
(Cambridge, 1935), for an analysis of the visual
perceptions of landscape. On the diorama and
panorama techniques, see **Helmut and Alison
Gernsheim**, *L. J. M. Daguerre: The History of
the Diorama and the Daguerreotype* (London,
1956); **R. Hyde**, *Panoramania! The Art and
Entertainment of the 'All-embracing View'*
(London, 1988).

Individual countries and artists

Britain

Michael Rosenthal, *British Landscape
Painting* (Oxford, 1982) is a valuable broad
introduction to the subject. **Geoffrey
Grigson**'s *Britain Observed: The Landscape
through Artists' Eyes* (London, 1975) is an
engaging chronological anthology of
landscapists working in Britain from the
sixteenth to the twentieth century. **Leslie
Parris**'s *Landscape in Britain 1750–1850*

(London, 1973) was the catalogue for an
important exhibition initiating a new wave
of interest in the subject. For the influence
of the Roman School and the Grand Tour on
eighteenth-century British landscape art see
D. Bull *et al.* *'Classic ground': British Artists and
the Landscape of Italy* (Yale, 1981). A number
of studies of the political ideologies informing
specifically eighteenth-century British
landscape art have been widely influential:
John Barrell, *The Dark Side of the Landscape:
The Rural Poor in English Painting 1730–1840*
(Cambridge, 1980); **David Solkin**, *Richard
Wilson: The Landscape of Reaction* (London,
1982); **Ann Bermingham**, *Landscape and
Ideology: The English Rustic Tradition*
(California and London, 1986). Romantic
landscape painting is attractively sampled
in **L. Hawes**, *Presences of Nature: British
Landscape, 1780–1830* (Yale, 1982). See also
Luke Hermann, *British Landscape Painting
of the 18th Century* (London, 1973). A special
study of the watercolourists' landscape work
of this period is **Lindsay Stainton**, *Nature into
Art: English Landscape Watercolours* (London,
1991). **Charlotte Klonk** explores relationships
between turn-of-the-century landscape art
and the intellectual background in *Science and
the Perception of Nature: British Landscape Art
in the Late Eighteenth and Early Nineteenth
Centuries* (New Haven and London, 1996).
Developments in the representation of the
Scottish landscape in art are focused in
J. Holloway and **L. Errington**, *The Discovery
of Scotland* (Edinburgh, 1978). British
landscape art as a metropolitan cultural form
has been examined in close detail in **Andrew
Hemingway**, *Landscape Imagery and Urban
Culture in Early Nineteenth-century Britain*
(Cambridge, 1992). Two studies of Pre-
Raphaelite landscape painting and photog-
raphy are **A. Staley**, *The Pre-Raphaelite
Landscape* (London, 1973) and **Michael
Bartram**, *The Pre-Raphaelite Camera: Aspects
of Victorian Photography* (London, 1985), Ch. 3.
Ian Jeffrey's *The British Landscape 1920–1950*
(1984) is a deft and lively introduction to its
subject.

On some of the principal individual
landscape artists see: **Kim Sloan**, *Alexander
and John Robert Cozens: The Poetry of
Landscape* (New Haven and London, 1986);
John Hayes, *The Landscape Painting of Thomas
Gainsborough* (London, 1982; two vols); **Mary
Woodall**, *Gainsborough's Landscape Drawings*
(London, 1939); **John Gage**'s fine study, *J. M.
W. Turner: 'A Wonderful Range of Mind'* (New
Haven and London, 1987). **Ruskin**'s major

critical homage to Turner is, of course, his *Modern Painters* (five vols, 1843–60), but there are other attractive testimonies to that relationship, such as **Ian Warrell**, *Through Switzerland with Turner* (London, 1995). See also **Andrew Wilton**, *Turner Abroad: France, Italy; Germany; Switzerland* (London, 1982) and *Turner and the Sublime* (London, 1980). On Constable, see **Ian Fleming-Williams**, *Constable: Landscape Watercolours and Drawings* (London, 1976). **Michael Rosenthal** in *Constable: The Painter and his Landscape* (New Haven and London, 1982) is particularly concerned to relate the landscape paintings to their social, economic, and political contexts. Two stimulating studies of Turner and Constable in relation to Romantic poetry are **K. Kroeber**, *Romantic Landscape Vision: Constable and Wordsworth* (London, 1975) and **R. Paulson**, *Literary Landscape: Turner and Constable* (New Haven, 1982). For Constable's own views on his art see **R. B. Beckett** (ed.), *John Constable's Correspondence* (Ipswich, 1962–68; seven vols) and *John Constable's Discourses* (Ipswich, 1970). **Roger Cardinal**'s *The Landscape Vision of Paul Nash* (London, 1989) is an acute study of the sharp sense of place for this artist.

France
A lively group of essays on early French landscape art can be found in **A. Wintermute** (ed.), *Claude to Corot: The Development of Landscape Painting in France* (New York, 1990). See also **Robert Cafritz**, 'Rococo Restoration of the Venetian Landscape and Watteau's Creation of the Fête Galante', in Robert Cafritz *et al.*, *Places of Delight* (London, 1988). Ch. 6 in **P. Conisbee**, *Painting in Eighteenth-century France* (Oxford and New York, 1981) concentrates on landscape painting. Taking the story on from there is the collection of essays by **K. S. Champa** *et al.*, *The Rise of Landscape Painting in France: Corot to Monet* (New Hampshire, 1991).

Landscape as a cultural commodity arising out of particular developments in urban planning in early nineteenth-century Paris is explored in **Nicholas Green**'s *The Spectacle of Nature: Landscape and Bourgeois Culture in Nineteenth-century France* (Manchester, 1990). For the influence of the State and the Academy on French landscape art in this period see **John House**, *Landscapes of France: Impressionism and its Rivals* (London, 1995); **A. Boime**, *The Academy and French Painting in the Nineteenth Century*

(London, 1971). See also **J. Bouret**, *The Barbizon School and 19th Century Landscape Painting* (London, 1973). The literature on French Impressionist landscape art is enormous and the reader will find, listed separately under individual artists, further titles below. Broader surveys since **John Rewald**'s magisterial *History of Impressionism* (New York, 1946) include the following: **R. R. Bretell** *et al.*, *A Day in the Country: Impressionism and the French Landscape* (Los Angeles, 1984); **R. Thomson**, *Monet to Matisse: Landscape Painting in France 1874–1914* (Edinburgh, 1994).

On individual artists see the following. The authoritative survey of the full range of Claude's paintings is **M. Roethlisberger**, *Claude Lorrain: The Paintings* (New Haven, 1961; two vols). **Helen Langdon**'s *Claude Lorrain* (Oxford, 1989) is a biographical and historical study of the painter. See also **Michael Kitson**'s *Claude Lorrain: 'Liber Veritatis'* (London, 1978). **Anthony Blunt**'s, *Nicolas Poussin* (London, 1967; rev. 1995; two vols) is the most detailed study. See also **C. Whitfield**, 'Poussin's Early Landscapes', *Burlington Magazine* 121 (1979), pp. 10–19. The landscape of Poussin's brother-in-law, Gaspard Dughet, is the subject of a valuable study by **Anne French**, *Gaspar Dughet, called Gaspar Poussin, 1615–75* (London, 1980). **Michael Clarke**, *Corot and the Art of Landscape* (London, 1991) is the fullest discussion of landscape in this painter's work. There is also interesting commentary on it in **M. Pantazzi, V. Pomarede** and **G. Tinterow**, *Corot* (New York, 1997). **Richard Kendall**'s *Degas Landscapes* (New Haven and London, 1993) is a detailed and extensive critical survey of a painter who was unexpectedly prolific in landscapes. **P. Hayes**, *Monet in the '90s* (London, 1990) is excellent on the series paintings of the 1890s. A detailed and well-focused monograph on Monet's landscapes is **John House**'s *Monet: Nature into Art* (New Haven, 1986). **R. Kendall**, *Cézanne by Himself* (London, 1988) is an absorbing anthology of the artist's comments on his art. A fine discussion of the relation of Cézanne's painted landscapes to the original sites is to be found in **P. Machotka**, *Cézanne: Landscape into Art* (New Haven and London, 1996). See also **Francoise Cachin** *et al.*, *Cézanne* (Philadelphia, 1996) and **R. Brettell**, *Pissaro and Pontoise: The Painter in a Landscape* (New Haven, 1977; 2nd edn New Haven and London, 1990).

Belgium and The Netherlands

Walter Gibson's *Mirror of the Earth: The World Landscape in Sixteenth-Century Flemish Painting* (Princeton, 1989) is a study principally of Lowlands painting and the panoramic landscapes in the Renaissance, and has some interesting points to make about the work of Patinir and de Momper, and Pieter Breughel in particular. Cross-fertilization between the great seventeenth-century European landscape traditions, the Dutch and the Roman, and between Venetian and northern European landscape painting are the subject of, respectively, **Walter Stechow**'s *Italy through Dutch Eyes: Dutch Seventeenth-century Landscape Artists in Italy* (Michigan, 1964) and **Robert Cafritz**'s 'Netherlandish Reflections of the Venetian Landscape Tradition' and 'Reverberations of Venetian Graphics in Rembrandt's Pastoral Landscapes', in R. Cafritz *et al.*, *Places of Delight* (London and Washington, 1988). **Walter Stechow** is also the author of the classic study, *Dutch Landscape Painting of the Seventeenth Century* (London, 1966). Some useful essays on the economic, political, and cultural context for the rise of landscape painting in early seventeenth-century Holland are collected in **Christopher Brown**, *Dutch Landscape: The Early Years: Haarlem and Amsterdam* (London, 1986); and in **P. C. Sutton** *et al.*, *Masters of 17th-century Dutch Landscape Painting* (Amsterdam and Philadelphia, 1988). Particularly worth noting in the latter collection is **A. Chong**'s 'The Market for Landscape Painting in Seventeenth-century Holland'. One of the most stimulating explorations of the relations between Dutch landscape painting and cartography in this period is **Svetlana Alpers**'s 'The Mapping Impulse in Dutch Art', in **David Wood** (ed.), *Art and Cartography: Six Historical Essays* (Chicago, 1987). See also **Alpers**'s *The Art of Describing; Dutch Art of the Seventeenth Century* (New York, 1984). Studies of individual landscape artists include the following: the fullest study of Patinir is by **Reindert Falkenburg**, *Joachim Patinir: Landscape as an Image of the Pilgrimage of Life* (Philadelphia, 1988). See also **R. Koch**, *Joachim Patinir* (Princeton, 1968). On Rubens and landscape, two extended studies stand out among others: **L. Vergara**, *Rubens and the Poetics of Landscape* (London, 1982) and **Christopher Brown**, *Rubens's Landscapes* (London, 1996). On Rembrandt, see **Cynthia Scheider**, *Rembrandt's Landscapes* (New Haven and London, 1990). The key study of Ruisdael's landscapes is **E. J. Walford**, *Jacob van Ruisdael*

and the Perception of Landscape (New Haven and London, 1991). **Seymour Slive** and **H. R. Hoetnik**, *Jacob van Ruisdael* (New York, 1981) is also a fine introduction. On Aelbert Cuyp, see **Stephen Reiss**, *Aelbert Cuyp* (Boston, 1975).

Italy

One of the fullest accounts of landscape painting in Italy in the early period is **Richard A. Turner**'s *The Vision of Landscape in Renaissance Italy* (Princeton, 1966). **Kenneth Clark**'s early chapters in *Landscape into Art* (London, 1949) are also useful in terms of broad summary. A classic and controversial essay on the origins of the landscape genre in Italy is **Ernst Gombrich**'s 'The Renaissance Theory of Art and the Rise of Landscape', *Norm and Form: Studies in the Art of the Renaissance* (London, 1966). An essay that also probes the origins of landscape painting is **Otto Pacht**'s 'Early Italian Nature Studies and the Early Calendar Landscape', *Journal of the Warburg and Courtauld Institutes* 13 (1950), pp. 13–47. The chapter 'Giorgione, Venice and the Pastoral Tradition' by **David Rosand** in **R. Cafritz** *et al.*, *Places of Delight: The Pastoral Landscape* (London and Washington, 1988) discusses *locus amoenus* and the rural idyll in sixteenth-century Italian painting, and relates them to contemporary revivals of pastoral in literature. In the same volume is **Robert C. Cafritz**'s essay on seventeenth-century Italian landscape developments, 'Classical Revision of the Pastoral Landscape'. Also on seventeenth-century landscape painting in Italy, see **A. S. Harris** and **R. L. Feigen**, *Landscape Painting in Rome, 1595–1675* (New York, 1985) and the lavish study of three seminal landscape artists working in Italy, **M. R. Lagerlof**'s *Ideal Landscape: Annibale Caracci, Nicolas Poussin and Claude Lorrain* (New Haven and London, 1990). The key contemporary missing from that trio is Salvator Rosa. The legend of Rosa's living with the banditti groups he so often painted was fostered in **Lady Morgan**'s *The Life and Times of Salvator Rosa* (London, 1824); and the story of Rosa's popularity in England is traced in **E. Manwaring**, *Italian Landscape in Eighteenth-Century England* (New York, 1925). The best modern study is **Jonathan Scott**, *Salvator Rosa: His Life and Times* (New Haven and London, 1995).

Germany

A provocative and closely focused study of Altdorfer and the Danube School in relation

to the emancipation of landscape from its conventionally accessory role is **Christopher Wood**'s monograph *Albrecht Altdorfer and the Origins of Landscape* (London, 1993). See also the essay by **Larry Silver**, 'Forest Primeval: Albrecht Altdorfer and the German Wilderness Landscape', *Simiolus* 13 (1983), No.1, pp. 5–43. The first two chapters of **Simon Schama**'s *Landscape and Memory* (London, 1995) open up the historical context for early German landscape valuation in art and literature. See also **Karen S. Pearson**, 'The Multi-media Approach to Landscape in German Renaissance Geography Books', in **S. Hindman** (ed.), *The Early Illustrated Book* (Washington DC, 1982). Landscape in the Romantic period is subjected to an absorbing investigation in **Timothy Mitchell**, *Art and Science in German Landscape Painting 1770–1840* (Oxford, 1993).

On Friedrich's landscape paintings, the fullest and best modern study is **Joseph Leo Koerner**, *Caspar David Friedrich and the Subject of Landscape* (London, 1990), See also **Alice A. Kuzniar**, 'The Temporality of Landscape: Romantic Allegory and C. D. Friedrich', *Studies in Romanticism* 28 (Spring 1989), pp. 69–93. On Anselm Kiefer, see **Gotz Adriani**, *The Books of Anselm Kiefer 1969–1990* (New York, 1990).

United States

On the relationship between landscape, art, and the sense of national identity, see **Albert Boime**, *The Magisterial Gaze: Manifest Destiny and American Landscape Painting, c. 1830–1865* (Washington DC, 1991). An excellent introduction to early American landscape painting is the exhibition catalogue edited by **E. J. Nygren**, *Views and Visions: American Landscape before 1830* (Washington, 1986). One of the most highly respected studies of the great nineteenth-century American landscape painters is **Barbara Novak**'s *Nature and Culture: American Landscape Painting 1825–1875* (New York, 1980). See also **Angela Miller**, *Empire of the Eye: Landscape, Representation and American Cultural Politics 1825–1875* (Ithaca, 1993). Specifically on Cole and the Hudson River School see **J. Howat** *American Paradise: The World of the Hudson River School* (New York, 1988); and on the Luminists, **J. Wilmering**, *American Light: The Luminist Movement, 1850–1875* (Washington DC, 1980). A useful overview is offered in **K. McShine** (ed.), *The Natural Paradise: Painting in America, 1801–1950* (New York, 1976), and

there is a searching essay by one of the most distinguished critic-historians of American landscape, **Leo Marx**, 'The American Ideology of Space', *Denatured Visions: Landscape and Culture in the Twentieth Century*, ed. **W. Wrede** and **W. H. Adams** (New York, 1991), pp. 2–78. A stimulating collection of essays is to be found in **M. Gidley** and **R. Lawson-Peebles** (eds), *Views of American Landscapes* (Cambridge, 1989). There is a very useful anthology of texts on American landscape, from the late seventeenth century onwards, compiled and edited by **Graham Clarke**, *The American Landscape: Literary Sources and Documents* (Sussex, 1993; three vols). On two of the most prominent nineteenth-century landscape artists, see **A. Wallach** and **W. Truettner** (eds), *Thomas Cole: Landscape into History* (New Haven, 1994) and **G. Hendricks**, *Albert Bierstadt: Painter of the American West* (New York, 1973).

Canada

M. Tooby, *The True North: Canadian Landscape Painting, 1896–1939* (London, 1991) demonstrates the vigorous flourishing of landscape art in early twentieth-century Canada, especially under the momentum of the Group of Seven. The group is more closely focused on in **Roger Boulet**, *The Canadian Earth: Landscape Paintings by the Group of Seven* (1982). See also **A. H. Robson**, *Canadian Landscape Painting* (London and Toronto, 1932) and **D. Reid**, *'Our Country Canada': Being an Account of the National Aspirations of the Principal Landscape Artists in Montreal and Toronto* (Ottawa, 1979).

Scandinavia

Nordic landscape art is discussed in the course of **Neil Kent**'s broad study, *The Triumph of Light and Nature: Nordic Art 1740–1940* (London, 1987), especially Chapters 3 and 6. More intensively focused is **Torsten Gunnarsson**'s *Nordic Landscape Painting in the Nineteenth Century* (New Haven and London, 1998). See also the exhibition catalogue, *Dreams of a Summer Night*, ed. **L. Ahtola-Moorhouse, C. T. Edam** and **B. Schreiber** (London, 1986), and **Roald Nasgaard**, *The Mystic North: Symbolist Landscape Painting in Northern Europe and North America, 1890–1940* (Toronto, 1984).

For some other European national traditions in landscape art, see: **Otto Benesch**, 'The

Rise of Landscape in the Austrian School of Painting at the Beginning of the Sixteenth Century', *Konsthistorisk Tidskrift* 28 (1959), pp. 34–58; and **E. A. Angles** (trans. **E. J. Sullivan**), 'Landscape Painting in Spain during the Romantic Period', *Arts Magazine* 59 (October 1984), pp. 110–18.

Land Art
The fullest study to date is **Gilles A. Tiberghien**, *Land Art* (London, 1995). Smithson's various essays and interviews have been collected in **Nancy Holt** (ed.), *The Writings of Robert Smithson* (New York, 1979). There are interviews with a number of interesting figures in English and German Land Art in **Udo Weilacher**, *Land Art and Landscape* (Basel, 1996). See also **Alan Sonfist** (ed.), *Art in the Land: A Critical Anthology of Environmental Art* (New York, 1983). The preoccupation of the artist with absorption in the land is addressed in the interesting collection, **S. Cutts** and **D. Reason**, *The Unpainted Landscape* (London, 1987). On the work of Richard Long see **Rudi Fuchs**, *Richard Long* (New York and London, 1986). A useful retrospective evaluation is offered in **Jeremy Gilbert-Rolfe**, 'Sculpture as Everything Else, Twenty Years or so of

the Question of Landscape', *Arts Magazine* (January 1988), pp. 71–5. Two important essays are: **Rosalind Krauss**, 'Sculpture in the Expanded Field', *October* 8 (Spring 1979), pp. 31–44, and **John Beardsley**, 'Earthworks: The Landscape after Modernism', in *Denatured Visions: Landscape and Culture in the Twentieth Century*, ed. **S. Wrede** and **W. H. Adams** (New York, 1991), pp. 110–17. On the relationship between mapping and Land Art see the stimulating essay by **Stephen Bann**, 'The Map as Index of the Real: Land Art and the Authentication of Travel', *Imago Mundi: The International Journal for the History of Cartography* 46 (1994).

Some primary sources for landscape art
See **L. B. Alberti**, *De Re Aedificatoria* 9 (1485), Ch. 4; **C. Sorte**, *Osservazione nella Pittura* (1580); **G. P. Lomazzo**, *Trattate dell'Arte della Pittura* 62 (1584); **E. Norgate**, *Miniatura, or the Art of Limning* (*c.* 1639/40); **Carel van Mander**, *Het Schilder-Boeck* (1604); **Roger de Piles**, *Cours de Peinture par Principes* (1708); **William Gilpin**, *Three Essays* (1792); **P. de Valenciennes**, *Elémens de Perspective Pratique* (1799–1800); and **Carl Gustav Carus**, *Nine Letters on Landscape Painting* (1831).

Index